Painting Gender, Constructing Theory

The MIT Press
Cambridge, Massachusetts
London, England

Marcia Brennan

# Painting Gender, Constructing Theory

**The Alfred Stieglitz
Circle and American
Formalist Aesthetics**

Publication of this book has been assisted by a grant from the Millard Meiss Publication Fund of the College Art Association.

This book was set in Bodoni and Futura by Graphic Composition, Inc., Athens, Georgia, and was printed and bound in the United States of America.

Library of Congress Cataloging-in-Publication Data
Brennan, Marcia.
    Painting gender, constructing theory : the Alfred Stieglitz Circle and American formalist aesthetics / Marcia Brennan.
        p. cm.
    Includes bibliographical references and index.
    ISBN 0-262-02488-8 (hc. : alk. paper)
    1. Stieglitz Circle (Group of artists). 2. Stieglitz, Alfred, 1864–1946—Aesthetics. 3. Modernism (Art)—United States. 4. Gender identity in art. I. Title.

N6512.5.S75 B74 2001
709'.73'09042—dc21

00-046060

For Scott Brennan

# Contents

*Acknowledgments*

This study was guided and inspired by the teaching and scholarship of Kermit S. Champa. He taught me that intense critical analysis and methodological questioning could converge productively with a rigorous dedication to works of art. Professor Champa has been a constant source of patience and generosity as my work has developed. He has influenced this study in more ways than I can enumerate, not the least of which are through the kindness and flexibility which have sustained me through every phase of the project.

This study has also benefited immeasurably from the contributions of three other scholars. Dian Kriz and Carolyn Dean offered invaluable advice and assistance from the formative stages of the project. Dian Kriz taught me the value of maintaining the social and historical embeddedness of works of art. Carolyn Dean provided new ways to envision the intersection of subjectivity and aesthetics within a theoretical account of American modernism. Both repeatedly offered incisive and sympathetic responses to my work. Michael Leja provided detailed comments on the entire dissertation with which this study began, and on the revised version of the book's final chapter. He has been an extraordinarily generous and sensitive reader, and I have learned much from his extensive knowledge of modern art and from his trenchant theoretical insights.

Other scholars and friends have contributed substantively to the development of this study. For their many important suggestions and encouragement, I would like to thank Jay Clarke, Sarah Greenough, Estelle and Stuart Lingo, and Kathleen Pyne. In different but complementary ways, Maureen Meister and David Feigenbaum brought light to moments of darkness and helped me to see my way forward.

The bibliography of the Stieglitz circle is both rich and extensive, and I would like to acknowledge the works of other scholars who have contributed to the development of my thinking. Anne M. Wagner's remarkable study *Three Artists (Three Women): Modernism and the Art of Hesse, Krasner, and O'Keeffe* was published just before I completed my dissertation. The rigor and creativity of her arguments extended my ability to see and imagine unexpected expressions of identity and unconventional corporeal structures in the artworks of Georgia O'Keeffe and Lee Krasner. Barbara Buhler Lynes's meticulous research and the vast documentary base she has assembled have been indispensable to my study of O'Keeffe. Anna C. Chave's scholarship has repeatedly underscored for me the significance of the relationship between gender and power that threads through the history of art and informs O'Keeffe's artistic production. Jonathan Weinberg's pioneering study *Speaking for Vice: Homosexuality in the Art of Charles Demuth, Marsden Hartley, and the First American Avant-Garde* opened up new ways for me to approach issues of subjectivity and sexual difference in De-

muth's and Hartley's artworks. Finally, Debra Bricker Balken's exhibition and catalogue *Arthur Dove: A Retrospective* provided new insights on the range and development of Dove's artistic practice. While some of my arguments diverge notably from the ones advanced in these texts, and on occasion some authors and I have reached a similar point by way of a different path, in every instance I have learned much from their important works.

The research for this study was facilitated by the staffs of several libraries and museums. I would particularly like to thank Donald Gallup and Patricia C. Willis of the Yale Collection of American Literature, Beinecke Rare Book and Manuscript Library, Yale University; Philip N. Cronenwett, Special Collections Librarian, Dartmouth College Library; Corinne Woodcock, Executive Director, the Demuth Foundation, Lancaster, PA; Margaret Heilbrun, Library Director, the New-York Historical Society; Nancy S. MacKechnie, Curator of Rare Books and Manuscripts, Vassar College Libraries, and Joann Potter of the Frances Lehman Loeb Art Center, Vassar College; Patricia McDonnell, Kathleen M. Bennewitz, and Laura Muessig of the Frederick R. Weisman Art Museum, University of Minnesota; and the Boston office of the Archives of American Art, Smithsonian Institution. For the expert research assistance that I received at Brown University, I would like to thank Jean Rainwater, Rosemary Cullen, and Patricia Sirois at the John Hay Library, and S. Duane Davies and Charles E. Flynn at the Rockefeller Library. At the Museum of Art, Rhode Island School of Design, Maureen C. O'Brien and Lora Urbanelli first taught me to appreciate the candid beauty of works on paper.

The research for this study was supported by grants from the Samuel H. Kress Foundation; Mount Holyoke College; and the Department of History of Art and Architecture, Brown University. A grant from the Millard Meiss Publication Fund of the College Art Association has enabled me to include color reproductions of key Stieglitz circle artworks in this study.

Much of the writing of this book was undertaken while I was a Visiting Faculty Member at the Center for Interdisciplinary and Special Studies at the College of the Holy Cross, Worcester, MA. I am especially grateful to Ann Bookman for providing me with a

sense of continuity within this stimulating and supportive environ-
ment, and with the chance to present my work at an Interdisciplinary
Research Roundtable. I would also like to thank the undergraduate
students who have participated in my Holy Cross seminars; the
freshness of their perspectives has continually renewed my own
understanding of modernism. At Holy Cross, Michael Beatty has
been an ideal colleague. Perhaps most of all, Jody Ziegler's faith and
friendship have anchored me in numerous meaningful ways.

Mike Weaver graciously enabled portions of chapters 2 and 3 to
appear first in *History of Photography* (vols. 21 and 23, Summer
1997 and Spring 1999), and these sections are reprinted with the
permission of Taylor & Francis Ltd., Oxfordshire, England. In invit-
ing me to contribute to the anthology *Abstrakter Expressionismus:
Konstruktionen ästhetischer Erfahrung,* Roger Buergel provided me
with the valuable opportunity to think through some of the theoreti-
cal and methodological issues raised by Abstract Expressionism; his
comments helped to shape the final chapter of this study.

At the MIT Press, Roger Conover provided expert advice and
assistance. His belief in this project has been a continual source
of encouragement. Matthew and Janet Abbate brought consider-
able editorial skills and much sensitivity to the manuscript. Jean
Wilcox's fine sense of design is reflected throughout the book. My
gratitude also goes to the three anonymous readers whose many
constructive suggestions have substantially improved the quality
and readability of this text.

The friendship of Sara Goddard, Angela Katsos, and Julie Red-
mon has sustained and enlivened my work for so long. My parents,
Joan and Alfred Gagliardi, my sister Camille Gagliardi, and her
partner Marybeth Shay have also expressed a long-standing inter-
est in this project. I thank them for their love and support. Shortly
after the manuscript was completed we were blessed when my
beautiful niece and goddaughter Kelsey Shay entered the world.

Finally my husband, Scott Brennan, has accompanied me
through every phase of the research and writing of this study, and
his lively challenges and keen insights are reflected throughout its
pages. His constant presence has fundamentally enriched my life
and strengthened my work in ways too numerous to mention.

Painting Gender, Constructing Theory

*Introduction*

During the autumn of 1922 Alfred Stieglitz was busy making preparations for the first exhibition of Georgia O'Keeffe's artworks to be held in almost six years. Somewhat dramatically entitled "Alfred Stieglitz Presents One Hundred Pictures: Oils, Watercolors, Pastels, Drawings by Georgia O'Keeffe, American," the exhibition ran from January 29 to February 10, 1923, at the Anderson Galleries in New York. The show attracted a notable 500 visitors a day and yielded $3,000 in sales.[1] The effectiveness

of Stieglitz's promotional strategies was even acknowledged by
the New York press. Writing in the *New York Herald,* Henry Mc-
Bride informed his readers that Stieglitz "is responsible for the
O'Keefe [sic] exhibition in the Anderson Galleries. Miss O'Keefe
says so herself, and it is reasonably sure that he is responsible for
Miss O'Keefe, the artist."[2] As McBride's comments suggest, the
success of this show cannot be dissociated from Stieglitz's ef-
forts to make the artists he sponsored, O'Keeffe foremost among
them, uniquely compelling figures in the New York art world. How
he managed this is remarkable. Stieglitz and a number of well-
established critics with whom he worked characterized the sym-
bolic forms and abstract, painterly structures of their group's
artworks as aestheticized analogues of the artists' own gendered
presences.

In the critical statements that accompanied O'Keeffe's 1923
exhibition, for example, the suggestion was repeatedly made that
her paintings provided a type of privileged if symbolic access to
the forms, feelings, and impulses of the artist's own gendered
body. Paul Rosenfeld, an important art, music, and literature
critic, published such an early interpretive account of O'Keeffe in
*Vanity Fair* (October 1922). In an attempt to stimulate interest in
the show and provide an explanation of such innovative paintings
as *Blue and Green Music* (1919, fig. I.1) and *Inside Red Canna*
(1919, plate 1), which would be on display at the Anderson Gal-
leries later that winter, Rosenfeld wrote: "There are canvases of
O'Keeffe's that make one to feel life in the dim regions where hu-
man and animal and plant are one, indistinguishable, and where
the state of existence is blind pressure and dumb unfolding. There
are spots in this work wherein the artist seems to bring before one
the outline of a whole universe, an entire course of life, mysteri-
ous cycles of birth and reproduction and death, expressed through
the terms of a woman's body. For, there is no stroke laid by her
brush, whatever it is she may paint, that is not curiously, arrest-
ingly female in quality. Essence of very womanhood permeates
her pictures."[3]

In Rosenfeld's analysis, femininity is to be perceived in *all*
of O'Keeffe's brushstrokes, "whatever it is she may paint."

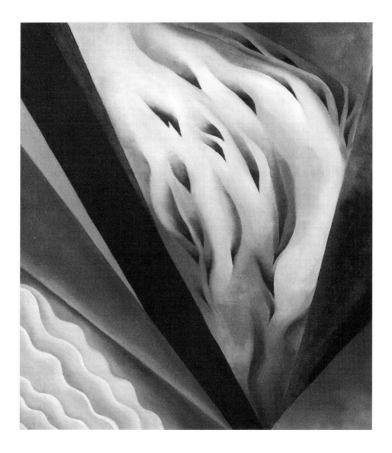

**I.1** Georgia O'Keeffe, *Blue and Green Music,* 1919. Oil on canvas, 58.4 × 48.3 cm. The Art Institute of Chicago, Gift of Georgia O'Keeffe to the Alfred Stieglitz Collection, 1969.835. Photograph ©1999 The Art Institute of Chicago. All rights reserved. ©2000 The Georgia O'Keeffe Foundation/Artists Rights Society (ARS), New York.

Significantly, such a critical description transcends any fixed iconographic reference points, functioning at the level of form itself. Rosenfeld elaborated on this conception of gendered form by noting that as "the widest plunges and the tenderest gradations play against each other, and fuse marvelously, so do severe, almost harsh forms combine with strangest, most sensitive flower-like shapes. In these masses there lives the same subtlety in bold strokes, the same profound effects in daintiness."[4] Thus, subjects as diverse as O'Keeffe's abstractions and her floral motifs were seen as united by similar compositional and thematic structures. Such an interpretation was informed by the critic's desire to read all of O'Keeffe's images through the gendered parameters of her "woman's body," whether the subjects she depicts are of human, animal, or plant life. At the same time, this interpretation is necessarily a metaphorical one, since O'Keeffe's abstracted artworks could never be mistaken for literal representations of the artist's own body. The conceptual shift that Rosenfeld and his colleagues effected between O'Keeffe's actual body and the gendered structures of her paintings allowed writers to substitute paint for flesh, an imaginative operation in which O'Keeffe's nonfigural images became infused with a ubiquitous sense of her femininity, and her images in turn were thought to offer transparent views into the symbolic "bodies" of her paintings. Yet Rosenfeld's critical account contains a curious ambivalence toward the body itself. This becomes evident as Rosenfeld expressed his admiration for O'Keeffe's "curiously passionate and yet crystallinely pure paintings."[5] According to this logic, O'Keeffe's paintings could be read as "passionate" *and* "pure," as sensuously corporeal *and* aesthetically transcendent, a configuration of meanings that allowed Rosenfeld to incorporate two seemingly contradictory associations into a single pictorial field.

This type of analysis elicited comments from writers who were not themselves members of Stieglitz's group. When reviewing O'Keeffe's 1923 exhibition for the *Brooklyn Daily Eagle*, Helen Appleton Read expressed her reservations about the Stieglitz circle's efforts to transform paintings into "living human documents." Yet Read herself proved quite willing to attribute

psychoanalytic meanings to O'Keeffe's nonfigural works. Responding to a statement written by Marsden Hartley, another artist closely affiliated with Stieglitz, Read observed that "the question comes up as to whether the average intelligentsia, without Stieglitz's sponsorship and Hartley's foreword, would 'get' these emotional abstractions. For some these living human documents are an open book, into which, having been given the key, we read perhaps more than the artist intended. To others the shameless naked statements are too veiled to be anything but rather disturbing abstractions. To me they seem to be a clear case of Freudian suppressed desires in paint."[6]

Rosenfeld, Hartley, and Read were not the only writers to locate provocative meanings in O'Keeffe's artworks. In 1923 two other members of Stieglitz's circle publicly expressed their perceptions of O'Keeffe's gendered artistic practice. In a letter published in the New York *World,* the photographer Paul Strand attempted to draw visitors to the O'Keeffe exhibition: "Here it is that the finest and most subtle perceptions of woman have crystallized for the first time in plastic terms, not only through line and form, but through color used with an expressiveness which it has never had before, which opens up vast new horizons in the evolution of painting as incarnation of the human spirit."[7] The essayist and critic Herbert J. Seligmann was even less reserved in his interpretation of O'Keeffe's paintings. Echoing Rosenfeld's earlier appraisal, Seligmann claimed that in O'Keeffe's images, "The body knows tree and fruit, breastlike contour of cloud and black cleaving of lake shore from water's reflection—all things and shapes related to the body, to its identity become conscious." Seligmann further asserted that O'Keeffe's abstract and naturalistic forms were mediated by the artist's direct knowledge of her own body. Referring to images such as *Blue and Green Music*, Seligmann concluded, "She has made music in color issuing from the finest bodily tremor in which sound and vision are united."[8]

In certain respects, such critical descriptions can be related to the pictorial qualities of O'Keeffe's paintings themselves. *Blue and Green Music* seems to contain a suggestive hybrid of abstract and organic forms. Linear, almost prismatic diagonals converge

along the bottom edge of the canvas as if to enclose a soft, rippling field of blue and green wisps that curl upward into tendrillike forms. Similar spatial structures and thematic transitions are visible in *Inside Red Canna*. This floral image is a tonal study in reds, pinks, oranges, and browns, with contrasting shades concentrating dramatically at the center of the composition. In both *Blue and Green Music* and *Inside Red Canna*, the viewer's gaze is directed downward into dark, intersecting structures only to be drawn back up into a cascade of vibrant, intermingling curves. The very title *Inside Red Canna* locates the viewer within this dynamic visual trajectory. The spectator is presented with an enlarged view of the canna's exterior forms as well as a privileged glimpse into the flower's interior regions. Thus the viewer is offered the possibility of looking *at* the canna and *inside* it at once, a mobile perspective that ostensibly dissolves the boundaries between interiority and exteriority. When such images become rhetorically invested with associations of the sensuous transparency of O'Keeffe's own gendered body, the paintings serve as screens onto which conceptions of an aestheticized, biomorphic eroticism can be imaginatively projected. Significantly, Rosenfeld himself owned one of O'Keeffe's red canna lilies.[9]

Yet the sensation surrounding the O'Keeffe exhibition can be attributed not only to the suggestive formal qualities of her paintings and the often fervent critical rhetoric that accompanied them. In fact, the 1923 show was not the first time that Stieglitz had publicly "presented" Georgia O'Keeffe to the New York art world. He had exhibited her works twice before at his first and pioneering art gallery at 291 Fifth Avenue, the Little Galleries of the Photo-Secession. Stieglitz had also presented selections from his composite photographic portrait of O'Keeffe in a retrospective exhibition of his works that was held at the Anderson Galleries in 1921. Grouped under the heading "A Demonstration of Portraiture," the exhibition featured 45 images of O'Keeffe, including various nude studies of the artist, many of which depicted aestheticized fragments and details of her body (figures 3.5–3.7). While Stieglitz's images were not actually on display at O'Keeffe's exhibition, lingering memories of these striking photographs permeated

O'Keeffe's show and shaped the atmosphere in which her own paintings were received.[10] As if to reinforce these associations still further, Stieglitz followed up O'Keeffe's 1923 show with an exhibition of 116 of his own photographs, including 25 new portraits of O'Keeffe as well as a sequence of ten of his latest photographic subject, studies of clouds (figure 2.6).

The Anderson Galleries exhibitions suggest some of the ways in which representations of the body served as a primary vehicle of signification within Stieglitz's modernist project, as corporeal elements often became conjoined with abstract and naturalistic forms. The result of these operations was a discursive tendency that I will call embodied formalism. From the mid-teens until the photographer's own death in 1946, conceptions of gender and human embodiment were repeatedly associated with the works of the five Stieglitz circle artists, a group that included Charles Demuth, Arthur Dove, Georgia O'Keeffe, Marsden Hartley, and John Marin. In critical descriptions of their works, writers close to Stieglitz often drew on the observations of the British sexologist Havelock Ellis and the psychoanalytic theories of Sigmund Freud to establish period conceptions of the heterosexual man and woman and the homosexual man. When these subject positions became paired with the artists' own works, the often dramatic result was a gendering of form itself. Painterly elements such as line, color, and composition were assigned sexual roles that played out in specific ways for each artist. These associations ranged from the viewer's supposed ability to perceive O'Keeffe's abstracted images as veritable gestalts of her femininity, to the imaginative capacity to see the world directly through John Marin's eyes, to the prospect of experiencing kinesthetically the intersubjective desires purportedly embodied in Arthur Dove's organic forms or Marsden Hartley's still lifes. Thus the term "embodied formalism" denotes a type of circular logic whereby gender provided critics with a means to discuss actual and symbolic bodies, and in turn such conceptions of embodiment enabled writers to ascribe gendered characteristics to abstract painterly forms. The novelist and cultural critic Waldo Frank described this sense of intercorporeal and aesthetic merger in his study *The*

*Re-discovery of America* (1929) when he observed that the "sense of aesthetic form is an unconscious adumbration of our sense of unity with our own body."[11] Notwithstanding the differences between the Stieglitz circle artists individually, such a unified theoretical approach to their artworks provided a sense of coherence to Stieglitz's overall group project. Indeed, one of the significant implications of the Stieglitz circle's critical history is that it clearly establishes that formalist discourse in America had profoundly gendered underpinnings that can be traced throughout the course of its development, as ostensibly "pure" formal elements were repeatedly discussed in sometimes explicit, and sometimes veiled, sexual terms.

In various ways the Stieglitz circle was at once promoting an innovative discourse and maintaining a connection to important precedents in American modernism. As Kathleen Pyne has shown, during the later nineteenth century several leading American artists, including John La Farge, James McNeill Whistler, and Thomas Dewing, drew on images of women and associations of the feminine to convey an elevated sense of spirituality and the sacred. By dematerializing the female body, these artists sought to promote a progressively oriented vision of higher consciousness and advanced civilization.[12] The trajectory that Pyne has identified, in which artists transform sublimated corporeality into idealized aesthetic expression, is one that the Stieglitz circle artists both extended and reversed in their own conceptions of embodied formalism. That is, while Stieglitz and his affiliated critics characterized their group's artworks in almost sensationally eroticized terms, the images ultimately stood as representations of aestheticized and sublimated corporeality.

The issue of aesthetic transparency, which would be so crucial in Stieglitz circle discourses, can be traced to a concept that was initially expressed by the critic James Gibbons Huneker. All but forgotten today, during the first two decades of the twentieth century Huneker was arguably the most influential fine arts critic in America. Through his art, music, drama, and literary criticism, he played a key role in forming particular notions of modernism in the United States. In his numerous journalistic essays and in the

more than seventeen books that he published between 1899 and 1921, Huneker introduced a wide variety of artistic subjects to an American audience. His topics ranged from Ibsen's dramas to Nietzsche's philosophy, from Cézanne's paintings to Richard Strauss's musical compositions.

While discussing Ibsen's plays in 1905, Huneker expressed an early conception of transparency in modernist aesthetics. The critic characterized Ibsen's works as "soul dramas," not only because they stirred the souls of their audience, but because the souls of the protagonists were often at stake in the plots of the dramas. When describing the intensely charged atmosphere of Ibsen's plays, Huneker drew on the metaphor of a room with an absent fourth wall. He wrote: "An open door to the chamber of the spirit is Ibsen. Through it we view the struggle of souls in pain and doubt and wrath. He himself has said that the stage should be considered as a room with the fourth wall knocked down so that the spectators could see what is going on within the enclosure. A tragic wall is this missing one, for between the listener and the actor there is interposed the soul of the playwright, the soul of Ibsen, which, prism-like, permits us to witness the refractions of his art. This open door, this absent barrier, is it not a symbol?"[13] According to Huneker, the missing "fourth wall" functioned as a kind of aperture that provided viewers with a means of accessing works of art that are not purely representational, but present intimate views of emotional states. Just as Stieglitz and his critics would later collapse the conceptual boundaries between artists and their works, here Huneker expressed the notion that the spiritual essence of the playwright *and* of his characters were "transparently" visible in Ibsen's modern dramas. Yet Huneker strategically combined this elevated conception of aesthetic transparency with the potential for a powerful voyeuristic appeal.

Notably, Huneker applied this principle to his analyses of modern art, including the critical reviews of the groundbreaking modernist exhibitions that Stieglitz held at 291. In his review of the first one-man show of Pablo Picasso's work in the United States (1911), Huneker wrote: "To a vision like Picasso's the external of the human form is only a rind to be peeled away. At times

he is an anatomist, not an analyst; the ugly asymmetry of the human body is pitilessly revealed, but as a rule he abstracts the shell and seeks to give shape and expression to his vision."[14] According to Huneker, Picasso's figure studies are literal examples of corporeal transparency as the artist exteriorizes interior visions and structural forms. While Huneker generally found Picasso's works to be ugly, he considered Henri Matisse's female figures to be intensely provocative. In his review of Matisse's first exhibition in the United States (1908), the first of three Matisse shows that Stieglitz would hold at 291, Huneker dramatically described his reaction to the artworks. He recounted that "with three furious scratches [Matisse] can give you a female animal in all her shame and horror. . . . There is one nude which the fantasy of the artist has turned into a hideous mask. The back of a reclining figure is on the wall opposite, and it is difficult not to applaud, so virile and masterly are its strokes. Then a creature from God knows what Parisian shambles leers at you—the economy of means employed and the results are alike significant—and you flee into another room."[15] Huneker's critical response is meant to seem spontaneous, suggesting an encounter so vividly charged that it erases any barriers between the depicted women and their audience. In this manner Huneker was able to conflate a connoisseurial appreciation of Matisse's spare linear compositions with the excitement of a voyeuristic glimpse into the "Parisian shambles."

Huneker's characteristic emphasis on the titillating aspects of modern art distinguished his progressive art criticism from the discourses of the early European formalists. The latter group of writers tended to exclude any considerations of gender or sexuality, and to focus instead on an artwork's abstract visual structures. One of the earliest such writers was Conrad Fiedler, a German theorist who in 1876 published a tract entitled *On Judging Works of Visual Art*. In this text Fiedler expressed his belief in pure visibility, or in the concept that artworks are reflections of the artist's consciousness, which becomes manifested through the visible appearance of their forms.[16] A similar emphasis on abstract stylistic principles threads through the texts of Heinrich Wölfflin and Wilhelm Worringer. In *Classic Art: An Introduction to the Italian Re-*

*naissance* (1898) Wölfflin undertook a categorical analysis of Renaissance artworks based on their formal properties. This approach led to the development of a set of oppositional stylistic terms that Wölfflin later systematized in *Principles of Art History* (1916).[17] Similarly, in *Abstraction and Empathy* (1908) Worringer identified a number of interrelated stylistic dichotomies in order to establish a framework for the development of abstract form. In particular, Worringer related artistic production to climatic and geographical factors, an approach that enabled him to distinguish what he perceived as a Northern tendency to withdraw from a hostile environment and produce abstract forms from a Southern proclivity toward the empathetic embrace of the landscape and the visual reproduction of its organic motifs.[18] In England notions of empathy and abstraction became elaborated by the Bloomsbury writers Vernon Lee (pen name of Violet Paget) and Roger Fry. Lee was responsible for translating and popularizing key elements of Theodor Lipps's empathy theory, which she described in two successive studies of 1912 and 1913 as a bodily and psychic response to images based on the quasi-mystical projection of the creative ego into the artwork.[19] Fry, in contrast, dissociated art from the domain of lived experience and linked aesthetics instead to the ideals of pure vision and emotion. Emphasizing the abstract, decorative elements of design, Fry identified as art's purpose an experience of imaginative contemplation that was valued in and of itself.[20]

In contrast to the early formalists, Huneker drew liberally on a range of ideas that he adapted from symbolist, aesthete, and decadent writers. Huneker's literary influences include Baudelaire, Huysmans, the Goncourts, Wilde, Pater, and, above all, Nietzsche. Much like these writers, Huneker was attraced not by an artwork's formal "purity" but rather by its "impurity," those exciting and ambivalently charged qualities that incited not disinterested intellectual contemplation but passionate human response. This ideal was perhaps most forcefully expressed in Huneker's image of the absent fourth wall, with its implicit promise of unimpeded (if ultimately fictive) contact. Finally, there is some further context for the Stieglitz circle's gendering of organic

forms within the symbolist movement itself. During the 1890s the symbolist artists equated a modern artistic style with natural forms, private interior spaces, and fluid, curving lines. These pictorial elements became linked to discourses on femininity and reproduction, as well as to an impulse to visualize inner psychological states in works of art and interior decoration.[21] Despite these similar thematic preoccupations, the advent of fully abstract painting and the American avant-garde's commitment to promoting a viable national culture contributed substantially to distinguishing Stieglitz's modernist project from its symbolist predecessors.

As an art critic for several major newspapers, Huneker was a frequent visitor to 291, and his reviews were often reproduced in the gallery's house organ, *Camera Work*. While Huneker's eclectic ideas never quite solidified into a consistent aesthetic program, his writings had a tremendous discursive momentum, key elements of which became systematized in Stieglitz circle discourses. Perhaps the most significant of these is Huneker's and Stieglitz's shared commitment to a progressive modernist aesthetics that offered the potential for direct, quasi-physical contact between artworks and their audience. Just as Huneker's absent fourth wall served to make works of art accessible to and even inclusive of their audience, so did the Stieglitz circle's notion of aesthetic and corporeal transparency, or the desire to read paintings as "living human documents," to paraphrase Helen Appleton Read. By the later 1940s, however, such inclusive dynamics of formal and corporeal merger would be superseded by a closed system of autotelic self-containment and a thematics of aggressive masculine accomplishment. These changes coincided with the slowing down of the aging Stieglitz's gallery activities, and the rise of Clement Greenberg as a powerful advocate of New York School art and a vociferous critic of Stieglitz.

In the theoretical writings that he published during the 1940s, Greenberg reformulated the precepts of the late Enlightenment philosopher Immanuel Kant to assert that advanced modern art is guided by the principle of self-criticism. As a result, Greenberg posited that a work of art is properly engaged with the

specific nature and limitations of its own medium. In the case of painting, these elements included the flatness of the supporting surface and the primacy of the artistic medium itself.[22] In an important sense, Greenberg's emphasis on the autoreferential dimension of modernist aesthetics can be seen as a variation on Huneker's concept of the fourth wall. Such comparisons are perhaps most apparent in Greenberg's critical accounts of Jackson Pollock, the most prominent of the New York School artists. During the forties and early fifties Greenberg repeatedly characterized Pollock's paintings as inviolable presences that are monumentally cohesive and hermetically sealed. For example, in February of 1952 Greenberg wrote of Pollock's drip paintings (such as figures 8.1 and 8.5) that "each picture is the result of the fusion, as it were, of dispersed particles of pigment into a more physical as well as aesthetic unity—whence the air-tight and monumental order of his best paintings of that time."[23] Like Stieglitz, Greenberg promoted a conception of formalism that was based on a strong dialectic of embodiment and transcendence. Yet Greenberg foreclosed the very conditions for aesthetic and intersubjective merger that Huneker and Stieglitz had valued so highly. By 1946 Greenberg dismissed Stieglitz circle artworks as "private fetishes with secret and arbitrary meanings," while the following year he praised Pollock as an artist whose "strength lies in the emphatic surfaces of his pictures, which it is his concern to maintain and intensify in all that thick, fuliginous flatness."[24]

In addition to revising Stieglitz's embodied formalist model by substituting emphatic painterly density for aesthetic transparency, during the forties Greenberg also strategically appropriated John Marin as a direct predecessor to Pollock. In January of 1948, a mere eighteen months after Stieglitz's death, Greenberg asserted that, "since Marin—with whom Pollock will in time be able to compete for recognition as the greatest American painter of the twentieth century—no other American artist has presented such a case [of artistic originality]. And this is not the only point of similarity between these two superb painters."[25] In short, during the forties Greenberg reworked key components of Stieglitz's artistic project in order to secure support for his own account of

American formalist aesthetics. In part, he accomplished this by reverting to an earlier, Enlightenment-based conception of closed, autonomous subjectivity, one that replaced the Stieglitz circle's "liberated" notions of uninhibited creative expression and intersubjective merger. By 1950 Huneker's absent fourth wall and the Stieglitz circle's concept of corporeal transparency had given way to Greenberg's autoreferential system of internal criticism and impenetrable, flat surfaces. With the aid of Kant, Greenberg had effectively rebuilt the fourth wall in formalist aesthetics.

With these themes in mind, this study is divided into three sections. Part I establishes the historical and cultural context for the modernist program that Stieglitz implemented from the 1920s onward. During the first two decades of the century, various intellectuals and cultural commentators lamented what they considered to be America's oppressive Puritan heritage, with its pervasive Victorian influences still present in contemporary life. In 1919 Waldo Frank drew on these historical prototypes to describe the motivations of the avant-garde artists and writers who had recently come to New York. According to Frank, "What they have found wanting is precisely the pioneer existence, the Puritan culture which their Fathers have set up." Instead, they "are the seekers of a world nearer their heart . . . who desire to create a world of their own to live in."[26] The Stieglitz circle writers often combined anti-Puritan rhetoric and appeals for sexual liberation with the expressed belief that these progressive attitudes would foster a vital new American art. Yet just as the calls resounded for a viable national culture, the second decade also saw the outbreak of the Great War and the rise of New York as a center of international modernism. Positioned in the thick of these concurrent developments, Stieglitz experienced initially friendly, and later conflicted, relations with the New York Dada movement. The cool, nihilistic humor and sterile, mechanomorphic figures routinely featured in Dada artworks provided a compelling antipode to the sense of generative organicism that Stieglitz envisioned for modern art. After the closing of 291 in 1917 and his brush with New

York Dada, Stieglitz developed close personal relationships with Paul Rosenfeld and Waldo Frank, the two critics who would be the most powerful champions of Stieglitz's later modernist project. Part II examines the specific ways in which the embodied formalist discourses advanced by Rosenfeld, Frank, and others were applied to each of the five Stieglitz circle artists, and how, in turn, such conceptions of gender and artistic identity served to secure each artist's position within Stieglitz's overall group project. Finally, part III considers the challenges that the Stieglitz circle faced from rival artistic movements during the 1930s and 1940s, all of whom competed for recognition and prestige in the ever-more-protean New York art world. Chief among them were Thomas Hart Benton's regionalist art and Clement Greenberg's reformulation of formalism. Despite the considerable differences between regionalist and abstract expressionist art, both groups claimed that their artworks supplanted those of the Stieglitz circle as the most compelling and viable embodiments of the ideal American subject.

In reconstructing a critical trajectory from the Stieglitz circle to Greenberg, I trace crucial transitions in American formalist aesthetics, as eroticized abstractions and modes of symbolic interpersonal joining ultimately became displaced by an emphasis on heroic individual accomplishment and a thematics of containment and boundedness. It is my hope that, by placing such an emphasis on gender and subjectivity, this study will contribute to the larger project of rethinking the very meaning and significance of formalist criticism, particularly formalism's relation to embodiment and transcendence, and the unexpected theoretical possibilities that emerged within this discourse historically.

Part I

# Embodied Formalism:

## The Formation of a Discourse

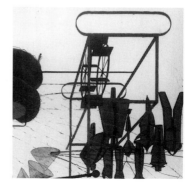

# Puritan Repression and the Whitmanic Ideal:

## The Stieglitz Circle and Debates
## in American High Culture, 1916–1929

Paul Rosenfeld deeply admired the earthy yet aestheticized qual-
ities of Arthur Dove's paintings. When preparing his article on
American art for the December 1921 issue of *The Dial*, Rosenfeld
drew directly on his firsthand knowledge of Dove's works in
Stieglitz's personal art collection. With images such as *Cow* (c.
1912–1913, fig. 1.1) in mind, Rosenfeld wrote, "Dove, too, to-
gether with his great delicacy and tenderness, exhibits a grasp of
the whole of life, takes in the animal with the spiritual, the gross

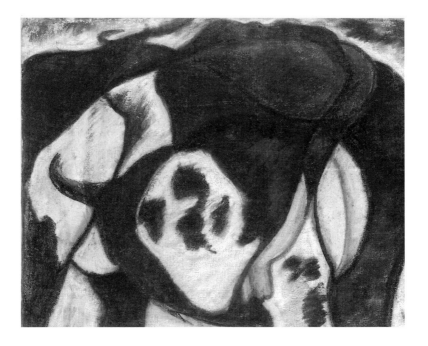

**1.1** Arthur G. Dove, *Cow*, c. 1912–1913. Pastel on linen, 17 ¾ × 21 ½ in. The Metropolitan Museum of Art, Alfred Stieglitz Collection, 1949.

teeming earth with a translucent sky."[1] As would be the case the following year in his articles on John Marin and Georgia O'Keeffe in *Vanity Fair*, here Rosenfeld characterized Dove's images as integrated expressions of flesh and the spirit, in this instance of ethereal translucency and animal corporeality. Yet Rosenfeld viewed Dove's interweaving of formal and thematic oppositions not simply as an aesthetic accomplishment, but as the realization of a larger ideal of liberated selfhood, one that was based on a full acknowledgment of the body. As Rosenfeld put it: "After having seen so much art made exclusively by man and for man as bourgeois society has chosen to view him, it is good to see work that, like this, is made with the full consent of the portions of the human frame which middle-class society is eager to ignore and forget. No vulgar laughter is here; no shamefulness and guilt, no titillation. Only the great udders and hairy flanks of nature; animals at their business of feeding; cows, calves, goats."[2] According to the critic, immersive contact with the earth and its creatures has resulted in a wholeness in the artist's sense of self, one which becomes expressed in Dove's organic imagery. Thus in the abstracted, interlocking, brown and white spotted patterns of Dove's *Cow*, Rosenfeld saw the artist transcending the boundaries of bourgeois propriety, with its polite dictates of corporeal disavowal, and embracing instead those "portions of the human frame which middle-class society is eager to ignore and forget."

Rosenfeld's discussion of Dove is typical of the ways in which the Stieglitz circle writers described their group's artworks as sites of intersubjective joining, in this case the merger of the human body with the natural world. This positive artistic vision was, however, forged in part as a polemic against the perceived inhibitions and restrictions of bourgeois society. During the teens and twenties the Stieglitz circle and various other members of the avant-garde claimed that America's "Puritan" heritage, with its lingering Victorian influences, was responsible for the pervasive sense of repression that they felt characterized contemporary social and cultural life. In contrast, many believed that only through liberated sexual and artistic expression could America finally produce a vital national culture.

While the Stieglitz circle's themes were thus consistent with ideas expressed in contemporary cultural discourses, during the twenties the Stieglitz circle in general, and Paul Rosenfeld in particular, drew a substantial amount of derision from rival artistic groups. A number of young writers, including Hart Crane, Gorham Munson, and Malcolm Cowley, publicly repudiated the Stieglitz circle for deploying communal rhetoric about organicism and Americanness to advance what they considered to be an elitist artistic agenda. Critics of the Stieglitz circle argued that its embodied formalist discourse was hopelessly mired in its own contradictions, since it promoted artworks that were somehow fertile yet pure, earthy yet clean, embodied yet aestheticized, and collectively "American" yet uncompromisingly exclusive in their intended appeal.[3]

## The Great American Sexquake:
## Anti-Puritanism and the Call for Sexual Liberation

As noted in the introduction, an important precursor to the Stieglitz circle's notions of aesthetic and corporeal transparency can be found in the art criticism that James Gibbons Huneker published during the first two decades of the century. Huneker's innovative concept of removing the "fourth wall" that separated the spectator from the interior domains of painting and drama established a crucial precedent for the avant-garde's slightly later project of overcoming the barriers of personal restraint and conventional morality that inhibited full creative expression. In these respects, Huneker was a pioneer not only in his early critical advocacy of advanced European and American modernism, but in his conception of a liberated modern self that combined a progressive stance against Puritanism with an appeal for sexual liberation.

The themes of "decadent," unrestrained sexuality coupled with triumphant aesthetic achievement are evident in Huneker's novel *Painted Veils* (1920). Set in the New York music world, *Painted Veils* is an autobiographical work loosely disguised under

a thin layer (or "veil") of fiction.[4] One of the story's principal characters is Easter (or "Istar") Brandes, a beautiful and highly successful Wagnerian opera singer and a cold-blooded seducer of all whom she desires. Arnold Schwab, Huneker's biographer, has noted that the character of Easter was based primarily on two singing actresses with whom Huneker himself was intimately acquainted, Olive Fremstad and Mary Garden.[5] Huneker also presented partial self-portraits in the figures of Alfred Stone, a hard-drinking, cynical music critic, and Ulick Invern, a non-drinking, womanizing theater critic. Like the author himself, Huneker's characters are self-proclaimed Egoists, Supermen in the Nietzschean sense. Invern is a "failed" Puritan who becomes a rake; Stone is a loquacious misogynist. In a voice that could well be Huneker's own, Stone at one point proclaimed, "Women don't think with their heads, they think with their matrix. They are too damned emotional. They are the sexual sex. . . . Putting an idea in their heads is like placing a razor in the hands of a child."[6]

While such unabashedly misogynistic attitudes may be difficult to accept today, in his own time Huneker's vivacious writing style and his *bon vivant* persona earned him a devoted following. One of Huneker's disciples was the acerbic Baltimore newspaperman H. L. Mencken. In 1917 Mencken summed up his mentor's achievements as a crusade against Puritanism and American provinciality: "If the United States is in any sort of contact today, however remotely, with what is aesthetically going on in the more civilized countries—if the Puritan tradition, for all its firm entrenchment, has eager and resourceful enemies besetting it—if the pall of Harvard quasi-culture, by the Oxford manner out of Calvinism, has been lifted ever so little—there is surely no man who can claim a larger share of credit for preparing the way."[7]

As art critic for the New York *Sun* as well as other major newspapers, Huneker reviewed a number of exhibitions that Stieglitz sponsored at 291. The two men seem to have maintained congenial professional relations. In 1914 Huneker appreciatively characterized Stieglitz as "still the enthusiast and rebel against the provinciality of American ideas in the region of art. He has fought a good fight, and for the sheer love of art; for the profit of his soul

and not of his pocket. An idealist born, not made."[8] The following year Stieglitz praised Huneker as "one of the very few writers in this country who knows what he's writing about."[9] Despite such cordialities, Huneker soon became one of the most prominent targets who had to be toppled in order for a new generation of critics to emerge. In Waldo Frank's influential study of American social and artistic life, *Our America* (1919), the younger critic attempted to do just this. Like Mencken, Frank acknowledged Huneker's pioneering efforts to bring a knowledge of European art and culture to an American audience. Yet according to Frank, Huneker's critical judgments often lacked substance and amounted only to clever or trivial observations. As a result, Huneker's writings merely satisfied American intellectuals' "hunger for spice" and "search of snobbery": "To supply this need, there arose a school of criticism which was in reality a school of gossip. Its master was James Gibbons Huneker." In short, Frank characterized Huneker as little more than a purveyor of European delicacies to an audience no longer satisfied with "the obsessive beat of American life, the dominant Puritan mind."[10]

By downplaying the seriousness of Huneker's achievements, Frank was able to assert that his friend and colleague Paul Rosenfeld had superseded Huneker in the field of criticism because, instead of leading his readers to European art, Rosenfeld directed their attention back to America. Regarding Huneker and his followers, Frank wrote: "In the advent of such critics as Paul Rosenfeld we understand that their day is over. . . . Rosenfeld could take his heart, together with his mind, to Europe, without danger of loss to his American nature. So he did. And now, as opposed to Huneker, his struggle is to bring back his conscious mind to his own land." Thus while Huneker's critical judgments were seen as superficial and indiscriminate, Rosenfeld's were characterized as genuine and profound, guided by "a discipline of taste."[11]

In *Our America* Frank had strategically, and somewhat misleadingly, minimized Huneker's role in promoting American art. In fact, between 1907 and 1912 Huneker wrote a number of important articles on American subjects, including reviews of the group of painters known as "The Eight" as well as the young

American artists whose work Stieglitz showed at 291.[12] Frank's telling omission suggests that the Stieglitz circle writers attempted to establish their own critical reputations by conveniently dismissing the older generation's interest in American modernism, thus leaving the younger critics free to assume the role of primary advocates of an underrecognized and virtually undiscovered American art.[13]

Given their shared preoccupations with aesthetics and the body, it is not surprising that writers later compared Huneker and Rosenfeld rather closely. In 1948 Edmund Wilson recalled: "Paul told me . . . that the point when he had felt his maturity was the moment when he realized with pride that he could turn out as good an article as Huneker; but actually he was better than Huneker, who, useful though he was in his role, always remained a rather harried journalist, trying to produce a maximum of copy in order to get money to go abroad. . . . Paul Rosenfeld seemed the spirit of a new and more fortunate age, whose cosmopolitanism was not self-conscious and which did not have to be on the defensive over its interest in the variety of life."[14] The critic Van Wyck Brooks also commented on the parallels between Huneker's and Rosenfeld's careers in his memoir *Days of the Phoenix: The Nineteen-Twenties I Remember:* "Like Huneker, who said he had always rejoiced when he caught the first glow of a rising sun, Paul too was a yea-sayer who had much in common with this earlier star-finder of the various arts. But while Huneker had discovered, for America, European talents, Paul found these talents at home, and few of his swans turned out to be geese, for he saw in his own time what others were to see twenty years later."[15] Despite their differences, many writers viewed Rosenfeld as the inheritor of Huneker's critical legacy. After Huneker's death in 1921, Rosenfeld became the afterimage of the critic that persisted in the New York press. In this milieu Rosenfeld was both hailed and attacked as the chief proponent of aesthetic criticism in its new, embodied formalist incarnation.

Huneker's and Rosenfeld's joint attacks on America's Puritan heritage can be situated within the larger appeals for a release from repression that were articulated by various American

intellectuals during the first decades of the century.[16] At the time, lingering Victorian inclinations toward materialism, convention, prudery, and gentility were placed under the general rubric "Puritanism" and identified as socially and culturally inhibiting forces. As Nathan G. Hale has observed, around 1912 many young intellectuals, including Waldo Frank, Randolph Bourne, and Floyd Dell, conflated Victorian and Puritan types in order to attack received notions of morality and provincialism in American culture.[17] Similarly, Frederick J. Hoffman has noted that, in Greenwich Village parlance, the term Puritan became "separated from its historical context and extended to include almost all of the guardians of the nation's morality and business. The sinful virtues of the founding fathers had been visited upon their sons, who were tainted with the original sin which no baptism could remove. In a word, the nation had fallen victim to a serious moral illness—repression. The Puritan had 'repressed' all normal reactions to sensible living, and as a result his descendants were sex-starved, puerile, and pitiful. Materialism had pushed aside normal life as inexpedient and had substituted Success for sex."[18]

One of the earliest such references to Puritanism can be found in the writings of the historian and scholar Henry Adams. In his autobiography *The Education of Henry Adams* (1907), Adams lamented the omnipresent Puritanism in American culture. As he put it, "Any one brought up among Puritans knew that sex was sin. In any previous age, sex was strength."[19] A few years later the journalist Benjamin De Casseres, another of Huneker's followers, noted a shift in Americans' attitudes toward sex. In 1914 he flamboyantly described their newborn resistance to Puritan morality as "The Great American Sexquake": "The great natural disturbance today in the United States is the sexquake. We have had earthquakes and Billy Sunday; but the sexquake is the most interesting disaster that has yet befallen us. We are sex-mad. It was in 1620 at Plymouth Rock that we were bottled up; and now some of the healthy human instincts that refuse to sit down and be good for long have burst their prison walls and are flowing down the gutters of our sensibility into the open."[20] The phenomenon that De Casseres identified in American life did not immediately

translate to the arts. In his 1920 essay on "The National Letters," H. L. Mencken attributed the thin, passionless character of American literature to a Puritan legacy that valued morality and virtue above all else.[21] Along these lines, in 1925 the poet William Carlos Williams mounted one of the most eloquent critiques of Puritanism. In his fictive account of American history, *In the American Grain*, Williams wrote that modern man lives with the legacy of Puritan morality. As a result, he routinely experiences sexual repression, inner conflict, and emptiness. Using history as a springboard for social commentary, Williams questioned: "Is there another place than America (which inherits this [Puritan] tradition) where a husband, after twenty years, knows of his wife's body not more than neck and ankles, and four children to attest to his fidelity; where books are written and read counseling women that upon marriage, should they allow themselves for one moment to *enjoy* their state, they lower themselves to the level of the whore? Such is the persistence of this abortion of the mind, this purity."[22]

For the Stieglitz circle writers, invoking the specter of "Puritanism" served as a highly effective rhetorical strategy because it implicitly called for its opposite—a sexually liberated and aesthetically generative American art. Waldo Frank drew on these thematic juxtapositions in *Our America* when he identified the ethos of the Puritan and the pioneer as predicated on the principle that spiritual and material progress were best accomplished through "the suppression of Desire."[23] In 1924 Herbert J. Seligmann implicitly contrasted America's sterile Puritan heritage with the Stieglitz circle's vital American modernism in his study of the English author D. H. Lawrence. Responding to critical opinions that Lawrence had expressed the previous year in *Studies in Classic American Literature* (1923), Seligmann asserted that, despite the pathologies of "sexless Puritan America," there are "things done in America that are not known to the multitude. They happen to be achievements not in literature, but in painting and photography. . . . They come out of the pioneers in the American wilderness of today who are fighting for the life of the soul. They are fighting and waiting."[24] Although he didn't mention the Stieglitz circle artists by name, Seligmann's book was dedicated

to Stieglitz and its message was clear. Much like Lawrence's literature, the Stieglitz circle's paintings and photographs were identified as the panacea for the failures of puritanical, materialist America. While Lawrence himself shared key values with the American avant-garde, including the belief in an organic community and in the wholeness of nonrepressed selfhood, the author maintained that the "new American" was yet unborn.[25]

## Purified Organicism:
## Alfred Stieglitz and the Whitmanic Ideal

While jeremiads on Puritan repression represented the negative aspect of the avant-garde's appeal for sexual and artistic liberation, various references to Walt Whitman constituted the positive side of this discourse. In the ongoing search for usable artistic and historical traditions, the Stieglitz circle and many other members of the American avant-garde embraced Whitman's poetry as a uniquely promising model of such uninhibited creative expression. Van Wyck Brooks made the links between Puritanism and Whitmanism explicit in his 1915 study *America's Coming-of-Age.* In this book Brooks coined the terms highbrow and lowbrow to characterize the split in American cultural identity between high-minded idealism and the practical realities of the business world. Brooks cited the Puritan theocracy as the origin of the highbrow/lowbrow split, and acclaimed Whitman as the "precipitant" of a middle tradition that spanned the spiritual and material aspects of life.[26] According to Brooks, Whitman's model of nonrepressed sexuality and enlightened social reform could help to heal the bifurcations in American cultural life.

Brooks's formulation was, in turn, indebted to the Harvard philosopher George Santayana. Two years earlier Santayana had outlined a similar dichotomy in American philosophy in his highly influential essay "The Genteel Tradition in American Philosophy" (1913). Santayana used the symbols of the colonial mansion and the skyscraper to characterize this division in American culture. He stated, "The American Will inhabits the sky-scraper;

the American Intellect inhabits the colonial mansion. The one is the sphere of the American man; the other, at least predominantly, of the American woman. The one is all aggressive enterprise; the other is all genteel tradition." Significantly, Santayana identified the philosophies of Calvinism and transcendentalism as the sources of this division in American culture. While transcendentalism advocated an experiential and scientific approach to life, Calvinism was "an expression of the agonised conscience" that dedicated itself to the punishment of sin. Santayana also noted that Walt Whitman was "the one American writer who has left the genteel tradition entirely behind." [27]

These discursive threads were soon picked up in *The Seven Arts,* one of the "little magazines" devoted to avant-garde writing and the promotion of American national culture. *The Seven Arts* was a monthly journal of literature and social commentary published in 1916 and 1917.[28] With contributions from a variety of writers, the magazine represented an attempt to form a uniquely *American* version of modernism. In 1929 Waldo Frank noted that, in addition to himself and James Oppenheim, the magazine's editor, Van Wyck Brooks, Randolph Bourne, Paul Rosenfeld, Louis Untermeyer, and Sherwood Anderson made up the inner circle of the magazine. Together, they "converge[d] into a national programme after Whitman, by which America shall become a creative focus in the modern world."[29] Reflecting on his own experiences at the journal, Brooks remarked on the similarity between *The Seven Arts* group and the Stieglitz circle. He recalled that the young critics who wrote for *The Seven Arts* "had, or wished to have, the feeling of a common cause, the sense of a community of writers building a new culture. This had been more or less Stieglitz's dream in gathering his disciples at '291,' which to so many who felt at the time like pioneers in the Indian country seemed a kind of sheltering frontier fort."[30]

In the inaugural issue of *The Seven Arts* the French novelist, musicologist, and pacifist Romain Rolland urged American artists to free themselves of European models and to look to their own people for a great national culture.[31] Rolland dramatically concluded his essay by proclaiming, "Behind you, alone, the

elemental Voice of a great pioneer, in whose messages you may well find an almost legendary omen of your task to come,—your Homer: Walt Whitman."[32] A few months later the magazine reprinted excerpts from Horace Traubel's conversations with Whitman in Camden, New Jersey.[33] Writing in *The Poetry Journal* that same year, William Carlos Williams identified Whitman as the great forefather of American poetry: "He is our rock, our first primitive. We cannot advance until we have grasped Whitman and then built upon him."[34] Marsden Hartley hailed Whitman and Cézanne as the two most important innovators in painting and poetry in his book *Adventures in the Arts* (1921). The following year the cultural critic Harold E. Stearns echoed what was by then a well-established theme, that Whitman's poetry contrasted sharply with the disembodied, rootless, and sterile qualities of American intellectual life.[35]

In various respects *The Seven Arts* project functioned as an important precursor to much 1920s Stieglitz circle criticism. What Rosenfeld, Frank, Anderson, and others carried with them from *The Seven Arts* period was the belief that art, literature, and social commentary could be instrumental in shaping a new vision of American culture. Marsden Hartley also shared this belief. Himself compelled to leave Europe by the outbreak of the First World War, Hartley observed in *The Seven Arts:* "There is a hopeful seriousness of interest developing in what is being done this side the sea, a rediscovery of native art of the sort that is occurring in all countries. The artist is being taught by means of war that there is no longer a conventional center of art, that the time-worn fetish of Paris as a necessity in his development has been dispensed with; and this is fortunate for the artist and for art in general."[36] Hartley's phrase "the time-worn fetish of Paris" is particularly salient. During the later nineteenth century Paris had replaced Germany as the training ground for young American artists. With his own pro-German background, it is not surprising that Hartley would rail against the prevalent conception of Paris-as-Europe.[37] Yet in keeping with the nationalist tenor of *The Seven Arts* project itself, Hartley suggested that Americans had put a misplaced emphasis on foreign, especially French, greatness.

"The time-worn fetish of Paris" had leached Americans' faith in themselves and their culture and projected it elsewhere. To amplify this point, Hartley entitled his article "A Painter's Faith."

Rosenfeld also shared this faith in American art and the will to break free from European cultural dominance. In 1923 he told Edmund Wilson: "One is either working in the hope of something starting in the mass of American life itself, or not at all, don't you agree? . . . I don't mean that one sets out to influence life—that is silly. But one is putting pennies in a bank—in order to swell some capital which belongs to no one and to every one at the same time."[38] Waldo Frank and Lewis Mumford expressed their critical aspirations in even more ambitious terms. Both saw their aesthetic discourses as instrumental in creating an American nation. In *Our America* Frank described his generation as "engaged in spiritual pioneering." He wrote, "We go forth all to seek America. And in the seeking we create her. In the quality of our search shall be the nature of the America that we create."[39] Similarly, in *The Golden Day* (1926) Mumford asserted that, by providing a framework of usable cultural ideals and symbols, his writings represented "nothing less than the effort to conceive a new world. *Allons!* the road is before us!"[40]

As these statements suggest, for the Stieglitz circle writers the great promise of the postwar period entailed, if not actually displacing Paris as the world art capital, then producing an American modernism that could be viable alongside its most advanced European counterparts. For this reason, art was more than a detached aesthetic pursuit. It was the means through which a vital American culture would form and the United States would finally merit international cultural recognition.

Given the high-stakes nature of their project, it is not surprising that, for many of the young critics who visited 291 during the teens, Alfred Stieglitz represented nothing less than the Whitmanic ideal to which they felt artists should aspire.[41] The connections between Stieglitz and Whitman were made explicit as early as 1916 when Horace Traubel, a well-known friend and disciple of Whitman's, published an article on the photographer in *The*

*Conservator.* Traubel praised Stieglitz's democratic efforts to pro-
vide innovative artists with a chance to have their work shown in
New York. Traubel described 291 as "a great reckoning in a little
room," and he stated, "Every time I visit two ninety one something
I find there, either Stieglitz himself, or one of his friends, or some
exhibit, makes a new man of me. I doubt if anything bigger ever
starts anywhere else in little New York."[42]

Waldo Frank also described Stieglitz as a spiritual pioneer in
the manner of Whitman in *Our America.* Commenting first on
Whitman's vision of New York and then on Stieglitz's photographs,
Frank asserted that Stieglitz was clearly Whitman's descendant
because he used photography as a means to spiritualize the mate-
rial and industrial worlds of New York. Frank wrote that, like
Whitman, Stieglitz "masters the dominant details of industrial
life, and makes them serve the unifying vision of human spirit."[43]
Two years later Rosenfeld employed the Whitman reference to
characterize Stieglitz's photographs as documents of personal lib-
eration and social reform. When reviewing Stieglitz's "comeback"
exhibition at the Anderson Galleries in 1921, Rosenfeld wrote
that Stieglitz's photographs, "machine-made though they were,
were an expression of life the like of which has scarcely before
been made in America. Save for Whitman, there has been
amongst us no native-born artist equal to this photographer."[44]

Such themes permeated the social and cultural environment
in which the Stieglitz circle writers lived and worked. During the
early twenties many New York artists and critics, including Paul
Rosenfeld, Van Wyck Brooks, and Arthur Dove, lived in West-
port, Connecticut. They were drawn there by the town's proximity
to New York City coupled with its pastoral landscape and colonial
New England character. When recalling the atmosphere in West-
port after the Great War, Brooks noted that many artists and writ-
ers "had returned from Paris in search of 'roots.'" As a result, "No
word was more constantly on their lips unless it was the native
'soil' or 'earth,' and this obsession lay deep in the minds of urban
cosmopolitans whom one saw toiling now with spade and pick."[45]
The somewhat incongruous image of the Westport elites laboring
in the earth provides a glimpse into the environment in which

American modernism was fostered. In this fashionable Westport community the "soil" was not merely dirt, but a sign of *de rigueur* rusticity imbued with generative cultural connotations.[46]

Such images of the fertile American soil and of a "liberated" Whitmanic organicism thread through Rosenfeld's discussion of Dove in *The Dial* (1921), as discussed at the beginning of this chapter. Rosenfeld drew on well-established typologies when he compared Dove to Whitman and contrasted him with the Puritans. Rosenfeld wrote, "After centuries of puritan unwillingness to perceive man in his relation with the rest of creation, here, as in Whitman, with all the sadness and tenderness and milky human kindness of Arthur Dove, there is the fearless and clean acceptance of the grossly animal processes."[47] In this single meandering sentence, Rosenfeld managed to encapsulate the major historical preoccupations and the central paradoxes of embodied formalism. According to the Stieglitz circle critics, their group's artworks were both sensuously embodied *and* aesthetically engaged, sexually liberated *and* spiritually purified, artistically innovative *and* bonded to a venerable American cultural tradition.[48] Rosenfeld concluded his discussion of Dove by lamenting that the artist "finds so little time for his art. For it is easily within his power to give us the pageant of the soil, and do Whitman-work in Whitman fashion indeed."[49]

## "Why Waste the Eggs?" Critical Responses to Stieglitz Circle Discourses

Shortly after Rosenfeld published this essay in *The Dial*, the novelist Sherwood Anderson commented appreciatively on the piece. Anderson told Rosenfeld: "Your 'American Painting' is a beautiful piece of work. I do not believe anything being done in the country in poetry or prose is more important or creative than this kind of writing. And I was particularly glad you could say what you have of Dove—the man I look to to do the biggest work we have had. I believe I know what your saying what you have will mean to him. Surely if there is some promise of rebirth here it will mean

nothing to have the romanticist merely routed by the realists. The flesh must come into its own."[50] Anderson's enthusiasm for Rosenfeld's critical writing is not surprising given the two men's personal history. Rosenfeld and Anderson had become friends during the late teens, following their tenure on *The Seven Arts*. In January of 1922 Rosenfeld published an admiring account of Anderson's writing in *The Dial*. This article appeared in modified form in Rosenfeld's collection of critical essays *Port of New York* (1924), where it was accompanied by a photograph of Anderson taken by Stieglitz himself. During the twenties Rosenfeld demonstrated a substantial critical interest in American literature, one which included Van Wyck Brooks, Carl Sandburg, and William Carlos Williams as well as Anderson. Along with the Stieglitz circle painters, Rosenfeld saw the writers as part of "a new spirit dawning in American life . . . [that has] awakened a sense of wealth, of confidence, and of power which was not there before."[51]

Like the Stieglitz circle, Anderson was a voluble critic of Puritanism who, as Frederick J. Hoffman has pointed out, "was hailed as the leader in the American fight against conventional repression."[52] Drawing on familiar cultural symbols in *Port of New York*, Rosenfeld wrote that Anderson's fictional characters "are flesh of our flesh and bone of our bone; and through them, we know ourselves in the roots of us, in the darkest chambers of the being. We know ourselves in Anderson as we knew ourselves in Whitman."[53] Echoing his earlier discussion of Dove's artworks, Rosenfeld asserted that in Anderson's literature "the delicacy and sweetness of the growing corn, the grittiness and firmness of black earth sifted by the fingers, the broad-breasted power of great laboring horses, has wavered again. The writing pleases the eye. It pleases the nostrils. It is moist and adhesive to the touch, like milk."[54] Thus along with Dove's paintings, in Anderson's prose Rosenfeld perceived a blend of aestheticized form and organic sensuousness that was realized through the interwovenness of the human body with the delicate, gritty qualities of earth and animals.

While Anderson admired Rosenfeld's writings, not all of Rosenfeld's readers were so complimentary. Although his oppo-

nents were less an organized group than a loose amalgam of ad-versarial voices, they nonetheless proved to be quite capable of converging on Rosenfeld in a uniform fashion. For example, in the "little magazine" *The Broom* the economist and author Harold Loeb characterized Rosenfeld's *Dial* article as full of "spumes-cent rhetoric and conscious fine writing." Loeb further asserted that Rosenfeld's persistent emphasis on sexuality encumbered abstracted paintings with unrelated literary content. Reducing Rosenfeld's embodied formalist discourse to a kind of low comedy, Loeb stated: "Mr. Rosenfeld is city bred and unfamiliar with nat-ural functions. No other explanation can account for his predilec-tion for 'grossly animal processes.' We suggest that next summer he beg permission of some friendly farmer to be present when the bull is let in on the cow. It is really more interesting in life than are paintings of the 'Organs that differentiate the sex.'"[55] In short, Loeb perceived a clash between Rosenfeld's overly refined writ-ing style and his inordinate interest in barnyard sexuality. As a re-sult, Loeb saw Rosenfeld's criticism as too "high" and too "low" at once.

Loeb was not alone in his critique of Rosenfeld. Another vo-cal opponent was Jane Heap. Heap, along with her partner Mar-garet Anderson, coedited the experimental literary periodical *The Little Review*. The magazine published a number of Dada and sur-realist pieces during the twenties, and generally served as a forum for groundbreaking modernist literature. Its contributors included Ezra Pound, T. S. Eliot, Ernest Hemingway, and Gertrude Stein. In 1918 Heap and Anderson began publishing installments of James Joyce's novel *Ulysses*. Shortly after, *The Little Review's* Greenwich Village office was raided, and copies of the journal were confiscated. Undeterred, Heap and Anderson continued to serialize Joyce's manuscript until 1921, when John S. Sumner of the Society for the Prevention of Vice had the women indicted for publishing indecent matter.[56]

With their dedication to "serious" literature, the editors of *The Little Review* found Rosenfeld's writings superficial and superfluous. In the Spring 1922 issue Heap described Rosen-feld's writings as nothing more than "fashionable" art criticism.

She observed that "criticism in New York is one of the allied fashion-designing trades. The art talk of the lay-intellectual is a radio of the fashion-art journals. Every smart journal has its Well-Dressed Man and its well-dressed artist feature. *The Dial* has Paul Rosenfeld." Upon reading this, Rosenfeld dispatched a telegram to Heap, protesting, "You do me a wrong. I have not been well-dressed since 1913."[57] Sherwood Anderson immediately incorporated this exchange into the "Impression" of Rosenfeld that he published in *The New Republic* (October 11, 1922). In this piece Anderson praised Rosenfeld's "sensitive" and "civilized" approach to criticism. Referring implicitly to Van Wyck Brooks and explicitly to Heap, Anderson wrote that Rosenfeld "has really freed himself from both the high and the low brows and has made of himself a real aristocrat among writers of prose." Anderson continued, "Miss Jean [sic] Heap recently spoke of him as 'our well dressed writer of prose,' and I should think Paul Rosenfeld would not too much resent the connotations of that. For, after all, Rosenfeld is our man of distinction, the American, it seems to me, who is unafraid and unashamed to live for the things of the spirit as expressed in the arts."[58]

Not surprisingly, Heap did not allow Anderson's interpretation of her remarks to pass without comment. In the Autumn 1922 issue of *The Little Review* Heap stated that she detected more friendship than conviction in Anderson's article. She added, "It doesn't seem possible that any nature, however sweet, could strain my connotations into a compliment. I can see nothing essential in Paul Rosenfeld's writing. The words are not essential to the subject, the subject is not essential to Mr. Rosenfeld. He writes about pleasant things pleasantly."[59] Underpinning Heap's dismissal of Rosenfeld were larger, irreconcilable differences in their respective aesthetic positions. In fact, the whole project of deriving art from the American soil was inherently at odds with the focus of *The Little Review*, which was devoted to expatriate work.

Despite the fact that Heap's commentaries appeared in two consecutive issues of *The Little Review*, the journal was not yet finished with Rosenfeld. The Winter 1922 number contained a symbolic portrait of the critic by the poet Hart Crane that con-

tained the caption, "Anointment of our Well Dressed Critic or Why Waste the Eggs? Three-Dimensional Vista, by Hart Crane" (fig. 1.2).[60] To make sense of Crane's "portrait," it is first necessary to unpack the meanings implied in his jesting question of "Why Waste the Eggs?" For Stieglitz, Rosenfeld, and Sherwood Anderson, the egg was a symbol of the nascent American modernism that they all championed so vigorously.[61] In 1921 Rosenfeld compared the advent of the American modernist painters to the hatching of chicks. He wrote: "All swans are fledged grey. In maturity, they become white. Are not people developed by the workings of a similar law? And to-day so many little water-fowl have been hatched are swimming about, marvelously automatically, in the American mill-stream!"[62] That same year Anderson published a collection of stories, or "impressions from American life," which he called *The Triumph of the Egg*.[63] In the title story, the main character's inability to perform simple tricks with eggs becomes a symbol for his lack of success in life. While the title of Anderson's story is ironic, his literary work itself represented a "triumph" of nascent American art. Yet implicit in Crane's mocking question of "Why Waste the Eggs?" is the suggestion that Anderson's and Rosenfeld's modernist activities amounted only to callow, misdirected efforts which were unworthy of further pursuit.

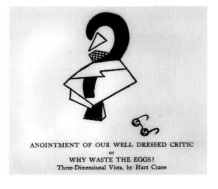

**1.2** Hart Crane, *Anointment of Our Well Dressed Critic or Why Waste the Eggs? Three-Dimensional Vista, by Hart Crane.* Reproduced in *The Little Review* (Winter 1922). Courtesy of the Brown University Library.

ANOINTMENT OF OUR WELL DRESSED CRITIC
or
WHY WASTE THE EGGS?
Three-Dimensional Vista, by Hart Crane

During the summer of 1922 Stieglitz himself contemplated making photographic "portraits" of eggs. As he told Rebecca Strand, "I'll try portraits of eggs, & see whether I can differentiate between a rotten egg & a fresh one—so that as you look at the pictures you'll get the psychology of that particular (or not particular) egg.—That will be a test of my powers."[64] While Stieglitz's egg portraits never materialized, the photographer had dedicated much of his professional life to making such character judgments. 291 was a kind of incubator where Stieglitz brooded over the most promising artistic "eggs" and cast out the "rotten" ones. Thus the egg represented not only the fledgling modernist artwork that Rosenfeld, Stieglitz, and Anderson promoted, but their own professional judgments, and hence, their identities as critics. Yet the "egg" also took on pejorative connotations during the teens. Recalling Brooks's notion of "highbrow" culture, "egghead" became a derogatory term for American intellectuals, particularly editorial writers.[65]

Given the various meanings associated with eggs, Crane's image is especially resonant. A comparison of Crane's drawing and a formal portrait of Rosenfeld taken by Stieglitz himself (1920, figure 3.4) suggests that Crane parodied Rosenfeld's oval face, his heavy-set features, and his habitual suit and tie. Crane's cartoon figure is composed of an egg-shaped head, a beak mouth, and a well dressed, question mark body. A pair of glasses, complete with eyes, rolls along the bottom edge of the drawing. In this image Crane seems to imply that, despite his status as Stieglitz's "anointed" art writer, Rosenfeld is not fully fledged in his professional judgments. Indeed, the fashionable persona of the "well dressed critic" is presented here as a thin-shelled, superficial *coquet*. Through the enigmatic question of "Why Waste the Eggs?" Crane seems to ask not only, Why bother to write superficial, fashionable art criticism? but also, Why bother to lavish too much attention and too many insults on Rosenfeld? Why waste the "eggs" to pelt (or anoint) him with?

In their *Little Review* commentaries both Heap and Crane attempted to undermine the seriousness of Rosenfeld's project. Heap's image of the "well-dressed" critic who "costumes" mod-

ern art in fashionable discourse is personified by Crane's caricature of a birdlike creature with a good tailor. Curiously, both writers represented Rosenfeld, a proponent of heterosexually determined aesthetics, as himself dandified and effete. We can only speculate on the extent to which Crane and Heap mobilized issues of fashion and gender to mount an oppositional discourse against Rosenfeld. (Crane openly engaged in homosexual relationships; Heap was a lesbian who, like Rosenfeld, dressed in men's suits.)[66] However, what is clear is that by presenting Rosenfeld as comical and ineffectual, Heap and Crane both challenged the heterosexist tenor of Rosenfeld's critical persona.

They were not the only writers to do so. In November of 1922 the Dada critic Gorham Munson published an invective against the "genteel" good taste and dearth of self-questioning that he and his colleagues felt permeated American criticism. Again questioning the "potency" of Rosenfeld's critical discourses, Munson compared Rosenfeld's polite professional judgments to "premature ejaculations." Munson exhorted: "Let a critic like PAUL ROSENFELD once gain [an audience's] ear regularly through the columns of the *Dial* and *Vanity Fair* and no rude voice will arise to interrupt his dreams of competence. His huge mud-bed of undisciplined emotionalism, his inflated windbag of premature ejaculations no one, apparently, thinks of dredging or pricking. Blithely complacent, he goes undisturbed."[67] Munson himself was part of the group of young American writers that included Hart Crane, Matthew Josephson, and Malcolm Cowley, all of whom identified themselves as part of a literary secessionist movement. Like its French predecessor, the American Dadaist movement of the twenties was a self-proclaimed revolt against the "genteel" tradition and a celebration of the machine and the intellect as agents of creative disruption.

Edmund Wilson captured the nature of the Stieglitz circle–Dada debates in the "Imaginary Conversation" that he published in the April 9, 1924, issue of *The New Republic*.[68] Wilson constructed a mock dialogue between Rosenfeld and Matthew Josephson, a journalist who founded and edited a number of "little magazines," including *Secession, Broom,* and *transition.*[69] Always

the clever ventriloquist, Wilson represented Rosenfeld as a rhapsodic, romantic critic who zealously championed high art. Meanwhile Josephson was portrayed as a fierce proponent of Dadaism who indiscriminately, even promiscuously, embraced all aspects of American mass culture, from vaudeville and advertising to plumbing and subway trains. In Wilson's imaginary dialogue, Rosenfeld accused Josephson of "want[ing] people not merely to appreciate the vulgar but also to forget the fine."[70] In turn, Josephson argued that American mass culture *is* American and *is* culture, while the Stieglitz circle promoted a rarefied and inaccessible art. Josephson asserted that, since advertising truly reflects the desires of the American people, Rosenfeld "will never be able to interest [the public] in what you call literature again. Or music. Or plastic art. What does 'literature' amount to now? Little poems in little magazines that nobody ever reads."[71] Siding primarily with Rosenfeld, Wilson used this dialogue as a means to suggest that Dada's anti-art posture and embrace of industrial culture amounted to little more than a self-serving type of cachet.

Throughout the twenties Rosenfeld's aesthetic discourses served as a lightning rod for such critical commentary. In the spring of 1922 the editors of *Secession* expressed their hopes "that there is ready for it an American public which has advanced beyond the fiction of Sinclair Lewis and Sherwood Anderson and the criticism of Paul Rosenfeld and Louis Untermeyer."[72] The following year Malcolm Cowley acknowledged that he and several of his colleagues had planned a Dadaist performance that would include "violent and profane attacks on the most famous contemporary writers, courts-martial of the more prominent critics, burlesques of Sherwood Anderson, Floyd Dell, Paul Rosenfeld and others— all this interspersed with card tricks, solos on the jew's harp, meaningless dialogues and whatever else would show our contempt for the audience and sanctity of American letters."[73]

Further implied criticism of the Stieglitz circle's aesthetic criticism came in Ernest Boyd's article "Aesthete: Model 1924," which was published in the January 1924 issue of *The American Mercury.* While it is unlikely that Boyd's essay was targeted specifically at any single writer, he included a passage which ap-

peared to be a caricature of Rosenfeld's art criticism. Boyd wrote of the aesthete critic: "His further contributions (if any) to the art of prose narrative have consisted of a breathless phallic symbolism—a sex obsession which sees the curves of a woman's body in every object not actually flat, including, I need hardly say, the Earth, our great Mother."[74] Boyd's remarks underscore the ways in which aesthetic criticism in general, and the Stieglitz circle's embodied formalist rhetoric in particular, was viewed by its opponents as a superficial, freewheeling discourse based on an obsessive interest in sexuality. References to the Stieglitz circle writers themselves were made explicit the following year when a sequel to Boyd's article was published as a satirical magazine, *Aesthete 1925*. On the cover the editors proclaimed: "Every article contained in this issue of A. 1925 is guaranteed to be in strictly bad taste." The editors had no trouble keeping their promise. Just above this guarantee appeared a table of contents which listed a fictitious article entitled "The Hard Professional Joy of the American Public (Rhapsodic criticism with 39 metaphors and no ideas, by Paulina Roseyfield.)" As in Heap's and Crane's *Little Review* pieces, the appellation "Paulina Roseyfield" again called Rosenfeld's gender into question. In "Paulina Roseyfield" both the critic himself *and* the logic of embodied formalism are "inverted": with "39 metaphors and no ideas," (s)he is at once feminized and empty. Upon opening the magazine's cover, these professional "joys" become clearer. A column labeled "Last Minute News of the Critics" announced, headline-style, "Paul Rosenfeld Finds Unknown Genius. Famous Adjector Discovers Boy Prodigy in Winesburg, O. Divulges Name of Sherwood Anderson on Tenth Page of Brilliant Essay."[75]

As all of this suggests, during the twenties Rosenfeld's adversaries repeatedly dismissed the critic as effeminate and ineffectual. In so doing, they simultaneously called into question the "potency" of an aesthetic criticism that placed at its center idealized representations of the liberated American subject. Yet the recurrent attacks on Rosenfeld also suggest that embodied formalist discourse represented a sufficiently important target that its authority had to be regularly questioned and denied. Thus the po-

lemicized debates that surrounded Rosenfeld can be seen as the other side of the dialogical coin from the discourses on liberated, de-Puritanized art that were championed by the Stieglitz circle and their contemporaries. Taken together, both perspectives provide a framework for understanding the significance that gendered formalist criticism held historically. For both their colleagues and their opponents, the Stieglitz circle's embodied formalist discourses—linked as they were to a vibrant array of modernist paintings—represented a vivid and highly contested model of aestheticized, integrated selfhood, one in which no divisions obtained between the subject's body, their spirit, and the world around them.

Faith, Love, and the Broken Camera

Alfred Stieglitz and New York Dada

It seemed like a tribute, but it wasn't. On the cover of the July–August 1915 issue of *291* was Francis Picabia's "portrait" of Alfred Stieglitz (fig. 2.1). *291* was an avant-garde "little magazine" named after Stieglitz's art gallery at 291 Fifth Avenue, where it was assembled in the back room. Boldly printed in black and red, Picabia's drawing featured an open camera and a caption which read *"Ici, c'est ici Stieglitz/Foi et Amour."* Faith and love were qualities which Stieglitz and his followers repeatedly claimed

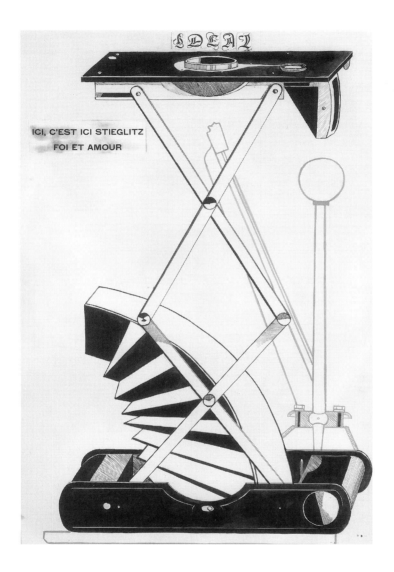

**2.1** Francis Picabia, *Ici, C'est Ici Stieglitz*, 1915. Pen and red and black ink, 29 ⅞ × 20 in. The Metropolitan Museum of Art, The Alfred Stieglitz Collection, 1949. ©2000 Artists Rights Society (ARS), New York / ADAGP, Paris.

the photographer lavished on both his gallery and his photographic activities. Yet in Picabia's image, the words appeared oddly flat and empty, more a mocking emblem than an accolade. In this "portrait" Picabia represented Stieglitz as a broken camera, its exposed and somewhat deflated bellows separated from its body, and its lens aiming at, but unable to make contact with, an "Ideal" which floated elusively above it. Picabia set the camera on a platform with a stick shift in neutral and an engaged hand brake. In this position, the camera is literally "going nowhere." Taken as a whole, Picabia's drawing suggests that Stieglitz is both eviscerated and stuck.[1]

Although enigmatic, an important clue to Picabia's symbolic portrait lies in an article by the Mexican caricaturist Marius De Zayas that appeared in the same issue of *291*. In his essay De Zayas stated outright that Stieglitz had failed to reach his professed "ideal" of educating the American public through modern art and photography. De Zayas attributed Stieglitz's "failure" to his unwillingness to pursue success directly through advertising and commercial means and his practice of hiding instead behind "the shield of psychology and metaphysics."[2] Over the next year De Zayas and Stieglitz would have a falling out over such ideological and practical issues.[3]

The camera in Picabia's portrait was not the only thing "broken" in Stieglitz's life in 1915. Sales were slow at 291, and Stieglitz was having a difficult time supporting the artists who depended on him financially. In addition, during the summer of 1915 Stieglitz had to admit that he felt greatly liberated by the absence of his estranged wife Emmeline and his daughter Kitty.[4] Yet between 1915 and 1921 Stieglitz would experience a period of major change. He would close 291, leave his wife and begin a relationship with Georgia O'Keeffe, and assemble a new group of disciples who would be instrumental in helping him to reassert his prominence in the New York art world.[5] Thus while Picabia's portrait captured the declining state of Stieglitz and his gallery around 1915, this icon also served as an important benchmark against which Stieglitz's identity would be redefined during the early 1920s. The image of the "broken" camera was to be replaced

by the notion that Stieglitz wielded his camera in a masterful way, creating photographs of great power.

Marcel Duchamp's works were also highly influential for Stieglitz and his circle. As exemplified by objects such as *Fountain* (1917, fig. 2.4) and *The Large Glass* (1915–1923, fig. 2.5), Duchamp based his artistic strategy on the desanctification of art and the privileging of cerebral jokes and intellectual content over sensuous painterly forms. Thus despite at least initially friendly relations and a degree of social overlap, New York Dada constituted one of the most important oppositional practices confronting Stieglitz and his circle. Unlike the unique and ostensibly fertile forms that critics repeatedly found embodied in Stieglitz circle artworks, Dada "bodies" characteristically were sterile, industrially inspired, mass-produced, and interchangeable. Along with contemporary discourses on Puritanism and derepression, the New York Dada movement exerted a formative influence on the development of Stieglitz's enterprise during the teens and early twenties. While elements of the Stieglitz circle's artistic project predated Duchamp's and Picabia's arrival on the New York art scene, its themes became solidified and amplified under the productive counterexample that the Dada artists offered.

## Stieglitz and the Dadaists

It was not Stieglitz's gallery but the salon of Walter and Louise Arensberg that served as the focal point of the New York Dada movement.[6] The Arensbergs were a wealthy couple with an avid interest in the arts. While Louise's primary concern was music, Walter's interests included poetry, philosophy, art, and above all, chess. Arensberg sponsored the poetry magazine *Others*, so many writers attended his almost nightly parties. Among them were Wallace Stevens, Marianne Moore, Arthur Cravan, Amy Lowell, Mina Loy, and William Carlos Williams. Alfred Kreymborg served as editor of *Others* and as a chess partner for Arensberg. The Arensberg salon also drew artists such as Picabia, Gleizes, Man Ray, Schamberg, Stella, Sheeler, Florine Stettheimer, and De Za-

yas, as well as two painters closely associated with Stieglitz, Marsden Hartley and Charles Demuth. In short, Arensberg seemed to "collect" avant-garde artists as well as their works and "exhibit" them in his New York apartment. Yet as brilliant as this group was, the star member was undoubtedly Marcel Duchamp. Shortly after the artist's arrival in New York, Arensberg invited Duchamp to stay at his studio on West 67th Street. In establishing this relation, Arensberg effectively "installed" Duchamp as a kind of living work into his collection. Stieglitz occasionally attended the Arensbergs' parties, and he and Arensberg exchanged a few pieces of polite correspondence during the teens.[7]

In 1921 Marsden Hartley commented on Stieglitz's somewhat reluctant affiliations with Dada. Hartley noted that Stieglitz "is an artistic idol of the Dadaists which is at least a happy indication of his modernism. If he were to shift his activities to Paris, he would be taken up at once for his actual value as modern artist [sic] expressing present day notions of actual things. Perhaps he will not care to be called Dada, but it is nevertheless true. He has ridden his own vivacious hobbyhorse with as much liberty, and one may

**2.2** Alfred Stieglitz, *Francis Picabia,* 1915. Platinum print, 9 ⅝ × 7 ⅝ in. Alfred Stieglitz Collection, © 1999 Board of Trustees, National Gallery of Art, Washington, DC.

even say license, as is possible for one intelligent human being."[8] Stieglitz's association with the Dada movement was ambivalent at best, and his relations with individuals varied greatly. Despite Picabia's portraying him as a broken camera, Stieglitz seems to have experienced genuine friendship with the painter and his wife, Gabrielle Buffet-Picabia. Stieglitz first became acquainted with Picabia in 1913 while the painter was visiting the Armory Show in New York. Soon after their initial meeting, Stieglitz gave Picabia his first one-man exhibition in the United States. A second show followed in January of 1915. It was Stieglitz's portrait of a very intense Francis Picabia (1915, fig. 2.2) that accompanied an article on the painter in the November 1915 issue of *Vanity Fair*.[9] Stieglitz would include this photograph of Picabia in his own comeback exhibition at the Anderson Galleries in February of 1921. Seven years later Stieglitz exhibited Picabia's large abstract works at The Intimate Gallery. At that time Stieglitz expressed his sustained enthusiasm for Picabia in a letter to Henry McBride. Stieglitz wrote: "Am glad you liked the Picabia's. I was amazed at them when they were placed. Had no idea of their worth till up!! He is a rare one—

**2.3** Alfred Stieglitz, *Marcel Duchamp*, 1923. Silver gelatin developed-out print. Alfred Stieglitz Collection, © 1999 Board of Trustees, National Gallery of Art, Washington, DC.

Full of invention & style & charm.—Even lovely—sardonic too. Duchamp has always insisted Picabia was the real thing. I never doubted it—but I never suspected him capable of what is before us here.—I hope most of these numbers stay here."[10]

In contrast, Stieglitz's relationship with Duchamp was more complicated in nature. On the one hand, Stieglitz and Duchamp openly expressed support for one another in various ways. Stieglitz's biographer and grandniece Sue Davidson Lowe has written that, during the teens, Stieglitz "became devoted to Duchamp."[11] In 1917 Stieglitz photographed Duchamp's most notorious readymade, *Fountain*, after the sculpture was removed from the exhibition of the Society of Independent Artists and brought to 291. Stieglitz photographed Duchamp himself in 1923 (fig. 2.3). Regarding Duchamp's unfinished masterpiece, *The Large Glass*, Herbert J. Seligmann recalled that in a public lecture Stieglitz delivered at the Brooklyn Museum in December of 1926, Stieglitz pointed to *The Large Glass*, "saying that he considered it a privilege to sit beside it, and that it was one of the grandest works in the art of all time not excluding Egyptian, Chinese, or even French, which was now the fad." A few weeks later Seligmann noted Stieglitz's admiration for Duchamp's film *Anemic Cinema:* "Stieglitz said today of a motion picture made by Marcel Duchamp that it was the first thing made by another person which he had ever wished he had done himself."[12]

Duchamp similarly expressed his admiration for Stieglitz to Dorothy Norman, one of Stieglitz's most devoted followers. After the photographer's death Duchamp told Norman that Stieglitz

was not a collector, but a teacher—a great man, with great judgment. A force. He abandoned the worldly conception of art. He helped American artists more than anyone else. He was primarily a humanist. He was not interested in aesthetic problems. He believed passionately that America should have its own artists. He felt his influence could force the issue.

He saw my *Nude Descending a Staircase* at the Armory Show in 1913. At the time he did not like my work just because it was in that exhibition. He thought I must be a fraud because of my success there.

When we met in 1915 we got on very well, at once. From then all went splendidly between us. He had my 'ready-made' R. Mutt figure at 291 when it was pushed aside by the Society of Independent Artists in 1917. He also photographed it.[13]

Despite these cordialities, Stieglitz had good reason to think of Duchamp as a rival. Duchamp's arrival in New York occurred at a crucial moment not only for Stieglitz and his circle, but for the development of avant-garde art in America. During the mid-teens American modernists were beginning to gain confidence as artists, and Duchamp arrived just in time to upstage the Americans, steal the show, and permanently alter the development of American art history. As Kermit Champa has noted, at first Duchamp and Picabia "moved in concert with Stieglitz—always the liberal assimilator, but finally they pushed him aside, symbolically 'breaking' his camera in Picabia's mechano-symbolic portrait published in the half-taunting journal *291*."[14]

Thus while Stieglitz publicly expressed support for Duchamp, in quieter ways he also distanced himself from the artist. In 1920 Stieglitz declined an invitation by Duchamp and Katherine Dreier to join the board of their newly founded and highly esoteric Museum of Modern Art, the Société Anonyme.[15] And when Sheldon Cheney was preparing the text of his book *A Primer of Modern Art* (1924), Stieglitz was quick to point out that Duchamp never was officially affiliated with the publication *291*. Stieglitz informed Cheney that "Picabia joined up with us at 291 when he came from the War in 1915. Duchamp and Man Ray never were identified with the publication of '291.'"[16]

In turn, Duchamp himself was well aware that he stood in an important relation to Stieglitz, yet one that was not exactly a friendship.[17] What was it then? Its complex nature is perhaps best characterized as a paradox, a state of complementary opposition. This wry arrangement is exemplified by Duchamp's response to the question, "Can a photograph have the significance of art?" for *Manuscripts*, a literary journal that Rosenfeld and Seligmann had established in 1921 at Stieglitz's urging. A collection of responses to this question, from artists, critics, poets, and even the com-

posers Ernst Bloch and Leo Ornstein, were published in the December issue of the journal. With characteristic high-handedness toward both Stieglitz and the question, Duchamp replied: "Dear Stieglitz, Even a few words I don't feel like writing. You know exactly how I feel about photography. I would like to see it make people despise painting until something else will make photography unbearable. There we are. Affectueusement, Marcel Duchamp (N.Y., May 22, 1922)"[18] In this contradictory statement, Duchamp acknowledged the importance of Stieglitz's photographic practice by dismissing the lasting appeal of the medium itself. The tenor of this exchange is telling. Stieglitz solicited and printed Duchamp's response to the question presumably because he wanted to include Duchamp's remarks in the collection he was compiling. At the same time, Duchamp's reply was disparaging toward both painting and photography, the two primary media that Stieglitz and his followers practiced. Beneath a characteristic veneer of flippancy and charm, Duchamp was testing the limits of American modernism itself. The first important challenge came in "readymade" form.

## Turning a Readymade into a Work of Art

Shortly after arriving in New York, Duchamp began the process of designating objects as "readymades." As Duchamp himself later explained, readymades are nonunique, preexisting objects encountered in ordinary life.[19] The objects become works of art once they are selected and endowed with an enigmatic title and often with a signature. In particular, Duchamp emphasized that "the choice of these 'readymades' was never dictated by esthetic delectation. This choice was based on a reaction of visual indifference with at the same time a total absence of good or bad taste. . . . In fact a complete anesthesia. One important characteristic was the short sentence which I occasionally inscribed on the 'readymade.' That sentence instead of describing the object like a title was meant to carry the mind of the spectator towards other regions more verbal."[20]

As William Camfield's extensive research on this work shows, Duchamp's *Fountain* (fig. 2.4) was one of the most important and notorious of all the readymades.[21] *Fountain* was at once a standard bathroom fixture purchased from a plumbing supply store *and* a piece of sculpture. Duchamp inscribed the object "R. Mutt," short for "Richard Mutt," a pun on the name of the original "author" of the object, the J. L. Mott Iron Works. *Fountain* is perhaps the ultimate readymade. It is decontextualized, esoterically humorous, challenging, lascivious, and artsy, all in one scandalous gesture.[22]

The well-known story behind *Fountain* is that Duchamp submitted the sculpture to the Society of Independent Artists for the 1917 exhibition. Despite the fact that Arensberg was the managing director of the show and Duchamp himself was the head of the hanging committee, the organizers of the exhibition decided to remove the work. Duchamp immediately resigned from the Society's board. In one account of the object's removal, Arensberg loudly demanded that *Fountain* be produced so that he could purchase it. Meanwhile Duchamp and Man Ray carried the work through the crowded galleries while Arensberg signed his check.[23] Duchamp's friend Beatrice Wood noted that the artist's purpose in exhibiting this work was "to test the allegedly liberal minds of the middle class." An unfortunate consequence, she added, was that "with all of the commotion, I think the real artists were neglected."[24]

By April 19, 1917, *Fountain* had been brought to 291, where it was photographed by Stieglitz. According to Wood, Stieglitz was greatly amused by Duchamp's *Fountain*, "but also felt it was important to fight bigotry in America. He took great pains with the lighting, and did it with such skill that a shadow fell across the urinal suggesting a veil. The piece was renamed: 'Madonna of the Bathroom.'"[25] Stieglitz himself related the story of *Fountain* to Henry McBride: "I wonder whether you could manage to drop in at 291 Friday some time. I have, at the request of Roché, Covert, Miss Wood, Duchamp & Co., photographed the rejected 'Fountain.' You may find the photograph of some use. It will amuse you to see it." Almost as if an afterthought, Stieglitz added, "The 'Fountain' is there too."[26]

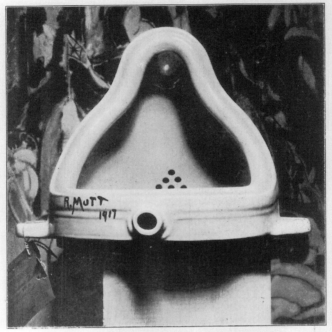

**2.4** Photograph by Alfred Stieglitz of Marcel Duchamp's *Fountain,* reproduced in *The Blind Man* (May 1917). Philadelphia Museum of Art: The Louise and Walter Arensberg Archives.

Defenders of Duchamp championed the work's classic lines.
Due to its overall form, one viewer dubbed the urinal "The Bud-
dha of the Bathroom." Arensberg argued the aesthetic merits of
the piece to the directors of the Society of Independent Artists,
claiming that "a lovely form has been revealed, freed from its
functional purpose, therefore a man clearly has made an aesthetic
contribution."[27] Stieglitz remarked on the Buddha-like form and
fine lines of *Fountain* in a letter to Georgia O'Keeffe.[28] Signifi-
cantly, though, Duchamp himself did not choose to emphasize the
aesthetic qualities of the object. Instead, he focused on his act of
selection and on his providing an unexpected (i.e., contemplative
and nonfunctional) context in which to view the object.

In an unsigned editorial that appeared in the May 1917 issue
of the Dada little magazine *The Blind Man*—a piece that was most
likely written by one or more of Duchamp, Arensberg, and Bea-
trice Wood[29]—the author(s) defended Duchamp's actions regard-
ing *Fountain*. At the same time, they provided a philosophy for his
readymade. The piece stated:

They say any artist paying six dollars may exhibit. Mr. Richard Mutt sent
in a fountain. Without discussion this article disappeared and never was
exhibited. What were the grounds for refusing Mr. Mutt's fountain:—1.
Some contended it was immoral, vulgar. 2. Others, it was plagiarism, a
plain piece of plumbing. Now Mr. Mutt's fountain is not immoral, that is
absurd, no more than a bath tub is immoral. It is a fixture that you see
every day in plumbers' show windows. Whether Mr. Mutt with his own
hands made the fountain or not has no importance. He CHOSE it. He
took an ordinary article of life, placed it so that its useful significance dis-
appeared under the new title and point of view—created a new thought
for that object. As for plumbing, that is absurd. The only works of art
America has given are her plumbing and her bridges.[30]

Such comments underscore the rather arbitrary nature of
*Fountain's* authorship. This factor, along with Duchamp's pro-
fessed indifference toward aesthetics, make the readymades
somewhat contradictory works of art. Their particular power
lies in the deployment of paradox.[31] As "ordinary" objects cum

artworks, the readymades are constructed entirely through Duchamp's complex interventions. As David Joselit has shown, the project of the readymades entailed a complicated relation between the body, the commodity, and language itself in that the readymades transformed commodities into artworks through the effects of language and inscription, a process which precipitated a form of endless play in which the materiality of the body became displaced by the commodity.[32] Through these physical and conceptual operations, the readymades inherently called into question the very nature and function of artistic production and consumption, of authorship and audience. As Clement Greenberg has noted, Duchamp's readymades "startled when first seen only because they were presented in a fine-art context, which is a purely cultural and social, not an esthetic or artistic context." Thus the readymades "showed that the difference between art and non-art was a conventionalized, not a securely experienced difference."[33]

Stieglitz's two contributions to the May 1917 issue of *The Blind Man*—his photograph of *Fountain* and an open letter to the magazine's editors—demonstrate that the photographer understood the nature of Duchamp's artistic and self-production. While in both pieces Stieglitz appears to take a radical approach to the conceptualization and exhibition of artworks, a careful examination of these documents reveals that Stieglitz was actually advancing a much more conservative position than Duchamp toward artistic authorship, aesthetics, and performance. Stieglitz can even be seen as using Duchamp to advance indirectly his own artistic agenda.

In his letter to *The Blind Man,* Stieglitz appeared not only to uphold the policies of the Independents, but to push them further. Stieglitz advised the Independent Society to withhold the names of the makers of all exhibited works, and to substitute numbers or some other anonymous marker for the artist's name. In this way, Stieglitz argued, the work would stand completely on its own merits: "As a reality. The public would be purchasing its own reality and not a commercialized and inflated name."[34] Significantly, Stieglitz's critique of inflated names and his advocacy of

anonymity simultaneously bolstered and undercut the strategy behind the readymades. Duchamp's readymades were at once the most *and* the least anonymous artworks possible. As preexisting, generic objects, the readymades were anonymous. Yet as "Duchamp" readymades, the objects became distinguished through their association with their maker.[35] In a single gesture, Duchamp was able to be "author" and iconoclast at once. Thus when Stieglitz advocated the banishing of "inflated names," his proposal was to abolish precisely what Duchamp's inscription on the readymade was—an inflated name that endowed a generic object with the sense of artistic presence, and hence agency, that ostensibly converted it into a work of art.[36]

While Duchamp framed his withholding of aesthetic qualities as a courageous gesture of refusal, Stieglitz's call for an independent, noncommercialized, and anonymous art was implicitly guided by the criteria of artistic quality. According to Stieglitz's logic, because the artwork inherently possessed artistic quality, it did not require the artist's signature as a supplementary mark of value. Yet intrinsic quality and aesthetic value were precisely what Duchamp disavowed in his readymades. Because Duchamp repeatedly emphasized his indifference to aesthetic values, the readymades literally couldn't stand on their own artistic merits, as Stieglitz had urged, because they did not necessarily have *any* intrinsic artistic merits to stand on. In contrast, Stieglitz's suggestion that the artist "withhold" his or her signature could be seen as an act of aesthetic courage, proof that nonessential, extrinsic marks of value could be jettisoned in favor of intrinsic quality. Thus Stieglitz's call for anonymity was a reversal of the strategy behind Duchamp's readymades. To paraphrase Greenberg's critical language, Stieglitz's position was that the experience of viewing anonymous artworks would demonstrate that the difference between art and nonart *was* a securely experienced, rather than a merely conventionalized, difference.

Stieglitz made the same point, in a different form, in his photograph of *Fountain*. While Duchamp chose to emphasize selection and context over the aesthetic qualities of the object, Stieglitz, as Beatrice Wood suggests, undoubtedly aestheticized

*Fountain* in the process of photographing it. In addition to his selection of the perspective, framing, and lighting of the work, Stieglitz placed Duchamp's *Fountain* in front of Marsden Hartley's painting *The Warriors* (1913). While Stieglitz often positioned his subjects in front of artworks (as, for example, in his portrait of Picabia), his choice of Hartley's canvas as a background for Duchamp's *Fountain* is highly suggestive. Hartley had painted *The Warriors* while working in prewar Berlin. Because of the ostensibly subversive nature of both works, the exhibition of Hartley's *Warriors* and of Duchamp's *Fountain* was highly problematic in 1917.

Yet another provocative possibility exists for Stieglitz's selection of Hartley's painting as a background for Duchamp's sculpture. Both works suggest an ambiguous display of sexuality. The *Fountain*, which Duchamp himself called *"Le pendu femelle,"* often was described as a curving, "feminine" form, but nevertheless it inescapably remained an object intended for male usage. Moreover, in a letter to his sister Suzanne, Duchamp identified Richard Mutt, the "author" of the work, as one of his female friends working under a masculine pseudonym.[37] Similarly, Duchamp apparently led Stieglitz to believe that *Fountain* had been submitted to the Society by a young woman.[38] Stieglitz responded in turn to Duchamp's deliberately gender-destabilizing gesture through his own careful positioning (and hence, recontextualizing) of the work in his photograph. Hartley's painting depicts a seemingly "masculine" subject: a display of soldiers, "warriors," in prewar Berlin. Yet as Stieglitz was well aware, Hartley was a homosexual artist who was openly attracted to the soldiers and reveled in displays such as military parades.[39] In his photographic "coupling" of Hartley's painting and Duchamp's sculpture, Stieglitz presented the issues of gender and sexuality surrounding *Fountain* as decidedly unfixed and polysemous. Thus in Stieglitz's photograph the ambiguous gender of *Fountain's* author was made to mirror the unstable, gendered qualities of the object itself. In addition, Stieglitz seems to have transformed the issue of artistic anonymity into a mechanism of recognition. The informed viewer would know that the background painting was a "Hartley," and the

photograph itself a "Stieglitz," without having to look for a signa-
ture. If anything, Stieglitz proved that photography (as well as a
signature) could make a readymade a "genuine" work of art, par-
ticularly since *Fountain* became increasingly aestheticized
through Stieglitz's representation of it.[40]

Ultimately, Stieglitz's photograph can be interpreted as an act
of meta-appropriation. As Thierry de Duve has observed, "The
surprising thing about this photograph is not so much that Stieglitz
annexed the urinal to his own aesthetics of symbolic correspon-
dences—he did that even with the works he was showing at 291—
but that Duchamp let him do it."[41] As a result of Duchamp's and
Stieglitz's mutually self-serving interactions, the object went from
being a urinal, to a readymade, finally to a Stieglitz photograph of
a Duchamp sculpture. While Duchamp's creative act was to make
an "ordinary" object a work of art, Stieglitz self-reflexively (re)-
produced an artwork about artworks. Stieglitz even got the last
word in the debate over aesthetics and authorship triggered by
*Fountain.* In being signed "R. Mutt" and vociferously defended
by Duchamp himself, *Fountain* had "Duchamp" written all over
it, yet in producing this signal record of the work, *Fountain* as we
now know it has "Stieglitz" metaphorically written all over it. That
is, since the actual *Fountain* was lost shortly after its removal from
the 1917 exhibition, Stieglitz's photograph is how *Fountain* is now
best known. Stieglitz himself may have foreseen this develop-
ment, since his letter to Henry McBride, quoted above, clearly
shows him attaching greater importance to his photograph of
*Fountain* than to the object itself. Thus while Duchamp's *Foun-
tain* enjoyed a sensational moment, Stieglitz's photograph is the
more enduring record that documents Duchamp's ephemeral ges-
ture. In the end *Fountain* is an artwork known through the lens
of Stieglitz's camera, and thus through the terms of Stieglitz's
authorship.[42]

Despite the important differences in their respective proj-
ects, Stieglitz's photographs and Duchamp's readymades share an
important similarity.[43] Since both art forms are executed through
acts of appropriation, in each case what the artist can make is
based on what he finds. Yet the familiar and intimate quality of the

subjects Stieglitz "found" to photograph could not be more differ-
ent from the "found" objects that constituted Duchamp's ready-
mades and the "bodies" of his mechanomorphic figures. In fact,
Duchamp's use of preexisting mechanical objects provided
Stieglitz and his critics with an antithetical model against which
to define Stieglitz's own relations with his camera and man-
machine relationships in general.

## Sexuality in Glass and Metal

Before turning to critical descriptions of the photographer and his
camera and to the critique of industrialization embedded within
them, it is first necessary to examine Duchamp's unfinished "mas-
terpiece," *The Bride Stripped Bare by Her Bachelors, Even*, or *The
Large Glass* (1915–1923, fig. 2.5). Like *Fountain*, *The Large Glass*
was highly influential for the New York avant-garde. Duchamp
himself stated that "The Large Glass is the most important single
work I ever made."[44] Stieglitz publicly admired the work at the
Brooklyn Museum in December of 1926; two years later Demuth
told Stieglitz that he considered *The Large Glass* to be "the great
picture of our time."[45]

Duchamp began constructing *The Bride Stripped Bare by her
Bachelors, Even* in 1915 while staying at the Arensbergs' New
York apartment. He abandoned the project in 1923, leaving the
work definitively unfinished. Resembling a double-paned win-
dow, Duchamp's "canvas" consists of two large sheets of glass. In
keeping with his emphasis on conceptual aspects of art over sen-
sual ones and "intellectualism" over emotion, in this work
Duchamp presents cerebral, mechanized bodies with nongenera-
tive sexualities. The "bride," a motorized assemblage, hovers
alone in the upper stratum; below, her "bachelors" stand waiting.
Yet the "bachelors" are destined to remain bachelors because
they can't reach the "bride" but ceaselessly engage in the futile
attempt to do so. Duchamp's bachelor figures resemble chess
pieces, players lined up for a game based on ritualized, patterned
movements. In both chess and in courtship, unfolding patterns

**2.5** Marcel Duchamp, *The Bride Stripped Bare by Her Bachelors, Even (The Large Glass),* 1915–1923. Oil and lead wire on glass, 109 ¼ × 69 ⅛ in. Philadelphia Museum of Art: Bequest of Katherine S. Dreier. ©2000 Artists Rights Society (ARS), New York / ADAGP, Paris / Estate of Marcel Duchamp.

typically reach an ending, or "consummation," of one sort or another. Yet in order for the game to go on, completion cannot occur. If either the bachelors or the chess pieces are "mated," then the game is over.[46]

Duchamp called his bachelor figures the "nine Mallic Moulds."[47] Like empty suits, the moulds are meant to represent generic male figures, while a glider moving to and fro suggests the repetition of the bachelors' lives. The two other principal objects in the bachelors' domain, the chocolate grinder and the oculist witnesses, signify sexual and optical functions respectively. In a 1913 drawing of the *Chocolate Grinder*, Duchamp inscribed the phrase "the bachelor grinds his chocolate himself." The "grinder" is thus emblematic of the bachelors' repetitive, onanistic motions. The oculist witnesses, meanwhile, suggest schematized, detached, and disembodied vision. These forms are based on oculists' charts, and seemingly serve as "witnesses" to the bachelors' actions. Taken as a whole, the objects in the bachelors' domain suggest a disassembled and fragmented version of subjectivity. For Duchamp, the bachelor is an eye, a sexual impulse, and an empty uniform.

Like the bachelors, the bride is not presented as a coherent human subject. As Duchamp explained, she is "basically a motor" with a reservoir of "love gasoline." In *The Large Glass* the bride undergoes two forms of stripping, an "electrical stripping" caused by the bachelors, and a psychological stripping which she voluntarily brings about through her own imagination and desire.[48] Despite the bride's "blossoming," *The Large Glass* is about the consummation that does not occur. While Duchamp presents typological models of sexuality in the figures of the "bachelors" and the "bride," he deliberately withholds distinguishing marks of gender or of coherent subjectivity.[49] The result is that, as in *Fountain*, *The Large Glass* remains ambiguous, puzzling, and provocatively unfixed in its gendered significations.

In creating artworks based on the oxymora of human machines, Duchamp's accomplishment was nothing less than problematizing comprehensively the categories through which human and artistic "subjects" were constituted. In *The Large Glass*

Duchamp simultaneously deconstructs *and* reaffirms tropes of disembodied subjectivity, parody, and negation. And through *The Large Glass* and many of the readymades, Duchamp offered a perversely humorous version of Descartes's philosophy, especially Descartes's *Optics*. As the quintessential French rationalist philosopher and the veritable author of the conditions of split subjectivity, Descartes divided the universe into the mutually exclusive but interacting realms of matter and spirit. In the *Optics* he offered a mechanistic view of the body and its processes in which perception is tied to cognitive functions in a uniform, generalizable (and hence depersonalized) manner.[50]

Like Descartes, Duchamp played the mechanical functions of the body off against the privileged (if not purified) status of cerebral and optical functions. Duchamp's figures emphasize the mechanical functions of the body, and correspondingly, connote a profound sense of futility and fragmentation in the subject's condition of emptiness. While Duchamp's bachelor and bride machines obviously are theatrical and performative, their actual point of reference remains unclear. At once profane and cerebral, Duchamp's artwork disavows sensuous aesthetic significance even as it bespeaks desire. In its resistance to aestheticization and generally unresolved state of physical and interpretive closure, Duchamp's *Large Glass* presents a theater of perpetual artistic and sexual crisis. Its aesthetic and erotic austerity offers sex without eroticism and "strips bare" some of painting's most powerful attributes. In so doing, this object, like *Fountain,* calls into question the categories of *how one knows* a work of art.

In denying the sensuality of both painting and the body, Duchamp's art resists a formalist aesthetic and insists instead on an alternative relation between the object and the viewer. In a pamphlet published by the Société Anonyme in 1944, Katherine Dreier and the surrealist painter Matta Echaurren offered their analysis of what this alternative might entail. In particular, they described Duchamp's *Large Glass* as a necessary move away from "turpentine and oil surfaces" and from traditional representations of the body in order to explore the philosophical issue of consciousness. Dreier and Matta began their "Analytical Reflection"

on Duchamp's Glass by setting out this duality: "The Renaissance brought to human consciousness the full awareness of the organic image of man's own body—the visible structure of Man and the natural world. The whole chain of association was controlled by the physical phenomena, and the interest in natural sciences was stimulated and began to grow. In contrast to natural sciences, phenomenology, which is the science of the transcendental consciousness as indicated by Kant, now helps us to realize the structure of the human spirit."[51]

Thus in contrast to painting, which emphasizes external vision, Duchamp "was the first to paint the image per se, to be completed by an act in consciousness on the part of the spectator." In *The Large Glass* the viewer encounters "a disturbing plastic conversation. This, the human spirit can only understand by means of poetic reasoning, which demands an intentional conscious act on our part."[52] Dreier and Matta claim that by placing the viewer in an unaccustomed position vis-à-vis the artwork, Duchamp is able to transform art into a spiritual experience: "Painting—glass—mirror—these are the three substances in dynamic interrelation to the final image of the 'Glass.' While we gaze upon the bride—there appears through the glass the image of the room wherein we stand and on the radiation of the mirror design lives the image of our own body. This dynamic reality, at once reflecting, enveloping and penetrating the observer, when grasped by the intentional act of consciousness, is the essence of a spiritual experience."[53] Again emphasizing the nonmaterial basis for spiritual experience, they conclude that Duchamp "causes one to realize the futility of trying to possess that which does not belong to the material world. For the moment one wants to possess and grasp at it—that moment it eludes one and like smoke, it vanishes into thin air!"[54] Thus according to Dreier and Matta, the viewer's relation to painting, to "turpentine and oil surfaces," is fundamentally similar to the bachelors' relation to the bride. Both concern the futile attempt to possess a desirable but always elusive "other." The trajectory that Dreier and Matta cite, from painting to glass to mirror, marks the shift from opacity (looking at) to transparency (looking through), finally to reflection (looking back). In fact, these opera-

tions describe not just a viewing process, but an intersubjective encounter. In this exchange, the "other" whom one looks "at" ultimately becomes the "self" who one recognizes.[55]

In order to facilitate the viewer's (self-)recognition, Duchamp's "figures" must be represented as disembodied, as chess pieces or as mechanical assemblages, and not as human agents. This is because the coherence of the viewer (including both his or her physical and psychological selves) exists in opposition to the coherence of the "others" represented in the work, in this case the bachelors and the bride. If Duchamp's "painting" were to contain sensuous erotic or aesthetic qualities, then it would continue to perpetuate the sense of split that Duchamp saw as endemic to traditional painting. According to Duchamp, in conventional painting the viewer is relegated to a position "outside" of the work, looking in the (perspectival) "window" at the alluring object, the desirable painted "other."[56]

In various ways *The Large Glass* generates a continuous dialogue between refusal and admittance. Duchamp denies the viewer traditional notions of perspective, aesthetics, and representations of the human subject. Yet as a philosophical problem and a reflective surface, *The Large Glass* unites the viewer's body and mind in an act of "reflection." The consummation that does not and cannot occur within *The Large Glass* occurs outside of it, according to Dreier and Matta, in the viewer's physical, conceptual, and ultimately "spiritual" encounter with the work. By turns, the "stripping" of the bride becomes the recognition of the self in the (large) glass, and "reflection" becomes an act of (corporeal and psychological) re-member-ing.

It is significant that Dreier's and Matta's remarks on *The Large Glass* appear in an American context, as their reading of the work is consistent with a longstanding preoccupation in American criticism—the desire to recover the fragmented self as a spiritual being.[57] Notwithstanding the holistic experience that Dreier and Matta describe as taking place outside of the object, within the glass itself the underlying strategy of the Bride and Bachelors remains the objectification of the human subject. Stieglitz's group took exactly the opposite approach: they merged aestheticized

objects and embodied subjects. Through their critical discourses, the Stieglitz circle described the sense of subjectivity invested in their paintings and photographs as coherent, embodied, and endowed with a kind of ontological status. Duchamp's artworks, meanwhile, deconstructed not only the coherent subject, but the conditions upon which this coherence was based. While Stieglitz circle artworks were produced by and for private individuals and tied to a larger project of social and cultural renewal, Duchamp's generic, alienated figures seem to revel in their own futility. Self-consciously styled as gratuitous and empty (as noted above, Duchamp called his bachelors "empty suits,") the presence of Duchamp's figures serves as a glorified expression of absence. The work is self-consciously and unabashedly a "construction," an exposed mechanism, a failed union and an incomplete (and definitively unfinished) work of art.[58]

## The Phallic Camera

Unlike the persistent ideology of absence and sterility associated with Duchamp's and Picabia's images, the Stieglitz circle critics repeatedly emphasized that the photographer's artworks were vitalized by his own unique and generative presence. Nowhere were these themes more prevalent than in the critical commentary which accompanied Stieglitz's 1921 "comeback" exhibition at the Anderson Galleries. In numerous critical accounts, the camera was described as an extension of Stieglitz's own body, and his photographs as an extension of his spirit. Because Stieglitz had ostensibly made the camera part of his own body, his photographs were understood to be informed by the same desires and emotions that had inspired Stieglitz in making the images, and these feelings and impulses were also presumably available to his viewers.

In the privately printed pamphlet that accompanied Stieglitz's 1921 show, the photographer Paul Strand wrote of Stieglitz's relation to the camera, "Stieglitz had accepted the machine, instinctively found in it something that was a part of himself, and loved it."[59] Paul Rosenfeld was even more explicit in his

review of the exhibition for the *Dial*. Rosenfeld claimed that as soon as Stieglitz learned to photograph, "He began attempting to make [the camera] a part of his living, changing, growing body." Moreover, Stieglitz had "above all, a savage desire to make the rebellious machine record what he felt, to make the resistant dead eye of the camera register that which his animal eye perceived."[60] Building on this interpretation, in 1922 Sherwood Anderson went so far as to locate Stieglitz's "maleness" in his relationship with his "tools." Anderson wrote, "I have quite definitely come to the conclusion that there is in the world a thing one thinks of as maleness that is represented by such men as Alfred Stieglitz. It has something to do with the craftsman's love of his tools and his materials."[61]

As an artist and a "craftsman," Stieglitz described himself as naturally sympathetic to machines. In a letter to Georgia O'Keeffe, Stieglitz commented: "Machines have great souls.— I know it.—Have always known it.—But they must be given a chance to show them—People interfere too much & have no faith."[62] Stieglitz not only claimed to be sympathetic to machines' souls; he also described man's creative employment of the machine as a mark of his sexual potency. In particular, Stieglitz described photography as a procreative activity. In September of 1920 Stieglitz sent a letter to Seligmann in which he used the metaphor of impotence to characterize his own failed prints. Stieglitz wrote: "I am getting to hate 'nearlys' more & more.—And the more nearly to the It—the more I hate that nearly.—It's like an incomplete erection—a sort of 7/8—I know the difference!— The 1/8 lacking is often due to too much 'Intellectuality.'"[63] Stieglitz's attributing notions of impotence to excessive intellectuality may well have been inspired by Picabia's mechanomorphic 'portrait' and by Duchamp's dualistic bachelor figures.[64]

The Stieglitz circle's critique of dualism becomes particularly evident in critical discussions that attempt to invest the photographer's relations with his camera with a larger social and cultural significance. Anderson, Rosenfeld, Frank, and others viewed the organic, even phallic, connection between Stieglitz and his camera as an antidote to the mechanized sexuality and the denial of

aesthetics they perceived in Duchamp's and Picabia's works *and* in modern industrial life. Rosenfeld clearly established this contrast in his review of Stieglitz's 1921 exhibition. Echoing themes that were popular among contemporary social and cultural critics, Rosenfeld claimed that "the whole of society was in conspiracy against itself, eager to separate body and soul, to give the body completely over to the affairs of business while leaving the soul straying aimlessly in the clouds."[65] Rosenfeld went on to describe a veritable fantasy of castration in which man is severed from his body and is rendered passive by the machine. He wrote: "During a century and a half, the race of machines has been enslaving man and impoverishing his experience. Like Frankensteins invented by the human brain to serve it, these creatures have turned upon their master, and made prey of him."[66] Yet while the machine has made man its prey, Stieglitz "has made the very machine demonstrate the unmechanicalness of the human spirit."[67] Eight years later Waldo Frank was even more vociferous in his polemic against the "cult of power" in modern industrial society, writing, "In our land, [the] paradox of Power is concrete. Power has spread the machine; the machine acts and man is passive." Perhaps referring to Duchamp's *Large Glass,* Frank added that in American society, "art becomes a mechanical mockery of life."[68] This is because modern man loves the machine "autoerotically. Its body of surfaces must shine, as if it were the body of the beloved."[69] Frank's description of modern man's "autoerotic" love for the machine is reminiscent of the onanistic motions of Duchamp's bachelors. Yet in Frank's and Rosenfeld's critical discourses, the relationship between man and machine is even more lurid and threatening than in Duchamp's works. Both writers implicated the machine in producing and perpetuating the conditions of split subjectivity and debilitating sterility associated with modernism.

Such statements can be interpreted as an almost inevitable response to the threat the camera posed to Renaissance perspective. As a representational device, the camera alters (and potentially shatters) traditional (humanist) perspectival space. Stieglitz and his critics countered the image of the camera as a disembodied, mechanical eye, detached and precise in its movements, with

the image of Stieglitz's organic incorporation of the camera into himself. With this rhetorical move, man became recentered, and was restored to a position of control and potency. Thus while Duchamp's art featured a disembodied portrayal of vision and of subjectivity, Stieglitz's art was described as the product of a guiding (embodied) human eye and a compliant mechanical lens. John Marin made this point in his response to the question, "Can a Photograph Have the Significance of Art?" when he wrote, "this photographer has made camera sight and his own sight into One."[70]

Unlike Duchamp's works, Stieglitz's photographs were seen not as sexually ambiguous, unfixed, or sterile, but as stable, positive, sublimated, and aestheticized. Duchamp's art, in contrast, does not permit such aestheticization. As Rosalind Krauss has pointed out, Duchamp's art acknowledges the physical body, yet denies the viewer the possibility of sublimation.[71] In fact, *The Large Glass* and the readymades insist on desublimation. In contrast, Stieglitz and his critics emphasized not only the presence of the sublimated sexual body in Stieglitz's photographs, but also the idea that even nonbodily subjects such as landscapes and still lifes were endowed with a kind of erotic vitality.[72] In *Port of New York*, for example, Rosenfeld wrote that Stieglitz's images evidence a profound resonance between landscapes, natural forms, and the body: "A button is a bone; a ruffling aspen, feminine; the stones full of flesh."[73]

Yet the most powerful way in which Stieglitz himself expressed his understanding of the continuities between nature, abstraction, and the self was through his concept of "Equivalents" (fig. 2.6). While Stieglitz used this term specifically to describe his photographs of clouds, the notion of "Equivalents" also took on important general connotations in Stieglitz's photographic practice. Dorothy Norman recalled Stieglitz's comment that "'My cloud photographs are *equivalents* of my most profound life experience, my basic philosophy of life.' In time he claimed that all of his prints were equivalents; finally that all art is an equivalent of the artist's most profound experience of life."[74] Stieglitz based his notion of "equivalents" on the perception of a continuous flow between natural and abstract forms, between the artist and his

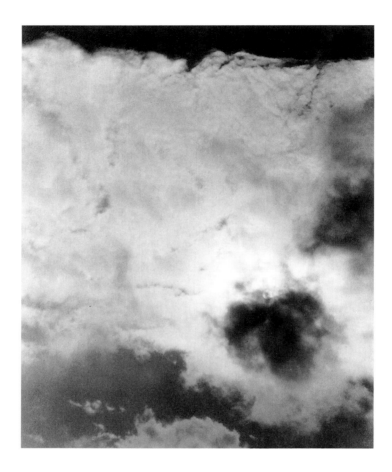

**2.6** Alfred Stieglitz, *Songs of the Sky,* 1923. Gelatin silver print, 4 ½ × 3 ⅝ in. The Phillips Collection, Washington, DC. The Alfred Stieglitz Collection, Gift of Georgia O'Keeffe, 1949.

corpus of works, and between sexuality and spirituality. Along these lines, Lewis Mumford identified the photographer's composite portrait of O'Keeffe (figs. 3.5–3.7) as a crucial turning point in Stieglitz's ability to establish photographic "equivalents." Mumford claimed that Stieglitz's "manly" response to O'Keeffe's body ultimately enabled him to perceive the essential relations between the body and other natural forms, such as clouds: "It was [Stieglitz's] manly sense of the realities of sex, developing out of his own renewed ecstasy in love, that resulted in some of Stieglitz's best photographs. In a part by part revelation of a woman's body, in the isolated presentation of a hand, a breast, a neck, a thigh, a leg, Stieglitz achieved the exact visual equivalent of the report of the hand or the face as it travels over the body of the beloved. . . . In more abstract, yet not in less intimate form, Stieglitz sought to symbolize the complete range of expression between man and woman in his cloud pictures, relying upon delicacies and depths of tone, and upon subtle formal relationships, to represent his own experiences."[75]

Mumford's account of Stieglitz's camera as a surrogate, or "equivalent," for the lover's hand traveling over his partner's body resonates with Rosenfeld's description of Stieglitz's making "his machine a portion of the living, changing, growing body; and the act of photography an experience." In each case, the embodied and more or less explicitly sexual relation is the gestalt which establishes all of the other relations in Stieglitz's photographs and, as we shall see, in the paintings of his followers. Furthermore, the consummated sexuality that Mumford and others described as the guiding knowledge behind Stieglitz's photographs stands in obvious contrast to Duchamp's unfinished masterpiece, *The Large Glass,* a work which critics have routinely compared to an unachieved orgasm.[76] More effective than anything else could have been, Stieglitz's public displays of his seemingly private representations of O'Keeffe were instrumental in mending his image as a "broken" camera and in restoring the photographer to a position of potency and originality. Clearly, Stieglitz was no "bachelor," and the sensuous allure of O'Keeffe's body was not to be outshone by the mechanized sexuality of Duchamp's "bride."

# Alfred Stieglitz and His Critics:

## An Aesthetics of Intimacy

One of the remarkable aspects of Alfred Stieglitz's artistic project is the considerable degree of power that he was able to exercise in the New York art world, given how little he actually wrote for publication. This was particularly the case after the cessation of *Camera Work*, the house organ of 291. This is not to say that Stieglitz stopped writing altogether. In addition to the occasional piece on photography, Stieglitz maintained a lively and voluminous personal correspondence. Yet when it came to the artists of his inner

circle, Stieglitz largely left it to others to promote their works in print. For strategic reasons, Stieglitz preferred the medium of private correspondence as a means to shape public discourse.

After the closing of 291 in 1917, Stieglitz assembled a small but powerful contingent of critics around himself and his artists, a group that included Herbert J. Seligmann, Lewis Mumford, Sherwood Anderson, Louis Kalonyme, Waldo Frank, and Paul Rosenfeld.[1] Under the photographer's guidance, these writers played a crucial role in formulating and sustaining a coherent aesthetic and ideological identity for the Stieglitz group. Yet of all the professional relationships that Stieglitz cultivated, arguably none were more important than those which he established with Rosenfeld and Frank.[2] Like Stieglitz himself, Rosenfeld and Frank were committed to promoting the Stieglitz circle artists as the fulfillment of a shared vision of vital, de-Puritanized American art.

## Stieglitz and the Critics: A Growing Affinity

Stieglitz and Rosenfeld first met around 1915.[3] From the outset, it is easy to see how the young critic would be attracted to the charismatic and paternal presence of the photographer, who was twenty-six years his senior. Stieglitz and Rosenfeld both came from affluent German-Jewish backgrounds. In fact, they were distantly related to one another by marriage, as they probably soon discovered.[4] Rosenfeld's mother was an accomplished pianist who had died when Paul was ten years old; his father, Julius, died around the time of Paul's graduation from Yale in 1912. The early loss of his parents left Rosenfeld with both an emotional void and a source of material support: he inherited a substantial independent income that, until the crash of 1929, enabled him to live quite comfortably in New York and Westport, Connecticut. After graduating from Yale Rosenfeld earned a degree in literature from the Columbia University School of Journalism, after which he worked briefly as a newspaper reporter in New York.

Rosenfeld was most likely introduced to Stieglitz by Waldo Frank. Like Rosenfeld, Frank came from an upper-middle-class

Jewish family. Frank had graduated from Yale in 1911, the year before Rosenfeld, with both a bachelor's and a master's degree.[5] While the two men may have met in college, their friendship developed shortly after, while both were working as newspaper reporters in New York (Rosenfeld was at the New York *Press* while Frank wrote for the *New York Evening Post* and the *New York Times*). Following their stints as journalists, both men spent time in Europe. By 1916 Frank had become associate editor of the newly founded *Seven Arts*. Rosenfeld's first article on Stieglitz appeared in the November issue of the journal under the pseudonym Peter Minuit. This essay clearly marked the beginning of his "conversion" to Stieglitz's project.

In this early piece Rosenfeld sketched a portrait of Stieglitz that he would extend and refine over the next decade. Rosenfeld asserted that at 291 Stieglitz was leading a generative, spiritual campaign to promote American "self-consciousness," writing: "Stieglitz' ideas are not what makes him Stieglitz. It is rathermore his spirit, that splendid desire to give himself to whosoever needs him—to America. It is his lofty conception of art, not as a *divertissement*, a refuge from the world, but as a bridge to consciousness of self, to life, and through that, to new life and new creation again."[6] Rosenfeld thus portrayed Stieglitz as a radiant, almost saintly figure whose gift lay in his ability to inspire spiritual awareness in his gallery's visitors. The critic concluded his article with this hyperbolic description of Stieglitz: "For which of us can tell how far the energy that radiates from him will reach, by what inscrutable processes it will again and again enrich life? That is his immortality. We, who have taken what we could, bow our heads in recognition of the generous spirit that has given itself to us."[7] As this statement suggests, from the first the structure of Rosenfeld's admiration for Stieglitz was clearly self-reflexive. That is, Rosenfeld's essay was not only a tribute to Stieglitz himself but also an account of the feelings that the photographer supposedly inspired in the critic. Eventually an almost familial bond existed between Rosenfeld and Stieglitz; Van Wyck Brooks once noted that Rosenfeld looked up to Stieglitz "as a prophet and almost a father."[8] Similarly, Edmund Wilson observed that Rosenfeld's "strongest tie

**3.1** Alfred Stieglitz, *Waldo Frank,* 1920. Platinum/palladium print, 24.3 × 19.2 cm. The Metropolitan Museum of Art, Alfred Stieglitz Collection, 1928.

was undoubtedly with Stieglitz, toward whom he stood in something like a filial relation; and the group around Stieglitz became for him both family and church."[9]

By 1920 Rosenfeld, having completed a term in the army, was in frequent contact with Stieglitz. That June Rosenfeld invited Stieglitz and O'Keeffe to spend a weekend at his suburban home in Westport. Waldo Frank and his wife, the educator Margaret Naumburg, visited Rosenfeld in Westport that September, and during the summer and fall of 1920 both Rosenfeld and Frank spent time at Stieglitz's family home in Lake George, New York. During these visits Stieglitz had the opportunity to photograph both young men. Stieglitz's portrait of Frank (fig. 3.1) shows the writer seated on the porch of the farmhouse in a Windsor chair. Frank gazes directly out at the photographer while holding a manuscript in his lap and peeling apples, a fruit that grew abundantly on the grounds of the property and that, as Charles C. Eldredge has shown, served as a symbol of American organicism for the entire Stieglitz circle.[10] (Stieglitz produced his own version of this symbolic subject in a slightly later photograph entitled *Apples and*

**3.2** Alfred Stieglitz, *Apples and Gable, Lake George,* 1922. Gelatin silver print, 4 ⅝ × 3 ⁹⁄₁₆ in. (11.4 × 9 cm). The Metropolitan Museum of Art, Ford Motor Company Collection, Gift of Ford Motor Company and John C. Waddell, 1987.

*Opposite:*
**3.3** Alfred Stieglitz, *Georgia O'Keeffe: A Portrait—with Paul Rosenfeld and Charles Duncan,* 1920. Silver gelatin print. Alfred Stieglitz Collection, © 1999 Board of Trustees, National Gallery of Art, Washington, DC.

*Gable, Lake George* [1922, fig. 3.2].) Yet just as Stieglitz was composing this portrait of Frank during the summer of 1920, the photographer was also reflecting on the verbal "portrait" that Frank had published of him in *Our America*. Stieglitz was so struck by Frank's writings that he read aloud the relevant passages to Georgia O'Keeffe while the two were vacationing at Lake George.[11]

Much as Rosenfeld had done in the *Seven Arts* essay (1916), in *Our America* Frank characterized Stieglitz as a "prophet" and a "mystic" and 291 as a holy place, a "church" and "a religious fact: like all such, a miracle."[12] Significantly, Frank described Stieglitz's photographs as examples of the photographer's spiritual and corporeal merger with his subjects. As Frank put it, Stieglitz transforms his subjects "and makes them serve the unifying vision of human spirit." Thus in his "portraiture and studies of the nude" Stieglitz "has achieved plasticity and intense subjective interpretation of the human form. He has mastered a deep reality and lifted it up to his own terms."[13] As these passages suggest, both Frank and Stieglitz regarded their early, reciprocal acts of portrait making as mutually self-creative activities. In *Our America* and in

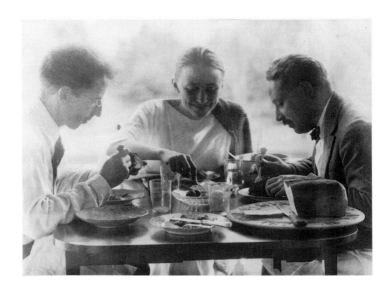

Stieglitz's photographs, the author's or artist's portrayal of his subjects serves at once as a representation of that person *and* as a reflection of the creator himself.

Similarly, a photograph taken during Rosenfeld's October stay at Lake George (fig. 3.3) suggests the growing intimacy that was developing between Stieglitz and the critic. The image depicts, from left to right, the artist Charles Duncan, Georgia O'Keeffe, and Rosenfeld himself seated at a table having lunch.[14] Stieglitz's presence is indicated by the used china at the empty place setting nearest the viewer. As in his gallery, Stieglitz manages in this photograph to be in two places at once. He is both a part of the scene, eating and walking among his guests, and at the same time he stands apart from them, making arrangements, orchestrating details, and taking life around him as the material for his art and the basis for his professional practice. In this manner, Stieglitz is able to be symbolically present in a photograph of his closest friends while at the same time remaining physically absent from the actual scene he represented. Stieglitz's ability to establish this sense of his symbolic presence would be crucial to the relationships that he formed with both Rosenfeld and Frank during the early twenties. For his own part, Rosenfeld was openly delighted to be included in Stieglitz's intimate circle at this early point. After returning from Lake George, O'Keeffe mailed Rosenfeld a copy of this luncheon photograph as well as other shots Stieglitz had taken during the visit. Shortly after receiving the images, Rosenfeld appreciatively told Stieglitz: "I enjoyed very much the [prints] Georgia mailed me. They brought back my happy days with you vividly. The one of the three of us at table is charming."[15]

## Portraits of Others, Symbols of the Self

One of the most important ways that Stieglitz bonded himself with Rosenfeld, as he had with Frank, was by making his portrait. During the autumn of 1920 Stieglitz made four photographic portraits of Rosenfeld (fig. 3.4), images that astonished the critic.[16] Upon

**3.4** Alfred Stieglitz, *Paul Rosenfeld,* 1920. Gelatin silver photograph. Alfred Stieglitz Collection, © 1999 Board of Trustees, National Gallery of Art, Washington, DC.

first viewing the prints, Rosenfeld was reportedly so impressed and moved that he was beyond speech. Rosenfeld told Stieglitz that he "was in the condition any one would be in to whom a wizard had just given the book of themselves, and bidden them read. I wanted to be alone with the pictures in order to begin to take out of them what you had placed there. I have been looking much at them, and feeling strange. I feel, especially before the laughing one, as though the Idea of myself which I have been having has begun a little to relax its grip, and as though I were wavering dimly toward another Idea which your wonderful photograph is commencing to show me. All four are remarkable things—I am no longer ashamed to look at one questioning one. I begin to see that they do the wonderful thing—express a spiritual concept through material form."[17]

Rosenfeld's remarks to Stieglitz recalled his earlier *Seven Arts* essay in which he described how his contact with the photographer had been a personally and spiritually transformative experience. Yet what is notable in 1920 is the degree to which Rosenfeld was aware that Stieglitz was "authoring" him in the photographs, or, to paraphrase the critic, how he was being handed the book of himself and bidden to read. In these images Stieglitz represented Rosenfeld as a man of letters seated in his study, surrounded by his professional attributes. Visible on Rosenfeld's desk are a typewriter, a crumpled pack of cigarettes, some galley proofs, and four recent volumes on American art and culture, one of which is Rosenfeld's own *Musical Portraits* (1920).[18] While the photographs retain the poses and conventions of formal portraiture, Stieglitz had introduced a personal element in the critic's upturned gaze and thoughtful, questioning expression. As a result of this intersubjective exchange, Rosenfeld could look into the pictures of himself to find traces of Stieglitz's presence, to internalize and take out of them what the photographer had placed there. In this intersubjective blurring of bodily and psychic boundaries, the portraits provided Stieglitz with the opportunity to construct Rosenfeld photographically, and Rosenfeld with the supposed ability to see himself through Stieglitz's eyes, or at least through the surrogate eye of Stieglitz's camera lens.

Stieglitz's largesse with the photographs elicited Rosenfeld's gratitude and his desire to reciprocate. As the critic told Stieglitz, "You have been sweet and generous to have given me these, and I wish I might give you as much of a 'chance' with something as you have given me with your camera."[19] In yet another mutually reflective exchange, Rosenfeld wished to return Stieglitz's gift of the portraits—of having Stieglitz represent him photographically—by representing Stieglitz in the critical press.

The opportunity came almost immediately. The first major event marking Stieglitz's return to the New York art world after the closing of 291 was a retrospective exhibition of his photographs that was held at the Anderson Galleries from February 7 to 14, 1921. In a flyer that accompanied the event, Stieglitz wrote: "This exhibition is the sharp focussing of an idea. The one hundred and forty-five prints constituting it represent my photographic development covering nearly forty years. They are the quintessence of that development."[20] As these remarks suggest, the Anderson Galleries exhibition provided Stieglitz with the opportunity to present a kind of extended self-portrait through his photographs of others. Of the 145 exhibited works, 19 images were of Stieglitz's family members, while another 44 photographs were of friends, and an additional 45 prints were selections from Stieglitz's composite portrait of Georgia O'Keeffe. In turn, the critical press did not hesitate to point out that Stieglitz's followers were very much extensions of the photographer himself. For example, Henry McBride explicitly stated in the *New York Herald* that the real subject of the Anderson Galleries exhibition was not Stieglitz's artwork but Stieglitz himself. McBride described the atmosphere at this landmark event: "Greater than the photographs was Alfred, and greater than Alfred was his talk—as copious, continuous and revolutionary as ever— and no sooner was this recognized than the well remembered look—a look compounded of comfort and exaltation—began to appear on the faces of [his followers], for to them it seemed that '291' was operating as usual and that this long hiatus had been a dream. There was a slight change of background, considerable red plush instead of the inconsiderable gray paint, but the main thing, Alfred, was there and they were happy."[21]

As McBride's comments suggest, at the Anderson Galleries Stieglitz was surrounded by his followers while the gallery's walls were filled with his photographs of them. Of those photographically present, Rosenfeld appeared among the images of Stieglitz's family members and close friends. Stieglitz also displayed three images of Frank and two of Margaret Naumburg, each group constituting a single "portrait." But no group of images was more central to Stieglitz's public self-construction than his composite portrait of Georgia O'Keeffe (figs. 3.5–3.7). Stieglitz and O'Keeffe had become acquainted in 1917. The following year they began what would be a lifelong relationship, and Stieglitz started to photograph O'Keeffe in earnest. O'Keeffe herself later commented on the self-reflexive nature of Stieglitz's photographs. She frankly observed that, in such images, Stieglitz "was always photographing himself."[22] O'Keeffe's remarks are telling because they present a virtual paraphrase of Stieglitz's own comments on his photographic practice. In 1919, just as he was producing these portraits of O'Keeffe, Stieglitz told R. Child Bayley that photography "must become an inherent part of oneself."[23] Stieglitz later reaffirmed this belief when he told Dorothy Norman that "my photographs and I are one."[24]

Stieglitz's photographs of O'Keeffe are, above all, reflections of their many-faceted relationship, depictions of the relationship between two lovers and two artists—between the photographer and his model, between the body and its surroundings, and among formal arrangements of light, pattern, and shape. In several images O'Keeffe's hands appear almost creaturelike as Stieglitz portrays them as complex, interacting forms. In one photograph O'Keeffe is shown holding her own breasts. In another she is peeling apples, the fruit that symbolized Stieglitz's American modernist project. Through this conflation of sensuous corporeal and still life elements, Stieglitz's photographs combined tactile and visual appeal as the interlace of O'Keeffe's long fingers is shown in contact with lush fabric, peeled apples, or the rounded curves of her exposed breasts. Significantly, Stieglitz's own presence in these photographs is symbolic rather than iconographic. That is, in these works the camera lens is made to serve as a kind of trans-

parent substitute for Stieglitz's own vision, assuming a position of propinquity to O'Keeffe's body that would only have been available to Stieglitz himself.

In the glowing review of the exhibition that Rosenfeld published in *The Dial*, the critic noted the profound sensory allure of Stieglitz's photographs. Echoing Stieglitz's own rhetoric, Rosenfeld observed that, "indeed, the prints of Stieglitz are among the very sensitive records of human existence. So vivid and delicate are they that one wants to touch them."[25] The critic further stated that Stieglitz "has arrested apparently insignificant motions of the hands, motions of hands sewing, gestures of hands poised fitfully on the breast, motions of hands peeling apples. And in each of them, he has found a symbol of himself."[26] Thus according to Rosenfeld, the aestheticized fragments of O'Keeffe's body actually functioned as symbols of Stieglitz himself, as agents of his sight and touch.

Stieglitz's presentation of O'Keeffe's portrait helped to facilitate Rosenfeld's interpretation. Stieglitz divided his images of O'Keeffe into six categories, each of which was presented as "a demonstration of portraiture." The groupings included twenty-seven images entitled "A Woman," eight images of "Hands," three images of "Feet," three images of "Hands and Breasts," three images of "Torsos," and two prints simply entitled "Interpretations." Stieglitz's portrait groupings seem to raise such questions as: What does it mean to present a "portrait" of "hands"? In Stieglitz's case it meant that a whole subject, "a woman" (and not just *any* woman, but O'Keeffe no less), could be subdivided into her body parts, yet the symbolic fragments of her body could simultaneously function as a portrait of her and a symbol of Stieglitz himself. Because each of the groups was considered a portrait in its own right, the "part" was made to signify the "whole" subject, which in this case denoted both Stieglitz and O'Keeffe. Stieglitz's radical approach to portraiture resulted in a highly individuated *and* an inherently dialogical conception of identity. That is, the photographs exemplified in aestheticized visual form the ways in which identity is itself constituted through an elaborate negotiation between self and others, a negotiation of parts and wholes, of reflections and joinings.

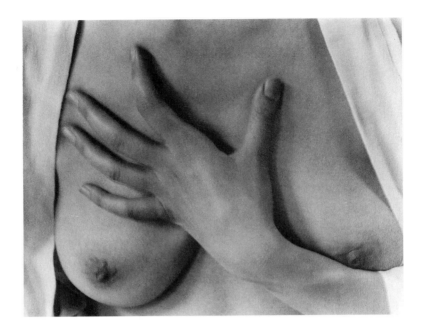

**3.5** Alfred Stieglitz, *Breasts and Hand,* 1919. Photograph. The Metropolitan Museum of Art, Gift of Mrs. Alma Wertheim, 1928.

*Opposite:*
**3.6** Alfred Stieglitz, *Georgia O'Keeffe: A Portrait—Hands and Thimble,* 1919. Solarized palladium photograph, 9 ⅝ × 7 ¾ in. Alfred Stieglitz Collection, © 1999 Board of Trustees, National Gallery of Art, Washington, DC.

**3.7** Alfred Stieglitz, *Georgia O'Keeffe: A Portrait—Hands,* 1918. Palladium photograph. Alfred Stieglitz Collection, © 1999 Board of Trustees, National Gallery of Art, Washington, DC.

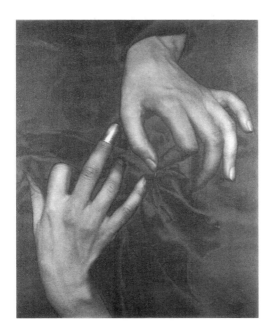

For Rosenfeld, the significance of these images transcended both Stieglitz and O'Keeffe to encompass the wider audience for whom the artworks were intended. Rosenfeld wrote that in these photographs "we see—not Stieglitz, but America, New York, ourselves."[27] Rosenfeld's ability to "see himself" in Stieglitz's photographs, including the nude portraits of O'Keeffe, influenced not only his critical writings but his own personal art purchases. Shortly after the 1921 show Rosenfeld acquired a copy of Stieglitz's *Breasts and Hand* (fig. 3.5), one of the images from the composite portrait of O'Keeffe. After studying the artwork, Rosenfeld described the photograph to Stieglitz in highly animated terms: "I have been watching it much, and find that it possesses remarkable 'pushing from within,' and has a movement extremely powerful, especially noteworthy in so small a thing."[28] Thus the photograph, which was at once a work of art *and* a symbol of both O'Keeffe and Stieglitz, was an object that Rosenfeld lived with and that was alive for him. Given the profound psychic investments that informed Stieglitz's production of the photograph as well as Rosenfeld's response to it, it is no wonder that the critic perceived the artwork as highly cathectic, as so powerfully charged as to be "pushing from within." Thus in yet another blurring of corporeal and subjective boundaries, Rosenfeld seemed to be informing Stieglitz that the sight and feel of O'Keeffe's body had become known to him by "watching" the portrait and feeling its powerful push. And as a result of his familiarity with this image, Rosenfeld was further able to identify with *Stieglitz* himself.

In addition to this photograph, Rosenfeld owned several paintings by O'Keeffe. During the autumn of 1921 Rosenfeld acquired from Stieglitz one of O'Keeffe's red canna lilies, an image such as plate 1. Shortly after purchasing the work, Rosenfeld expressed his admiration for the painting, and Stieglitz responded by emphasizing the ostensibly transparent relations between artworks and their makers. As the photographer told Rosenfeld, "I am glad you like the flaming cana [sic] O'Keeffe so much. It is certainly a very beautiful canvas. And all O'Keeffes are O'Keeffes. And she is always Georgia."[29] Over the next few years Rosenfeld added five more paintings by O'Keeffe to his collection, including

a blue mountain landscape of Lake George (1922); one of the paintings from O'Keeffe's "Black Spot" series (1919); a still life group of apples; a still life of alligator pears (1923) that featured an untitled landscape of Lake George (of c. 1920) on its verso; and the highly abstract floral image *Dark Iris No. III* (1927).[30] Rosenfeld also owned several paintings by Marin, Hartley, and Dove.[31] And the critic not only filled his own home with Stieglitz circle artworks; he brought the paintings along when he visited his friends. During the 1920s various members of the New York avant-garde, including Rosenfeld, Arthur Dove, Edmund Wilson, and Van Wyck Brooks, lived in Westport, Connecticut. In this crowd Rosenfeld was more than a personal ambassador of the Stieglitz circle painters; he was their proselytizer. Brooks recalled Rosenfeld's extended loans of artworks to his friends: "A true apostle of all art, Paul would appear from time to time with a picture of Marsden Hartley's under his arm, or one by our fellow-Westporter Arthur Dove which he called 'a sort of *Leaves of Grass* through pigment,' covering our dining-room walls with them for a few weeks or months so that the new sun would also dawn for us. He was all for what he called 'the dream growing out of reality.'"[32] After moving out of his Westport home in late 1923, Rosenfeld took an apartment on the west side of Irving Place, where Brooks remembered "the mantel and the walls were covered with Marins, Doves, Hartleys and O'Keeffes."[33] As the music critic for *The Dial*, Rosenfeld entertained many important artists, musicians, and writers in his apartment. Thus in Rosenfeld's salon a highly influential group of people could routinely be found conversing, playing music, and reading poetry while surrounded by a collection of Stieglitz circle artworks.

Rosenfeld had carefully chosen these images to create an ambiance in which his own identity merged with that of the other members of the Stieglitz group. Through his close ties to Stieglitz, Rosenfeld had both an intimate knowledge of and considerable access to the subjects about whom he wrote. Herbert J. Seligmann attempted to express this arrangement in positive terms: "[Rosenfeld] wrote and sought to write, not as an external interrogator merely, but as a close participant in the lives of his subjects."[34]

Along these lines, Rosenfeld himself told Stieglitz that he considered the photographer's guidance to be a sustaining bond that joined him with the larger aesthetic and spiritual enterprise that Stieglitz represented. In September of 1922 Rosenfeld wrote, "My guess is that something has happened to me partly because of the presence around me of certain people. Something has interplayed, back and forth, in my consciousness." The critic felt that this "something" was part of a larger movement "on which I as well as the others have been floated."[35]

While Rosenfeld would continue to cultivate an intense personal relationship with Stieglitz, Edmund Wilson felt that this degree of intimacy greatly hampered Rosenfeld's professional judgments as an art critic. Wilson asserted that Rosenfeld's "range as a writer on the plastic arts was limited by the exclusiveness of his interest in the work of the Stieglitz group. It was difficult, if not impossible, to persuade him to pay attention to any contemporary American painter who was not a protégé of Stieglitz', and if Stieglitz had excommunicated a refractory or competitive disciple, Paul, following the official directive, would condemn him, not merely as an artist but as a reprobate who had somehow committed an unpardonable moral treason."[36] But the behavior Wilson criticized may have been inevitable, given that Rosenfeld's identity as an art critic would likely have broken down had he devoted substantial attention to painters outside of the Stieglitz group.

## Port of New York

During the early twenties Stieglitz and Rosenfeld began to collaborate on what would be the critic's single most powerful contribution to Stieglitz's modernist project, the book of essays *Port of New York* (1924).[37] While based on articles that had previously been published in periodicals such as *The Bookman, The Dial,* and *Vanity Fair, Port of New York* is not a disparate collection of essays but a work unified by a common theme: Rosenfeld's desire to illuminate what he considered to be the most promising new devel-

opments in American art and culture. The genesis for the essays on the Stieglitz circle artists came from Rosenfeld's lengthy article on American painting that had first appeared in the December 1921 issue of *The Dial*. Over the course of the next year, Rosenfeld published individual essays on Marin, Hartley, and O'Keeffe in the popular magazine *Vanity Fair*.[38] When Rosenfeld went to revise these essays for a book-length study, he consulted extensively with Stieglitz throughout the entire process. The result, as Dorothy Norman has observed, is that along with Waldo Frank's *Our America*, "Paul Rosenfeld's *Port of New York* reveals much about Stieglitz."[39] Due to their ongoing exchanges, *Port* represents another instance in which Stieglitz and Rosenfeld came to share a single symbolic body—the corpus of this text.

In August of 1922 Rosenfeld first told Stieglitz that he intended to dedicate his second book, *Musical Chronicle*, to him. In September Rosenfeld informed Stieglitz of his plan to produce a new book on American art and literature, and Stieglitz immediately offered to supply Rosenfeld with photographs. During the summer and fall of 1923 Rosenfeld sent Stieglitz drafts of the chapters on O'Keeffe, Hartley, Dove, Marin, and the photographer himself for Stieglitz's revision and commentary.[40] In turn, Stieglitz furnished Rosenfeld with portrait photographs of the four painters as well as of the novelist Sherwood Anderson to accompany the text.[41] Through these numerous exchanges, *Port of New York* ultimately represented a double portrait of the Stieglitz circle artists: as Rosenfeld characterized them in prose and as Stieglitz constructed them in photography.[42]

Understandably, Stieglitz was highly invested in the publication of *Port of New York* and encouraged Rosenfeld throughout its writing. In July of 1923 Stieglitz urged Rosenfeld to trust his own instincts as a writer. Rosenfeld's reply a few months later placed the significance of his book within the larger framework of American cultural identity. Rosenfeld told Stieglitz, "I still believe the fight against provincialism in America is the crucial one. We do all sorts of stupid things principally because we have no respect for ourselves as Americans. I am sick of foreign reputations and France-worship. France and her good taste has been the bane of

every European country. This reminds me I ought to go to work on my book. It has a purpose, I suddenly see."[43] Stieglitz immediately responded to Rosenfeld's letter. Emphasizing the fundamental convergence of their aesthetic projects, Stieglitz impressed upon Rosenfeld the necessity of bringing the book to completion. As Stieglitz put it, *Port of New York*

*must be*—and *can be completed*—as contracted for. Yes, you have struck it—why it's so important: America without that damned French flavor!—It has made me sick all these years. No one respects France [more] than I do. But when the world is to be France I strenuously hate the idea quite as much as if the world were to be made "American" or "Prussian." I'm glad that you have made the discovery for yourself.—That's why I continued my fight single-handed at 291—That's why I'm really fighting for Georgia. She *is* American. So is Marin. So am I. Of course by American I mean something much more comprehensive than is usually understood—if anything is usually understood at all!—Of course the world must be considered as a whole in the final analysis. That's really a platitude—so self-understood. But there is America.—Or isn't there an America. Are we only a marked down bargain day remnant of Europe?—Haven't we any of our own courage in matters "aesthetic"? Well, you are on the true track.[44]

By November of 1923 the manuscript was fully completed, and the book itself appeared the following April.

Rosenfeld's and Stieglitz's intense level of collaboration makes *Port of New York* the single best example of an "official" period account of the Stieglitz circle. While the author of the study was nominally Paul Rosenfeld, the book itself came into being through Stieglitz's and Rosenfeld's creative symbiosis. In many respects their arrangement was a highly practical one. Rosenfeld benefited from Stieglitz's extensive input, which enabled him to produce a text that he could never have formulated so powerfully on his own. As for Stieglitz, while he could be quite eloquent and perceptive in his letters, he was not a professional writer. The author Hutchins Hapgood once observed that, while Stieglitz habitually spoke at length to the visitors to his galleries, the

photographer "does not feel the word with the sensitiveness of a gifted writer. He is rather maladroit in speech, too redundant, too emphatic, hardly ever is there a perfectly selected word or a happily chosen phrase; never the poetic phrase—the picture in words that tells the whole of truth."[45] Moreover, as a professional critic, Rosenfeld could speak publicly for the Stieglitz group in a way that the photographer himself could not; Rosenfeld's praise carried the weight and substance that were conferred by his professional credentials. At the same time, when Stieglitz's critical model came under fire from rival modernist groups, it was Rosenfeld who bore the brunt of the attack, and not Stieglitz himself or his artists. Not surprisingly, Stieglitz was quite pleased with *Port of New York*. For several years after the book first made its appearance, Stieglitz continued to refer individuals to *Port* for background information on himself and his artists.[46]

   *Port of New York* did nothing less than establish the rhetorical conditions necessary for the Stieglitz circle's full-scale comeback after the closing of 291. As we have seen, the methodological structures of Stieglitz circle aesthetics were themselves based on the symbolic merger of bodies. This theorization tended to produce a highly eroticized conception of aesthetics, one that was associated both with the Stieglitz circle's artworks and with the critical discourses that accompanied them. *Port of New York* represented a mirroring of theory and practice since the book at once reflected the content of Stieglitz circle artworks *and* the intimate structures of relationships through which these meanings were produced.[47] That is, *Port of New York* was the result of the elaborate, almost ritualistic bonding process that Rosenfeld and Stieglitz had experienced, a process that encompassed their literary collaboration, art acquisitions, the cultivation of an almost familial personal relationship, and the making of numerous conversant images of one another and of the other members of their circle.

## Coda

Unlike Rosenfeld, who would demonstrate his devotion to Stieglitz throughout the twenties and beyond, Frank's relationship with the photographer remained highly ambivalent. In 1923 Frank and Stieglitz had a falling out over personal and professional matters, with Frank accusing Stieglitz of fostering patterns of dependency among his followers.[48] While Rosenfeld included an appreciative essay on Margaret Naumburg in *Port of New York*, Frank himself was conspicuously absent from the text. However, Frank did attend the opening of the "Alfred Stieglitz Presents Seven Americans" exhibition at the Anderson Galleries in March of 1925, the show that officially announced the Stieglitz circle's comeback.[49] The following year Frank devoted a chapter each to Stieglitz and O'Keeffe in *Time Exposures* (1926), a book of satirical essays published under the pseudonym Search Light, and as he had for Rosenfeld, Stieglitz provided Frank with a photographic portrait of O'Keeffe to accompany the author's verbal portrait of her. Picking up the threads of his and Rosenfeld's previous discussions of the photographer in *The Seven Arts* and *Our America*, Frank subtitled his piece on Stieglitz "The Prophet." Yet the most vivid image in this essay is at once humorous and grotesque, as Frank portrayed Stieglitz as a kind of predator who used modern art to lure visitors to his gallery so that he could subsequently devour them through conversation. As Frank colorfully put it, "Stieglitz will talk to you for two hours. At the end whereof, you may be exhausted: but he *knows you*. His words have agglutinated you (digested you), (swallowed) you. If you let Stieglitz talk to you for a year, you will have become wholly part of Stieglitz."[50] Thus with cutting humor, Frank parodied and inverted Stieglitz's and Rosenfeld's signature themes of the photographer's spiritual and corporeal merger with his subjects.

By May of 1927 Stieglitz and Frank had sufficiently mended their relations so that Frank could publish in *McCall's Magazine* an article hyperbolically entitled "Alfred Stieglitz: The World's Greatest Photographer."[51] And by 1933 Frank and Rosenfeld collaborated with one another as coeditors of *America & Alfred*

*Stieglitz* (1934), a tribute volume assembled for Stieglitz's seventieth birthday. Despite his efforts on this project, Frank would increasingly withdraw from Stieglitz during the 1940s.[52]

Rosenfeld, however, would demonstrate his dedication to the photographer until the very end of his life. Rosenfeld's final affirmation of Stieglitz's career is found in the obituary of the photographer that Rosenfeld wrote for *The Commonweal* (August 2, 1946). Echoing themes that he had first proposed in his *Seven Arts* essay some thirty years before, Rosenfeld emphasized the photographer's unwavering commitment to art, spirituality, and American life itself. Rosenfeld wrote that Stieglitz "created a sort of spiritual climate in which it was possible for artists to give their best by holding all things to their fairest level, as he did while affirming the value of true art and standing up to the American world day after day for its sake. His fellows knew he was there, ready to struggle for them. They knew that the higher and purer their endeavors, the gladder he was to see them and to try and bring the rest of the world around to seeing. Other things might change. But he would not."[53] Despite his own declining health, Rosenfeld lived just long enough to publish this final tribute to Stieglitz. The two men died within eight days of one another, Stieglitz on July 13 and Rosenfeld on July 21, 1946.

Part II

The Stieglitz Circle's Symbolic Body

# Arthur Dove and Georgia O'Keeffe

Corporeal Transparency
and Strategies of Inclusion

The personal and artistic relationship of Georgia O'Keeffe and Alfred Stieglitz has been the subject of much debate. While a range of critical interpretations surrounds these figures, their collaboration has frequently been celebrated within the history of American modernism. As discussed in chapter 3, O'Keeffe's generative presence revitalized Stieglitz at a crucial, transitional point in his career. At Stieglitz's comeback exhibition of 1921, aestheticized fragments of O'Keeffe's body were made to serve as symbols of

Stieglitz himself, as equivalents of the photographer's own sense of sight and touch. O'Keeffe's gendered identity also functioned as a critical reference point for other constructions of masculine creativity within the Stieglitz circle. In particular, throughout the twenties and early thirties Arthur Dove's and Georgia O'Keeffe's artworks were repeatedly described in highly gendered, complementary terms. While Dove's paintings were seen as examples of his "virile" merger with and dissemination of himself into the natural world, O'Keeffe's were equated with notions of feminine interiority and with a receptivity to incorporating the other into the self. Surprisingly, these themes were typically associated with Dove's and O'Keeffe's *nonfigural* works, including their landscapes, still lifes, and most suggestively, their outright abstractions.

In themselves, the abstracted surfaces of Dove's and O'Keeffe's paintings rarely contain any conventional signs to indicate a "male" or "female" presence. Instead, these quasi-abstract works became "gendered" as critics repeatedly affixed a layer of discourse to the surfaces of the paintings. Thus while Stieglitz circle artists tended not to represent the body itself, their artworks nevertheless were read as a sign of the body when placed within the discursive context of Stieglitz circle criticism. Paradoxically, some of the Stieglitz circle's most abstract images received the most explicitly eroticized interpretations.

Because gendered formalist critical discourses were applied to each of the painters associated with Stieglitz, this theory provided the group with a unified sense of identity after the closing of 291. Stieglitz himself greatly valued the almost familial sense of coherence that resulted from this critical model. Stieglitz viewed the artists and their works as direct extensions of himself, repeatedly referring to the painters as his "own children."[1] For example, in 1923, six years after the closing of 291, Stieglitz told the author Sheldon Cheney that "Marin, O'Keeffe, Dove, Hartley are 291ers—babes of mine. I am their friend. And they look to me.— So maybe that's what you call having charge of them. In that sense I have.—It is quite a responsibility.—But it's very worth while watching them develop their free beautiful spirits free from all

commercial taint."[2] Although his tone was often paternalistic, Stieglitz clearly felt great concern and personal responsibility for the artists, and he in turn provided them with an important source of material and emotional support.

While Stieglitz's strategy had obvious advantages, it also had drawbacks. It is easy to imagine the artists being hampered, somewhat ironically, by Stieglitz's constant emphases on nonrepression and sexual and artistic liberation. The repetition of these themes over the course of two decades contributed substantially to the pat interpretations that collected around Stieglitz circle artworks, some of which persist even today. These ossified discourses may also account for the relatively modest development many of the artists experienced during their careers, especially after the mid-twenties. Since a certain amount of stylistic consistency was necessary to sustain these discourses, Stieglitz was only able to promote his circle by carefully circumscribing the limits of what was possible for them both individually and collectively. In turn, the artists' responses to Stieglitz's critical model varied significantly.[3] While some of the painters repeated Stieglitz's views in their own writings, others attempted to subvert them in a variety of creative ways. Yet whatever their individual response, Stieglitz's critical discourses provided each of the painters with a conceptual and practical structure to work within—or against. All of the artists seemed to understand that subjectivity is based on contingency, and each used their affiliations and position within the group as a tool to define the self.

## An Ideal Union: Arthur Dove and Georgia O'Keeffe

From the beginning, Arthur Dove and Georgia O'Keeffe expressed genuine admiration for one another's work, and they seemed to share certain fundamental notions about image making.[4] Both painters perceived a close relation between abstract and natural forms, and both claimed to have painted "portraits" of people using abstract forms. As O'Keeffe put it: "I have painted portraits that to me are almost photographic. I remember hesitat-

ing to show the paintings, they looked so real to me. But they have passed into the world as abstractions—no one seeing what they are."[5] Similarly, in 1921 Dove informed Stieglitz that he had completed a series of drawings which he considered to be self-portraits even though they were based on natural objects. The artist told the photographer that he had made "five or six drawings for paintings that are almost self-portraits in spite of their having been done from outside things. They seem to me more real than anything yet. It is *great* to be at it again, feel more like a person than I have in years. Trying to develop an ego—purple or red. I don't know which yet.—Think that is what has been lacking. You will understand."[6] As this letter indicates, the summer of 1921 was an important time for Dove. His unsympathetic father had died the previous June, and after a lapse in his painting, Dove began to work productively again. In addition, Dove had become involved with Helen Torr, an artist whose auburn hair earned her the nickname "Reds." That autumn Dove left his wife and his farm in Westport, Connecticut; Torr left her husband, the cartoonist Clive Weed; and together the couple moved into a 42-foot houseboat, the *Mona*, which was moored in the Harlem River.[7]

A few months later Rosenfeld published his essay on "American Painting" in the *Dial* (December 1921). In this piece Rosenfeld characterized Dove's and Marin's paintings as the "male" counterparts of O'Keeffe's works, and he went on to equate Dove's painterly structures with the forms and rhythms of masculine physicality.[8] As Rosenfeld put it: "A tremendous muscular tension is revealed in the fullest of the man's pastels. Great rhythmic forms suffuse the canvases; are one and swelled out to the borders; knock against the frames for egress. A male vitality is being released."[9] In this manner, Rosenfeld conflated Dove's sexual energy with the aesthetic structures of his artworks as the act of painting became synonymous with the release of "male vitality."

During the early twenties Stieglitz himself went to great lengths to emphasize the congruence between Dove's and O'Keeffe's artworks. In the summer of 1923 Stieglitz told Sheldon Cheney, who was then preparing a book on modern art, that "Dove about 6 years ago, when he saw O'Ks water-colors at '291' said to

me: 'This girl . . . is doing what we fellows are trying to do, I'd rather have one of her watercolors than anything I know.'"[10] (During the early twenties Dove in fact lived with a small O'Keeffe painting, *Abstraction*.)[11] Stieglitz concluded his letter to Cheney, a writer whom he wished to impress, by adding, "Dove understands O'Keeffes [sic] work. Hers & his are related."[12]

It was also during the summer of 1923 that Stieglitz began to collaborate with Rosenfeld on the Dove essay for *Port of New York* (1924). That July Rosenfeld told Stieglitz that he was writing the Marin and Dove pieces, and he admitted having trouble understanding Dove's work. In an exchange that typifies the habitual cooperation between the photographer and the critic, Stieglitz wrote to Rosenfeld about Dove, and his prose so impressed Rosenfeld that he asked Stieglitz's permission to "lift a few phrases" for use in his paper.[13]

In this essay Rosenfeld (and implicitly Stieglitz) identified a complementary pairing of formal and sexual impulses in Dove's and O'Keeffe's artworks. Rosenfeld wrote:

For Dove is very directly the man in painting, precisely as Georgia O'Keeffe is the female; neither type has been known in quite the degree of purity before. Dove's manner of uniting with his subject matter manifests the mechanism proper to his sex as simply as O'Keeffe's method manifests the mechanism proper to her own. For Georgia O'Keeffe the world is within herself. Its elements are felt by her in terms of her own person. Objects make her to receive the gift of her woman's body in disruptive pain or in white gradual beauty. Color, for her, flows from her own state rather than from the object; is there because she feels as she does and because it expresses her feeling. . . . Dove feels otherwise; from a point of view directly opposed to that of his sister artist. He does not feel the world within himself. He feels himself present out in its proper elements. Objects do not bring him consciousness of his own person. Rather, they make him to lose it in the discovery of the qualities and identities of the object. The center of life comes to exist for him outside himself, in the thing, tree or lamp or woman, opposite him. He has moved himself out into the object.[14]

According to Rosenfeld, because "the mechanism proper to [each artist's] sex" determined both what and how Dove and O'Keeffe painted, this trait was "transparently" visible in the formal structures of their artworks. While O'Keeffe represented forms and feelings that were internal to her body, Dove disseminated himself into the world around him. Thus while O'Keeffe's paintings were characterized as incorporating the "other" into the "self," Dove's images were understood to be formed by his infusing the "self" into the "other." Despite the potential for gender instabilities and imaginative corporeal formations in O'Keeffe's unconventional imaging practices, her works and Dove's were repeatedly presented as ideal counterparts in an aesthetic and sexual synthesis.[15]

Rosenfeld was not the only writer to identify complementary gendered structures in Dove's and O'Keeffe's paintings. Rosenfeld's close friend, the literary critic Edmund Wilson, also expressed this notion in his review of the "Alfred Stieglitz Presents Seven Americans" show (1925) for the *New Republic*. Before noting specific similarities between Dove's and O'Keeffe's paintings, Wilson stated more generally that "male artists, in communicating this quality [of artistic intensity], seem usually not merely to impart it to the representation of external objects but also, in the work of art, to produce an external object—that is something detachable from themselves; whereas women imbue the objects they represent with so immediate a personal emotion that they absorb the subject into themselves."[16] Stieglitz himself had expressed a similar view of the sexual underpinnings of art in a 1919 letter, asserting that "Woman *feels* the World *differently* than Man feels it. And one of the chief generating forces crystallizing into art is undoubtedly elemental feeling—Woman's & Man's are differentiated through the difference in their sex make-up. They are *One* together—potentially One always. The Woman receives the World through her Womb. That is the seat of her deepest feeling. Mind comes second."[17] Stieglitz had also escorted Wilson around the 1925 exhibition while the critic prepared his review for the *New Republic*.[18] Thus if a pronounced echo is discernible between Rosenfeld's and Wilson's analyses, it is because these writers

were both reflecting Stieglitz's own views. O'Keeffe herself put the matter of influence in these gendered critical discourses succinctly when she noted that "Alfred talked that way and people took it from him."[19]

As these statements exemplify, Stieglitz and his advocates spun a set of dichotomies around Dove and O'Keeffe based on such oppositions as male/female, exterior/interior, assertive/receptive, and detachment/absorption. To an audience today, familiar with the projects of deconstructive and feminist reading, these gendered binary pairings seem so familiar as to be almost banal. Yet Stieglitz broke away from the traditional binary oppositions between matter and form, substance and spirit, and abstraction and naturalism that occur so often in Western metaphysics. In Stieglitz's philosophy these themes tended to function in an inclusive, both/and type of relation instead of an exclusive, either/or association. This pattern distinguishes Stieglitz circle constructs from philosophical systems in which nature and emotion characteristically are the subordinate, feminized terms, and abstraction and reason the privileged, masculinized ones. Instead, the *abstracted* paintings of the Stieglitz group can be seen as suspended between two states of being and thus able to incorporate tendencies of both. Because Stieglitz circle works often maintain a provocatively unfixed status between representational and abstract modes of imaging, it was possible for artists and critics to perceive a variety of "subjects" (and subjectivities) expressed within them. Moreover, the use of gender and sexuality as a structural model to characterize the representation of nonbodily subjects, including abstractions, landscapes, and still lifes, represented an innovative development at the time. In part, this development can be traced to the emergence and popularization of discourses of sexuality in the United States, a trend that was elaborated extensively in Stieglitz circle criticism.

When discussing Freud's impact on American modernist aesthetics, Frederick J. Hoffman cautions against the making of overly precise or rigid comparisons between the psychoanalyst's theories and those of the American avant-garde. Hoffman points out that, while Freud's controversial theories have been widely de-

bated in American culture, "any serious effort to determine the nature and extent of [Freud's] influence reveals a complicated and confusing pattern, not easily defined or labeled."[20] Ann Douglas makes a similar assertion in her discussion of Freud's influence on American writers, noting that "a powerful kind of like-mindedness is at work here as well, a set of affinities that indicate an influence deeper than conscious assimilation can exercise. Time and again, the modernist writers came up with thoughts and words strikingly like Freud's, and there is often no evidence of direct transmission."[21] Such admonitions provide an apt point of departure when considering the role that psychoanalytic discourses played in the formation of Stieglitz circle criticism. Rather than being a matter of strict adherence to psychoanalytical theories or a precise application of these principles to discourses on modern art, the writings of Freud and the British researcher Havelock Ellis provided Stieglitz, Rosenfeld, Frank, and others with a loose set of terms and concepts that resonated with their own project of sexual and artistic liberation. The Stieglitz circle's selective reading and adaptation of ideas inspired by Freud and Ellis proved to be highly useful in the promotion of their own interpretive strategies. On the one hand, Freud's and Ellis's discourses were instrumental in sanctioning candid public discussions of sexuality and desire within the context of aesthetic and cultural criticism. On the other hand, the wide circulation of Freudian ideas in popular culture helps to account for the currency and appeal that embodied formalist discourses have held historically.[22] During the teens and twenties American intellectuals routinely drew on Freudian concepts to substantiate their own calls for derepression. As discussed in chapter 1, various members of the American avant-garde equated repression with Puritanism, a set of social and cultural forces that inhibited free creative expression. Ann Douglas has noted that Freudian ideas "found echoes in a culture still far from free and, more important, still far from wanting to be free of its stern and histrionic Calvinist heritage."[23] Nathan G. Hale, Jr., has similarly observed that American intellectuals used psychoanalysis as a tool to attack Puritan virtues by simultaneously

discouraging repression and placing a romanticized emphasis on the sex instincts.[24]

In 1909 Freud presented lectures on psychoanalysis at Clark University in Worcester, Massachusetts. The first English translation of *The Interpretation of Dreams* was published in 1913, and five years later Freud's *Three Essays on the Theory of Sexuality* was in its third English edition.[25] Waldo Frank called this latter study "epoch-making."[26] Early in 1914 the society hostess Mabel Dodge invited Freud's American colleague and translator, Dr. Abraham A. Brill, to discuss Freud's theory of the unconscious at one of her evening salons; two years later Stieglitz spent an evening with Brill and hoped to collaborate with him on a special issue of *Camera Work* to be devoted to the question of the unconscious (to Stieglitz's regret, this issue never materialized).[27] Within the American avant-garde, the author Hutchins Hapgood recalled that "psychoanalysis had been overdone to such an extent that nobody could say anything about a dream, no matter how colorless it was, without his friends' winking at one another and wondering how he could have been so indiscreet."[28] During the twenties, popular magazines published articles on various aspects of psychic life, and discussions of Freud became such a fashionable pastime among an educated American audience that Edmund Wilson remarked that many people espoused psychoanalysis "like a religion." Wilson further noted that a central concept from psychoanalysis that had become prominent in contemporary discussions of art and literature was the notion that psychic energy could not be successfully repressed, because the inhibited desire would manifest itself elsewhere in a sublimated form.[29]

Within the Stieglitz circle itself, Freud's influence was widely acknowledged. Waldo Frank included a discussion of Brill in his collection of essays *Time Exposures* (1926). Regarding America's receptivity to Freud, Frank commented that "Dr. Brill returned to the land which, all unconscious, craved his new creed: the enthusiastic land, the psychopathic land—the Neurotic States. It is true that he spoke our language poorly; but he was in tune with our nature. We were ripe for his peculiar brand of wisdom." Frank also

offered important insight into the adaptability of Freudian ideas to American culture. Frank observed, "Freud is a great maker of symbols. The old ones were wearing out. Yet the old hunger remained; and unless the old hunger got new symbols to feed on, the result was Neurosis."[30] It was precisely the highly suggestive and fluid nature of these symbolic reference points that enabled the Stieglitz circle writers to make key transitions between psychoanalytic and sexual discourses, cultural criticism, and works of art. Thus in *Port of New York* (1924), Rosenfeld asserted that Freud, along with Stieglitz, Picasso, D. H. Lawrence, and Sherwood Anderson, constituted a group of thinkers whose task it was "to remind an age that it is in the nucleus of sex that all the lights and the confusions have their center, and that to the nucleus of sex they all return to further illuminate or further tangle."[31] Rosenfeld's own receptivity to Freudian discourses led Edmund Wilson to identify their signal presence in his criticism. In 1925 Wilson wrote: "[Rosenfeld] knows something of modern psychology and an application of certain principles of Freud is almost the only non-artistic idea which appears throughout his work."[32] Similarly, Sue Davidson Lowe, Stieglitz's grandniece and biographer, recalled that the photographer himself sampled Freud "like a smorgasbord." Lowe further elaborated that Stieglitz "read eagerly each volume of Freud as it appeared, was beguiled by the analyst's emphasis on the potency of dreams, and embraced wholeheartedly his theories of sexuality."[33] In short, selective readings and adaptations of Freud's ideas served as a kind of master discourse in Stieglitz circle criticism because they authorized the privileging of sexuality within the interpretation of aesthetics. As such, these theories were instrumental in providing an explanatory nexus between meaning and pleasure in the visual arts.

The writings of Havelock Ellis functioned in a similar manner for Stieglitz. Ellis was an English researcher and essayist who, in his pioneering series *Studies in the Psychology of Sex* (1897–1910), addressed topics such as the evolution of modesty, autoeroticism, erotic symbolism, and sexual inversion. By the end of 1911 Stieglitz had ordered all six volumes of Ellis's works from the Philadelphia publisher F. A. Davis, and he had expressed

particular interest in Ellis's writings on sexual modesty in women.[34] During the autumn of 1923, just as Stieglitz was offering Rosenfeld his suggestions on the *Port of New York* manuscript, he was also reading Ellis's *The Dance of Life* (1923). At the time Stieglitz remarked to Rosenfeld that "Ellis is gentle, his line is flowing smoothly."[35] In *The Dance of Life* Ellis posited a direct link between sexual and artistic impulses when he identified subconscious sexual energy as the basis for all artistic pursuits. Citing Freud and Freud's follower Dr. Otto Rank, Ellis noted that art forms inherently possess "a sublimated life-force which has its root in some modification of sexual energy."[36] Ellis had made a similar observation in *Studies in the Psychology of Sex* when he asserted that the sexual impulse "largely enters into and molds all of these emotions and aptitudes [i.e. those for sympathy, art, and religion], and that by virtue of its two most peculiar characteristics: it is, in the first place, the deepest and most volcanic of human impulses, and, in the second place, . . . it can, to a large extent, be transmuted into a new force capable of the strangest and most various uses."[37]

Applying these insights to the artists of their circle, Stieglitz, Rosenfeld, and others asserted that the painters intuitively incorporated sexual and psychic structures within the formal and iconographic components of their artworks. When Stieglitz first exhibited Georgia O'Keeffe's drawings at 291 in 1916, he commented in the accompanying issue of *Camera Work* that "Miss O'Keeffe's drawings besides their other value were of intense interest from a psycho-analytical point of view. '291' had never before seen woman express herself so frankly on paper."[38] In this manner, Stieglitz's brief allusion to psychoanalysis was followed by an essentialist interpretation of O'Keeffe's artworks as records of "woman's" self-expression. Along these lines, Hutchins Hapgood recalled that, in his galleries, Stieglitz often used artworks as a means to reconcile people to "their more unconscious selves." As Hapgood recounted, "Apropos of a picture by Marin, a drawing by Rodin, or a painting by O'Keeffe, Stieglitz would talk by the hour about 'life,' as it manifests, or should manifest, itself in all human relations—marriage, politics, morality. Through the new

light that came from the free art-forms, Stieglitz saw the possibility of enhancing our human relations, or at least a stirring way of pointing to this more vivid, more abundant existence."[39]

The application of ideas loosely inspired by Freud and Ellis allowed the paintings of Dove and O'Keeffe to be seen as constituting an aesthetic and subjective "whole" based on the ideal "masculine" and "feminine" qualities contained within them. O'Keeffe's "feminine" works were seen as deriving from her imaging the interior forms and sensations of her body, while Dove's "masculine" paintings were described as generated by the artist's ability to infuse himself into external objects, thus "impregnating" the surfaces of his paintings with his artistic identity. In both cases, the notion that Dove's and O'Keeffe's works expressed these themes "transparently" on their "surfaces" was crucial to the rhetorical force of Stieglitz circle criticism.

## Arthur Dove's "Transparent" Surfaces

The notion of transparency in portraiture helped to bridge the gap between self-identity and abstraction in Dove's works. In 1930 Dove stated outright that "self-portraiture in painting . . . after all is what painting is."[40] For decades Dove had described the formal aspects of his painting as a means to evoke human sensations and experience. Dove is quoted in Arthur Jerome Eddy's study *Cubists and Post-Impressionism* (1914) as emphasizing the subjective aspects of his formal procedures, particularly his ability "to remember certain sensations *purely through their form and color.*"[41] Similarly, in his essay for the "Forum Exhibition of Modern American Painters" (1916), Dove posited a kind of "transparency" between himself and his artworks. The artist expressed his wish to work in such an uninhibited manner that he would be free to capture "the reality of the sensation": "My wish is to work so unassailably that one could let one's worst instincts go unanalyzed, not to revolutionize nor to reform, but to enjoy life out loud. That is what I need and indicates my direction."[42] In short, Dove sought

to invest his abstracted paintings with an experiential immediacy that could translate directly into pictorial form.

During the early twenties Stieglitz glowingly promoted Dove by emphasizing the painter's personal "transparency" and artistic ingenuousness. In April of 1923 Stieglitz told Henry McBride that, among his artists, "Dove is another who will eventually be heard from."[43] That July Stieglitz informed Dove that Rosenfeld "likes your work. And I feel it as most important that you finally appear properly in print.—It's time. And you deserve that 'people' know more about you than you do. You are one of the few painters really counting as painters—as men. I know that."[44] In August Stieglitz sought Sheldon Cheney's support for Marin, Dove, and O'Keeffe in conjunction with Cheney's upcoming book on modern art.[45] The following month Stieglitz emphasized to Dove that his work must be included in the study of American art that the art historian and critic Frank Jewett Mather, Jr., was planning.[46] Dove then broached the subject of writing a book on his own painting "experiments." Stieglitz responded enthusiastically, stressing the importance of such writing both for Dove and for Stieglitz's larger project: "for all concerned, including yourself & myself & everybody—the writing now is essential."[47] As these various statements indicate, Stieglitz was well aware of the necessity and the power of promotional writing for the success of his overall venture.

For his own part, Dove openly acknowledged and paid tribute to Stieglitz's role as image maker. When Dove constructed a symbolic artistic portrait of Stieglitz in 1924 or early 1925 (fig. 4.1), he included a camera lens and a photographic plate as the central components of the work. (Dove also attached some steel wool, which probably was meant to symbolize the photographer's bristling gray hair.) By representing Stieglitz as a camera, Dove's portrait was consistent with the various critical descriptions of Stieglitz as an embodied camera that had proliferated during the late teens and twenties (see fig. 2.1). Like these works, Dove's portrait was based not on Stieglitz's personal likeness but on his particular type of agency, namely the capacity for image making that Stieglitz exercised both as a photographer and as an impresario.[48]

At Stieglitz's urging, Dove was included in both Mather's *The American Spirit in Art* (1927) and Cheney's *A Primer of Modern Art* (1924). Yet Rosenfeld's article on "American Painting" (1921) and his essay on Dove in *Port of New York* (1924) arguably provided the artist's most important introduction in print. In turn, Dove responded appreciatively to Rosenfeld's writings. In 1925 he told Stieglitz, "If Rosenfeld is still there [at Lake George] give him our love. He has had some very fine thoughts of the whole thing, quite as fine as paintings."[49] Dove would continue to value Rosenfeld's work throughout his career; as late as 1940 Dove told Stieglitz, "We happened on Paul's article in the 'Nation.' It was good to read something that was big to think of again."[50]

Building on the artist's own statements, in 1921 Rosenfeld posited a kind of "transparency" between the physical and symbolic aspects of Dove's paintings. In particular, Rosenfeld characterized Dove's pigments as the formal equivalents of his organic subjects *and* of the artist's own corporeal presence. Rosenfeld wrote that in Dove's art, "Reds and blues have the strength of the rocks. One of Dove's earlier abstracts, with its blood reds and

**4.1** Arthur G. Dove, *Portrait of Alfred Stieglitz,* 1925. Assemblage: camera lens, photographic plate, clock and watch springs, and steel wool on cardboard, 15 ⅞ × 12 ⅛ in. (40.3 × 30.8 cm). The Museum of Modern Art, New York. Purchase. Photograph ©2000 The Museum of Modern Art, New York.

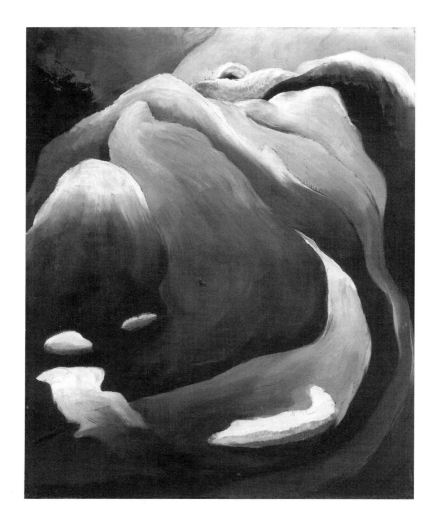

**4.2** Arthur G. Dove, *Waterfall*, 1925.
Oil on masonite, 10 × 8 in. The Phillips
Collection, Washington, DC.

mouse greys and straw-colour, its jagged cogs, is tended as though heavy inert masses were being lifted in it, slowly gotten under way. And in everything he does, there is the nether trunk, the gross and vital organs, the human being as the indelicate processes of nature have shaped him."[51] Extending these themes in *Port of New York*, Rosenfeld wrote that Dove's paintings and his palette were drawn directly from the body and the earth. This literal merger of the artist with nature *and* with his medium underpinned the concept of embodied formalism operative in Rosenfeld's descriptions of both Dove and O'Keeffe. Rosenfeld wrote that when Dove painted, "the pressure on the brush in his hand carries the weight of the body as a whole, and the life of the body as a whole. He has always a fund of robust and delicate animalism to express. He has dark, pungent, gritty hues in his palette; dark subtle schemes and delicate gradations of earth-browns and dull shadowy greens and dirt-grays and intestiny whites that seem to flow from the body's fearless complete acceptance of itself."[52] Guided by Stieglitz and Dove himself, Rosenfeld saw Dove's paintings as transparently expressing the artist's subconscious awareness of his body and its connection with the natural world. This perception allowed Rosenfeld to posit a free play between abstraction and embodiment in Dove's works: "Dove's compositions are built up of abstract shapes that suggest the body's semi-consciousness of itself: of intestine-like shapes, shapes of fern-foetuses in May, animal udder-forms, forms in nature which doubtlessly had a fascination for the mind unafraid of its own body, and recorded themselves under the lintel of consciousness."[53]

Early in 1926 Waldo Frank published a related analysis of Dove's works to accompany an exhibition that was held at The Intimate Gallery. Like Rosenfeld, Frank wrote that Dove's paintings represent the "fleshed realities" of his visions and his interwovenness with the world. According to Frank, Dove's works depict the "organic nexus between Dove and his world which has endowed him with the *substance* for his own self-expression." Frank then chose the metaphor of pregnancy to describe Dove's artistic (and implicitly heterosexual) generativity. Frank claimed that Dove's "embryonic" art represented an America as yet unborn; he

wrote that the paintings, which "presage the body of tomorrow without the rhetoric, and which flesh prophecy without the banners, live so humbly within their home-made frames."[54] For Frank, Dove's "pregnancy of spirit" was located in both his subject matter and in his use of materials: "Arthur Dove makes a picture of a cow—or the bottom of a brook—or a sawmill—or rain in winter woods—or storm upon sea. The pregnancy of spirit, the prophecy of beauty inhere, for him, in such humble everyday affairs. They must be implicit in the materials and in the forms of his own homely craftsman's world."[55] Yet such characterizations of Dove's "embryonic" paintings and his "pregnancy of spirit" were not seen as being at odds with the overtly masculinist descriptions of Dove's "impregnation" of his painted surfaces. As Debra Bricker Balken has observed, Dove himself attributed highly gendered meanings to his water imagery, as for example when he described his own abstracted depiction of "a bottom of a brook" to Sheldon Cheney. In *A Primer of Modern Art* Cheney recounted that he had asked Dove about one of his sketches, and Dove "said that he drew it while knee-deep in flowing water, looking downstream into the woods; but that his friends called it *Penetration*—which came nearer to his intention."[56]

Such inter-"penetration" between embodiment, organicism, and abstract forms is evident in Dove's paintings *Waterfall* (1925, plate 2, fig. 4.2) and *Golden Storm* (1925, fig. 4.3). At first glance *Waterfall* resembles a freestanding abstraction. When paired with its title, the work becomes iconographically legible, its intense flowing forms and rippling shapes implying stones and water. As Frank suggests, Dove's painting could be read either as a landscape view of a waterfall or as an underwater scene viewed from above the bottom of a brook.[57] While a degree of interpretive mobility exists in the play between abstraction and representation in Dove's works, the artist's gendered "presence" theoretically provides a sense of stability. Here oil paint is made to suggest the fluidity of water and the opacity of stone, while Dove himself was thought to be so completely "immersed" in his artistic forms and materials that his identity was transparently visible in, and even coursing through, the opaque surfaces of his paintings.

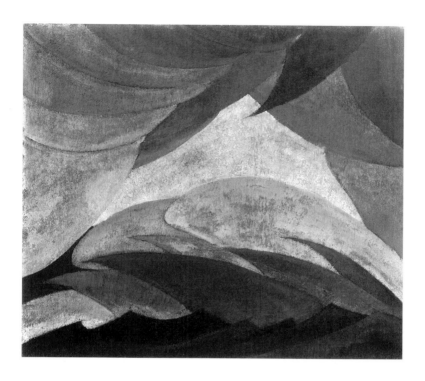

**4.3** Arthur G. Dove, *Golden Storm*, 1925. Oil and metallic paint on plywood panel, 19 ¼ × 21 in. The Phillips Collection, Washington, DC.

Similarly, Frank described Dove's storm paintings as at once nascent, corporeal, and emotionally charged: "The waves are solid and ponderous: this water pulses like a body to the glower of wind and mist and moonlight. This sea is solid because it is locked: it is not free to move, to breathe: it is an unborn sea. Its emotion whelms its actual form. It is a gravid sea—a pregnancy again."[58] Much like Dove's early biomorphic pastels, *Golden Storm* displays an interleaving of rippled, geometric forms. When viewed alone these forms appear abstract; when paired with their title, they indicate waves and clouds. (On more than one occasion Dove told Stieglitz that he tried to memorize the storms he experienced at sea so that he could paint them.)[59] And when placed in the context of Rosenfeld's and Frank's commentaries, the painting becomes the site of a series of charged encounters between abstraction and natural motifs, between clouds and the sea, between the artist and his materials, and between aesthetic and sexual generativity.

Stieglitz was so pleased with Rosenfeld's and Frank's writings that he recommended them to Duncan Phillips, a collector who had recently visited The Intimate Gallery and who would eventually acquire Dove's two pictures.[60] Phillips had become enthusiastic about Dove's and O'Keeffe's artworks after seeing them at The Intimate Gallery early in 1926, especially Dove's *Waterfall*, a painting he avidly wished to purchase. The work wasn't for sale, however, since Rosenfeld had already bought it. At Phillips's urging, Stieglitz persuaded a reluctant Rosenfeld to relinquish the painting, convincing the critic that he was making "a sacrifice" for "the Cause."[61]

As these exchanges exemplify, Stieglitz went to considerable lengths to cultivate an important patron and to shape his perception of the works he was acquiring, paintings that Stieglitz knew Phillips would exhibit at his museum in Washington, D.C.[62] In recommending Rosenfeld's and Frank's writings, Stieglitz was attempting to package his ideology of American modernism, so patently reflected in both essays, along with the paintings.[63] In Dove's case, this ideology took the form of an idealization of American masculine heterosexuality clothed in the abstracted structures of Dove's art.

Dove's own statements are consistent with the Stieglitz circle's gendered interpretations of his paintings. In 1930 Dove told Stieglitz that he opposed the *"sexless* thinking of the men painters of this country." In the same letter he observed that "the bursting of a phallic symbol into white light may be the thing we all need."[64] Dove's *Silver Sun* (1929, plate 3, fig. 4.4), painted the previous year, seems to fit his description of "the thing we all need." Floating painterly rings of silver, black, blue, and gray appear to hover and "burst" above an earthly ground. Like *Waterfall* and *Golden Storm*, at first glance *Silver Sun* appears abstract; when paired with its title, it suggests natural forms; and when considered in relation to Dove's statements, the starkly abstract forms seem to evince the embedded sexuality of a "phallic" burst. As in his views of water, gendered imagery underpins the abstracted symbolism of Dove's organic forms. Here the sheer scale and energy of the priapic silver sun implies that it will soon fertilize the seeds buried in the earth below.

Dove also enlisted the procreative imagery of growth and breeding when he described his own artistic development to the art critic Elizabeth McCausland during the early 1930s: "The making of objects 'That please the eye' will always continue as will talent. The real breeder one is genius, the great sire. A great sire can make a whole section of the country fruitful and productive and the same is true of ideas. To save the finest and breed from it is better than saving all. That is what 'Modern' in the real sense means."[65] According to Dove, the artist is a "sire" who "breeds" ideas that are "fruitful and productive" and in the process advances the development of modern art itself.

Given the tenor of the Stieglitz circle's critical rhetoric, it is not surprising that Dove thought of his paintings as "children," as embodied beings and even as extensions of himself. While an artist's referring to his or her paintings as children may be a familiar trope historically, in Stieglitz circle discourses this theme became renaturalized. After viewing an exhibition of his works at The Intimate Gallery in 1929, Dove warmly remarked to Stieglitz that "if it had not been for your tenacity these so-called 'children' might have had no age and still be stillborn in the mind."[66] Along

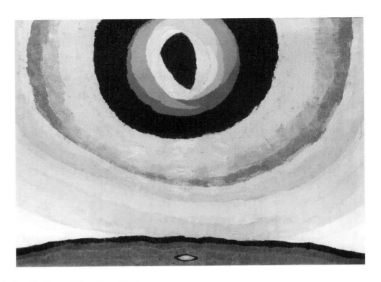

**4.4** Arthur G. Dove, *Silver Sun*, 1929. Oil and metallic paint on canvas, 55 × 75.3 cm. The Art Institute of Chicago, Gift of Georgia O'Keeffe to the Alfred Stieglitz Collection, 1949.531. Photograph ©1999 The Art Institute of Chicago. All rights reserved.

these lines, in 1932 Rosenfeld described Dove's paintings as embodied, almost sentient presences. Rosenfeld wrote that in Dove's works "the represented objects look at us. There is something behind them, something in them, which watches us inquisitively; menacingly at times, at others with secret complicity. The portholes of the boats and boathouses are mute, cryptic, regardful eyes."[67] In 1933 Dove again emphasized the notion of artworks as anthropomorphic presences when he told Duncan Phillips that his paintings were like people to him.[68]

Similarly, Stieglitz thought of O'Keeffe's paintings as children. Herbert J. Seligmann noted Stieglitz's comment that out of his support for O'Keeffe "had come the work, for which, as for O'Keeffe's 'children,' the paintings being children, he was looking for people in the world to take care, knowing that the world was often likely to be unkind to children."[69] In *Port of New York* Rosenfeld literally described O'Keeffe's paintings as children, as

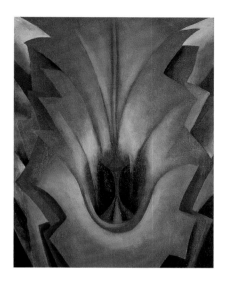

Plate 1 Georgia O'Keeffe, *Inside Red Canna*, 1919. Oil on canvas, 22 × 17 in. (55.9 × 43.2 cm). The Scharf Family Collection. ©2000 The Georgia O'Keeffe Foundation/Artists Rights Society (ARS), New York.

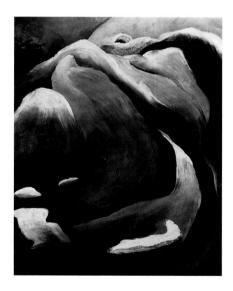

Plate 2 Arthur G. Dove, *Waterfall*, 1925. Oil on masonite, 10 × 8 in. The Phillips Collection, Washington, DC.

**Plate 3** Arthur G. Dove, *Silver Sun*, 1929. Oil and metallic paint on canvas, 55 × 75.3 cm. The Art Institute of Chicago, Gift of Georgia O'Keeffe to the Alfred Stieglitz Collection, 1949.531. Photograph ©1999 The Art Institute of Chicago. All rights reserved.

**Plate 4** Georgia O'Keeffe, *From the Lake #3*, 1924. Oil on canvas, 36 × 30 in. Philadelphia Museum of Art, The Alfred Stieglitz Collection: Bequest of Georgia O'Keeffe. ©2000 The Georgia O'Keeffe Foundation/Artists Rights Society (ARS), New York.

**Plate 5** John Marin, *Lower Manhattan,* 1920. Watercolor and charcoal on paper, 21 ⅞ × 26 ¾ in. (55.4 × 68 cm). The Museum of Modern Art, New York. The Philip L. Goodwin Collection. Photograph ©2000 The Museum of Modern Art, New York.

**Plate 6** John Marin, *Maine Islands,* 1922. Watercolor on paper, 16 ⅞ × 19 ¾ in. The Phillips Collection, Washington, DC.

Plate 7 Marsden Hartley, *The Sustained Comedy (Portrait of an Object)*, 1939. Oil on board, 28 ⅛ × 22 in. (71.4 × 55.9 cm). Carnegie Museum of Art, Pittsburgh; Gift of Mervin Jules in memory of Hudson Walker.

Plate 8 Charles Demuth, *At a House in Harley Street:* Illustration for the novel *The Turn of the Screw* by Henry James, 1918. Watercolor and pencil on paper, 8 × 11 in. (20.3 × 27.9 cm). The Museum of Modern Art, New York. Gift of Abby Aldrich Rockefeller. Photograph ©2000 The Museum of Modern Art, New York. Courtesy of the Demuth Foundation, Lancaster, PA.

"impregnated" surfaces she had "pushed from within."[70] As these various statements indicate, the Stieglitz circle writers repeatedly inscribed their group's artworks within the gendered parameters of heterosexual reproduction. Thus while O'Keeffe's "paint children" were seen as emerging from the interior spaces of her body, Dove's paintings were characterized as beings existing in the world outside of himself, or to paraphrase the artist, as the seeds that he has sown. Through these images, the notion of Dove's and O'Keeffe's heterosexual generativity became projected onto the symbolic "bodies" of their paintings.

## Dove and O'Keeffe: The Conditions of Looking

Despite the gendered oppositions that critics identified within their works, Dove's and O'Keeffe's paintings share a formal similarity. Both artists seem to cultivate a sense of identification between the viewer and their works by positioning the spectator as somehow *within* the paintings themselves. Dove and O'Keeffe frequently present intimate, close-up views or enlarged fragments of their subjects, often without definitive compositional borders. Because it is generally possible to imagine their subjects continuing beyond their frames, their works tend to suggest expansiveness and inclusiveness rather than finality or closure.[71] In addition, the thematic pairing of embodiment and abstraction helps to facilitate the double play between mediation and "immediacy" in Stieglitz circle artworks. In the accompanying critical literature, the artist's "presence" often became elided with "the present" to connote a sense of imminent unfolding, an engulfing experience in which the viewer is implicitly included. For example, in 1927 Dove paraphrased Kandinsky's expressionist rhetoric when he characterized the experience of viewing his works as the reverse of the painting process. Instead of crystallizing into a stable state, the painted surface becomes animated and evolves toward the present.[72] When describing a painting he made while looking downward into a running stream, Dove observed: "As the point moves it becomes a line, as the line moves it becomes a plane, as

the plane moves, it becomes a solid, as the solid moves, it becomes life and as life moves, it becomes the present."[73] Thus according to Dove, not only could the viewer reenact the world within his paintings, but he or she could experience at first hand the generative process through which the works themselves came into being.[74]

Along these lines, Stieglitz and his critics repeatedly emphasized a sense of transparency and unbrokenness when describing embodied aesthetics as a participatory phenomenon, a state of "interwovenness" between bodies and the world and between bodies and paintings. This embodiment was neither a uniform nor a neutral construct, but was laced with allusions to the artist's sexuality. This rhetoric undoubtedly was intended to heighten the sensuous appeal of the paintings and to stimulate the viewer's desires to experience and own them. By 1937 Stieglitz could even joke about his tactics. He told Dove that he could easily attract visitors to Dove's December exhibition at An American Place: "I know all the tricks that bring the mob.—All I would have had to do is called the Show 'Exhibition of the Original Sin.'"[75]

With slowing sales during the thirties, Stieglitz could joke self-reflectively about his own external strategies.[76] Yet Stieglitz *had* used these strategies quite successfully during the previous decade to promote his artists. Dove's and O'Keeffe's works were repeatedly described as representing the merger of the artist and the world, Dove's by extending himself outward and O'Keeffe's by absorbing the world into herself. The result in both cases was that Stieglitz and his critics collapsed the boundaries between abstraction and the gendered body and allowed these categories to flow into one another. This interpretive tendency points up the paradoxical nature of opacity and transparency in Stieglitz circle discourses (and in expressionist writings in general). It is possible to read Dove's and O'Keeffe's artworks not only as "transparent" surfaces but as "mirrors" that "reflect" the desires of their viewers on their own sensuous, opaque surfaces. Transparency is situated within a mirroring function, one that operates through the conflation of presence and desire. As a result, the highly gendered and ostensibly stable union between "self" and "other" in Dove's

and O'Keeffe's artworks was seen as being achieved through *and* symbolically "reflected" in the collapse of boundaries between self and other, between embodiment and abstract form.

From the outset, Dove's and O'Keeffe's images presented Stieglitz and the critics with the challenge of finding an appropriate language to describe a seeming oxymoron—nonfigural corporeality.[77] Yet it was precisely *because* Dove's, O'Keeffe's, and, as we shall see, Marin's works are largely nonfigural that Stieglitz and the critics could exercise considerable imaginative freedom in their critical interpretations. The loosely suggestive character of the paintings allowed the Stieglitz circle writers to produce readings which (dis)placed bodily forms and desires onto abstracted painterly fields. For this reason, Stieglitz circle criticism functioned as much more than an iconographic master code that allowed viewers to decipher "difficult" artworks. Stieglitz's critical discourses were extremely flexible in their potential applications because they encompassed a philosophy of embodied form. Since these discourses located gender broadly in aesthetic structures as well as in iconography, gender could be perceived in *any* of Dove's or O'Keeffe's paintings, regardless of their nominal subject matter. Thus the "potency" of Stieglitz's critical discourses lay precisely in their conceptual amorphousness. Like water, they flowed freely and took the shape of whatever vessel (or canvas) they were poured into. Ironically, their very fluidity of reference contributed to their fixity of meaning. In O'Keeffe's case, a highly conventional notion of female heterosexuality became the inescapable signified of her art. This interpretation persisted regardless of O'Keeffe's attempts to present gender-neutral subject matter.

For example, like Dove's *Waterfall*, O'Keeffe's *From the Lake #3* (1924, plate 4, fig. 4.5) is a proto-abstract image based loosely on a water motif. This scene is one of a series of works that was most likely inspired by O'Keeffe's visit to Lake George during the summer of 1924, and seems to derive from her observation of sunlight on water. A cascade of green, brown, and orange forms creates a loose, rippled pattern, while glimmering fragments cluster at the center and bottom of the composition. According to Rosen-

**4.5** Georgia O'Keeffe, *From the Lake #3,* 1924. Oil on canvas, 36 × 30 in. Philadelphia Museum of Art, The Alfred Stieglitz Collection: Bequest of Georgia O'Keeffe. ©2000 The Georgia O'Keeffe Foundation/Artists Rights Society (ARS), New York.

feld, while Dove had ostensibly "moved himself out into the object," O'Keeffe created her work by feeling "the world within herself." Thus the soft, sensuous quality of O'Keeffe's water imagery was perceived not as a form of "penetration," as it had been for Dove, but rather as a kind of "transparent" view into the artist's body and into her inner feelings and desires. In actuality, neither work contains conventional signs to indicate a "male" or "female" presence. Instead, gendered identities were applied to the formal structures of the paintings ex post facto in accompanying critical discourses.

## O'Keeffe's Corporeal Transparency

In 1921 Stieglitz and the critics began an intensive effort to shape public perceptions of O'Keeffe and her art. As discussed in chapter 3, in February of that year Stieglitz exhibited selections from his composite portrait of O'Keeffe at the Anderson Galleries, including several intimate nude photographs. The following autumn Marsden Hartley published his book *Adventures in the Arts,* which included a section on O'Keeffe in his essay on modern women artists. Elaborating on the Stieglitz circle's notion of corporeal transparency, Hartley wrote that "with Georgia O'Keeffe one takes a far jump into volcanic crateral ethers, and sees the world of a woman turned inside out." Hartley further described her paintings as "probably as living and shameless private documents as exist, in painting certainly, and probably in any other art. By shamelessness I mean unqualified nakedness of statement."[78] In December Rosenfeld's provocative article on "American Painting" appeared in the *Dial.*[79] In this piece Rosenfeld identified O'Keeffe's paintings as the product of her womb, and the works themselves as orgasmic. Echoing Stieglitz's own 1919 statement on Woman receiving the World through the Womb, Rosenfeld wrote that O'Keeffe's "great painful and ecstatic climaxes make us at last to know something the man has always wanted to know. For here, in this painting, there is registered the manner of perception anchored in the constitution of the woman. The organs that differ-

entiate the sex speak. Women, one would judge, always feel, when they feel strongly, through the womb."[80] As these passages suggest, Stieglitz and Rosenfeld, following Freud, identified the interior regions of the female body—the sites of penetration and reproduction—as the locus of adult female sexual response.[81]

While some critics dismissed these writings as excessively mystical and sexual, the Stieglitz circle's discourses nonetheless proved to be highly influential in shaping subsequent critical interpretations of O'Keeffe's work.[82] For example, when reviewing O'Keeffe's 1923 solo exhibition at the Anderson Galleries, the critic Alexander Brook described his experience of O'Keeffe's paintings in terms similar to Rosenfeld's: "One does not feel the arm's length that is usual between the artist and the picture; these things of hers seem to be painted with her very body."[83] Similarly, Herbert J. Seligmann wrote that "color is [O'Keeffe's] language. Her body acknowledges its kindred shapes and renders the visible scene in those terms."[84] Because O'Keeffe's body was taken to be the ultimate reference point for her abstracted formal structures, an essentialist notion of female heterosexuality was thought to be "transparently" visible in her art. As in his discussion of Dove, Rosenfeld reinforced these critical associations through references to O'Keeffe's subconscious impulses and desires. As Rosenfeld stated: "No man could feel as Georgia O'Keeffe and utter himself in precisely such curves and colors; for in those curves and spots of prismatic color there is the woman referring the universe to her own frame, her own balance; and rendering in her picture of things her body's subconscious knowledge of itself. The feeling of shapes in this painting is certainly one pushed from within. What men have always wanted to know, and women to hide, this girl sets forth. Essence of womanhood impregnates color and mass, giving proof of the truthfulness of a life."[85]

Rosenfeld and others thus located the allure of O'Keeffe's art in her "exposing" that which is hidden and which "men have always wanted to know"—her sexuality—by finding an "equivalent" set of forms and formal relations within her aesthetic vocabulary.[86] In addition to identifying O'Keeffe's body as the central reference point for her paintings, the writers posited that the abstract *formal*

principles of O'Keeffe's artworks reflected a tendency to combine two opposing impulses within the interior space of a single artwork. (In the case of *From the Lake, No. 3*, for example, this trait was thought to be manifested in her juxtaposition of sharp edges with soft, blunted forms.) Rosenfeld began his essay on O'Keeffe in *Port of New York* by establishing this second convergence:

Known in the body of a woman, the largeness of life greets us in color. A white intensity drives the painting of Georgia O'Keeffe. Hers is not the mind capable of feeling one principle merely. She is not conscious of a single principle without becoming simultaneously aware of that contrary which gives it life. The greatest extremes lie close in her burning vision one upon the other; far upon near, hot upon cold, bitter upon sweet; two halves of truth. Subtleties of statement are fused with greatest boldness of feeling; tenderest, rose-petal gradations with widest, most robustious oppositions of color. . . . She has the might of creating deft, subtle, intricate chords and of concentrating two such complexes with all the oppositional power of two simple complementary voices; of making them abut their flames directly upon each other and fill with delicate and forceful thrust and counterthrust the spaces of her canvases.[87]

Rosenfeld returned to this theme throughout his essay, finding "fertile" oppositions in virtually every aspect of O'Keeffe's art, including her colors, textures, shapes, forms, and motifs: "A combination of immense Picasso-like power and crisp daintiness exists not alone in the color of O'Keeffe. It exists likewise in the textures of her paintings and in the shapes born in her mind with her color-schemes, and expressed through them. Precisely as the widest plunges and the tenderest gradations point against each other in her harmonies and fuse marvelously, so in her surfaces do heavily varnished passages combine with blotting-paper textures, and severe, harsh forms with strangest, sensitive flower-like shapes."[88]

Because embodied formalism operated at the level of form as well as iconography, gendered readings could be applied to works as different as *Flower Abstraction* (1924, fig. 4.6) and *Corn, Dark I* (1924, fig. 4.7). *Flower Abstraction* seems more likely to lend itself to a sexual interpretation, since O'Keeffe's "strange" and

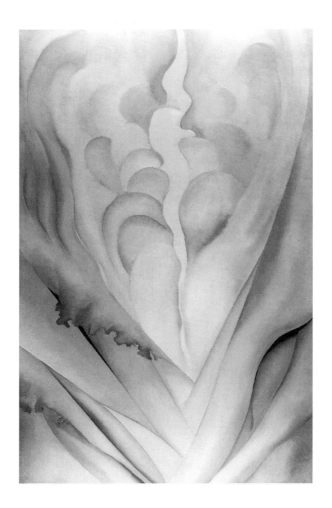

**4.6** Georgia O'Keeffe, *Flower Abstraction,* 1924. Oil on canvas, 48 × 30 in. (121.9 × 76.2 cm). Collection of Whitney Museum of American Art, New York, 50th Anniversary Gift of Sandra Payson. ©2000 The Georgia O'Keeffe Foundation/Artists Rights Society (ARS), New York.

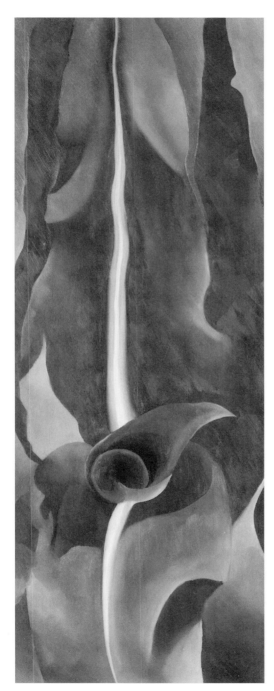

**4.7** Georgia O'Keeffe, *Corn, Dark I,* 1924. Oil on composition board, 31 ¾ × 11 ⅞ in. The Metropolitan Museum of Art, The Alfred Stieglitz Collection, 1949. ©2000 The Georgia O'Keeffe Foundation/Artists Rights Society (ARS), New York.

"sensitive" flower forms resemble female genitalia. Rosenfeld's description of the *formal* aspects of such works, in which "the widest plunges and the tenderest gradations point against each other in her harmonies and fuse marvelously," adds to this imagery a metaphor for a sexual encounter, in particular, male sexual penetration into the female body.[89] The painting itself is startlingly large, bright, and engulfing, a composite work that suggests both the ways in which representations can generate abstractions and the ways in which abstractions can be made to "represent" the gendered body. Once again, Stieglitz himself was the motivating force behind such critical interpretations. In 1924, the same year that *Flower Abstraction* was painted, Stieglitz told Rosenfeld that O'Keeffe's paintings displayed "the unconscious expression of woman in every touch.—Self portrayed through flowers and fruits and nuts found in the fields."[90]

In *Corn, Dark I* O'Keeffe presents another "intimate" yet seemingly more literal view of plant foliage.[91] A dew drop swirls at the center of a floral form that is surrounded by clusters of sharply veined corn leaves. In this work O'Keeffe employs striking tonal contrasts in her juxtaposition of dark and luminous passages. Edmund Wilson singled out this painting for praise in his review of the "Seven Americans" exhibition. He wrote: "The dark green stalks of one of her corn paintings have become so charged with her personal current and fused by her personal heat that they seem to us not a picture at all but a kind of dynamo of feeling, along which the fierce white line strikes like an electric spark. This last picture, in its solidity and life, seems to me one of her most successful."[92] Following Rosenfeld, Wilson imaginatively projected sublimated desire onto the surface of this still life, citing O'Keeffe's "personal heat" as the force that "fused" the otherwise disjunctive elements of the composition. Thus even in an image in which bodily forms are not remotely present, the painting could still be seen as "electrified" by the "heat" of O'Keeffe's presence.

By the mid-twenties sexual interpretations of O'Keeffe's works had become so pervasive that Waldo Frank, Henry McBride, and Charles Demuth already scoffed at them. Rather

than acknowledging the simplicity of O'Keeffe's art, Frank taunted, "Better talk of 'mystic figures of womanhood,' of 'Sumerian entrail-symbols,' of womb-dark hieroglyphics. Doubtless, all this would make the woman tired—if she could not smile."[93] In 1928 McBride jested, "There is 'Dark Iris, No. 1,' which began as a simple study of an innocent flower, but which now presents abysses of blackness into which the timid scarcely dare peer."[94] Later that year Demuth directly challenged the Freudian interpretation of O'Keeffe's flowers: "Things tedious, over long, or, over large and slightly Freudian, at the moment, have a much better chance of being acclaimed great . . . the flowers of Georgia O'Keeffe are not what I'm thinking about."[95] It was not until considerably later, however, that O'Keeffe herself publicly critiqued the eroticized interpretation of her flower imagery. In 1939 O'Keeffe protested: "when you took time to really notice my flower you hung all your own associations with flowers on my flower and you wrote about my flower as if I think and see what you think and see of the flower—and I don't."[96] A strong statement, but one that came a full twenty years after Stieglitz and the critics began to advance sexualized interpretations of O'Keeffe's painterly imagery. Yet how did O'Keeffe herself react to the gendered interpretations of her work when they were being formulated during the early twenties and thereafter? And what was the nature of her relationship with the critics, especially Rosenfeld?

## O'Keeffe and the Critics

Based on the extant archival materials, O'Keeffe's response seems to have been a truly ambivalent one. At an early point O'Keeffe openly expressed mixed feelings toward pictures, exhibitions, and criticism. In 1922 she wrote, "I paint because color is a significant language to me but I do not like pictures and I do not like exhibitions of pictures. However I am very much interested in them."[97] Although extremely sensitive to feedback and protective of her privacy, O'Keeffe wanted her things seen and was curious about people's responses to them. The statement she published to ac-

company her 1923 exhibition at the Anderson Galleries captures this contradictory attitude: "I say that I do not want to have this exhibition because, among other reasons, there are so many exhibitions that it seems ridiculous for me to add to the mess, but I guess I'm lying. I probably do want to see my things hang on a wall as other things hang so as to be able to place them in my mind in relation to other things I have seen done. And I presume, if I must be honest, that I am also interested in what anybody else has to say about them and also in what they don't say because that means something to me too."[98]

O'Keeffe's relationship with Rosenfeld was also ambivalent. In October of 1920 Rosenfeld visited Stieglitz and O'Keeffe at Lake George, and several months later he drafted his article on American painting for the *Dial*, believing that his writings reflected his personal knowledge of both O'Keeffe and Stieglitz.[99] As would later be his practice, it is likely that Rosenfeld shared a copy of this manuscript with Stieglitz before it went into print, because in a letter dated June 13, 1921 Rosenfeld told Stieglitz, "I'm very happy Georgia liked what I wrote about her."[100] Two months later Rosenfeld again commented to Stieglitz on O'Keeffe's apparently positive response to his *Dial* essay: "So Georgia liked the biff in my stuff! She is really a bellicose deity, and it's a shame not to satisfy her."[101] That October Rosenfeld sent O'Keeffe a painting by the artist Charles Duncan as a personal gift, telling her "I want to give it to you because I think I am beginning to understand what you are and what you stand for and what you have suffered; and what you do suffer."[102] Yet O'Keeffe would later express reservations about Rosenfeld's work. This contradiction suggests either that Stieglitz misrepresented O'Keeffe's reactions to Rosenfeld's essay; or that at this relatively early point O'Keeffe feigned approbation for the piece; or else that she did actually like it but later changed her mind; or perhaps some combination of all of these.

In July of 1922 O'Keeffe expressed contempt for a brief paragraph by an unidentified writer in that month's *Vanity Fair* that echoed some of the themes of the Stieglitz circle critics. The piece stated that O'Keeffe had become a successful artist once she

abandoned the "mediocrity" of her academic training and em-
braced Stieglitz's "freedom of expression" and "discovered her
own feminine self. Her more recent paintings seem to be a revela-
tion of the very essence of woman as Life Giver." At the bottom of
the page was the caption "Woman Painters of America Whose
Work Exhibits Distinctiveness of Style and Marked Individual-
ity."[103] To her former classmate Doris McMurdo, O'Keeffe wrote,
"Every time I think of that page in Vanity Fair I just want to
snort—its only redeeming feature is the line at the bottom of it—
I mean at the bottom of the page—There was something about me
in the Dial for December 1921 and a reproduction of one of my
things—later this year—I imagine in the autumn—Vanity Fair is
going to have an article on me with five illustrations I think—At
any rate they say they are—But I never believe anything till it
happens."[104]

O'Keeffe did not make derisive comments about Rosenfeld's
*Dial* article, and she seems to have been looking forward to the
publication of his essay in *Vanity Fair.* Yet a few months later her
comments on these writings were less positive. Sarah Greenough
has noted that in the fall of 1922 Mitchell Kennerley, president of
the Anderson Galleries, presented O'Keeffe with a scrapbook into
which he had pasted Rosenfeld's two articles.[105] In acknowledg-
ing the gift O'Keeffe told Kennerley that she was pleased by the
book but admitted that

Rosenfeld's articles have embarrassed me—I wanted to lose the one for
the Hartley book when I had the only copy of it to read—so it couldnt
[sic] be in the book. The things they write sound so strange and far re-
moved from what I feel of myself[.] They make me seem like some strange
unearthly sort of a creature floating in the air—breathing in clouds for
nourishment—when the truth is that I like beef steak—and like it rare
at that.

   Hapgood came in when I was reading Rosenfelds [sic] article in the
Dial—I was in a fury—and he laughed—He thought it very funny that
I should mind—telling me they were only writing their own autobiogra-
phy—that it really wasnt [sic] about me at all—

   So—what could I do about it—[106]

She continued by noting that while she will paste her future reviews into the book, "every time I do it—it will shiver and have a queer feeling of being invaded the way I do when I read things about myself." Ironically, although O'Keeffe felt "embarrassed" and "invaded" by Rosenfeld's and Hartley's writings, her protests focused not on the fact that their interpretations were sexual, but on the opposite issue, namely that they were overly ethereal.

In her notes to this letter Greenough observed that O'Keeffe "often repeated Hapgood's remarks throughout her life whenever she was confronted with critical opinion she did not like."[107] O'Keeffe's gesture can be seen as a strategic counterattack, an apt turning of the "mirror" of autobiography back on the critics.[108] Much as Duchamp had done in the *Large Glass,* O'Keeffe attempted to expose the notion that the viewer's own desires, particularly his or her need to affirm an authentic sense of self, are "reflected" in their response to and aestheticization of the other. If, as Duchamp claimed, the canvas was really a "mirror," then why, as O'Keeffe and Hapgood asserted, couldn't criticism also be one?

Although she told Kennerley she was "in a fury" over Rosenfeld's writings, O'Keeffe generally seems not to have objected to being described as uninhibited or as Stieglitz's protégé. In 1923 Henry McBride wrote that O'Keeffe had become free of her inhibitions without the aid of Freud, but with the help of Stieglitz, who was responsible for both O'Keeffe's exhibition at the Anderson Galleries and for O'Keeffe herself. McBride also noted that O'Keeffe's emancipation had made her a moralist, and that other women would come to her seeking advice. "My own advice to her—" McBride concluded, "is, immediately after the show, to get herself to a nunnery."[109] Shortly after this piece was printed O'Keeffe told McBride that his review "pleased me immensely—and made me laugh—. I thought it very funny—."[110]

Rosenfeld, however, was evidently aware of O'Keeffe's discomfort at having her work publicly discussed in terms of her personal life. When Rosenfeld prepared his article on O'Keeffe for *Vanity Fair* he expressed regret "for Georgia's sake" that Rebecca Strand, the wife of photographer Paul Strand and a close friend of

O'Keeffe's, had interpreted the essay as a personal declaration of his feelings toward Georgia. Rosenfeld told Stieglitz: "Beck Strand's remark will, I am afraid, be made by others, too. I am sorry for Georgia's sake, for it will keep people from seeing why I really wrote my piece. People are all so foolishly personal; they don't see that one can have a perfectly abstract passion for taking off one's hat to geniuses and to ladies; or that in certain states one loves everybody not possessively, but for something lovely in them." Rosenfeld also expressed great interest in O'Keeffe's response to his essay, and looked forward to hearing from her directly regarding the piece: "I am glad Georgia is going to write—She writes always very nice and thrilling letters. I wonder whether my attempted analysis of her art interested her at all."[111]

Despite O'Keeffe's professed negative feelings about Rosenfeld's writings, she and Rosenfeld seem to have maintained a friendly relationship with one another during the early and mid-twenties.[112] Although O'Keeffe's letters to Rosenfeld appear not to have survived (or were perhaps intentionally destroyed), the critic mentions receiving friendly correspondence from her during the early twenties. A handful of letters that Rosenfeld sent to O'Keeffe have been preserved at the Beinecke Rare Book and Manuscript Library at Yale University,[113] and these documents demonstrate that in fact O'Keeffe directly contributed to Rosenfeld's early critical writings. In October of 1923 Rosenfeld told Stieglitz how much he enjoyed O'Keeffe's letters and how pleased he was that she was reading his work.[114] The following month Rosenfeld sent Stieglitz drafts of his *Port of New York* essays to edit. Shortly after, Rosenfeld told Stieglitz that he had received "a lovely letter" from Georgia.[115] Three days later, on November 18, 1923, Rosenfeld wrote to O'Keeffe directly. After mentioning a birthday present he had sent her, Rosenfeld stated: "Many thanks for your letter, Georgia. It contained several ideas upon which I pounced like the Hyrcan tiger[116] on his prey, and made them my own without any ado. That is to say, I lifted them direct. I have the feeling that not one tenth of the article is my own in the real sense of the word; nevertheless I feel quite happy about it just at present." Rosenfeld concluded this letter by assuring O'Keeffe that

"the book is off, as they say in the races. Much love all around[,] PR".[117] While the precise nature of their collaboration remains uncertain, Rosenfeld's remarks unambiguously indicate that O'Keeffe's comments shaped the final version of the *Port of New York* manuscript. Perhaps it is not surprising, therefore, that in April of 1924, just after the book appeared in print, Stieglitz expressed O'Keeffe's unqualified admiration for Rosenfeld's essay on her: "Georgia delighted with what you wrote about her."[118]

Two decades after the publication of *Port of New York*, O'Keeffe herself admitted to having conflicting feelings about the previous critical commentary her work had generated. In 1945 James Johnson Sweeney, then a curator at the Museum of Modern Art, was planning a retrospective show and a monograph on O'Keeffe.[119] To aid Sweeney's undertaking, O'Keeffe sent him scrapbooks of her clippings, but told him, "Dont [sic] take those clippings very seriously—I've never denied anything they wrote so it isn't always true—I always thought it didn't matter much— maybe I even really enjoyed usually feeling quite different about myself—than people often seemed to see me."[120]

Like the archival materials, O'Keeffe's paintings constitute a source of "primary" information by which to gauge her response to the critics. Despite numerous critical accounts of a formal and sexual dialectic in her work, O'Keeffe did not appreciably alter her painting practice; throughout her long career and across a broad range of subject matter, she continually placed oppositional forms and colors against one another.[121] O'Keeffe herself made conflicting statements about the influence of criticism on her artistic practice. In September of 1923 she told Sherwood Anderson that her painting process evolved independently of critical commentary: "What others have called form has nothing to do with form—I want to create my own I cant [sic] do anything else— if I stop to think of what others—authorities or the public—or anyone—would say of my form I'd not be able to do anything."[122] Yet several months later she contradicted her earlier statement, telling Anderson why she did not plan to paint or exhibit more than a handful of abstract works during 1924: "I suppose the reason I got down to an effort to be objective is that I didn't like the

interpretations of my other things."[123] This latter statement clearly reveals not only that O'Keeffe took into account what others said about her works, but that her artistic output of 1924 was directly shaped by previous critical commentary.

Yet although she claimed not to like the interpretations that her abstract works had generated, O'Keeffe continued to produce naturalistic and abstract images that displayed similar formal structures. Between 1921 and 1923 various writers had described her abstracted fruit and flower imagery as expressions of her sexuality; despite this—or perhaps anticipating such a response—in 1924 O'Keeffe again presented the critics with fruit and flowers. In fact, her paintings and the criticism that accompanied them seemed to be mutually producing one another. In September of 1921 Rosenfeld even told O'Keeffe that her painting "is like a new form of language."[124]

A curiously suggestive resonance is discernible between the formal structures of O'Keeffe's paintings and the artist's own situation as the only woman within the Stieglitz group. O'Keeffe's proclivity for placing oppositional forms and colors against one another repeatedly enabled her to explore the relational nature of identity itself, particularly the ways in which formal units (and perhaps, by symbolic extension, people) could be pitted against one another yet ultimately be made to coexist within a unified framework. Thus like her own structural position within the Stieglitz circle, the single most distinctive characteristic of O'Keeffe's painterly practice was her continual exploration of the ways in which oppositions could be negotiated and situated within larger structural harmonies.

Despite her professed indifference to the critics, there was one person whose opinion O'Keeffe cared about deeply—Stieglitz's. In 1926 O'Keeffe publicly affirmed her gratitude to Stieglitz to Blanche Matthias, an art critic for the *Chicago Evening Post*. When describing the ways in which the photographer had nurtured her career, O'Keeffe told Matthias that "I feel like a little plant that [Stieglitz] has watered and weeded and dug around."[125] Thus it is likely that one of the primary reasons why O'Keeffe did not protest against Rosenfeld's and Hartley's assertions was that

these discourses were consistent with Stieglitz's own views.[126] Similarly, while O'Keeffe's posing nude for Stieglitz suggests her complicity in the sexualization of her persona, a refusal to pose would have constituted a break with him that she probably was not ready to make. Yet it is also possible that O'Keeffe did not find these images objectionable. Sarah Whitaker Peters has noted that when Stieglitz first displayed his highly personal photographs of O'Keeffe at the Anderson Galleries in 1921, "at the time O'Keeffe seems not to have recorded either her distress or her indignation over attaining instant sexual 'stardom' in the New York art world."[127] Significantly, she even posed for additional nude photos in 1922 and 1932, well after Rosenfeld and Hartley had published their gender-inflected assessments of her work.[128] In addition, O'Keeffe's own long-standing positive feelings for these photographs are clearly indicated by her much later involvement in an important exhibition of these works at The Metropolitan Museum of Art (1978). This show, for which O'Keeffe herself wrote the accompanying catalogue essay, included several nude photographs of her culled from Stieglitz's composite portrait.[129]

As all of this suggests, the complex intertwining of O'Keeffe's and Stieglitz's personal and professional lives produced a densely entangled situation, one that is far from "transparent" to the interpreter. While it is not possible to know fully the personal dynamics from which their public personas were crafted, O'Keeffe's "victimhood" at the hands of a powerful contingent of male critics has been widely asserted.[130] O'Keeffe's collaboration with Rosenfeld and Stieglitz, in which she directly shaped the published interpretations of her works, suggests that she was no victim. At the same time, it is important to acknowledge that her situation was not specific to her as an individual, but was a function of her structural position as a female artist in a predominately male environment. As Barbara Buhler Lynes has observed, even if O'Keeffe did not agree with the opinions of Stieglitz and his critics, her opposition may have been muted by the fact that she depended on them for her recognition in an art world in which the galleries and critical press were controlled almost exclusively by men.[131]

During the early twenties O'Keeffe seems primarily to have been watching interpretations of herself develop rather than directing or intruding in them, but by the mid-twenties O'Keeffe began to support an alternative critical reading of her work. In 1927 she thanked Henry McBride for his review of her work in the *New York Sun*, noting: "I am particularly amused and pleased to have the emotional faucet turned off—no matter what other ones you turn on."[132] That year she also remarked cryptically to Waldo Frank that she had come to the end of something, an end that she was still trying to clarify for herself.[133]

Perhaps she *had* come to the end of something. From the summer of 1928 onward O'Keeffe began to spend significant amounts of time away from Stieglitz. During the thirties she increasingly established an independent life, though each year she did return to him. Her letters from the late twenties and thirties reveal that she felt torn between her own way of life and her relationship with Stieglitz.[134] As she told her friend, the artist Russell Vernon Hunter, "I am divided between my man and a life with him—and some thing of the outdoors . . . that is in my blood—and that I know I will never get rid of—I have to get along with my divided self the best way I can."[135] In the Metropolitan Museum catalogue O'Keeffe expressed a similarly ambivalent sentiment toward Stieglitz himself: "It was as if something hot, dark, and destructive was hitched to the highest, brightest star. For me he was much more wonderful in his work than as a human being. I believe it was the work that kept me with him—though I loved him as a human being. I could see his strengths and weaknesses. I put up with what seemed to me a good deal of contradictory nonsense because of what seemed clear and bright and wonderful."[136] The result, in O'Keeffe's own words, was that she had to live with her "divided self." These statements suggest a final paradox. While O'Keeffe may have experienced a divided sense of allegiance between Stieglitz himself and his artistic project, her presence nevertheless remained integral to the "wholeness" of the "circle" that Stieglitz, his critics, and O'Keeffe herself had so carefully and elaborately constructed.

# John Marin:

Framed Landscapes and Embodied Visions

With the exception of Georgia O'Keeffe, no artist has been more closely associated with Alfred Stieglitz than John Marin.[1] Marin began showing his nascent abstracted artworks at 291 along with the select group of modernists whose work Stieglitz exhibited there; but Marin would be central to Stieglitz's activities well after the closing of the gallery, and he would remain so for the rest of the photographer's life. The mutually beneficial relationship that the two men shared is reflected in the unique position that Marin occupied in Stieglitz's aesthetic project.

**5.1** Alfred Stieglitz, *Portrait of John Marin*, 1922. Silver gelatin developed-out print. Alfred Stieglitz Collection, © 1999 Board of Trustees, National Gallery of Art, Washington, DC.

A portrait of Marin taken by Stieglitz served as the frontispiece to *Port of New York* (fig. 5.1). While Marin's intense image greeted readers at the outset of Rosenfeld's text, a chapter devoted to Marin's painting practice appeared at the very heart of the book. In this essay Rosenfeld wrote, "None but one American-born could have rubbed this pigment and made it into the peculiarly tempered color it is. It strikes a western dominant with its salt and slap. Something Walt Whitmanish abides in its essence. There is richness of touch; sensuality, even, crushed out like fruit juice, in Marin. But it is a richness economically emitted, athletically held in rein; a sensuality not repressed and sour, but chaste and not easy."[2] By now Rosenfeld's rhetoric is familiar. The critic

drew on images of Walt Whitman and on the paradoxes of embod-
ied formalist discourse to characterize Marin's art as somehow
transcending the body in its "chaste" and essential character
while remaining juicy, sensual, and nonrepressed. In this essay
Rosenfeld also noted that Marin had been both nurtured and
shaped by the atmosphere that Stieglitz created at 291: "Stieglitz
and 291 Fifth Avenue have been a home for [Marin's] spirit for the
reason he has been able to use them; to take nourishment where
nourishment is to be found." Rosenfeld continued, "There can be
no doubt that the experience of 291 Fifth Avenue, particularly the
experience of the back room, where the painters sat about the iron
stove and warmed their feet and thrashed violently through aes-
thetics, helped considerably in this development. Marin, who did
not so passionately care for thought, was forced to reason. The
problems of his art began seriously to engross him."[3] Thus like
Dove's and O'Keeffe's, Marin's paintings were presented as an ex-
pression of Stieglitz's aesthetic project, and Stieglitz was seen as
integral to Marin's artistic development. As Stieglitz's associate
Marius de Zayas put it, "As far as artists are concerned, the Photo-
Secession had results or at least one result in John Marin."[4]

## Alfred Stieglitz's "Transparent" Artist

While the particular details vary slightly, in all of the published
accounts in which Stieglitz described his initial contact and bud-
ding relationship with Marin, the photographer presented himself
as the earliest and staunchest supporter of Marin's modernist art-
work. From the outset, Stieglitz encouraged Marin to pursue his
own artistic vision rather than generate the conventional and more
readily salable Whistlerian etchings that Marin produced during
the early part of his career. Stieglitz repeatedly described how, re-
buffing such authority figures as Marin's first dealers and even the
artist's own father, he stepped forward to assume responsibility for
the painter. Herbert J. Seligmann, Stieglitz's amanuensis, later
recorded how, during his first meeting with Marin, Stieglitz re-
portedly advised the young artist: "'Well, if I were you and could

do what you have done,' said Stieglitz, 'I'd tell the dealer and your father to go to hell.' Then Stieglitz realized, having given this advice, he would have to back up Marin. He had lived up to that for sixteen years."[5]

In a later, more extended version of this story, the photographer recounted how Marin's father himself once came to 291 to urge Stieglitz to persuade Marin to produce his more marketable etchings in the morning and his "mad," commercially risky watercolors in the afternoon. As Stieglitz recalled: "'Mr. Marin,' I said, 'before I say anything to your son, John, I wish you'd ask your wife, that very fine woman, does she think that a woman can be a prostitute in the morning and a virgin in the afternoon.' He looked shocked. I said, 'I do not want to give offense, but that's what you are asking me to tell your son to be.'"[6] Stieglitz's conflation of artistic and sexual purity in Marin's oeuvre is consistent with Rosenfeld's discussion of Marin's chaste painterly sensualism. Stieglitz's stories also indicate that the photographer was well aware of the extent to which Marin's career and public persona were Stieglitz's own constructions. In assuming such responsibility for Marin, the photographer also felt himself responsible for the artworks that Marin produced. Describing Stieglitz's activities at the Intimate Gallery, Seligmann remarked: "The Room could not exist in its present form without the work of Marin, O'Keeffe, and one or two others. But neither Marin's nor O'Keeffe's work would have existed without Stieglitz. Marin would have been making pleasant etchings, nice little water colors. O'Keeffe's work would not have existed at all. So the question was, was not their work also an expression of Stieglitz?"[7] Much later, the novelist Henry Miller described his perception of the intimate bond that existed between Marin and Stieglitz: "[The two] are constantly fecundating each other, nourishing each other, inspiring each other. There is no more glorious wedlock known to man than this marriage of kindred spirits. Everything they touch becomes ennobled."[8] Miller thus situated Marin and Stieglitz within a kind of symbiotic spiritual and corporeal relationship not unlike that which the photographer experienced with Rosenfeld during the early twenties. In fact, Stieglitz's support of Marin was unstinting. In addition to

showing Marin's early modernist artworks at 291, Stieglitz sustained a high level of enthusiasm and support for Marin throughout the artist's entire career. Not only did Stieglitz hold annual exhibitions of Marin's painting at the Intimate Gallery and An American Place, but the first exhibitions he held at both galleries were Marin shows.[9]

Yet even though Stieglitz considered Marin to be an extension of himself, the photographer also emphasized that a "transparent" relation existed between Marin and his paintings. When promoting Marin's artworks to the collector and critic A. E. Gallatin in 1922, for example, Stieglitz wrote that Marin "is a rare artist.—And an extraordinarily modest fellow—a fine character."[10] Earlier that year Stieglitz had thanked the critic Henry McBride for his review of Marin's works, noting that "Marin is as modest as ever. He is a constant pleasure. Exactly like his pictures."[11] In a slightly later article, McBride brought the issue of reciprocity between Stieglitz and Marin full circle by characterizing Stieglitz as the guardian of Marin's works. Stieglitz recycled McBride's review as publicity material by reprinting it on the front page of a flyer that accompanied Marin's December 1925 exhibition at the Intimate Gallery.[12] Such promotional machinations notwithstanding, Stieglitz consistently emphasized the qualities of modesty, ingenuousness, and spontaneity in Marin's paintings *and* in his personal character.

Stieglitz also felt that he was responsible for preserving these virtues in Marin. When commenting on Marin's 1926 exhibition at An American Place, the photographer told Seligmann, "Here in the room was Marin, who had been able to stay a pure and free spirit. If he, Stieglitz, had not been there, he wondered if that would have been possible."[13] To underscore this point, Stieglitz periodically reprinted Marin's letters and poems as catalogue statements in the fliers that accompanied his exhibitions at An American Place. Stieglitz also published a volume of Marin's writings in 1931, a book composed almost entirely of letters addressed to the photographer himself.[14] As this book demonstrates, Marin often affected a rustic, vernacular tone in his letters. Stieglitz greatly enjoyed Marin's writings, not least of all because, along

with Marin's paintings, he viewed them as expressions of the ingenuousness and spontaneity of Marin's character. Upon receiving a copy of Marin's letters, Arthur Dove told Stieglitz, "I love the spirit of them, and it is fine to see you behind his finest feelings."[15] Perhaps unwittingly, Dove exposed the important notion that when one encountered a public construction of Marin, one also was encountering Stieglitz.

The full extent to which Stieglitz was successful in guiding key interpretations of Marin's work is perhaps best judged by the critical writings of the period.[16] In 1923 Stieglitz sought Sheldon Cheney's support for Marin, Dove, and O'Keeffe in conjunction with Cheney's book *A Primer of Modern Art* (1924). In his correspondence with the author, Stieglitz particularly emphasized that Marin and O'Keeffe were "supremely American."[17] Echoing Stieglitz's own views, Cheney wrote that "John Marin and Georgia O'Keeffe are perhaps the Americans who have escaped most freely and most joyously from the confines of the older painting." Yet Cheney did more than emphasize the indigenous aspects of Marin's and O'Keeffe's artworks. Like the Stieglitz circle writers themselves, Cheney characterized the formal aspects of Marin's and O'Keeffe's paintings in terms of authentic embodied and emotional experience. When contrasting the two artists, Cheney wrote that "where Marin seems to capture emotional intensity rapidly, brilliantly, with feverish abandon, getting down the palpitating image broadly in emotional outline—Georgia O'Keeffe seems to intensify calmly, to work through clear-headedly in silence, but with heart no less stirred and kept aflame in her steady way."[18] Thus, according to Cheney, while O'Keeffe's works were quietly "aflame," Marin's (nonfigural) paintings seemed to quiver with rapid intensity and "feverish abandon."

Cheney was not the only writer to characterize Marin's artworks in such animated terms. Nor was his text the only one to imply that such interpretations were traceable to Stieglitz himself. Edmund Wilson confronted these issues directly in his review of the "Alfred Stieglitz Presents Seven Americans" show for *The New Republic* (March 18, 1925), and in the critical commentary which he later appended to this essay. In his initial review, the

critic conflated the gendered character of Marin's paintings with the artist himself. Wilson praised Marin's watercolors as "masculine masterpieces: they represent the investiture of nature with the qualities of a distinguished temperament." Yet Wilson later acknowledged that he had been "subjected to Stieglitz's spell" when he originally wrote the piece, particularly regarding Marin, "whose reputation I now suspect Stieglitz of having rather unduly inflated, and I might have discovered this if I had been left alone with the pictures."[19]

In 1932 Herbert J. Seligmann commented glowingly on the link between Stieglitz's personal presence and Marin's paintings. Seligmann wrote that both Marin and his work "are a fruit of the most creative criticism of which I have any knowledge in our time, the criticism of Alfred Stieglitz." According to Seligmann, over the years the photographer had kept Marin's art pure by steadfastly protecting him from "the degraded tastes of current society and the slimy assaults of commercialism." Stieglitz and his critics found Marin's aesthetic and corporeal purity expressed in the intense and uninhibited quality of his painterly ejaculations. As Seligmann put it, "When pigment has the luminosity of inner spiritual birth, when bright rivulets of color evidence the delight in vision that coursed through the painter's body, then painting becomes something more than self-indulgence, flattery or commerce."[20]

Not surprisingly, the earliest expression of these themes is found in Paul Rosenfeld's writings. In his influential essay on "American Painting" published in the *Dial* (December 1921), Rosenfeld drew on Freudian notions of the unconscious to describe Marin's watercolors in terms of sublimated orgasmic experience. According to Rosenfeld, Marin's watercolors exemplify "a complete harmonious release" in which "the conscious and the unconscious mind interplay in this expression. Flashes of red lightning, pure ecstatic invasions of the conscious field, tear through the subdued and reticent American colour of the wash."[21] Building on the relations between fertility and fluidity in *Port of New York*, Rosenfeld wrote that Marin's art demonstrates "a man's implicit confidence in his senses; a man's complete truthfulness

to self, principle of fecundity in humankind, which, married to a delight in playing with water-color, has brought this shower of little masterworks upon the world."[22] Lest anyone be unclear as to the phallic overtones associated with Marin's paint handling, Rosenfeld described the artist as "strewing on the soil about him his explosions of tart water-color," paint strokes which represented nothing less than "climax of life succeeding climax with indecent unceremoniousness."[23]

Yet according to Rosenfeld, Marin's discharges were not empty spillages, but the components of a masterful design organized by an elaborate system of frames. Rosenfeld interpreted Marin's pictorial framing devices as containers of his energy, his paint, and his "psychic matter." As Rosenfeld put it: "And the substance at play within the four outlines of his white oblongs is psychic matter running unclotted, squeezed as from a sponge; all open, all loose, all free. It courses in utmost relaxation."[24] Thus if Rosenfeld perceived Marin's paint handling as explosive, his finished works represented something like a postorgasmic state of "relaxation." In this manner Rosenfeld identified a generative fusion between the erotic and aesthetic elements of Marin's artworks as the artist "rubs" his pigments to produce his "marvelously stained sheets."[25]

As we have seen, the critical interpretations expressed in *Port of New York* reflected not only Rosenfeld's views but Stieglitz's own opinions. As he did with the other Stieglitz circle artists, Rosenfeld sent the photographer a draft of the Marin essay before it went into print, and in July of 1923 he told Stieglitz that he was "delighted" that Stieglitz was pleased with the piece.[26] Rosenfeld himself owned at least five of Marin's watercolors from the teens and early twenties, the later works being landscapes from Marin's Deer Isle, Maine, series.[27] And during the twenties Rosenfeld helped to subsidize the artist by contributing to the Marin Fund, an endowment that Stieglitz established for Marin.[28] As all of this suggests, Rosenfeld was deeply invested both in Marin personally and in the artist's structural position within Stieglitz's modernist project.

The conflation of vision and desire, or the positing of a kind of metaphoric equivalency between flesh and form, was a rhetorical tactic that Stieglitz himself deployed when discussing Marin's artworks. Dorothy Norman recalled that a woman once entered a Marin exhibition at An American Place and requested help in understanding the paintings. "She turns to Stieglitz: 'Is there someone who can explain these pictures to me? I don't understand them at all. I want to know why they arouse no emotion in me.' Before Stieglitz quite realizes what he is saying, he replies, 'Can you tell me this: Why don't you give me an erection?' He walks back into his office. The woman acts as though she isn't quite sure she has heard him correctly. She seems afraid to leave at once. She walks around the Place for a while, stares at the pictures, then flees."[29] Stieglitz's allegory of the missing erection, and the Stieglitz circle's repeated emphases on pleasure and reproduction, were collectively enlisted as explanatory tools for Marin's paintings, making Marin's nonfigural imagery discussible within the discursive parameters of embodied formalism. A final, striking instance of Marin's characterization in Stieglitz circle discourses is found in the writings of the critic Louis Kalonyme. Following Rosenfeld, in 1926 Kalonyme elided the boundary between Marin's paintings and the process through which they came into being, characterizing both within the overtly masculinist terms of power and agency. Kalonyme wrote that Marin "expresses his joy with great joyous lunges and thrusts. He is of the Promethean fraternity who affirmatively tear beauty from the life of the world."[30] Kalonyme further noted that "Marin is always visibly working up to a pregnant climax," and that "the birth pains of creation" are visible in his work.[31] Despite Kalonyme's references to pregnancy and birth, Marin's watercolors nonetheless were seen as retaining their masculine qualities. Such an interpretation is consistent with Freudian concepts; in *The Interpretation of Dreams* Freud linked the sexual symbolism of male ejaculation in dream imagery to water, semen, and amniotic fluid as well as to other symbols of fertility.[32]

Given the thread of associations that connects eroticism and procreativity in Stieglitz circle discourses, it is not surprising that

Marin referred to his own water- and oil-based images as his "paint children." Like Stieglitz and Dove, Marin thought of his paintings as embodied beings and even as his children. In an exhibition catalogue published by An American Place, Marin publicly addressed his own paintings paternalistically as his "Paint Children," and he identified himself as their "loving Poppa."[33] In *Port of New York* Rosenfeld similarly emphasized the experiences of delight and fecundity as he described Marin's artistic practice as "generations being littered every four or five years."[34] Duncan Phillips also associated the development of Marin's paintings with notions of fertility and organic procreativity. Echoing his rhetoric on Dove's works, Phillips advised Marin to devote himself to his watercolors, "to an intensive cultivation of the field of effort in which his sowing will bear the richest and soundest of fruit."[35]

## The Flow and The Frame

During the twenties and thirties the Stieglitz circle critics repeatedly enlisted such flamboyant rhetoric to link Marin's painterly (and implicitly seminal) "flows" to his artistic vision, a vision the artist controlled through elements such as frames and "pull forces." Both linear and painterly framing devices appear at an early point in Marin's images, and they become pronounced in the increasingly self-confident work that he produced after 1915. While this analysis focuses primarily on two paintings, Marin's *Lower Manhattan* (1920, plate 5, fig. 5.2) and *Maine Islands* (1922, plate 6, fig. 5.3), the structural devices displayed in these artworks recur throughout Marin's oeuvre. They are widely evident in the artist's urban scenes of New York as well as in the rural views of New England and New Mexico that he produced throughout the twenties and thirties, though after 1945 Marin's strokes tend to become increasingly free and, ultimately, wildly calligraphic.[36]

Unlike Demuth and most traditional watercolorists, Marin tended not to use a tightly definitive scaffolding of pencil underdrawing to guide and support his more fluid overlays of paint.

**5.2** John Marin, *Lower Manhattan,* 1920. Watercolor and charcoal on paper, 21 ⅞ × 26 ¾ in. (55.4 × 68 cm). The Museum of Modern Art, New York. The Philip L. Goodwin Collection. Photograph ©2000 The Museum of Modern Art, New York.

Rather, he typically organized his compositions through clusters of forms over which he applied dense, graphic strokes of paint or charcoal. These strokes helped to frame and organize his scenes while at the same time appearing to be interwoven within the composition itself. And through his symbolic use of picture frames, window panes, and other structural devices, which he called "pull forces," Marin was able to suggest that he had built his personal "perspective" into his artworks.

In 1913 Marin offered an explanation of "pull forces." When describing the animism that he perceived in New York architecture such as the Brooklyn Bridge and the Woolworth Building,

**5.3** John Marin, *Maine Islands*, 1922. Watercolor on paper, 16 ⅞ × 19 ¾ in. The Phillips Collection, Washington, DC.

Marin wrote: "I see great forces at work: great movements; the large buildings and the small buildings; the warring of the great and the small; influences of one mass on another greater or smaller mass. Feelings are aroused which give me the desire to express the reaction of these 'pull forces,' those influences which play with one another; great masses pulling smaller masses, each subject in some degree to the other's power. . . . And so I try to express graphically what a great city is doing. Within the frames there must be a balance, a controlling of these warring, pushing, pulling forces. That is what I am trying to realize."[37] Marin thus characterized himself as a mediating presence who strives to bring bal-

ance and control to the competing formal rhythms of architecture. In *Port of New York* Rosenfeld described Marin's architectonic "pull forces" in more explicitly embodied terms, noting that "a skyscraper has but to jab its giant thumb into falling skies . . . and the singing intensity, the sonorous beat, is present in [Marin's] body."[38]

In (kin)esthetic terms, *Lower Manhattan* seems to exemplify both Marin's account of "pull forces" and Rosenfeld's corporeally inflected description of architecture "jab[bing] its giant thumb into falling skies." Skyscrapers rise in the background of this painting, while an El, or elevated train, forms a "bridge" that spans nearly the entire width of the sheet. Rich tonal concentrations of brown, blue, green, and orange create a dense "frame" around the work. The dominant central form of the El joins this painted frame to its background landscape, thus uniting two otherwise disjunctive areas of the painting. In this manner Marin's emphatic diagonals guide the composition, providing a skeletal structure to support his lush, seemingly animated flows of paint. These prominent diagonals not only frame the particular view of New York that Marin presents, but also function as markers of Marin's artistic presence, suggesting that traces of his bodily movements and artistic "perspective" have been incorporated into the image itself.

*Lower Manhattan* also exemplifies the ways in which Marin's frames function as a bridge between the artist's loose, painterly structures and his iconography. Because Marin often presented highly abstracted views of the landscape, his images tend to vacillate abruptly between two and three dimensions. For this reason it is often possible to read Marin's images as both flat, painterly surfaces and as recognizable landscape scenes. When examining a work by Marin, the viewer becomes conscious of the simultaneous play between the lush surface of the sheet and the suggestion of recognizable landmarks and spatial formations. Marin's "frames" are instrumental in creating a sense of stability around these potentially disjunctive pictorial effects. The framing device of the El in *Lower Manhattan* can be seen as functioning in precisely these terms, since it unites various opposing forces in the

image. Formally, the El is both representational and abstract. Compositionally, it joins the edges and the center of the work, furnishing coherence to the painting as a whole. And symbolically, it suggests the union of the "inner" and "outer" aspects of Marin's painterly "vision."

While *Lower Manhattan* is an urban scene that relies on the device of the El to unite the composition, *Maine Islands* is a rural scene that employs another of Marin's characteristic pictorial strategies: the double frame. This watercolor is set in a "Marin frame," a decorated wooden picture frame made by the artist himself. This outer frame is played off against the illusion of a faceted window pane that appears within the image. When engaging this work, the spectator must look through the picture frame and then through a glass "window" to view a foreground landscape consisting of a body of water and a series of three small, receding islands. Compositionally, the assertive diagonals of the window pane focus the scene by providing a central point of emphasis. Symbolically, the viewer "sees" the landscape through the "vision" of it that Marin presents. Taken together, the artist's window and picture frames imply that the viewer is able to look directly through Marin's eyes and thus occupies a highly privileged—and impossibly unmediated—viewing position.[39]

Ironically, though, the signs of Marin's vision, such as his frames and "pull forces," connote artistic mediation rather than immediacy, and thus serve to indicate the workings of representation rather than transparency. Marin's various "frames" enhance the viewer's ability to access his work, but they dictate the terms under which this access is granted. While the expressive presence of the frame illusively suggests the viewer's unimpeded ability to share in the painter's vision, by the frame's very nature the viewer is detached from the work and positioned outside the frame looking in. Thus Marin's two frames stand in a paradoxical relation to one another. While Marin's internal frame is part of the *painting's* space, the external frame is part of the *viewer's* space. The resonance between the two frames, and the mechanism of double framing in general, efface the notion of difference between the internal and external spaces of Marin's painting *while at the*

*same time* reinscribing and emphasizing the crucial presence of the border itself. In this manner Marin sets up provocatively fluid boundaries in his works in order for his viewers to cross and re-cross them.

Marin's paintings simultaneously evoke the contradictory experiences of interior and exterior, containment and flow. Yet how was it possible for Marin's artworks to sustain such ambivalent readings? That is, how were his paintings able to appear both solid and fluid, motile and encapsulated, embodied and abstracted, at the same time? As was the case for Dove and O'Keeffe, such readings were possible because they were situated within the convergence of Marin's symbolic iconography and his abstract, painterly structures. In Marin's case, these themes were linked directly to his practice in watercolor. In his watercolors, Marin's painterly "discharges" transform that which is fluid (and hence formless) into form. Thus Marin's particular type of expressive agency necessarily involved both a "flow"—a sense of mobility and expansiveness—and a "frame"—a sense of containment within discrete pictorial and conceptual boundaries. Marin's watercolors appeared to lend themselves to such a reading because, in them, congealed pigment transforms flow itself (the paint, which is the surrogate of the male body) into a boundary that is at once stable and fluid, visionary and corporeal, the ostensive product of carnal enthusiasm and self-confident technical realization. At the same time, Marin's paint strokes serve to demarcate the material presence of represented objects by defining their edges and surfaces while simultaneously retaining the loose, fluid, painterly character that signifies the process of flow itself. Marin's paint marks can thus be seen as "embodying" iconographic solidity *and* abstract fluidity within a single graphic expression.

As was the case with Dove and O'Keeffe, Marin's art presented Stieglitz and his critics with the challenge of formulating a discourse in which fluids (painterly and bodily) become culturally representable. The Stieglitz circle's emphases on the "ecstatic" character of Marin's paint flows and the "transparency" of his artistic vision facilitated conceptual parallels between the interiority and the exteriority of both the body and the painting itself.

Taken together, Marin's "transparent" frames and his semiopaque pigments at once marked a boundary and signified a flow. As a result, these paint marks—the symbolic attributes of corporeality—enabled the Stieglitz circle critics to sustain a particular conception of masculinity in Marin's oeuvre as being both solid and liquid, corporeal and aestheticized, fluid and phallic.[40] In addition, Marin's watercolors could themselves be seen as exemplifying both a process and a product. As such, the images could stand as finished works of art *and* as documents of their own inception.

As all of this suggests, intrinsic to the Stieglitz circle's critical construction of Marin was the notion of bringing the inside outside as a result of a fluid's having passed through a boundary (or, in this instance, through the collapsed boundaries of the flesh and the frame). This conflation of Marin's artistic vision and his corporeal presence was key to the conception of integrated subjectivity that the Stieglitz circle critics attributed to Marin's paintings. Critics maintained that his art represented nothing less than the merger of internal and external vision as expressed through vitalistic flow and aestheticized form. Marin himself identified a similar sense of equilibrium in his art when he described the ways in which the rhythms of his own body became interwoven with the structures of his artworks. In 1928 he wrote, "Weight balances as my body exerts a downward pressure on the floor the floor in turn exerts an upward pressure on my body. [T]oo the pressure of the air against my body—my body against the air—all this I have to recognize when building the picture."[41] Marin also believed that his inner and outer vision were inseparable, and that his paintings represented their synthesis. The same year that Marin painted *Lower Manhattan* he told Stieglitz: "It's a question as to whether the open sight vision—that is of things you see—isn't better than the inner, I mean, vision things. . . . After writing this, my answer now, to myself, is that you cannot divorce the two, they are unseparable, they go together. The inner picture being a composite of things seen with the eye, the art object being neither the one or the other but a separate thing in itself."[42] Lewis Mumford identified a similar visual "synthesis" in Marin's art

when he wrote that "the fusion of the inner and the outer eye, focused unconsciously in the living gesture of the brush, not brought together by any set formula of design, puts Marin at the very summit of his art; and this means, at the present moment, of American art."[43] Mumford thus characterized Marin's painting as the unconscious joining of inner and outer vision through the expressive physical gestures of the brush.

But it was in the writings of Paul Rosenfeld and Samuel M. Kootz that Marin's physical presence became most explicitly linked to conceptions of integrated subjectivity and a stance against "intellectualism."[44] In *Modern American Painters* (1930) Kootz praised Marin's art as exemplifying the "purest marriage of the brain with the heart," one that represented "a positive force, not the continual negations of our world-weary intellectuals." Kootz additionally perceived "a complete absence of the sniveling emasculation that corrodes American pictures" in Marin's works, asserting that Marin's aesthetic and corporeal flows were nothing short of orgasmic: "The man possesses as great a fountain of fecundity as those very waterfalls that go brilliantly cascading through his works."[45] Kootz thus linked images of the ejaculatory body in Marin's artworks to a polemic against intellectualism and the artistic "emasculation" that supposedly accompanied European (especially French) influences. Kootz identified this "stillborn," derivative tendency in the works of Raphael Soyer, Charles Sheeler, Abraham Walkowitz, Marsden Hartley, and Stuart Davis among others. In addition, Kootz drew on well-established cultural tropes when he attributed the ostensibly stilted and inauthentic character of such works to "the smothering influence of the Puritan ideal" and "the Puritan hang-over of shame at any revelation of emotion. This characteristic has sweetened their stale ideas with a sickly refinement, unfortunately become dominant everywhere." In contrast to this lingering Puritan repression, Marin was praised for his "lusty masculine seeing."[46]

Rosenfeld was equally explicit regarding the thematic convergence of aesthetics and embodied subjectivity in Marin's oeuvre. In *Port of New York* Rosenfeld wrote that Marin "paints from the navel and addresses not the brain but the navel. And only be-

cause there is no schism in him between hand and brain has he mastered his medium." According to the critic, this unified conception of subjectivity has enabled Marin to "master" the medium of watercolor, which "requires a sort of instantaneous discharge of energy; a concentration and complete unification of resources, for its service."[47] Hence, Rosenfeld located Marin's creative agency, as expressed in the aesthetic "potency" of his painterly discharges, in the artist's being utterly uninhibited by the emasculating tendencies of "intellectualism." In 1932 Rosenfeld again made this point when he wrote that Marin "is the least cerebral of artists, and the most self-assured."[48]

## Duchamp and Marin: The Mirror and The Stain

Like the Stieglitz circle critics, Marin himself described the painting process as lusty, experiential, and decidedly anti-intellectual. In particular, Marin rejected "intellectualism" in favor of a physical and emotional immersion that brought aesthetics and desire to the "surface" of his paintings. In 1931 he told Stieglitz, "I am afraid that in the crazed desire to be modern—to have ideas—to be original—to belong to the tribe *intelligencia*—we have gotten away from the paint job which is a *lusty thing . . .* and I almost feel like saying 'what you have to say don't amount to so much'—but the *lusty* desire to splash about—submerge oneself in a medium—you might come up to surface with something worth while."[49]

I think it is possible to read the Stieglitz circle's descriptions of aestheticized painterly ejaculation in Marin's works as being not only anti-intellectual but curiously anti-Duchampian. As discussed in chapter 2, during the late teens and early twenties Stieglitz reformulated his own artistic identity and that of his circle in the wake of his unsettling encounters with the New York Dada movement. Among the artworks produced by the New York avant-garde, Marcel Duchamp's *Large Glass* (1915–1923, fig. 2.5) arguably stands as *the* monumental expression of European "intellectualism," and, not incidentally, as the great allegory of mas-

turbation in the early history of American modernism. In the glass Duchamp created a painting devoid of aesthetics in order to showcase sex without eroticism. Both the painting's "subject" (the bride and bachelors) and the viewing subject are represented as engaged in related forms of masturbation. While the "bachelors" remain separated from the "bride," onanistically "grinding their own chocolate," the viewer experiences Duchamp's (literally) "transparent" painting as a "mirror" that "reflects" his own image and desires back to him on the surface of the glass.[50]

In contrast to Duchamp's masturbating bachelors, Marin's paint flows were characterized as joyous and fertile, not as empty and futile. While Marin's artistic gestures were understood to be based on the unified actions of the hand, the heart, and the brain, Duchamp's mechanized figures embodied the conditions of alienated subjectivity itself. And while Duchamp's art privileges the intellect, Marin's painting appeals to the entire body. Marin's "strokes," the marks ostensibly produced by his paint and his desire, are absorbed onto thick layers of Whatman paper to form lush works of art. Yet while Duchamp's substantial and literally transparent "glass" remains impenetrable and reflective, Marin's "sheets" are "stained." And the viewer is invited not so much to "reflect" on a Marin painting as to be "absorbed" by it and relive the artist's delight in its production.

Despite the differences in their respective projects, Duchamp's and Marin's artworks seem to share a crucial similarity. Both evidence a notable absence of female sexual agency. Duchamp's bride is a motorized assemblage who hovers alone in her own domain, forever separated from the bachelors who "strip her bare." Meanwhile Marin's "pregnant" paintings were characterized as somehow produced without the aid of female sexual presence. While Marin's images were repeatedly compared to spontaneous ejaculations, it is the world in general, and not the woman in particular, that supposedly serves as the stimulus for his pleasure and, ultimately, for his art. In Stieglitz circle discourses, Marin's responsive "partner" was not a woman but the canvas itself, or more often the sheet of Whatman paper. Its receptive sur-

face constituted the groundwork of Marin's creation as it recorded the artist's rapid and ecstatic merger with the world.

Thus Marin's paintings potentially offered an alternative yet complementary construction of heterosexual and aesthetic (pro)creativity to the works of Dove and O'Keeffe. While Dove's paintings were seen as examples of the artist's "penetration" and dissemination of himself into the natural world and O'Keeffe's were viewed as symbolic representations of a woman's intense embrace of the world through the incorporation of the other into the self, Marin's works were repeatedly described as a kind of spontaneous ejaculation, a state of excitement bordering on frenzy that was triggered by the artist's intense and uninhibited response to the world around him. The gendered critical commentary on the Stieglitz circle artists was also closely related to the media in which they painted. Both Dove and O'Keeffe worked in pastel and oil, dense substances that can approximate the fleshy substantiality of organic matter and configure that sensuousness into painting. Marin's watercolors, in contrast, were composed of washes and "stains," materials that were seen as literally and symbolically more "fluid." Moreover, the compositional structures of the artists' works were crucial in establishing such interpretations. Dove's and O'Keeffe's images were thought to replicate the dynamics of an actual physical union, since the viewer is presumably positioned "inside" the "body" of a Dove or O'Keeffe painting, engulfed by the apparent boundlessness of the experience. When engaging a work by Marin, the viewer is constantly looking through frames, passing over thresholds, and entering into liminal spaces. As a result, Marin's watercolors suggest not so much the stable materiality of the sensate body but rather the shifting, fleeting impressions that accompany intensely felt, lived experience. Yet Marin's paintings were seen as being of a piece with Stieglitz circle artworks, because the resonance between their corporeal and aesthetic structures was located not merely within the confines of an established iconographic repertoire but also within the larger relations between abstract form and the body itself, and hence in the fluid, interpenetrating spaces between vision and desire.

# Marsden Hartley and Charles Demuth

## The Edges of the Circle

For more than three decades, Georgia O'Keeffe, John Marin, and Arthur Dove represented the very center of Stieglitz's circle. Their artworks were regularly and prominently displayed in exhibitions that Stieglitz sponsored from the days of 291 through his activities at An American Place. In contrast, Marsden Hartley and Charles Demuth represented not the center but the edges of Stieglitz's project. Stieglitz had given Hartley his first solo exhibition at 291, and hence his introduction to the New York avant-garde, in May

of 1909. Their relationship would continue well into the 1930s as Hartley participated in both individual and group shows at The Intimate Gallery and An American Place. Demuth, on the other hand, only began to exhibit with Stieglitz in 1925, when he contributed four poster portraits to the "Alfred Stieglitz Presents Seven Americans" exhibition at the Anderson Galleries. Following this exhibition, Demuth would regularly show his paintings at Stieglitz's galleries until his own early death in 1935, after which he bequeathed all of his oil paintings to Georgia O'Keeffe, an artist to whom he was particularly close.[1]

Despite such personal friendships and overlapping exhibition histories, Demuth and Hartley remained on the margins of Stieglitz's group. Both artists were associated with the New York Dada movement as well as with the Stieglitz circle, and Demuth himself was especially close to Marcel Duchamp. Also, since Demuth was a watercolorist, Stieglitz may have perceived him to be a potential competitor of Marin's and thus may have been reluctant to exhibit Demuth's paintings regularly at his galleries.[2] Hartley for his part adopted working conditions that seemed to call into question his commitment to Stieglitz's American modernist project. Unlike Marin, Dove, and O'Keeffe, from the teens onward Hartley traveled extensively throughout the United States, Mexico, and Europe. As a result, a wide variety of geographic locations, artistic influences, and subject matter appeared in his paintings. The Stieglitz circle writers routinely interpreted Hartley's travels as a sign of the artist's own rootlessness, restlessness, and, more darkly, his personal sense of incompletion.

Not surprisingly, Demuth's and Hartley's peripheralization in the Stieglitz circle extended to the critical discourses on their paintings. Drawing selectively on the theories of Havelock Ellis and Sigmund Freud, the Stieglitz circle writers identified various characteristics of male effeminacy—sometimes naming these traits outright as attributes of homosexuality—in Demuth's and Hartley's artworks. Homosexual identity was characterized as an extreme form of self-absorption that prevented an individual from engaging beyond the boundaries of the self. This notion fostered a critical interpretation of Demuth's and Hartley's paintings as be-

ing artificial, overly refined, and autoreferential. As discussed in chapters 4 and 5, the Stieglitz critics repeatedly identified vital processes of self-renewal as being "transparently" evident in Marin's, Dove's, and O'Keeffe's paintings, either through the artists' dissemination of the self into the other or through the incorporation of the other into the self. In the critical writings on Hartley in particular, the artist's supposed inability to transgress the boundaries of the self signified a "difference" that the Stieglitz circle writers felt was transparently expressed in his paintings. Yet as Hartley's and Demuth's own self-representations suggest, such crucial aspects of identity were far from transparent in their artworks.

## Period Discourses on Sexual Inversion

The writings of Havelock Ellis and the psychoanalytic theories of Sigmund Freud provided the Stieglitz circle critics with a loose framework of terms and concepts that they could bring to the interpretation of Demuth's and Hartley's works.[3] While Freud's and Ellis's respective theorizations of the homosexual male contained significant differences, these distinctions tended to become elided in Stieglitz circle criticism. In his volume on "Sexual Inversion" (1910), Havelock Ellis brought numerous case histories and an extensive array of research to bear on his analysis of the "invert," a person in whom the "sexual instinct [is] turned by inborn constitutional abnormality toward persons of the same sex."[4] Ellis asserted that sexual inversion was primarily an innate characteristic, "a fundamental—usually, it is probable, inborn—perversion of the sexual instinct, rendering the individual organically abnormal."[5] Because Ellis viewed sexual inversion as a congenital condition but not a pathological one, he advocated that inversion not be prosecuted as a criminal activity or seen as an instance of degeneration or a "study of the morbid."[6] Furthermore, Ellis observed that sexual inversion has historically been associated with persons of exceptional ability, and is pronounced among artists and men of letters.[7]

Throughout his compendious study, Ellis repeatedly refer-
enced a common set of characteristics that he and others believed
to be associated with male homosexuals, including the traits of be-
ing sensitive, nervous, delicate, and "feminine."[8] As we shall see,
these terms would be applied both to Demuth and Hartley
throughout the teens and twenties. Ellis himself went so far as to
relate these personal characteristics to a penchant for theatrical-
ism: "The dramatic and artistic aptitudes of inverts are, therefore,
partly due to the circumstances of the invert's life, which render
him necessarily an actor . . . and partly, it is probable, to a con-
genital nervous predisposition allied to the predisposition to dra-
matic aptitude."[9] Ellis thus characterized the male invert's life as
an elaborate performance of identity, a concept that would res-
onate within Demuth's and Hartley's own self-representations.

Freud's theorizations of sexuality were also instrumental in
shaping the Stieglitz circle's discourses of embodied formalism.
Like Ellis, Freud distinguished between inversion and degenera-
tion, but he disputed the notion that inversion was an innate as op-
posed to an acquired tendency.[10] In *Three Essays on the Theory of
Sexuality* Freud posited that "inverts" proceed from a narcissistic
basis in their same-sex object choice. Thus Freud characterized
inversion as primarily a narcissistic structure in which individu-
als "take *themselves* as their sexual object," a formation that leads
that person to seek out as an object of desire someone who re-
sembles himself.[11]

Identifying the traces of Freud's and Ellis's theories in Stieg-
litz circle writings demonstrates how embodied formalist criticism
was a socially and culturally constructed phenomenon, particu-
larly in its naturalization and denaturalization of certain concep-
tions of sexuality. When applying these concepts to the visual arts,
Rosenfeld and others located Hartley's and Demuth's sexual and
aesthetic "difference," somewhat ironically, in their inability to
differentiate between dissimilar objects. As a consequence, their
works supposedly manifested a tendency toward uniformity and
self-referentiality. Rosenfeld put the matter quite bluntly in *Port
of New York*. According to the critic, not only has Hartley "not
been able to lose himself in his 'object,'" but his art "stresses in

what he shapes the sexual interests of the mind." Thus "the large cucumbers, bananas, pears, goblets, lilies, and rubber plants in his compositions, [were] chosen doubtlessly because of a physical resemblance to the painter himself to express his ego."[12] According to Rosenfeld, such an autoreferential structure at once constituted the basis of Hartley's uniqueness and marked the limitations of his artistic practice.

## Sad Blossoms and Morbid Beauty: Critical Constructions of Hartley

From the outset, Hartley struck Rosenfeld as a gifted but problematic figure, and the critic expressed a consistently ambivalent response to Hartley's art. While Rosenfeld often voiced his admiration for Hartley's paintings, his praise had from the first a wry tinge that foreshadowed much of his subsequent commentary. In October of 1920 Rosenfeld told Stieglitz that he saw "a very interesting Hartley" at Charles Daniel's gallery: "It is a sort of plant with El Greco shadows, and looks like Marsden on the cross waiting for Djuna Barnes to drive in the last nail."[13] Clever and cutting, Rosenfeld's remark alludes to Hartley's alleged romance with the writer Djuna Barnes.[14] Yet Rosenfeld's comment was more perceptive than he may have realized. The poignant image of Hartley as a crucified figure tormented by a possible lover suggests the themes of suffering, pain, and mysticism that were in fact leitmotifs in Hartley's paintings, poems, and general construction of himself.

When Rosenfeld began to assemble his own personal art collection in 1920, Hartley presented the critic with three of his New Mexico canvases for consideration. In a subsequent letter to Stieglitz, Rosenfeld recorded his ambivalent response to the paintings: "I feel mixed wonder and loathing; wonder for the art, loathing for something I sense in it. I admire the work immensely, know it is superb and unique, but don't quite know whether I can manage to live with it. It is really charnel-house; a bestial and over-refined appetite without pity, without love, without joy, with-

out hope. And yet it is, I believe, a marvelous piece of invention."[15] As this letter suggests, Rosenfeld's own mixed sense of "wonder and loathing" underpinned his contradictory response to Hartley's paintings, works he found to be bestial yet overly refined, superb yet unbearable. Clearly, Rosenfeld's difficulty with Hartley's paintings stemmed from his inability to separate the artist's personal character from that of his artwork. For his own part, Stieglitz encouraged Rosenfeld in such readings. In his response to Rosenfeld's letter, Stieglitz assured the critic, "Of course all H[artley]'s pictures are autobiographical to a very great degree."[16]

When Rosenfeld purchased one of Hartley's calla lily paintings in September of 1921, his feelings about the acquisition were profoundly mixed. Rosenfeld told Stieglitz that, although he considered the work to be one of the finest in his collection, he found the painting to be abject and disruptive. As Rosenfeld put it shortly after the work arrived at his home in Westport, Connecticut, "The big Hartley lily [was] screeching and flapping its devilish wings like a fiend on a holiday."[17] Hartley did seem to merge religious and corporeal references in his paintings of lilies. In *Tinseled Flowers* (1917, fig. 6.1), for example, Hartley depicts a single white calla lily emerging from a pink, chalicelike vase. The painting's stark black and yellow background heightens the iconic appearance of the lily. A pointed green hood surrounds the flower, while a thick yellow pistil covered with red specks pokes out from its center. Hartley's dramatic presentation gives the flower a monumental, ornamental, and even creaturely appearance.

Rosenfeld perceived a number of interrelated meanings in Hartley's calla lilies, not the least of which were sadness and death: "With the chill of death on its breath it murmurs in the funeral black folds amid which sad blossoms and broken chalices are set, in the morbid beauty of languorous white callas."[18] While Rosenfeld's description of Hartley's "regal white lily with its wickedly horned leaves"[19] was clearly melodramatic, his reference to fantastic floral imagery was a well-established signifier of male homosexuality in symbolist and decadent literature. For example, writing in Stieglitz's own magazine, *291*, in 1915, Marius

**6.1** Marsden Hartley, *Tinseled Flowers,*
1917. Tempera, silver foil, and gold foil
on glass, 16 ⅞ × 9 ¼ in. (42.9 × 23.5 cm).
Museum of Fine Arts, Boston, Gift of the
William H. Lane Foundation, 1990.413.
Courtesy Museum of Fine Arts, Boston.
Reproduced with permission. ©1999 Mu-
seum of Fine Arts, Boston. All rights re-
served.

de Zayas had characterized American artists as "cold blooded an-
imals" who have "the mentality of homosexuals, they are flowers
of artificial breeding."[20] Thus in his discussion of Hartley, Rosen-
feld drew freely on a literary tradition that associated homosexu-
ality with religion, artifice, and death.[21]

Rosenfeld himself acknowledged the role that psychoanalytic
theory had played in shaping his interpretation of Hartley. During
the summer of 1921, as he was preparing the *Dial* essay on Amer-
ican painting as well as a review of Hartley's book *Adventures in
the Arts* (1921) for publication in *The Bookman*, Rosenfeld
confided to Stieglitz that he feared he was doing Hartley an injus-
tice.[22] In particular, Rosenfeld admitted that his interpretation of
Hartley's paintings had been influenced by his psychological the-
ory of the artist.[23] When later reworking the *Dial* and *Bookman*
pieces for publication in *Port of New York*, Rosenfeld told Stieglitz
that he was not pleased with the Hartley essay and that he would
do it differently if he had it to do again.[24] In response, Stieglitz
specifically instructed Rosenfeld not to rewrite the Hartley essay,
assuring him that Hartley was satisfied with it and that Stieglitz
himself thought it had a particular freshness.[25] These comments
suggest Stieglitz's own ambivalent feelings about Hartley, as both
man and artist.

In *Port of New York* Rosenfeld characterized Hartley's artis-
tic subject matter as exemplifying the artist's particular vision of
the world. When discussing Hartley's paintings of *Pears* (1911,
fig. 6.2), three examples of which Rosenfeld himself owned, the
critic wrote: "And so, in the paintings of Hartley, these great dark
pears, for instance, bedded upon hospital-white linen on a back-
ground of severe dry black, are both the magnificent fruits shown
against ascetic noble stuffs, and the entire world as a certain grim
experience of life has proven it to the painter. In their doubleness,
they satisfy the entire organism."[26] Rosenfeld similarly character-
ized Hartley's New Mexico landscapes as displaying an aestheti-
cized yet relentless sterility. As Rosenfeld put it: "And New
Mexico, with its strange depraved topography: earth-forms fitting
into each other like coupling organs; strawberry-pink mountains
dotted by fuzzy poison-green shrubs, recalling breasts and wombs

**6.2** Marsden Hartley, *Pears*, 1911. Oil on wood, 16 × 12 ½ in. Collection Frederick R. Weisman Art Museum at the University of Minnesota, Minneapolis. Bequest of Hudson Walker from the Ione and Hudson Walker Collection.

of clay; clouds like sky-sailing featherbeds; boneyard aridity, is in [Hartley's] pastels and the oils done in the southwest."[27]

Although lurid, Rosenfeld's description of Hartley's New Mexico work is not entirely inaccurate. While the landscapes are not overtly figural, Hartley does seem to have embedded certain fleshlike elements in their topography. For example, the row of foreground boulders in *Landscape, New Mexico* (1919–1920, fig. 6.3) loosely resembles a series of nude torsos viewed from the rear. The rocks appear to be quasi-symbolic units heavily modeled in high-value flesh tones. This effect evokes the residual presence of the human figure in the landscape. Yet at issue in Rosen-

**6.3** Marsden Hartley, *Landscape, New Mexico,* 1919–1920. Oil on canvas, 28 × 36 in. (71.1 × 91.4 cm). Collection of Whitney Museum of American Art, New York. Purchase, with funds from Frances and Sydney Lewis.

feld's commentary is not simply his pointing out an embodied presence in Hartley's landscape forms, or his identifying a grim magnificence in Hartley's pears, but his gendered coding of Hartley's artistic output in general. Unlike the "fertile" and "generative" qualities that Rosenfeld and others perceived in Marin's, Dove's, and O'Keeffe's landscapes, Hartley's canvases were seen instead as grave and morbid, albeit aesthetically powerful, variations on the embodied formalist theme.

As he had with the other Stieglitz circle artists, Rosenfeld located gender and sexuality not merely within Hartley's iconography but also within the abstract formal structures of Hartley's

paintings. In particular, Rosenfeld identified a pervasive homo-
geneity in Hartley's treatment of color, form, and perspective that
led the artist to impose an artificial similarity on otherwise dis-
similar objects. As Rosenfeld put it, Hartley "seems to find plea-
sure in recording the analogies between objects and colorations
superficially very dissimilar. Things apparently singular in shape
and hue, will be approached to each other, and shown of a fam-
ily. The broad defined color areas found in so much of modern
painting appear in Hartley; but instead of being used in a sort
of powerful clash, a powerful play of elemental forces, they
will be approached and delicately worked into one another."[28]
Thus Rosenfeld perceived Hartley as making legitimately strong
contrasts seem "delicate" and analogous, a propensity that
contributed to the general effects of homogeneousness and
unnaturalness that threaded through his artworks. Furthermore,
because Hartley's canvases acknowledged the flatness of their
surfaces, they seemed too willing to accept the conventions of
their own artificiality. Rosenfeld wrote that, instead of actively en-
gaging with life itself, Hartley's canvases were hermetically self-
contained: "On the materials of the exterior cosmos he establishes
a little sealed world declarative of his own inward human order."[29]

The full extent to which Hartley's works were constructed in
opposition to those of his fellow Stieglitz circle artists becomes
clear when *Port of New York* is viewed as a whole. As was his prac-
tice, Rosenfeld interpreted the artists' choice and treatment of
subject matter, along with the disposition of their paint structures,
as indices of their own gendered identity. When contrasting the
formal tendencies of Hartley's and O'Keeffe's artworks, Rosenfeld
observed: "[Hartley] is utterly opposed, for example, to Georgia
O'Keeffe, who seems to feel instinctively the mutual resistances,
the stubborn opposition of forms and things entirely to each other,
and to achieve her composition through a juxtaposition of con-
trasting color-areas, a sort of counterpoint of exclusive and resis-
tant forces. Hartley, in forgoing this sort of primitive robustious
clash, gets a sort of intricacy and refinement of effect characteris-
tic of the work of advanced, Alexandrian civilizations."[30] Thus
while O'Keeffe's compositions were guided by powerful counter-

rhythms of opposing forces, Hartley's works displayed an intricate homogeneousness and a pervasive sense of uniformity. And while O'Keeffe's "primitive," robust art implicitly signified the passion and the promise of a vital new America, Hartley's "Alexandrian" paintings were seen as artificial and passé, a veritable artifact of a dead civilization.

Rosenfeld's descriptions also helped to differentiate Hartley's art from Marin's. Unlike the strength and vitality that Marin purportedly derived from Maine, Hartley's alleged overrefinement and narrowness were attributed to his own New England upbringing. Rosenfeld drew on images of nature and fertility to cast Hartley's regional identity in explicitly sexual terms. He asserted that the Yankee has separated himself from the vitality of the soil; he "has always ravished the earth" since "there has been no love in his intercourse with it."[31] As both "Yankee" and "Alexandrian," Hartley was described as an artist who considered himself too refined to merge with the soil, with his painted subjects, or with another human being. According to Rosenfeld, the inevitable result was anachronism and sterility.

Rosenfeld was not alone in characterizing Hartley's works as weary, enervated, and dandified. As early as 1921 Herbert J. Seligmann had presented a similar, if more discreetly worded, assessment of Hartley's career in *International Studio.* Echoing Havelock Ellis, Seligmann characterized Hartley's art as elegant, sensitive, and cultivated, yet disillusioned, spiritually restless, and fundamentally "incomplete." Seligmann also described Hartley's paintings as reflections of the artist's own character, the products of an "obstreperous, dejected, attitudinous, New Englander, but keen and avid for the fine touch."[32] The reviews of the "Alfred Stieglitz Presents Seven Americans" exhibition (1925) reflected similar interpretive tendencies. The critic Deogh Fulton described Hartley's pictures as mannered, posturing, and dandified.[33] Edmund Wilson found Hartley's paintings to be imbued with the artist's own "characteristic sullen felicity."[34] And Henry McBride asserted that Hartley's works required elegant surroundings since "they are old world, old souled, and awfully fatigued."[35]

In 1927 Frank Jewett Mather, Jr., concurred with Rosenfeld that Hartley's "restless versatility" was an impediment to his own artistic success, thus making Hartley "a capital example of the uprooted painter."[36] Extending these themes in 1930, Samuel M. Kootz wrote that Hartley's paintings were typically "mincing, dainty canvasses that are experienced through shopworn eyes." While many of Hartley's works exhibited quality and taste, Kootz felt that "their complete lack of any originality, their measured emotions and unfortunate elegance leave a decided want."[37] Steeped in this "unfortunate elegance," Hartley's works were seen by Kootz as lacking in original generative power, a judgment that entwined the artist's own questionable masculinity with his compromised aesthetic potency.

## Hartley's Counterconstruction I: "The Importance of Being Dada"

Despite the shortcomings that critics perceived in his paintings, Hartley nevertheless occupied an important position in the Stieglitz group. For Stieglitz and his critics, Hartley was a "distinguished," "sensitive," and "refined" member of their circle, an elegant craftsman who was at once a part of the group yet remained apart from them. Hartley was one of the original "seven Americans" whose work Stieglitz devoted himself to championing at The Intimate Gallery and An American Place.[38] Hartley was both physically and symbolically present at Stieglitz's comeback exhibition at the Anderson Galleries (February 1921), which included two portraits of Hartley from 1915 that contributed to representing "The Days of '291.'"

Yet Hartley was also straddling the philosophical and aesthetic positions of the Stieglitz and Dada groups. While the Stieglitz circle writers typically associated the "intellectualism" of the New York Dada movement with foreignness and compromised sexual expression, Hartley had embraced Dada's sense of intellectual detachment and cosmopolitanism as a welcome alternative to the Stieglitz circle's overly personal themes of sexual and

aesthetic "transparency." Thus while Rosenfeld considered Hartley's uniform treatment of objects to be a serious shortcoming, Hartley had deliberately adopted this artistic method in order to showcase his "intellectual" approach to painting while distancing himself from "emotional" content. In November of 1920 Hartley gave a lecture at the Société Anonyme, the modern art museum recently founded by Duchamp, Man Ray, and Katherine Dreier, in which he emphasized the importance of a unified imaging system in painting: "The experience which the painter presents is his personal appreciation of his object, but he should not translate that appreciation into purely personal terms but should make it the penetrating understanding of the object itself. His experience of the object he will get from his sensations of colour and line but he will in painting it synthesize his sensations into one impression according to his own system. That system, while personal, should not be swayed merely by his mood but should be controlled by his intellectual interest in the thing for painting is essentially intellectual."[39]

Hartley's emphasis on the artist's "intellect," like his participation in Dada events such as lectures at the Société Anonyme, signaled his affiliation with the New York Dada movement.[40] Hartley himself chose an essay entitled "The Importance of Being Dada" as an afterward to his collection of essays *Adventures in the Arts* (1921). In this piece Hartley discussed his shift from expressionism to Dadaism, a movement that he considered to be "the latest phase of modernism in painting as well as in literature."[41] In 1928 Hartley extended his critique of emotionalism in expressionist discourses and characterized aesthetics as an intellectual undertaking. He wrote, "I have joined, once and for all, the ranks of the intellectual experimentalists. I can hardly bear the sound of the words 'expressionism,' 'emotionalism,' 'personality,' and such, because they imply the wish to express personal life, and I prefer to have no personal life."[42] While Hartley's engagement with Dadaism and his disavowal of the personal may seem puzzling, these statements become comprehensible in light of the fact that Hartley had a personal life that he was unable to express openly. With Dada's characteristic iconoclasm and critique of an authen-

tic self, the movement offered what must have seemed to Hartley like a "readymade" (if temporary) safe haven from the Stieglitz circle's persistent emphasis on the most intimate aspects of the self.

## Hartley's Counterconstruction II: The "Return of the Native"

Hartley's affiliation with the New York Dada movement constituted only one of his strategies of self-representation. Another was his emphasis on his own Americanness, on being "the painter from Maine." However convenient a reference point Hartley may have been for the Stieglitz circle critics during the twenties, by the early thirties the artist attempted to reverse the stereotypes of effeminacy, expatriotism, and incompletion that had come to be associated with his work.[43] Hartley returned to New England and actively began to paint and write poetry. One of his poems, "Return of the Native," was published as a foreword to his 1932 exhibition at the Downtown Gallery, "Pictures of New England by a New Englander." In this poem Hartley described his art as strong, solid, and, like the New England landscape itself, resistant to adversity. He wrote that by returning to New England and reestablishing a connection to his native environment, he hoped to make "what was broken, whole."[44] As these phrases suggest, during the thirties Hartley attempted to alter the perceptions of cosmopolitanism and fragmentation (or "brokenness") that had come to be associated with his previous style of modernism. Yet since the underlying formal structures of Hartley's paintings themselves remained basically unchanged, these developments suggest a counterconstruction that was inherently word-driven.

Along these lines, "The Subject of Nativeness—A Tribute to Maine" comprised the theme of Hartley's 1937 exhibition at An American Place. In the catalogue accompanying this show, Hartley reiterated his personal connection to Maine, noting that "nativeness is built on such primitive things, and whatever is one's nativeness, one holds and never loses no matter how far afield the traveling may be. . . . The quality of nativeness is colored by her-

itage, birth, and environment, and it is therefore for this reason that I wish to declare myself the painter from Maine."[45] Borrowing a familiar Stieglitz circle tactic, Hartley wrote that his landscapes and still lifes should be read as "portraits of objects," and implicitly, as symbols of himself. Furthermore, he wished that self to be seen as firmly grounded in the New England soil. In a letter to Stieglitz written in November of 1937 Hartley emphasized, "My return to my native state was one of the best things I ever did to myself, and I was sure it would be, and one knows such things not by the mind, but by the more primitive means of the senses, as one really knows most things. I have never seen or known my native state as well as I do now."[46] Despite his professed attachment to New England, Hartley continued to roam during the thirties, spending time in Mexico, Germany, Bermuda, and Nova Scotia. And by roaming, Hartley was able to keep returning home.

Central to Hartley's reinterpretation of himself was his rejection of intellectualism and his emphases on "coming home" and on "wholeness." In his published statements Hartley seemed to be encouraging critics to perceive the nativeness, granite strength, and naturalness of his paintings. In part, he got what he wanted. After years of financial struggle Hartley finally realized a fair degree of commercial success and professional recognition. At the same time, critics started describing Hartley's paintings in terms typically associated with Marin's work rather than his own. For example, in 1940 *Artnews* published a review entitled "The Virile Paintings by Marsden Hartley." The article stated that "Marsden Hartley's masculine, well-designed bluntness is the note at present pervading the galleries of Hudson Walker. All strength and sinew, uncompromising and a bit crusty, are these paintings."[47]

Hartley's reinvention of himself almost worked—but not quite. Hartley died on September 2, 1943. Two weeks later Paul Rosenfeld published a memorial essay in *The Nation* in which he recapitulated the substance of his previous critique of Hartley under the guise of a eulogy. In a characteristically backhanded fashion, Rosenfeld called Hartley "an extraordinary, an almost gigantic secondary artist." Rosenfeld added that, had his work

been more inclusive and consecutive, "he might easily have become a major one." Rosenfeld praised Hartley's talent, imagination, and refinement, but he persisted in reading the paintings as dandified, grandiose, "almost diabolical," and markedly autoreferential. Rosenfeld summed it up by saying that "his life really had no center outside himself." Even Hartley's late Maine works were reinscribed with associations of death: "Contact with his natal soil doubtless also facilitated the expression of his life long and mystical sense of death."[48] In other words, nothing had changed, at least not for Rosenfeld.

Rosenfeld was not the only critic to express such opinions. Jerome Mellquist, another writer closely associated with Stieglitz during the forties, had published a similar assessment of Hartley's career in *The Commonweal*. Mellquist wrote that, for all of Hartley's pose of being fashionable and dandified, the artist was essentially aloof, alone, and tormented to the point of being periodically suicidal. Like Rosenfeld, Mellquist emphasized Hartley's inconsistent flashes of greatness. Mellquist concluded that, while Hartley's works were often "pretentious" and "utiliz[ed] a speech not entirely his own . . . he certainly will be remembered as a spirit who, withstanding all vexations, sometimes attained the upper air."[49]

## Sustained Tragedies, Portraits of Friends

Rosenfeld and Mellquist had made some accurate observations in their otherwise ambivalent reviews of Hartley's career. Death and mysticism were leitmotifs in some of Hartley's most profound and moving paintings, which include memorials to other men as well as a very revealing and disturbing self-portrait.[50] For Hartley, paying homage to the dead was central to the processes of self-expression and of "coming home." As he wrote in his autobiography, *Somehow a Past*, for him "home" meant Berlin and Maine.[51]

Hartley first visited Berlin in May of 1913. With the exception of a four-month return to the United States, the artist re-

**6.4** Marsden Hartley, *Portrait of a German Officer,* 1914. Oil on canvas, 68 ¼ × 41 ⅜ in. (173 × 104 cm). The Metropolitan Museum of Art, Alfred Stieglitz Collection, 1949.

mained in Germany until December of 1915. When Hartley first exhibited at 291 the group of images that he had painted in Berlin, including the symbolic portrait of his dead friend and possible lover, the Prussian officer Karl von Freyburg (1914, fig. 6.4), the artist distanced himself from any emotional interpretation of his paintings, and he publicly denied that the works contained any personal symbolism whatsoever. Hartley was emphatic on this point in the statement that he wrote to accompany his 1916 exhibition. Regarding what he called his "Germanic group" of paintings, Hartley claimed, "The forms are only those which I have observed casually from day to day. There is no hidden symbolism whatsoever in them; there is no slight intention of that anywhere. Things under observation, just pictures of any day, any hour. I have expressed only what I have seen. They are merely consultations of the eye—in no sense [a] problem; my notion of the purely pictural."[52]

On the face of it, Hartley's disavowal of any "hidden symbolism" might be taken to mean that the artist did not want his Amer-

**6.5** Lee Simonson, *Caricature of Marsden Hartley,* 1913. Watercolor on paper, 17 × 11 in. Yale Collection of American Literature, Beinecke Rare Book and Manuscript Library.

ican audience to believe that his paintings expressed an affinity
for Germany, a country with which the United States was experi-
encing growing tensions and would soon enter into war. Yet Hart-
ley's emphasis on his own disinterested observation belies his
personal attachment to the German military in general and his
friendship with von Freyburg in particular. These affiliations are
merely hinted at in the original title of Hartley's *Portrait of a Ger-
man Officer,* which was *Portrait of My Friend.*[53] Hartley was more
forthcoming about his private experiences in other written state-
ments. Shortly after he had arrived in Berlin, Hartley told Stieglitz
that the new developments in his painting represented deeply
personal, even spiritual, experiences. Hartley informed Stieglitz
that, in Berlin, the image of the "soldier triangle" was very real to
him, and that the developments in his art constituted "a natural
evolution because new phases of my life are a natural evolution—
I cannot talk of them because they are too intimate & personal—
they have to do with religious attitudes—attitudes only to be sure
not convictions, for I believe nothing except that I believe all
things, are good & bad false & true for somebody."[54] Twenty years
later, when recalling his experiences in prewar Berlin, Hartley
further described the sexual tensions that had shaped his paint-
ings: "It was of course the age of iron—of blood and iron, every
back bone in Germany was made of it—or had new iron poured
into it—the whole scene was fairly bursting with organized energy
and the tension was terrific and somehow most voluptuous in the
feeling of power—a sexual immensity even in it—when passion
rises to the full and something must happen to quiet it."[55]

   While Hartley's later autobiographical account is candid in
its sensuous immediacy, his 1916 catalogue statement is deliber-
ately evasive. Nonetheless, critics were quick to look beyond
Hartley's rhetoric of disavowal. In the New York press Charles H.
Caffin and Robert J. Cole identified romanticized emblems of
chivalry and heraldry in Hartley's paintings. More suggestively,
Henry McBride noted that "all the pomp and circumstance of
war" were so clearly manifested in Hartley's works that "even a
Philadelphian could make [them] out. But as to the exact episode
or emotion that the artist portrays there will be less certainty, al-

though Mr. Hartley says he has expressed only what he saw during his travels in Germany."[56]

During the teens Hartley's enthusiasm for the German military was the subject of a caricature by Lee Simonson (1913, fig. 6.5). Simonson depicts Hartley in a German military uniform holding a flag that is loosely decorated in expressionist style. On this work Simonson printed the caption "Marsden adopts Germany!" Hartley is presented in a mannered pose with pointing toes, a dangling pinky, and exaggerated musculature. While Hartley's Germanic affiliations were thus open to parody, the artist's own pro-German stance found a degree of sympathy with Stieglitz himself.[57] Stieglitz's commitment to maintaining a posture of internationalism at 291 proved to be a source of friction during the First World War. As the photographer remembered, "Much of the enthusiasm that had existed at 291 gradually disappeared because of the war. Close friends seemed to fall by the wayside. I could not turn 291 into a political institution, nor could I see Germany as all wrong and the Allies as all right. The work going on at the gallery, I felt, was universal."[58]

*Portrait of a German Officer* is one of Hartley's best-known paintings, painted after Karl von Freyburg was killed in action during the Great War. Almost a quarter of a century later Hartley painted another such memorial to a man who was dear to him and who had died at sea, the Nova Scotia fisherman Alty Mason.[59] This image is mythically entitled *Adelard the Drowned, Master of the "Phantom"* (c. 1938–1939, fig. 6.6). Contemporary with the latter painting is a self-portrait that Hartley cryptically but meaningfully entitled *Sustained Comedy—Portrait of an Object* (1939, plate 7, fig. 6.7).[60]

In *Portrait of a German Officer* Hartley built a quasi-anthropomorphic image from bold layers of seemingly collaged forms. While Hartley's composition recalls flat pattern cubism, his dramatic colors suggest a German expressionist palette. Some of the objects in the portrait, such as flags and medals, are recognizable attributes of the German military. Others seem to be more abstractly pictorial. Yet taken together, the elements combine to create the monumental presence of the "German Officer." In con-

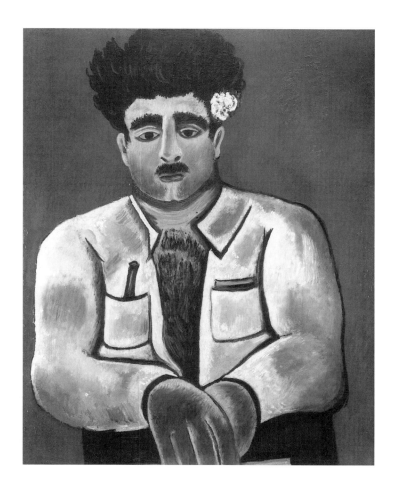

**6.6** Marsden Hartley, *Adelard the Drowned, Master of the "Phantom,"* c. 1938–1939. Oil on academy board, 28 × 22 in. Collection Frederick R. Weisman Art Museum at the University of Minnesota, Minneapolis. Bequest of Hudson Walker from the Ione and Hudson Walker Collection.

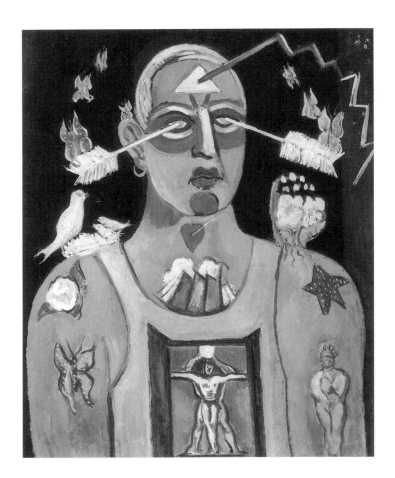

**6.7** Marsden Hartley, *The Sustained Comedy (Portrait of an Object)*, 1939. Oil on board, 28 ⅛ × 22 in. (71.4 × 55.9 cm). Carnegie Museum of Art, Pittsburgh; Gift of Mervin Jules in memory of Hudson Walker.

trast to this enigmatic assemblage, Hartley took a more directly figural approach to his portrait of Alty Mason. Mason is presented with his hair standing on end, his hands clasped in front of him, and a flower tucked behind one ear.[61] Despite the differences between the two paintings and the circumstances surrounding their production, in both works Hartley seems to be creating highly condensed images that take separation as their theme. Both compositions are vertical, frontal, and strongly keyed to saturated areas of red and black. In these works Hartley undertakes an elaborate veiling, layering, and masking of identity.[62] In the process, he achieves a formal and emotional density that makes the Stieglitz circle's notion of subjective and aesthetic transparency seem particularly ironic.

A month after von Freyburg's 1914 death Hartley was still grieving. He told Stieglitz that he wanted "to be an Indian—to paint my face with the symbols of that race I adore[,] go to the west & face the sun forever—that would seem the true expression of human dignity."[63] Hartley seems to have carried out his intention twenty-five years later in his own masklike self-portrait. Like *Adelard the Drowned*, Hartley presents himself through a frontal figural image. And like the early von Freyburg portrait, Hartley's *Sustained Comedy* is strongly emblematic. As Jonathan Weinberg has observed, "What we are shown ostensibly is a young sailor wearing a gold earring and covered with tattoos of a rose, butterfly, stars, and a sinking ship. He wears a tank top with the curious image of a man holding a globe over the head of the crucified Christ. There is a mask over the eyes of the portrait—not unlike the kind that Hartley had described wearing during the Berlin costume ball—but the openings for the eyes are punctured with arrows."[64] Through an open red patch just below his chin, Hartley literally presents himself with his "heart in his throat." Just below this "heart" appears the top of a ship with upright sails flanked by an ominous pair of clouds. This symbol possibly refers to another "Hart," Hart Crane, the poet whose suicide by drowning Hartley commemorated in his painting *Eight Bells Folly: Memorial for Hart Crane* (1933). As Weinberg has remarked, "The sinking ship on the sailor's shoulder [sic] recalls *Eight Bells Folly* and Crane's

death; the rose on his shoulder and the Christ figure recall the various paintings associated with the Mason family. The form of the painting, with a single figure placed in the center against a dark background, over which the various symbols are collaged, is a reprise of the war motif series."[65] Through these typological conflations, Hartley seems to be suggesting the great potential of man *and* the great suffering he must endure. Significantly, both themes are expressed through the exposed flesh of the male body as a site of idealization and sacrifice.

In *Sustained Comedy* Hartley seems to be playing on the conventions of sexual and sacred imagery in order to emphasize the ambivalence of his own self-representation. In its flat, frontal character and in the "primitive" treatment of the figure, Hartley's self-portrait recalls the Santo paintings of the American Southwest and Mexico, a region with which Hartley was extremely familiar.[66] As Susan Elizabeth Ryan has noted, ritual figures with pierced eyes are common in Mexican devotional imagery. Ryan reads Hartley's self-representation as "a picture of ritual blinding," one that engages a dynamic between the artist's likeness and his blindness, between presence and absence, between self-creation and self-annihilation.[67] Much like Santo imagery, a strong element of sadomasochism floats through the painting as the arrows both "blind" and "penetrate" the figure.[68] One slender white shaft pierces the "heart" in Hartley's throat. Although a jolting depiction of violence to the body, this blend of aggression and eroticism is not unprecedented in Hartley's oeuvre but generally characterizes his fascination with and aestheticization of the German military. Thus in *Sustained Comedy* Hartley paints himself in the same condition as his friends—a "stilled life" (a "portrait of an object") that continues to pulse with its own inner vitality.[69]

In making these connections, Hartley literally "wears" the symbols of von Freyburg, Mason, and possibly Crane on his own body, while the surfaces of his "body" and of his canvas become synonymous through the painting's subtitle, "Portrait of an Object." Another such layering of meanings is suggested by the fact that Hartley equated the death of von Freyburg with the loss of Mason. More than a month after Mason's death, Hartley expressed

his feelings for the two men in a letter to his friend Arnold Rön-
nebeck: "I am all but heartbroken . . . I haven't felt anything like
it since the death of Karl von F[reyburg]"[70] Hartley appears to
have condensed his feelings for the two men with his own self-
portrait; yet he did much more than superimpose their presences
atop his own. He painted, and hence symbolically "incorporated,"
Mason and von Freyburg into himself. In so doing, Hartley pro-
duced dense artworks that provide a view into his intensely felt (if
relatively short-lived) relationships with Mason and von Frey-
burg, associations that spanned time and place, desire and loss,
only to become fixed in the opaque yet interpenetrating structures
of Hartley's canvases.

However private or tacit an expression *Sustained Comedy*
may be, Hartley's painting exemplifies precisely the opposite ten-
dencies of exclusiveness and self-absorption that contemporary
critics attributed to his works. While as a self-portrait the paint-
ing is necessarily self-referential, and while death is a leitmotif in
the work, this combination of imagery issued not from Hartley's
apartness or his self-containment but from a deeply felt bond with
others. As I have noted, in the catalogue that accompanied his
1937 exhibition at An American Place, Hartley had advocated
that his images of his native Maine be read as "portraits of ob-
jects." This interchange between the portrait and the object, be-
tween the intrinsic and the extrinsic, the self and the other,
becomes revisited in the subtitle and imagery of Hartley's own
self-portrait, "Portrait of an Object." In this work Hartley did
nothing less than collapse the boundaries between subjectivity
and intersubjectivity to position himself on the painterly thresh-
old of a loss and a joining.

## Charles Demuth's "Queer Elegance"

Charles Demuth was an even more marginal figure in the Stieglitz
group than Hartley. As with Hartley, critics often attached gen-
dered connotations to Demuth's paintings, typically finding his
works excessively refined and predictably effeminate, if not nec-

essarily "homosexual." In 1917 Willard Huntington Wright wrote that Demuth's "water-colours possess a delicacy of colour, a nervousness, a lightness, and occasionally a sensitivity of line. . . . The unfortunate thing about Demuth's work is that it reveals in the artist a contentment with his tricks and mannerisms and a lack of striving for more solid and masculine attributes."[71] Paraphrasing Havelock Ellis's terminology, Wright characterized Demuth's paintings as "sensitive," "nervous," "delicate," and if not overtly "feminine," than insufficiently "solid" and "masculine."

Wright was not alone in ascribing such dubiously gendered characteristics to Demuth's paintings. Two years later the artist and critic Guy Pène du Bois described Demuth's art as overrefined, precious, and unhealthy. Du Bois wrote that Demuth "hints timidly at the sensuous luxuriance of nature. His temper is meticulously refined; its estheticism verges on aridity, but it is not arid. It wants health above everything, but given health would it also have this tremendous sensitiveness?"[72] In du Bois's analysis, Demuth's "sensitiveness" is at once suggestive of his pathology and of the aesthete's questionable masculinity.

In 1921 Rosenfeld similarly remarked on the "infallible taste, daintiness of touch, [and] distinction of conception" displayed in Demuth's paintings.[73] Yet the critic associated these traits with cowardice and femininity. As Rosenfeld observed, "Always, [Demuth's] work has airiness, daintiness, charm. Only, the artist appears to be a trifle too much the Gentlemanly Johnny of his profession. The polite demeanor of his craft, the preciousness, the parnassian jewellery, are they not a little the cowl of fear? Demuth seems obliged to candy and beribbon everything a little before he can quite bring himself to the point of facing it. There is always the suspicion of an almost feminine refinement in his wash."[74]

Despite this initial critique, Rosenfeld's views of Demuth broadened considerably over the years with the artist's later, albeit partial, acceptance in the Stieglitz circle. While he did not include a "portrait" of Demuth in *Port of New York*, in 1931 Rosenfeld published a monographic essay on the artist in *The Nation*. At this late date (Demuth died only four years later) Rosenfeld as-

serted that Demuth's artworks met the all-important criteria of be-
ing able to engage beyond a single impulse. As Rosenfeld ob-
served, "All [Demuth's] paintings proper contain effective,
original antitheses of shape and color and line and texture, and the
oppositions are never conventional or weak. The antithetical ele-
ments are boldly conceived and extremely heterogeneous." Yet
Rosenfeld persisted in reading Demuth's paintings as "dainty,"
"precious," and informed by a "queer elegance": "What one saw
was all refined, distilled, tempered, scrupulous. The phrase 'the
gentlemanly Johnny of American painting' returned almost com-
pulsively as one stood amidst [the Demuth exhibition]." At the
same time, Rosenfeld acknowledged that, "for all their delicacy,
the forms are tense, stripped, and steely. They are spontaneous
creations, not induced and artificial things: they have roots be-
neath them. And they bring one into relation with life, with Amer-
ican life in particular." As in his dealings with Hartley, Rosenfeld
emphasized the morbid and erotic aspects of Demuth's paintings:
"Doubtless there is a decided note of morbidity in Demuth, an ex-
pression of the lure and perfection of death; it appears very obvi-
ously in the illustrations to the stories of Henry James. There is
also a certain nervous erotic suffusion in his paintings of wharves
and chimneys: the blush and incandescence of things severe, an-
gular, unyielding, and instantaneously charged by the incalcu-
lable ecstasy."[75]

In part, Rosenfeld's essay reiterated tropes that had come to
be associated with Demuth's work throughout the twenties. For
example, in February of 1922 the novelist Carl Van Vechten com-
mented on the "perverse" undertones of Demuth's paintings. Van
Vechten wrote, "How beautiful and how terrible the flowers:
daisies with cabalistic secrets, cyclamens rosy with vice, orchids
wet with the mystery of the Rosicrucians! And the acrobats, the
jugglers, and the clowns all contribute their share to the glory of
this perverse genius, a genius which would be recognized at once
at full-value in Germany or France."[76] While Van Vechten located
Demuth's "perverse genius" in his iconography, the critic and
collector A. E. Gallatin perceived personal characteristics in
Demuth's formal practice itself. In his book *American Water-*

*Colourists* (1922), Gallatin noted that "Demuth's talent is confined within very definite limits; his drawings are always conspicuous for their perfect taste and a certain daintiness which amounts at times almost to fastidiousness."[77] Similarly, Frank Jewett Mather, Jr., remarked on the "delicately intellectual vein" that threads through Demuth's paintings.[78] In 1930 Samuel M. Kootz placed a positive emphasis on these traits in Demuth's work: "Some of the fastidiousness of Watteau and Fragonard is in [Demuth's] painting, for these elegants helped form Demuth's taste, but never to such an extent that his canvases are over-refined. The elegance that is Demuth's is compounded of well-bred, civilized ideas realized plastically. Severity, urbanity, freshness, what-ever the picture demands, Demuth furnishes."[79]

This collective critical emphasis on Demuth's elegance, intellect, and effeminacy made him an effective point of contrast for Marin. Because of their shared high status as watercolorists, critics often compared the two. When reviewing Demuth's debut exhibition at the Daniel Gallery in 1914, Henry McBride wrote that the principal question surrounding Demuth would be, "Is he sufficiently different from Marin?"[80] That question would eventually be answered definitively. In 1926 Louis Kalonyme distinguished Marin and Demuth on the basis of a gendered aesthetic. Kalonyme wrote: "Where Marin is always visibly working up to a pregnant climax, Demuth begins beyond the realm of climax. The birth pains of creation are never visible in his work. Moreover, he is casual, something Marin never is. He is gay and serene and quiet. He would, I suspect, consider it vulgar to be or even to seem active in his affirmations. For his is a self-contained, almost passive, music."[81] In Kalonyme's account, Marin's works are associated with generativity and climax, while Demuth's art is "self-contained" and "almost passive." Five years later Rosenfeld contrasted the spontaneous discharges of Marin's paint handling with Demuth's more meticulous and controlled flows. Rosenfeld wrote that "Demuth's watercolor is not the free-running wash of John Marin, for example, but watercolor carefully blotted and wiped."[82] Thus while Marin's paint flows are seen as streaming forth in an uninhibited manner, Demuth's painterly impulses are

discreetly reigned in, with the artist himself careful to wipe up any excess spillage.

In 1926 Henry McBride discussed the two painters in equally provocative terms. When reviewing an exhibition of Demuth's work at The Intimate Gallery, McBride noted that "the submerged, inner life of Marin revolts at science and fights it. But the science that kills Marin keeps Demuth alive. Demuth chants the Hymn Intellectual, as Walt Whitman would say."[83] By contrasting Demuth's "intellectual" paintings with Marin's more "passionate" and "tempestuous" ones, McBride reiterated the contrasting tropes of Marin's uninhibited spontaneity and Demuth's more careful, intellectually oriented approach to painting. The following year A. E. Gallatin articulated precisely this distinction in his monograph on Demuth, noting that "Marin and Demuth, the most important figures in contemporary American painting, have evolved their forms in altogether different manners. Their temperaments differ as much as do the results of their investigations. Marin's water-colours are at times as lyrical as the poetry of Shelley, at other times they are dynamic in pent-up energy. They have been washed-in rapidly in the white heat of inspiration. Demuth's drawings are always most carefully and beautifully organized. He has aimed at perfection, which usually he has obtained."[84]

Thus critics routinely drew on notions of embodiment and subjectivity to differentiate Demuth's and Marin's aesthetic practices. As we have seen, Marin's lush and often dense watercolors were thought to offer their audiences direct access to the artist's own physical impulses and an authentic view through Marin's eyes, a construction of intersubjective "transparency" that became expressed through the artist's elaborate use of window and framing devices. Meanwhile Demuth's watercolors, for all of their material lightness and actual painterly transparency, tended to be conceptually dense and interpretively elusive. As a result, his works often seem mobile, unfixed, and anything but "transparent."

Yet while critics persistently contrasted the two artists, Demuth himself expressed unreserved admiration for both Marin and his work. On February 8, 1922, Demuth commented to Gallatin, after the collector had acquired some of his own paintings:

"It was nice to know that my two water-colours which you now own, will be with the Marins,—Marin, whom I think the greatest water-colourist of our time."[85] The following year Demuth generously tried to persuade the Philadelphia collector Albert Barnes to purchase some of Marin's sea pictures, which Demuth considered to be "the only really great marines since Courbet."[86] In 1927 and again in 1929, Demuth purchased Marin's watercolors for his own personal collection, paintings that he hung prominently in his home in Lancaster, Pennsylvania.[87]

## Posters at an Exhibition

When Stieglitz held the "Alfred Stieglitz Presents Seven Americans" exhibition in 1925, he invited Demuth to contribute four colorful, boldly designed, poster-size works, images which Demuth called "poster portraits." Three of the paintings were portraits of Dove, Hartley, and O'Keeffe (fig. 6.8), while a fourth image represented either John Marin or the painter Charles Duncan.[88] Demuth's portraits were based not on direct likenesses of his subjects, but were indirect statements expressed through arrangements of symbolic objects.[89] As in Stieglitz circle criticism, in these paintings Demuth embedded attributes of human identity in highly suggestive landscape and still life forms.

Viewed as a coherent project, Demuth's posters arguably represented his most earnest appeal for inclusion in Stieglitz's circle and acceptance on Stieglitz's established terms. Demuth had begun to associate his own artistic project with Stieglitz as early as 1921.[90] In a letter to the photographer written that November, just after he had returned from Paris, Demuth informed Stieglitz of the activities of several European artists, including "Marcel, dear Marcel." Yet Demuth went on to reaffirm his own commitment to working in America: "What work I do will be done here; terrible as it is to work in this 'our land of the free.'" Demuth concluded his letter by positioning himself within Stieglitz's artistic project, saying, "We will talk it out together, soon. I could write a book about it, of course, but, all that is left of my energy, I suspect, had

better go into painting! Together we will add to the American
scene, more than has been added since the [18]60's and 70's,—
maybe more than they added. I feel that all together we are more
or less fine."[91]

The personal correspondence that Demuth and Stieglitz ex-
changed during the early twenties suggests several important
points regarding their relationship. On a practical level, Demuth
wished to be part of Stieglitz's group, and he sought the photogra-
pher's advice regarding the pricing and handling of his work.[92] Yet
as the preceding letter suggests, Demuth also professed a deep
commitment to Stieglitz's project of producing American mod-
ernist artworks that could be viable alongside their European
counterparts, and even pledged to work in the United States in or-
der to achieve this goal.

Throughout the twenties Demuth's and Stieglitz's relations
grew steadily closer. Dorothy Norman recorded that "Stieglitz ad-
mired Charles Demuth's paintings from the moment he first saw
them during the 291 period."[93] By early 1923 Stieglitz informed
Demuth of his desire to acquire one of Demuth's watercolors. The
artist warmly responded: "I'm glad you want the egg plant.—I

**6.8** Charles Demuth, *Poster Portrait:
O'Keeffe,* 1923–1924. Poster paint on
pressed-paper board, 20 ½ × 16 ½ in.
(52 × 41.9 cm). Gift of Georgia O'Keeffe
to the Yale Collection of American Litera-
ture, Beinecke Rare Book and Manuscript
Library. Courtesy of the Demuth Founda-
tion, Lancaster, PA.

kept it here; it turned into a heart;—maybe mine; any way I hope no one will discover 'art' or 'painting' engraved on it."[94] Later that spring Stieglitz included a portrait of Demuth (as well as one of Duchamp) in his photographic exhibition at the Anderson Galleries.[95] The following summer Demuth was self-consciously positioning his poster portraits within Stieglitz's larger vision of American modernism. In a letter to the photographer dated July 7, 1924, Demuth told Stieglitz that he wanted to finish the posters and compare them to the essays and photographs in Rosenfeld's then newly published *Port of New York*.[96] Yet Demuth's choice of subjects for his first group of posters suggests his dual affiliations between the Stieglitz and Dada groups. Early in 1924, at the same time he was painting his posters of Dove and O'Keeffe, Demuth told Stieglitz that he was also working on a poster of "Marcel."[97] A few years later Stieglitz sent Demuth a photograph of Duchamp, which Demuth hung in his bedroom along with works by Marin and O'Keeffe.[98] This seemingly incongruous mixture of personal associations and artistic influences helps to account for Stieglitz's inclusion *and* marginalization of Demuth in his project. To a greater degree than the other painters, Demuth kept his identity sufficiently loose and mobile to make certain that he couldn't be pinned down to any single aesthetic position. As discussed in detail below, in both his personal relationships and the conceptual and gender ambiguities that characterize his works, Demuth seemed to float between various options and to destabilize the traditional signifiers of identity without necessarily subverting them.[99] In his poster portraits, for example, Demuth combined Dadaesque "intellectualism," with its complex symbolism and detached, cerebral humor, with the material sensuousness and self-consciously "American" iconography that characterized Stieglitz circle images themselves.

Stieglitz's hanging of Demuth's posters at the "Seven Americans" exhibition provides an especially revealing glimpse into the ways in which the photographer constituted his circle vis-à-vis the Dada movement. Just as Demuth's undertaking the poster portraits indicates his desire to be included finally in Stieglitz's circle, the physical placement of these objects in the gallery and

the critical reception they garnered attest to his more marginal position. Demuth's four paintings were hung at the entrance of the first gallery of the "Seven Americans" exhibition. While they were the first works visitors encountered, they remained separate from the rest of the show and effectively functioned as something like elaborate advertisements (literally posters) for the main exhibition.[100]

In the end, the hanging of the poster portraits suggests that Stieglitz used Demuth to introduce and advertise the artists of his inner circle while implicitly inscribing, if not a history, then a trajectory of American modernism. Stieglitz positioned Demuth's works (and by implication, New York Dada) as a kind of precursor to the celebrated version of American modernism exemplified by the artworks of the other six "Americans," including of course the photographer himself. As this arrangement so clearly revealed, the public identities of *all* of the artists reflected their degree of intimacy with the true "center" of the circle, Alfred Stieglitz.

## Demuth's Mobility of Self-Representation

As Demuth's poster portraits, vaudeville images, and book illustrations suggest, the artist often depicted his subjects using symbolic iconography and subtle modes of disclosure that stood in opposition to the Stieglitz circle's emphasis on aesthetic and gendered "transparency." In the circus and vaudeville works in particular, Demuth seems to experiment with various configurations of identity and relationality. In the watercolor *Vaudeville* (1917, fig. 6.9), for example, Demuth depicts three dancing figures, including a surprised woman on the right, a solicitous sailor on the left, and between them a man who is literally caught in the middle. While the woman looks back over her right shoulder, the sailor taps the central man's right shoulder, attempting to lead him off in "another direction." The three figures display similar poses, with crossed legs and extended right arms that stretch laterally across the surface of the drawing. Yet their left hands break the symmetry of the composition, establishing the scene as a competing play

**6.9** Charles Demuth, *Vaudeville*, 1917. Watercolor and pencil, 8 × 10 ½ in. (20.3 × 29.2 cm). The Museum of Modern Art, New York. Katharine Cornell Fund. Photograph ©2000 The Museum of Modern Art, New York. Courtesy of the Demuth Foundation, Lancaster, PA.

of difference. The woman's left hand seems at once to propel herself and the man forward and to push the intruding presence away. In contrast, the sailor's left arm curls sinuously downward, his fingers tapering inward to point to his own genital area. Both of the flanking figures gaze directly at the central man, establishing him as their shared object of desire. The tension between these figures is underscored by the animated gray and olive green background, presumably that of the stage curtain, which contains writhing lines moving in divergent directions. As this vaudeville scene suggests, in Demuth's compositions elements of the humorous and the playful are often balanced against the aesthetically charged and sexually unsettled aspects of the paintings. In this manner, Demuth's works seem less to enact a single identity than to comment provocatively on various possible configurations of desire and identification.

Like Hartley, Demuth often chose to depict himself through an elaborate play of disguises, affiliations and identities. While Hartley consolidated his personal and fictional narratives within the formal structures of his paintings, Demuth's works seem to exemplify his ability to incorporate himself and others into various imaginative contexts and relational possibilities. For example, in 1918 Demuth painted an image depicting what is most likely a homosexual encounter between a group of nude men in a bathhouse. Included in this work is a mustached figure who resembles the artist himself (fig. 6.10).[101] This scene may have been inspired by the Lafayette Baths, then one of New York City's most popular bathhouses. The Lafayette Baths was in fact so renowned a meeting place for homosexuals that it was raided (and finally closed) by the police in 1929.[102] Regarding such institutions, George Chauncey has written, "The safest, most enduring, and one of the most affirmative of the settings in which gay men gathered in the first half of the twentieth century was the baths."[103] Why in particular were these places so important for Demuth and others? As Chauncey has observed, unlike most social spaces "which negated the body and homosexual desire, the baths affirmed them."[104] In various ways *Turkish Bath* can be seen as an affirmation of Demuth's identity through convergent expressions of sexuality and aesthetics. Much like the sailor in *Vaudeville*, Demuth portrays himself with his left arm hanging down and his fingers tapering inward toward the lower portion of his body. Demuth's right arm, in contrast, remains concealed by the toweled figure: Could it, one wonders, be touching the shoulder of the nude man to the artist's right? While the physical disposition of the bodies remains unclear, within their concealment lies at least the possibility of intimate contact.

As an image of concealment *and* of disclosure, Demuth's self-affirmation in *Turkish Bath* was not completely unqualified. As Jonathan Weinberg has pointed out, a pronounced element of hiding is associated with this image. Weinberg has interpreted the foreground figure garbed in a towel standing opposite Demuth as "spectral," "a figure of death" who symbolizes the necessary "hiding" associated with homosexual desire.[105] Much like Hartley's

**6.10** Charles Demuth, *Turkish Bath,* 1918. Watercolor, 11 × 8 ½ in. Private collection. Photograph courtesy of Kennedy Galleries, New York. Courtesy of the Demuth Foundation, Lancaster, PA.

**6.11** Charles Demuth, *Turkish Bath,* c. 1915. Watercolor and pencil on paper, 10 ⅞ × 8 ⁷⁄₁₆ in. Yale University Art Gallery; gift of George Hopper Fitch. Courtesy of the Demuth Foundation, Lancaster, PA.

self-portrait, the history of this work also suggests the private na-
ture of Demuth's self-representation. *Turkish Bath* was never pub-
licly exhibited during the artist's lifetime. Weinberg has noted
that during the 1930s Demuth gave *Turkish Bath* to his friend Dar-
rell Larsen, who "supposedly kept the picture in a closet because
he felt its subject was too explicit for mixed company."[106]

Thus *Turkish Bath* remains highly ambivalent due to its con-
tradictory elements of frankness and camouflage. While Demuth
placed a recognizable nude self-portrait in sexually explicit sur-
roundings, the artist did not actually risk exposure since the work
was, one suspects, intended to be kept in a closet. The pictorial
evolution of the image is also quite suggestive. In a study for this
work now at the Yale University Art Gallery (c. 1915, fig. 6.11)
Demuth paints a dark, seated figure crouching at the side of the
drawing. In the later version of *Turkish Bath*, this figure is re-
placed by two pairs of nude men who engage in various homosex-
ual activities.[107] Significantly, in the transition from the study to
the finished painting, the appearance of the background men and
of a recognizable self-portrait coincides with the disappearance of
the dark, shadowy figure lurking at the margins. While this devel-
opment indicates a certain incisive boldness in Demuth's self-
representation, it nonetheless remains a private gesture that could
only be recognized by a very limited audience.

Like *Turkish Bath*, *At a House in Harley Street* (1918, plate 8,
fig. 6.12), the first of five illustrations that Demuth produced for
Henry James's novelette *The Turn of the Screw*, is probably an-
other unnamed self-portrait.[108] This painting's ambiguous, highly
encoded character makes it consistent with the James story from
which it derives. The image's deliberately enigmatic quality can
perhaps be attributed to the fact that, unlike *Turkish Bath*, De-
muth produced this work for a public audience.[109] Even so, the
early exhibition history of Demuth's illustrations suggests that
they fell just outside the bounds of public propriety. Henry
McBride reports that Charles Daniel, Demuth's first dealer, did
not hang Demuth's figural works in his gallery due to their slightly
risqué nature. Instead, Daniel showed the paintings surrepti-
tiously to interested parties.[110]

**6.12** Charles Demuth, *At a House in Harley Street:* illustration for the novel *The Turn of the Screw* by Henry James, 1918. Watercolor and pencil on paper, 8 × 11 in. (20.3 × 27.9 cm). The Museum of Modern Art, New York. Gift of Abby Aldrich Rockefeller. Photograph ©2000 The Museum of Modern Art, New York. Courtesy of the Demuth Foundation, Lancaster, PA.

Contemporary critics often commented on the appeal that Henry James's works held for Demuth.[111] Rosenfeld remarked that Demuth's "James illustrations give mordantly the atmosphere of Puritan refinement."[112] McBride, who knew Demuth well, said of the drawings for *The Turn of the Screw* that "no hint of reproach could be attached to them. A very faint tinge of evil, perhaps. Naturally we got that idea. We were not so obtuse in Lancaster, Pa., but that we recognized that Charles was playing with fire. But the aura of Henry James glossed all that over. A Henry James evil could not possibly bear any slightest resemblance to a Toulouse-

Lautrec evil. It was, one might say—and in these modern days is so more than ever—a highly respectable evil."[113] In another context McBride recalled that Demuth "had an unholy delight in toying with the danger" that he perceived in modernist literature, since "any undue frankness such as that to be encountered in the novels of Henry James, or even in those of Zola, might 'shatter the atom' and blow us all to smithereens."[114] As McBride's comments suggest, Demuth seemed to take great pleasure in his ability to maneuver between dramatic counterpoints. This was no less the case in the modernist literature that he chose to illustrate than in the artist's own lifestyle, which alternated between a sheltered existence at his family home in Lancaster and the bohemian activities that Demuth indulged in during his frequent forays to New York and elsewhere. Hartley, who was a close friend of Demuth's during these years, recalled the experiences the two men enjoyed together and how these impressions affected Demuth's art:

Charles liked being in on these parties, those tiger-like stalkings after amusement down the courses of the night, he like being swept into atmospheres and getting his own funny kick out of them, and they were big ideas and issues for Charles, bringing some of the best of his work out of him, and I am sure he gave them far-reaching importance by virtue of the fact that his imagination was essentially of the spiral variety.

Charles was doing somewhere about this time the series of witty water colours of acrobats, sailors in wild pursuit, ladies in quest of submarine favours, motives which I always felt ended too soon, as they brought so much of the fun out of him, and from these he veered over to Henry James's Turn of the Screw, which fine drawings did as much probably as any of his efforts to establish him in his place in the prevailing art history of America.[115]

Hartley summed up the artist's mobile self-positioning by noting that Demuth "was not strictly speaking, flaneur, but he liked the picture of life which such a position offered."

Like *Turkish Bath, At a House in Harley Street* displays the artist's ability to pivot between different modes of self-representation. In this work Demuth places himself in the fic-

tional guise of the wealthy uncle who contracts the services of the governess.[116] Not unlike Demuth himself, James's character is a charming and fashionable man and a "bachelor" in the prime of life. In both the James story and the watercolor illustrations, Demuth/the uncle places himself at the center of the composition and presides over an ambiguous scene.[117] Although this figure makes only a cameo appearance at the beginning of the narrative, he exerts his presence throughout the story without obviously appearing to do so. Demuth's self-portrait likewise conflates seemingly opposing characteristics as the artist positions himself as at once central and marginal to the story.

In this watercolor Demuth seems to be offering a humorous yet formally and psychologically intense interpretation of James's text. In the story, the residence at Harley Street is described as imposing and opulent, "a big house filled with the spoils of travel and the trophies of the chase."[118] In Demuth's painting, a pair of moose's heads hang over the mantelpiece. One stares directly out at the spectator, while the other glances inquisitively at its partner. Similarly, the governess herself seems to sprout curious, antlerlike forms that rise from the top of her hat. These hornlike forms can be seen as indicative of a subtext of sexual dysfunction on the governess's part, which would account for her preoccupation with the ghost of Peter Quint and her obsessive behavior toward the children.[119] It is precisely this combination of uncertainty, humor, and psychological complexity that makes the watercolor consistent with Demuth's oeuvre and such a provocative "portrait" of Demuth himself.

In both James's text and Demuth's image, the meeting of the patron and the prospective governess is a highly charged encounter. In the watercolor the man appears to be touching the upper part of the governess' foreshortened body, yet the precise nature of their contact remains uncertain (they do not appear to be shaking hands.) Demuth further unsettles the work by combining a writhing mass of jagged pencil underdrawing with densely mottled red and black washes. Mirroring James's nuanced manner of expression, Demuth strategically works the absorptiveness of the paper and the fluidity of the paint to build a provocatively un-

stable atmosphere, one that makes the drawing appear richly am-
biguous. As McBride once observed, "Like James, [Demuth] has
given just the necessary hint as to the facts of the case, relying
rather on atmospheric envelopes of thought and feeling."[120] Simi-
larly, the critic Angela E. Hagen noted in *Creative Art* (1931) that,
in Demuth's illustrations of Henry James, "the drama of the situ-
ations lies not in the attitudes or gestures of these people, but in
the complexities of thought and emotion that seem in the calligra-
phy of the fine drawing with which the washes are combined, ac-
tually to live and weave through space, from person to person."[121]
The critics thus recognized, in the James illustrations, Demuth's
characteristic ability to maneuver between allusive and highly
charged counterpoints.

A final example of Demuth's ability to pivot between different
forms of self-representation can be found in his watercolor *The
Purple Pup* (1918, fig. 6.13). This painting was named after a tea
room located in Washington Square, in the heart of New York's
Greenwich Village. Along with restaurants like the Mad Hatter
and the Samovar, the Purple Pup was a spot frequented by various
members of the New York avant-garde, including Demuth him-
self. This watercolor is presented from the vantage point of some-
one who has just entered the room. The viewer's gaze bounces
from table to table as the faces of the seated people provide focal
points in an atmosphere that ripples with dense currents of smoke
and conversation. Clusters of figures emerge from Demuth's
configurations of spiky pencil lines and interwoven patches of wa-
tercolor wash. The moment itself, like Demuth's painting, appears
colorful, animated, and highly ephemeral.

In *The Purple Pup* Demuth provides not only an insider's view
of Greenwich Village at the height of its activity, but, I would ar-
gue, another very revealing self-portrait.[122] A tall, dark-haired
figure stands by a pole near the foreground table. He looks down
at the room, taking everything in while remaining slightly apart
from the conversations taking place around him. This figure not
only resembles Demuth physically; he *behaves* like Demuth. As
Hartley recalled, Demuth possessed a flaneur's sensibility and
was known for his "many little bits of fun and droll waggery."[123] In

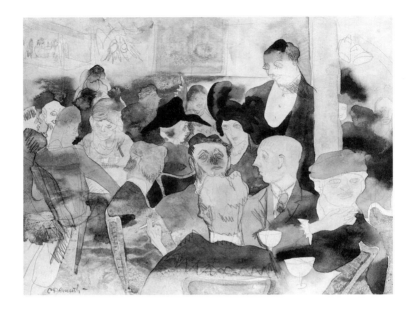

**6.13** Charles Demuth, *The Purple Pup,* c. 1918. Watercolor over graphite on paper, 8 ⅛ × 10 ⅞ in. (20.5 × 26.5 cm). Museum of Fine Arts, Boston. The Hayden Collection, 62.324. Courtesy Museum of Fine Arts, Boston. Reproduced with permission. ©1999 Museum of Fine Arts, Boston. All rights reserved. Courtesy of the Demuth Foundation, Lancaster, PA.

this watercolor the standing figure's cool, detached expression conceals his amusement, as peeking out from the opposite side of the pole is a smiling jester's head. While the figure indulges in a slight smile, Demuth himself seems to be laughing (as a doubled image) through the figure of the jester. By playfully but overtly acknowledging his role as a sort of "puppet master," Demuth presents an image that self-consciously alludes to its own status as a representation. In so doing, Demuth appears to be at once "inside" the drawing as a character in the scene and "outside" of it as an artist commenting humorously on the possibilities of representation. Significantly, in all three self-portraits Demuth seems

to adopt a decidedly "decentered" perspective. That is, through his own shifting and contingent self-positionings, Demuth's works appear to be meditations on interiority and exteriority, on the status of being both an "insider" and an "outsider," a liminal position much like the one that he actually occupied in the Stieglitz circle.

While Demuth's and Hartley's careers in the Stieglitz circle were marked by dynamics of marginality and centrality, their artworks seem to have been informed by their various personal affiliations and adjacency to a number of artistic movements. In both cases, these dynamics were a long way from the reductive charges of autoreferentiality, predictable transparency, and the inability to engage beyond the boundaries of the self that marked period discourses on homosexuality. In fact, the limitations of the Stieglitz circle's embodied formalist model are perhaps most clearly demonstrated by the group's most marginal members. As we have seen, the Stieglitz circle's privileged conception of heterosexual identity was based on the notion that the artist was able to transcend the boundaries of his or her own gendered body in order to merge with an "other." The supposed result was a stable and coherent synthesis of oppositions that could be expressed "transparently" within the formal structures of paintings. In contrast, Demuth's and Hartley's representations tend to fuse the positions of "inside" and "outside" in a complex, often elusive, play of disclosure and concealment. In playing along this interpretive edge, Demuth's and Hartley's artworks seem to offer provocative commentaries on the fragile boundary between the self's "truths" and its "fictions."

Part III

Contests and Counterdiscourses,
circa 1930–1950

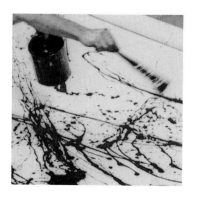

# Modernism's Masculine Subjects

Alfred Stieglitz versus Thomas Hart Benton

In honor of his seventieth birthday, Alfred Stieglitz's followers as-
sembled a volume entitled *America & Alfred Stieglitz: A Collective
Portrait* (1934).[1] Intended as a "composite portrait" of the pho-
tographer, the book was a compilation of essays, poems, and more
than 100 illustrations of the European and American modernist
artworks that Stieglitz had exhibited at 291, as well as recent
paintings and photographs by the Stieglitz circle artists. While its
themes were not new, *America & Alfred Stieglitz* represented

much more than a testimonial to Stieglitz's past accomplishments. The volume was an assertion of the photographer's *living* presence, and as such it was a confirmation that the project that Stieglitz had begun several decades ago at 291 still continued at his present gallery, An American Place.[2]

In the introduction to the volume the editors, who included Paul Rosenfeld, Waldo Frank, Lewis Mumford, Dorothy Norman, and the educator Harold Rugg, reiterated themes that had been prominent in Stieglitz circle discourses over the past decades. Emphasizing the links between nationalism and spirituality, they asserted that Stieglitz's "life has been an incarnation, singularly perfect, of the struggle toward truth, an incarnation indeed, in humble modern form, of Man . . . and in American terms and on American soil."[3] With over twenty contributors and a lavish array of illustrations, *America & Alfred Stieglitz* embodies the ways in which a group of artists, writers, and even a particular trajectory of American modernism were collectively portrayed as an extension of Stieglitz's own public identity, a direct expression of the photographer's life and career.

Although the Literary Guild named *America & Alfred Stieglitz* as its December selection, the book received only mixed notices.[4] Many critics were put off by the unrestrained adulation of Stieglitz's admirers coupled with the opaque and often mystical tenor of their writings. By the time Stieglitz had reached the age of seventy, he had accumulated not only a devoted group of followers but a vociferous contingent of adversaries. The publication of *America & Alfred Stieglitz* provided the latter with a prime opportunity to settle old scores while reaffirming their own positions at Stieglitz's expense.

While a number of New York critics took jabs at the book, the most overtly polemical response came from the American regionalist painter Thomas Hart Benton. In his review in *Common Sense,* Benton characterized Stieglitz circle writings as nothing other than "the offensive pretensions and petty snobberies of the self-elected elite."[5] Benton described Stieglitz himself as a boundlessly egotistical faux mystic who convinced his disciples that he had single-handedly discovered the expressive power of art, reli-

gion, and sexuality. As Benton put it: "When Stieglitz aims his camera at a young woman's backside it is as if he had *discovered* for the first time in history that a young woman's backside *is* attractive. He believes so sincerely in the exalted character of his contacts that he has escaped the necessity, which weighs so heavily on his literary followers, of defining and judging things. The fact that he, Stieglitz, has seen, serves both for definition and judgment."[6]

Benton further parodied the sexual tenor of the Stieglitz circle's discourses when he characterized the photographer and his critics as engaged in a form of intellectual masturbation that made them unfit for life itself: "This man and his confreres are like boys addicted to bad habits whose imaginative constructions have so defined the qualities of 'life' that they are impotent before the fact."[7] Emphasizing his firsthand knowledge of both Stieglitz and the art that hung in his galleries, Benton wrote that *America & Alfred Stieglitz* is "a collection of tributes to a man whose influence, once potent in the field of American art, is now dead. Stieglitz had an effective place in the days when the 'modern movement' held its illusory promise of achievement through 'mood cultivation,' when painters believed they could safely abandon representation for what has turned out to be an empty purity. Those days are past: the flow of American Art has run toward a socially and environmentally conditioned expression. It has forgotten them."[8] Benton's statements reveal his own implicit desire to place his "socially and environmentally conditioned" (i.e., regionalist) paintings above the "empty purity" of the Stieglitz circle's abstracted modern works. As we shall see, Stieglitz's and Benton's deepest and most long-standing disagreements centered on precisely the issue of whether artistic "potency" could be most fully realized through the abstraction or through the literal representation of the American subject.

Not surprisingly, Benton's statements in *Common Sense* struck a nerve. Stieglitz was a master at psychological battles, and his private response to Benton reveals him at the very top of his form. Stieglitz told Benton, "ye gods didn't I chuckle as I read for I shared the good time you had while writing it. In short I shared

your own chuckle. Six columns, long columns, of scintillating brilliancy. Contortions similar to those in your paintings & murals." Stieglitz then noted that the article took him back to the old days at 291 when he listened patiently to the young artist's "cocksure diatribes on art" and his pleas to have his works shown at the gallery, despite the fact that they never quite fit in there: "You placed me in an embarrassing position for I liked you personally as I still do. I understood your desperate position & your ambitions." Having plunged in the knife, Stieglitz proceeded to twist it: "As for my being dead in your esteem, I rather enjoy the idea. As a matter of fact I was always dead in your estimation even when you tried so hard & so often to persuade me how important it was for you—& so for '291'—to show your things at that place." Stieglitz concluded by calling Benton's review "a most revealing self-portrait," thus reducing the mature and successful Benton to a dejected young bully who betrayed his own shortcomings in his attacks on others.[9] Notably, Stieglitz's comments to Benton would have been devastating if they had appeared in print. Yet by engaging Benton directly through the medium of private correspondence, Stieglitz was preserving an ambivalent personal bond with the artist even as he was chastising him.

Benton responded immediately to Stieglitz's letter. He told the photographer that he wrote what he did because Stieglitz and his followers were "just in the way." Benton denied ever having asked Stieglitz for a show at 291, and he agreed that his paintings didn't belong there because they were based on life itself and not on empty literary theories. As Benton put it: "I'll let the literary gigolos do the 'thinking' if I can keep tangled up in situations. I'm an American and when I have a theory, its [sic] a tool and not a God. You ask old Marin about this. And tell him for me, that he also was just in the way and that, even though I do think I make better pictures than he does, I'm his friend and salute him. One brother to another in the stew."[10] Still unable to let the notion of "the literary gigolos" or of his own "death" pass, Stieglitz wrote to Benton the following day. The photographer adamantly denied that he was responsible for the publication of *America & Alfred Stieglitz* or that his days in the New York art world were over. As

he told Benton, "I have lived life much more than you have any idea of, and I am still very alive in spite of your thinking the contrary."[11]

As the fraught yet somehow familiar tenor of this exchange suggests, Benton's and Stieglitz's argument had been staged for quite some time. Since the late teens the two had experienced an intensely conflicted relationship, the details of which are discussed below. Why then did their rhetoric become so heated in late 1934 and early 1935? Primarily because both artists had much to gain from their sustained patterns of confrontation. During the thirties the regionalists and the Stieglitz group each claimed to be the "true" representatives of American identity. Throughout the decade the Stieglitz circle became officially recognized as leading practitioners of modern art by institutions such as the Museum of Modern Art, yet they also faced increasingly conservative cultural attitudes and even outright hostility toward modernism. It was in this social and cultural ambiance that the regionalists rose to prominence. Benton in particular received wide popular support for his "regionalist" depictions of American subjects. Yet Benton's notion of regionalism was itself problematic, given the highly uniform and excessively mannered character of his ostensibly heterogeneous regional subjects. In short, both the Stieglitz circle and the regionalists faced considerable success and significant challenges throughout the thirties. In this competitive atmosphere, the two groups interacted with one another almost symbiotically to sustain and corroborate their respective discourses on the body. Through their almost histrionic confrontations, aesthetics became staged as a contest of masculinity, a competition in which Stieglitz and Benton each attempted to ensure the "life" of their respective artistic projects by periodically declaring the "impotence," insufficiency, and "death" of the other.

Stieglitz's final rebuttal of Benton took the form of an imaginary dialogue that Dorothy Norman published in the magazine *The Art of Today* (February 1935). In Norman's article Stieglitz stated that Benton's "stupid" and "unfounded" attack was an example of "the increasing gangsterism in what is called the art

world." Still unable to dismiss the notion of his own "death," Stieglitz emphasized the agency of his living presence. As he put it, "the real joke of the matter is, that these people who are so cock-sure that I am dead, don't even come up here to see what is actually taking place. After all, I am still a pretty live corpse."[12]

## Stieglitz and Benton: A History of Conflict

Not surprisingly, a long and troubled personal history underlay Benton's desire to declare Stieglitz's "death" and deny him his "potency." Yet Benton himself was never actually a member of the Stieglitz circle. During the early part of his career Benton was associated with the painters Morgan Russell and Stanton Macdonald-Wright, brother of the critic Willard Huntington Wright. Together these figures developed a mode of painting known as synchromism. Named for the analogy between music and color relationships, synchromism was the American equivalent of orphic cubism. In their aesthetic theory, the synchromists conceived of movement as a displacement of volumes and a juxtaposition of colors in which rhythmic organization was related to the positions and poses of the human body. The body, in turn, became constituted abstractly in synchromist painting through conglomerations of modulated color. The synchromists were particularly fascinated by Michelangelo's artworks, which they felt were unparalleled representations of the distribution of volume, weight, and balance to convey the emotional and physical states of the body.[13]

Benton's *Figure Organization No. 3* (1915–1916, fig. 7.1) exemplifies the synchromists' characteristic engagement with Michelangelo's representations of the heroic male figure.[14] In this work, carefully structured tonal rhythms are derived from underlying sculptural forms. While the human figure tends to be buried in the paintings of Russell and Macdonald-Wright, the body remains a more literal presence in Benton's images. Well after the synchromist elements drop out of Benton's paintings, the Michelangelesque treatment of the human figure continues to be a distinguishing characteristic of his artworks.[15]

**7.1** Thomas Hart Benton, *Figure Organi-
zation No. 3*, c. 1915–1916. Oil on can-
vas, now lost. Reprinted from *The Forum
Exhibition of Modern American Painters*
(1916). Courtesy of the Brown University
Library.

Stieglitz exhibited Macdonald-Wright's paintings at 291 in
1916 and 1917 and at An American Place during the autumn of
1932. During the late teens Stieglitz reportedly remarked that
Macdonald-Wright's paintings and Georgia O'Keeffe's images
represented the masculine and feminine sides of a new art.[16]
Notwithstanding their mutual engagement with abstraction and
embodied form, the synchromists' works differed significantly
from those of the Stieglitz circle. While the Stieglitz circle tended
to project corporeal and emotional meanings onto the abstracted
surfaces of their largely nonfigural paintings, the synchromists
took actual and sculptural bodies as points of departure for their
experiments in chromatic abstraction. During the later teens and
twenties the literalization of the body would become a pronounced

tendency in Benton's works as he made the transition from synchromism to regionalism. Meanwhile, the Stieglitz circle critics would become increasingly preoccupied with the notion of gendered abstractions, or the presence of nonbodily bodies, in their group's nonfigural paintings.

Benton had exhibited *Figure Organization No. 3* at the 1916 "Forum Exhibition of Modern American Painters," a show of American modernist artworks that was jointly organized by Stieglitz and Willard Huntington Wright.[17] Several of the Forum participants, including Macdonald-Wright, Marin, and Hartley, were given one-man exhibitions at 291 during the teens. Benton, however, was never invited to show his paintings at the gallery. Shortly after the opening of Macdonald-Wright's one-man show in 1917, Benton told the art critic and social reformer John Weischel that, while Macdonald-Wright "seems to be quite in vogue" at Stieglitz's place, the photographer had "no use" for his own paintings. Piqued by Stieglitz's judgmental attitude, Benton commented that "Stieglitz, beyond a pleasant enough exterior for everyone, has respect only for those who care enough for him personally to tolerate his loquacity. I can't listen to him and am quite naturally not well-received by his group. Stieglitz takes it upon himself to judge the value of all art which is especially irritating to me as he knows nothing about what I myself am trying to do."[18]

Benton's irritation with Stieglitz only increased during the twenties. The next major confrontation came in December of 1921, when Paul Rosenfeld's essay on "American Painting" appeared in the *Dial*.[19] Rosenfeld had written that, despite Benton's having attained "a great dignity and fullness of form," his paintings appeared uncoordinated and sluggish. More pointedly, the critic attributed the problematic aspects of Benton's figures to the inadequacy of the artist's own physical prowess. As Rosenfeld put it: "The bodies of [Benton's] bathers themselves want the powerful grip and handling; have something unleavened in them. At first, all Benton's figures seem Michel Angelesque. Later, one is not sure what it is they have under their clothes. They do protest too much. It is as though the artist himself were not using his body properly."[20] Implicit in Rosenfeld's comments is a sense of Ben-

ton's own compromised virility, one that stemmed from the artist's weak-wristedness, or his want of "powerful grip and handling." As we have seen, Rosenfeld perceived precisely the opposite characteristics in Stieglitz circle artworks, as for example when he wrote that Arthur Dove's paintings were produced through "a tremendous muscular tension," one which demonstrated that "male vitality is being released."[21]

Shortly after the publication of Rosenfeld's article, Benton wrote to Stieglitz. He was particularly indignant that Rosenfeld had interpreted his paintings as "completely derivative." Believing that he had developed genuinely new art forms, Benton asserted: "I am trying to get at a *realism* that shall be more convincing than that which the imitation of natural tone has ended in and I have done a lot of God damned hard work and absolutely original investigation and experiment developing a process to further me. I do not believe it is altogether petty that my pride should revolt at having that fact publicly slighted every time I show a canvas.[22] Benton went on to contrast his "extended sculptural form" with the "purely arbitrary" work of "so many of the moderns." Despite his evident anger, Benton concluded by appealing to Stieglitz: "I ask you again to look at the work and if the occasion arises to give me credit for that which is mine even though it seems to you of little value. Sincerely, Benton."[23] Thus even though Benton took issue with Rosenfeld's critical comments, he continued to seek Stieglitz's approval and recognition.

While Stieglitz and his critics never accepted him, Benton found a powerful supporter in the art critic Thomas Craven.[24] Craven was not only an important advocate of regionalism; he was also a common ally against Stieglitz.[25] From the mid-twenties through the mid-thirties Craven persistently critiqued the photographer. For example, in 1924 Craven accused Stieglitz of relying on art criticism to compensate for what was inherently lacking in his own photographs. As Craven wrote in *The Nation:* "I think that Stieglitz feels unconsciously the meager success of his intentions, and for this reason discovers symbolical meanings and curious psychic values in what are only remarkable transcripts of nature."[26]

By the mid-twenties the Stieglitz circle had come to regard Benton and Craven as a unit. Herbert J. Seligmann conflated the two men's identities in a satirical dialogue that he entitled "The Great Crenton-Baven Conspiracy." Lampooning Craven's socially conservative ideology and provincial cultural views, Seligmann portrayed the critic as an opinionated loudmouth who established his own reputation by promoting banal nationalistic stereotypes. In turn, Benton was represented as a willing accomplice who championed pictorial representation while denigrating both photography and abstraction.[27] Notwithstanding the exaggerations in Seligmann's caricature, the antagonism he captured between the two camps was real. With his fame increasing during the later twenties, Benton derived considerable momentum from portraying himself as an opponent of abstract painting in general and of the Stieglitz circle in particular.

Benton's own antimodernist attitudes are clearly expressed in his essay "My American Epic in Paint" (1928). Benton wrote that, early on, he realized that his "theoretic development as an abstractionist [was] frustrated by a secret interest in objects and especially figures." Once he decisively rejected abstraction and other such "mysticism" in favor of the portrayal of the human figure, Benton found himself an outsider at 291: "My stubbornness on this subject kept me out of the real current of the movement, and I remember, on my return from France, how very lonely I used to feel in Stieglitz's '291,' where others were practicing that to which I could only give an argumentative lip service. Later I was deeply antagonized to discover that cryptic significances were being attached to these modern abstractions. The horse sense that still remained to a Missouri lawyer's son after five years of art revolted, and I began to wonder why, logic or no logic, I should continue to try getting representative meanings out of my art if I was going to put mystical ones in."[28] Benton further asserted that his current mode of painting was an antidote to the Stieglitz circle's "empty" abstractions since this approach combined High Renaissance motifs with actual representations of the American people.[29]

Craven developed these themes further in his book *Modern Art* (1934). In this study Craven celebrated what he considered to

be the courageousness of the American scene painters who had broken decisively with France and discarded the influences that were so damaging "to the development of an indigenous art-culture."[30] According to Craven, great art was necessarily rooted in the local conditions of life. "Art is not a philosophical system embracing the whole world," Craven commented, "it is the expression of the adventures and discoveries of the human organism reacting to environment, of the perpetual readjustment of habit to the procession of changing facts."[31] Craven not only championed Benton's "American" painting in *Modern Art;* he denigrated the "foreignness" of the Stieglitz circle's works. In particular, Craven stingingly portrayed Stieglitz as both Jewish and a traitor. The critic characterized American modernism as an unsuccessful style practiced in the United States by "every Jean, Jacques, or Judas," and he stated outright that Stieglitz's "particular notions of art had no possible bearing on American life."[32] Craven described 291 as a laboratory where Stieglitz shrewdly posed as a prophet ("Judas") to peddle "half-baked philosophies and cock-eyed visions" of abstract art to an unsuspecting and impressionable American public. Craven's account was thus anti-Semitic as well as anti-French since "Jean" and "Jacques" were joined by "Judas." Throughout this disparaging portrayal, Stieglitz was framed as both elitist and un-American. As Craven put it: "Stieglitz, a Hoboken Jew without knowledge of, or interest in, the historical American background, was—quite apart from the doses of purified art he had swallowed—hardly equipped for the leadership of a genuine American expression; and it is a matter of record that none of the artists whose names and work he has exploited has been noticeably American in flavor."[33]

Craven's description of Stieglitz was particularly corrosive since it was a paraphrase of the self-description that Stieglitz had published in his 1921 "comeback" exhibition at the Anderson Galleries. Stieglitz had written: "I was born in Hoboken. I am an American. Photography is my passion. The search for Truth my obsession."[34] While Stieglitz cited Hoboken as his birthplace to emphasize that he was an *American,* Craven latched onto this detail to make precisely the opposite point—that as a "Hoboken

Jew," Stieglitz was foreign, traitorous, and essentially un-American. As Craven's statements suggest, by 1934 anti-Semitism was perceived as a legitimate route of attack when constructing "native" identities explicitly against Jewish ones.[35] Moreover, Craven deployed such inflammatory rhetoric comparatively to deflate Stieglitz's accomplishments while championing Benton's regionalist project: "Of late years, Stieglitz's prestige has steadily declined. Young artists, under the influence of a new conception of art wherein form is definitely allied with and dependent on content no longer listen to his hieratic monologues. In spirit, his present gallery, *An American Place*, is a dwindling continuation of the spirit of 291—alien to the current drive for an explicitly native art. The new trend of painting, following Benton's pioneering example, is toward strong representation and clearly defined meanings which may be shared and verified by large groups of people; and in this movement the elusive apparitions of the Stieglitz group have no function."[36]

In questioning the authenticity of Stieglitz's claims to Americanness, Benton and Craven strategically, if erroneously, conflated the photographer's personal background with the wave of immigrants who had arrived in this country during the first decade. *Modern Art* thus constituted an important part of the regionalists' ongoing polemic against Stieglitz, one that had begun with Benton's article in *Creative Art* (1928) and extended to his review of *America & Alfred Stieglitz* in *Common Sense* (1935). In each instance, Stieglitz's artistic enterprise was conveniently made to serve as a locus of "otherness" and difference against which Benton and Craven could establish an alternative vision for American art, one that had surpassed the "alien" impulses of modernism to culminate finally in Benton's "native" works.

Instead of dignifying Craven's attack with a direct response, Stieglitz again chose to engage privately with Benton. Stieglitz told the artist, "I know that neither you nor Craven have the slightest idea what I have been doing. I repeat emphatically, not the slightest. And why should you or Craven care a tinker's dam about it. I know that Craven in a way is as blind as a bat and as prejudiced as anyone I have ever met. That may be his strength."[37] In

other pieces of private correspondence Stieglitz vociferously denounced Craven's book. Shortly after *Modern Art* was published, Stieglitz wrote to the critic Sheldon Cheney, exclaiming "I suppose you have seen Craven's book. Ye gads I wonder does he recognize *art* when he is in front of it. I doubt it." To Stieglitz's satisfaction, however, he was able to direct Cheney to Lewis Mumford's "fine criticism of Craven's book" in that week's *New Yorker*.[38] In his brief mention of *Modern Art* Mumford had equated Craven's regionalist sympathizers with barnyard rabble, writing: "Craven's attack on the abstractionists and on the unhealthy aspects of the French salon and drawing room tradition will probably stir up the animals."[39]

### Benton's Whitney Murals:
### An Alternative Vision of Embodied Form

As all of this suggests, during the late twenties and early thirties Benton and Craven openly criticized the Stieglitz circle's modernist practice in order to advance an aesthetic alternative, one that embodied "the collective American spirit" as ideally exemplified in Benton's works.[40] Two years before the publication of *Modern Art*, Benton completed one of his most important projects, a series of murals entitled *The Arts of Life in America* (1932). Now in the collection of the New Britain Museum of American Art in Connecticut, these works were originally commissioned to decorate the reading room of the Whitney Museum of American Art. The cycle consists of four panels depicting scenes from American regional life, including *Indian Arts, Arts of the West* (fig. 7.2), *Arts of the South* (fig.7.3), *Arts of the City* (fig. 7.4), and a lunette entitled *Political Business and Intellectual Ballyhoo* (fig. 7.5).[41] In the pamphlet that accompanied the opening of the Whitney Museum's newly decorated reading room, Benton explained his motley array of subject matter: "The Arts of Life are the popular arts and are generally undisciplined. They run into pure unreflective play. People indulge in personal display; they drink, sing, dance, pitch horse shoes, get religion and even set up opinions as the spirit moves them."[42]

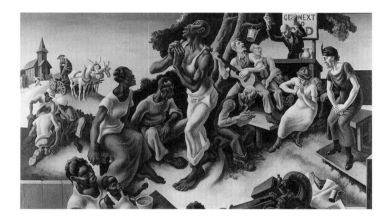

**7.2** Thomas Hart Benton, *Arts of the West*, from *The Arts of Life in America*, 1932. Tempera with oil glaze on canvas, 8 × 13 feet. Courtesy of the New Britain Museum of American Art, Connecticut, Harriet Russell Stanley Fund. © T. H. Benton and R. P. Benton Testamentary Trusts / Licensed by VAGA, New York, NY.

**7.3** Thomas Hart Benton, *Arts of the South*, from *The Arts of Life in America*, 1932. Tempera with oil glaze on canvas, 8 × 13 feet. Courtesy of the New Britain Museum of American Art, Connecticut, Harriet Russell Stanley Fund. © T. H. Benton and R. P. Benton Testamentary Trusts / Licensed by VAGA, New York, NY.

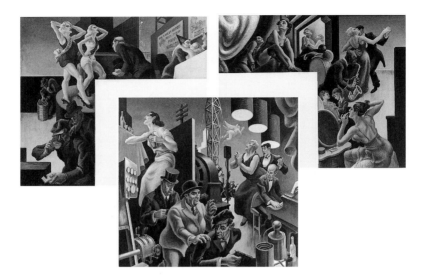

**7.4** Thomas Hart Benton, *Arts of the City,* from *The Arts of Life in America,* 1932. Tempera with oil glaze on canvas, 8 × 22 feet. Courtesy of the New Britain Museum of American Art, Connecticut, Harriet Russell Stanley Fund. © T. H. Benton and R. P. Benton Testamentary Trusts / Licensed by VAGA, New York, NY.

In the Whitney murals, Benton presents a profusion of overlapping figures, many of which are life-size. Through his use of tempera and oil glaze, Benton's people appear to be modeled in three dimensions, yet their forms are unnaturally vivid due to his use of intense, saturated color. The interwoven limbs, exposed flesh, animated gestures, and exaggerated anatomical contours of Benton's figures border on grotesque self-parody. (Henry McBride once called them "tabloid.")[43] Women are frequently portrayed as objects of sexual curiosity, literally falling out of their dresses (see fig. 7.4). Similarly, the men are less individuated portraits than regional stereotypes and caricatures. In these murals, Ben-

ton showcases the sensational body. Yet the figures' curvilinear exaggerations endow the surfaces of the paintings with a sense of formal coherence. This was a deliberate move on Benton's part, as he explained in the Whitney brochure: "In the process of correlating things directly known, needs arise which cannot be met with logical devices of the past. The devices are then modified, more or less unconsciously. Also the direct knowledge represented is inevitably subjected to some distortion as it becomes part of a logical sequence. Experience is not of a logical nature— all integration involves distortion of some sort."[44] For Benton, figural distortion represented a means of integrating the artist's direct experiences into a unified painterly field. Paradoxically though, the homogenizing stylistic effects of Benton's sinuous lines, saturated colors, and repetitive tonal rhythms heighten the choppy and disjunctive character of Benton's figures themselves, and their contorted bodies become woven across the surfaces of the paintings. As a result, the viewer is left less with a "realistic" sense of regional scenes and popular culture than with a collectively mannered and corporeally distorted impression of Benton's regionalist vision.

Benton's hyperbolic pictorial mode conditions not only how the figures are portrayed within his paintings, but the experience of the viewer who stands before them. In Benton's murals multiple, fantastic presences are jammed into a series of contained panels. Like elements of montage in period filmic structures, space shifts abruptly in Benton's cinematically scaled murals as scenes protrude, recess, and meander due to the lack of a dominant compositional focus.[45] The overlapping vignettes of *Arts of the West*, for example, suggest a sequence of action-packed scenes that project not only backward into fictive depth and across a horizontal expanse, but forward into the viewer's own space. As a result, Benton manages to create the impression that the viewer is somehow *inside* the paintings and *outside* of them as well. For example, in the extreme foreground of *Arts of the West* Benton presents a circular poker table and a pair of disembodied hands that presumably belong to the (implicitly male) spectator. Just visible in this fragment of the painting are the king of hearts and the

queen of clubs, cards which suggest that the player/viewer is attempting a high-ranking straight. This type of representational "open-handedness" facilitates the viewer's imaginative projection into the painting through his participation in the fictive poker game. Yet at the same time, Benton's abrupt spatial juxtapositions make it all but impossible for the spectator to be "inside" the painting, much less focusing on any single area of any given panel. Instead, multiple subjects are experienced simultaneously, an effect that evokes not a sense of perspectival coherence but of rupture or split. The overlapping boundaries of Benton's vignettes convey a mosaic of fractured identities, and the spectator is caught in the whirlpool as he or she confronts Benton's large-scale figures as potential sites of identification, repulsion, or desire.

Through this montage of anecdotes, Benton's murals subvert the logic of narrativity. This was a purposeful move.[46] Benton and Craven considered the lack of a dominant narrative, along with the contrived formal randomness of Benton's paintings, to be an analogue for American life itself. As Craven stated, "The tumultuous forces of America, its manifold dissonances, and its social anarchy, are perfectly expressed in the restless counterplay of [Benton's] forms."[47] The intentionally disruptive, even "decentered" appearance of Benton's murals is thus consistent with Benton's and Craven's own understanding of "regionalism" as a conglomeration of local cultures, subjects, and incidents.

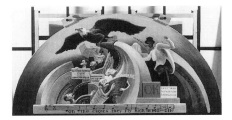

**7.5** Thomas Hart Benton, *Political Business and Intellectual Ballyhoo,* from *The Arts of Life in America,* 1932. Tempera with oil glaze on canvas, 4 feet 8 ½ in. × 9 feet 5 in. Courtesy of the New Britain Museum of American Art, Connecticut, Alix W. Stanley Fund. © T. H. Benton and R. P. Benton Testamentary Trusts / Licensed by VAGA, New York, NY.

Not surprisingly, modernist critics expressed reservations about Benton's works. For example, Sheldon Cheney voiced the modernist counterposition in 1934: "Benton's murals often are restless, formless and confusing. We may appreciate his work intellectually, for many unusual qualities: intense liveliness, courageous satire, and—God save the mark!—a sense of bustling mid-Western Americanism. But the virtues are illustrational; the picture as an organization often falls to pieces—figures seem in imminent danger of tumbling out of the wall to the floor at one's feet, parades march through the border-frame, the eye jumps from prize-fight to locomotive to cabaret."[48] Cheney's description reads less like art criticism than like an account of a brewing rebellion. The critic seems to be most troubled by the sense that Benton's disruptive, mass-cultural subjects cannot be contained within the boundaries of their frames, but instead threaten to break free and "tumble" into the viewer's space.

The disruptive effects that Cheney described are heightened by the physical context in which Benton's murals were (and still are) experienced. In 1933 Paul Rosenfeld described the room in the Whitney where the works originally hung. According to Rosenfeld, the museum's reading room lay "directly beneath the eaves of the old brick house high over the galleries. One reaches it from the third story by means of a special little steep, narrow flight of stairs. Entering its low doorway, one finds oneself in a cubicle, peaceful despite the mounting clatter of the Eighth Street cars."[49] Much as in their original installation, today the murals are hung in a single gallery at the New Britain Museum. Upon entering this smallish, rectangular room, the viewer is surrounded on three sides by Benton's vivid paintings. In both their original and present settings, the works are hung low and it is difficult to step back sufficiently to achieve adequate distance from the paintings. As a result, the viewer is not so much absorbed in Benton's murals as entangled in them.

Like Cheney, Rosenfeld had little positive to say about the Whitney murals. Comparing their linear rhythms to the "lunging," "ducking," and "body-blows" of professional boxers, Rosenfeld wrote that "spiraling painted forms strike the eye of the frightened

visitor immediately he enters the apartment. The super-life-sized Michelangelesque figures violently projected on the walls imperiously attract his attention to themselves; squirming forward and up and making as if to spring out and land full force upon him."[50] Thus unlike the symbolic bodies found in the Stieglitz circle's intimately scaled easel paintings, Rosenfeld considered the "lunging," "ducking" figures who populated Benton's murals to be decidedly unaesthetic. According to the critic, Benton's figures appeared deformed, defective, and threatening to break out of control. With the addition of Benton's murals to the Whitney Reading Room, Rosenfeld contended that the atmosphere had shifted from one of peaceful contemplation to one of violent visual, and implicitly physical, assault. Curiously, Benton seems to have anticipated Rosenfeld and Cheney's criticism. In the Whitney brochure the artist wrote, "it is inevitable that the sequences of the whole mural be subjected to strains more or less violent. In the interest of representational inclusiveness, the flow of a line is frequently broken, twisted and sent back on itself. As a consequence of this, some other line needs be treated violently as an offset or counter."[51] Thus Benton justified the formal violence of his compositions as operating in the service of "representational inclusiveness."

Yet Rosenfeld took issue not only with Benton's formal turbulence and with the "ugly" portrayal of his subjects, but with "his thesis that the arts of life in America are thoroughly crude, gross and ungracious." The critic asserted that Benton turned his subjects "into objects of contempt, aversion and dread, first by concentrating on their deathliness and impotence, nastiness and brutality, practically to the exclusion of all other traits; and second, by making them super-life-sized; thus attributing to them a power and importance which they actually have not got."[52] Thus in his 1933 review of Benton's murals Rosenfeld coupled the themes of "impotence" and "death," precisely the same insulting combination that Benton would apply to Stieglitz himself in 1935. Yet the two groups attached different meanings to this symbolic pairing. While Rosenfeld associated Benton's artistic "impotence" with the supposedly savage and deathly qualities of his

figures, Benton and Craven equated the Stieglitz circle's artistic "impotence" with the "empty purity" of an abstraction that annihilates the literal presence of the human figure. Given his adamantly antimodernist posture, it is not surprising that Benton insisted that his *Arts of Life in America* murals were not aesthetically "pure." As Benton explained in the Whitney brochure: "In life, the claim to purity is practically a declaration of impotence. It is a compensatory value, born and reared in some kind of frustration. Set up as an ideal to be maintained, it is an indication of defeat . . . the brutal assertiveness of direct knowledge is avoided by the 'pure.' This mural, 'The Arts of Life in America,' is certainly not a pure work."[53]

In short, the regionalists' and the Stieglitz circle's artistic and critical projects represented competing constructions of American masculine subjectivity. Conversely, the two groups also battled over the terms in which a *lack* of sexual potency could be linked to the aesthetic failure of either modernism or regionalism. In either case, such rhetorical tactics were not new. As we have seen, during the twenties the Stieglitz circle's American Dadaist opponents described Rosenfeld himself as feminized ("Paulina Roseyfield") in order to question the validity of his critical judgments and subvert his gendered aesthetic discourses. During the thirties the regionalists and the Stieglitz circle described one another not as feminized but as exemplars of a failed masculinity that was both "impotent" and "dead." In both instances, the Stieglitz circle's embodied formalist criticism provided their opponents with an alternative means for framing aesthetics as a discourse on the body. For Benton, this entailed a valorization of brutality and figural distortion as a means for achieving a "potent" formal unity.[54] Yet in so empowering their adversaries, the Stieglitz circle also empowered themselves, since they became the originators of a dominant (and hence "potent") discourse against which their rivals were compelled to react.

## Old Master References: Constructing a Past

In this competition for artistic prowess, Benton and Craven posited that regionalist painting was at once innovative and connected to a powerful art historical past. In a gesture that recalled the synchromists' celebration of Michelangelo, Benton invoked the tradition of Renaissance mural painting as a precedent for his "American" works. As he put it in the Whitney brochure: "The religious Art of the Renaissance pictured the life of the Renaissance. . . . I mention all this mainly for those who have notions about the traditional dignity of mural art. There is the precedent for taking the Arts of Life seriously. It deals, as do the great religious paintings, in spite of their names, with things found in an artist's direct experience."[55] By drawing on the tradition of the Renaissance masters, Benton was able to construct a European artistic past that was disconnected, and even shielded from, contemporary modernist developments. Moreover, Benton's Old Master rhetoric and imaging practices enabled him to present himself as historically one with the followers of Michelangelo.[56] Thus for Benton and Craven, selective allusions to the Old Masters functioned as a highly effective means of appropriating Europe's artistic past while polemicizing against a relation to its present.

Significantly, this was not a neutral artistic past, but once again a highly gendered one. References to the "Old Masters" signified a long and venerable tradition of masculine creative power.[57] The Old Masters have historically been recognized as the great creators of culture. In the case of Michelangelo in particular, the artist is not only a revered exponent of social and aesthetic expression, but a genius whose creativity stemmed from divine inspiration. In one sense, Benton and his colleagues could not have chosen a more "potent" spiritual, cultural, and art historical lineage for themselves than claiming to be the descendants of Michelangelo. Yet in another sense, their choice was also problematic. In naming Michelangelo as their art historical ancestor, it became necessary for the regionalists to refute any charges of the artist's homosexuality. Craven addressed this issue directly in

*Men of Art* (1931). The critic devoted 50 pages to a discussion of Michelangelo's creative accomplishments, and several passages to denying any implications of his homosexuality. In particular, Craven emphasized Michelangelo's abstinence from the pleasures of food, drink, and the flesh, and he flatly denied any suspicious or "irregular attachment" between the artist and his young friend Tommaso Cavalieri. Instead Craven insisted that Michelangelo worshipped physical beauty for its own sake, "as an absolute quality dissociated from sex."[58] In this chastened form, Michelangelo's achievements were made to support the regionalists' notions of cultural patrimony. Not surprisingly, the Stieglitz circle artists remained scornful of Benton's and Craven's Old Master discourses *and* of the underlying antimodernist attitudes that they fueled. As Arthur Dove told Stieglitz in 1931, "When people damn Picasso and Joyce and save Benton and Sloan along with Michelangelo they get to the stage of breaking plate glass windows."[59]

While Benton and Craven drew on Michelangelo as a stylistic prototype in which to recast and glorify the contemporary American subject, the Stieglitz circle writers celebrated the works of a different Old Master, El Greco.[60] In 1928, shortly after the Metropolitan Museum of Art acquired a Greco self-portrait, Rosenfeld wrote an essay in which he located the very essence of embodied formalism in the aestheticized yet corporeal structures of Greco's paintings. Rosenfeld wrote: "No painting is more penetratingly corporeal, more 'sexual' even, than [El Greco's]. One moves through tides of flesh, through tissue, membrane and ligament before his mighty canvases. Yet no painting is more divinely pure, abstract, ideal."[61] Rosenfeld thus identified an elevated sense of abstract purity *and* a dense corporeal sensuousness in the surfaces of Greco's paintings. This formal and thematic combination led Rosenfeld to assert that *all* of the master's works could be interpreted as self-portraits since in them, "a form, a feeling and a man remain indivisible and one."[62] Charles Demuth expressed a similar notion in his contemporary essay "Across a Greco Is Written" (1929). Citing Greco as his primary example, Demuth posited that a painter's identity is literally "written" across the surfaces of his artworks: "Across a Greco, across a Blake, across

a Rubens, across a Watteau, across a Beardsley is written in larger letters than any printed page will ever dare to hold, or Broadway facade or roof support what its creator had to say about it."[63] Such references to "their" Old Master, El Greco, provided the Stieglitz circle writers with yet another means for recapitulating the notion of aestheticized corporeality as an expression of creative agency, one that was resonant with their chosen art historical prototype.

In turn, the modernist discourses on El Greco were instrumental in shaping Benton's and Craven's regionalist assessment of the Old Master genealogy. In *Men of Art* Craven claimed that El Greco has been hailed as "the Messiah of Modernism" and used to justify otherwise meaningless abstractions: "El Greco . . . has been a spiritual brother to a large body of outlaws whom modern society has refused to sanction, and who have, therefore, painted solely to please themselves, speaking to one another in a language of abstractions."[64] In contrast, "the Renaissance culminated in a body of great artists whose work is a perfectly consistent expression of the temper and ideals of the Italian people."[65] By claiming that the Italian Renaissance painters produced not irrelevant abstractions but artworks replete with social values, Benton and Craven managed to construct a historical precedent for regionalism while further amplifying their opposition to the "empty purity" of the modernists' own designated forebear, El Greco.

## Regionalist Popularity versus the Institutionalization of Modernism in the 1930s

During the thirties the regionalists' opposition to modernism was as instrumental as it was vociferous. Antimodernist attitudes enabled Benton and Craven to stake out a position that was distinct from the audience for modernist painting. This became increasingly useful as modernism's stature expanded during the decade as the movement became an institutionally recognized force.

A few months before Benton's murals were unveiled at the Whitney Museum, the Museum of Modern Art mounted an exhibition entitled "Murals by American Painters and Photogra-

phers." Although Benton was briefly mentioned in the catalogue's
introductory essay, he seems not to have been invited to partici-
pate in the exhibition itself.[66] Among the exhibited works, how-
ever, was Georgia O'Keeffe's only known mural composition,
*Cityscape with Roses* (1932, fig. 7.6). In this painting O'Keeffe
presents a stark but intricate image of Manhattan skyscrapers
through a quasi-cubist arrangement of angular, stacked planes.
The otherwise severe lines of O'Keeffe's composition are softened
by the presence of three floating roses in red, blue, and pink. Like
a greatly enlarged Demuth painting (such as fig. 7.7), O'Keeffe's
architectural forms seem to be precariously tilted yet simul-
taneously balanced and certain.

As *Cityscape with Roses* exemplifies, during the thirties
Stieglitz circle artworks could be received as both modern *and*
American. This versatility made it possible for their paintings to
appeal to both of the newly established New York art museums,
the Museum of Modern Art and the Whitney Museum of Ameri-
can Art. The Museum of Modern Art was founded in 1929 through
the efforts of Mrs. John D. Rockefeller, Jr. During the thirties the
museum's first director, Alfred H. Barr, Jr., mounted a number of
important exhibitions, including "Cubism and Abstract Art" and
"Fantastic Art, Dada, Surrealism" (both of 1936). Dove's and
O'Keeffe's artworks were included in the latter show. In October
of 1936 John Marin received a retrospective exhibition at the Mu-
seum of Modern Art, the first Stieglitz circle artist to be honored
by such an event. As these developments suggest, while the mu-
seum favored a European-inspired version of modernism, the
Stieglitz circle artists could nonetheless find a place in the Mod-
ern's program. Benton, however, could not. During the thirties, at
the height of his popularity, the Museum of Modern Art acquired
only a single work by Benton, *Homestead* (1934).[67] Benton's posi-
tion was not helped any by Craven's overtly polemical stance to-
ward the institution, which the critic denounced in 1932 as "the
high-toned asylum of French art and culture in America."[68]

Unlike the Museum of Modern Art, the Whitney Museum was
primarily devoted to exhibiting contemporary works by living
Americans. Originally begun as the Whitney Studio Club, later

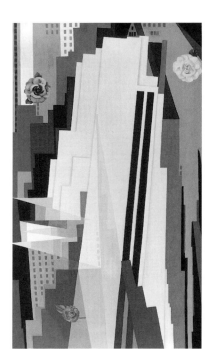

**7.6** Georgia O'Keeffe, *Cityscape with Roses*, 1932. National Museum of American Art, Smithsonian Institution. Gift of the Georgia O'Keeffe Foundation. ©2000 The Georgia O'Keeffe Foundation/Artists Rights Society (ARS), New York.

**7.7** Charles Demuth, *Roofs and Steeple*, 1921. Watercolor and pencil, 14 3/16 × 10 3/8 in. (36 × 26.4 cm). Brooklyn Museum of Art, Dick S. Ramsay Fund, 50.159. Courtesy of the Demuth Foundation, Lancaster, PA.

the Whitney Studio Gallery, the Whitney Museum opened in November of 1931 after Gertrude Vanderbilt Whitney had four residences on West Eighth Street converted into art galleries. In 1935 the museum stated its commitment to American art: "Art is not created in a vacuum; the artist is a human being, subject to all the currents of experience that influence his fellow-man. Among the most powerful of these influences are the racial and national traits, and these elements added to the more abstract, aesthetic qualities give to art an extra pungency and vigor which we shall attempt to recognize and encourage."[69]

Given the Whitney Museum's expressed interest in both "aesthetic qualities" and in "national traits," the appeal of Benton's and the Stieglitz circle's paintings becomes readily apparent. By the end of the thirties, the Whitney Museum had acquired not only Benton's *Arts of Life in America* murals, but two of Benton's oil paintings, two lithographs, and numerous drawings.[70] In addition, the Whitney Museum had added thirteen Stieglitz circle works to its permanent collection.[71] Meanwhile the Museum of Modern Art had also acquired thirteen works by members of the Stieglitz group, six of which were watercolors by Demuth, who had died in 1935. While both institutions regularly exhibited Stieglitz circle paintings throughout the decade, the photographer himself remained contemptuous of the "rich" trustees of the Museum of Modern Art. As he told Arthur Dove, "those who bend the knee to their arrogance are the only welcome servants."[72]

Despite, or perhaps because of, the regionalists' overtly oppositional stance toward modernism, Benton's works gained considerable notoriety during the early thirties. Regionalism became recognized as a movement in 1934 when works by the "Midwestern" painters Benton, Grant Wood, and John Steuart Curry were exhibited together at the Ferargil Galleries in New York. By the end of that year Benton could claim the distinction of being the first artist ever to be featured on the cover of *Time* magazine (December 24, 1934; fig. 7.8). The Benton self-portrait that appeared on the cover of *Time* is notable primarily for its extreme characteristics, including the artist's scowling expression and his firm grasp of a large, phallic paintbrush. Inside the magazine's pages,

Benton was hailed as "the most virile of U.S. painters of the U.S. Scene," a phrase which conflated the artist's excessively masculinist pose with his American national identity.[73] Along these lines, *Time* celebrated Benton as the leader in the movement away from French modernism toward more traditional cultural reference points. As the magazine observed, "this year the French schools seem to be slipping in popular favor while a U. S. school, bent on portraying the U. S. scene, is coming to the fore." *Time* further noted that "in the U.S. opposition to such outlandish art first took root in the Midwest. A small group of native painters began to offer direct representation in place of introspective abstractions. . . . Of these earthy Midwesterners none represents the objectivity and purpose of their school more clearly than Missouri's Thomas Hart Benton."[74] Taking cues from Benton's and Craven's own regionalist diatribes, *Time* recapitulated what was by then a well-established opposition between Benton's "virile," "native" paintings and the modernists' "outlandish" and "introspective" abstractions.

Once again, the Stieglitz circle remained disdainful of Benton's tactics. Arthur Dove characterized the regionalists' posturing in *Time* as a "self give-away." Regarding Benton himself, Dove commented, "If the people, in *general* even, do not see through that, they *are* dumb. . . . Wonder what the Craven mixture will think up next. Maybe they're all actors, and we didn't get it."[75] The antagonism between the regionalists and the Stieglitz circle was exacerbated by the timing of the magazine article. A week after the Benton cover story appeared in *Time,* the issue of *Common Sense* was published in which Benton lambasted *America & Alfred Stieglitz.* A few months later, Benton announced his plans to leave New York City, which had "lost all masculinity," and return permanently to Missouri.[76] In actuality, Benton probably did not have much choice but to leave New York, since he had alienated so many figures in the art world there. Yet with customary swagger and bravado, Benton explained in his autobiography, *An Artist in America* (1937), "I had the desire to escape the narrow intellectualism of the New York people with whom I associated and to get more closely acquainted with the actual temper of the common

people of America."[77] Benton went on to contrast the budding promise of the Midwest with the "morbidly narrow" taste of such art centers as New York and New Mexico, regions with which the Stieglitz circle artists were closely associated.

The final issue in the regionalists' and the Stieglitz circle's debate over American art took the form of the Stieglitz group's disparagement of the WPA murals during the thirties.[78] At the end of the decade Stieglitz summed up his distaste for such politically oriented art in a letter to the critic Henry McBride: "Politics. Everything seems to be smeared with politics. And as for murals under politic's regime, remember I spoke of the Rape of Innocent Walls when the W.P.A. and P.W.A. went into effect."[79] Rosenfeld concurred with Stieglitz's opinion regarding the majority of murals produced under the New Deal initiatives. Citing Benton's works as a prototype for American mural painting, the critic wrote in *The Nation* that these images recycled a repertoire of trite subject matter, including "Bentonian corruscations of lust in the form of reflections on the vulgarity of night club life."[80]

As they had throughout the decade, the Stieglitz circle critics once again leveraged the issues of aesthetics and embodiment to disparage the PWA and WPA murals, omnipresent public images that bore traces of Benton's influence. Such responses were not surprising, given that Benton's "vulgar" subjects provided the perfect foil for the Stieglitz circle's abstracted and aestheticized conceptions of gender and embodiment. Yet when viewed collectively, the regionalists' and the Stieglitz circle's contrasting discourses generated a convergent set of themes, including the "death" of the aesthetic under regionalism versus the "empty purity" of embodied formalism, and the "impotence" of the Stieglitz circle's modernism versus the violated character of Benton's figures and his "rape" of innocent walls. Indeed, without the example of Benton and Craven, Stieglitz and his critics would have spoken increasingly into a void during the thirties. In 1941 Stieglitz himself acknowledged the value of Benton's polemical presence. The photographer told Selden Rodman, editor of *Common Sense,* that while "I still am no admirer of [Benton] as either painter or artist," Benton "is a very good bantam fighter, even

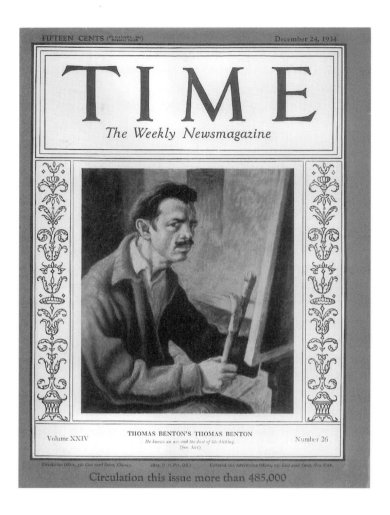

**7.8** Thomas Hart Benton, cover, *Time,*
December 24, 1934. © 1934 Time Inc.
Reprinted by permission.

though he may occasionally hit below the belt, and whether he is an enemy of mine or not, I do admire him for his bantam fighting capacities."[81]

Thus in his own colorful and contentious way, Stieglitz acknowledged that his and Benton's strategy of mutual counterdefinition yielded surprisingly rewarding results. Since both groups placed heroic masculinity at the core of authentic modern selfhood, much of Benton's and Craven's commentary can be read as an extended protest against the Stieglitz circle's claims to the monopolistic possession of these essential modern identities. With modern art under such attack during the 1930s, the Stieglitz circle had to reconsolidate their position and reaffirm their standing in the New York art world. Yet at the same time, this state of mutual opposition provided both the Stieglitz circle and the regionalists with a means to sustain the clarity and force of their respective projects, largely through their vivid reactions, and even overreactions, to one another.

*Chapter 8*

# The Contest for "the Greatest American Painter of the Twentieth Century"

Alfred Stieglitz and Clement Greenberg

Most accounts of the abstract expressionist movement—the theoretical complexity and methodological diversity of this corpus of texts notwithstanding—tend to emphasize the presence of Jackson Pollock but overlook the role of another artist who was in fact crucial to its history, John Marin. While it may be appealing to view forties abstract painting as a unique achievement, and hence a "triumph" unlike anything that had preceded it, this body of work was in fact deeply bonded to a well-established tradition of

American modernism. In the highly influential critical writings that Clement Greenberg published throughout the 1940s, he elaborated a genealogy for modernism as an unbroken thread that extended seemingly inevitably from the visual and literary arts of the nineteenth century through the latest developments in abstraction. More specifically, Greenberg portrayed John Marin as a bridge figure between the first and second generations of American modernists and as a precursor to Jackson Pollock.

Marin was a compelling choice for Greenberg, particularly since the artist had attained considerable status among both popular and elite audiences during the 1940s. At the time, Marin was even regarded as a kind of "old master" of American modernism.[1] Thus the motivations underlying Greenberg's strategic linkage of Marin and Pollock were clear: the critic wished Pollock to be regarded as the "heir apparent" in this privileged artistic lineage. Yet Marin's artworks offered Greenberg much more than a stable and prestigious landmark by which to locate Pollock's innovative and unfamiliar paintings. Through their association with Marin, Pollock's works became firmly grounded in a tradition of American modernism that was at once rooted in the past and yet could be seen as unmistakably advancing forward. For Greenberg, the stakes were extremely high during the forties. What was represented was nothing less than the opportunity to back the two "greatest American painter[s] of the twentieth century."[2]

Greenberg's exchanges with Stieglitz—the last great polemical encounter of the photographer's life—represented yet another instance in which prominent figures in the New York art world advanced competing yet suggestively similar accounts of gender and subjectivity in American modernism. As we shall see, during the forties Greenberg's opposition to Stieglitz and his support of Marin enabled the critic first to reject, then subsequently to reproduce, key aspects of Stieglitz's project. While Greenberg cast off the "impure" or "scatological" elements of the Stieglitz circle's symbolic body, his acceptance of Marin made it possible for him to appropriate not only the then most famous member of Stieglitz's group, but perhaps the single most powerful idea behind Stieglitz's embodied formalist model, that of the gendered and

corporealized abstraction. Reconstructing the interwovenness of Greenberg's and Stieglitz's aesthetic projects clearly establishes Greenberg's connection to an earlier generation of American modernists and provides valuable perspective on, and perhaps even a new standard by which to measure, Greenberg's redefinition of formalism.

## Stieglitz's Modernism

The Stieglitz circle represented an appealing target for Greenberg during the 1940s because of the group's well-established status within American modernism. Stieglitz had forged a productive relationship with the Museum of Modern Art as early as 1929, the year of the institution's founding. Yet Stieglitz envisioned his own gallery activities at An American Place as representing a kind of American modernist response to that museum. Dorothy Norman recalled that, during the autumn of 1929, Stieglitz was "distressed . . . by rumors that a Museum of Modern Art is about to open with a loan exhibition of Cézanne, Van Gogh, Seurat, and Gauguin—in his opinion, French 'Old Masters.' Everything he hears about the proposed venture makes him feel more than ever the need to gain support for his 'own children.' He is appalled by the idea that an expensive showcase is to be set up—that most of the money will be spent for staff and upkeep, rather than for the livelihood of American artists."[3] But despite the photographer's reservations about the new museum, it offered the Stieglitz circle artists an important source of exposure and support once Stieglitz's own activities had slowed down during the forties.[4] The Stieglitz group was well represented in exhibitions ranging from "Painting and Sculpture by Living Americans" (1930–1931) to "Murals by American Painters and Photographers" (1932); the Modern's "Fifth Anniversary Exhibition" (1934); "Fantastic Art, Dada, Surrealism" (1936); "Three Centuries of Art in the United States" (1938), a show that was jointly organized with the Musée du Jeu de Paume;[5] and "Romantic Painting in America" (1943). In addition to their participation in these group shows, during the

1930s and 1940s the Stieglitz circle members were also recognized by a series of retrospective exhibitions. In 1936 John Marin received a retrospective at the Museum of Modern Art, the first Stieglitz circle artist to be so honored. Georgia O'Keeffe and Paul Rosenfeld both lent artworks from their personal collections to this show, and Stieglitz's photographic portrait of Marin appeared on the jacket of the catalogue.[6] Retrospectives for Hartley and O'Keeffe would follow in 1944–1945 and 1946, respectively. By the time the O'Keeffe exhibition opened during the summer of 1946, multiple, important examples of works by each of the Stieglitz circle artists had entered the Modern's permanent collection.[7]

Despite Stieglitz's declining health and his relatively limited gallery schedule, the years 1936 to 1946 saw the Stieglitz circle's position in the history of American art become securely established.[8] The Museum of Modern Art recognized the Stieglitz circle not only for their past contributions to American art but also for their continuing role as active producers of abstract painting. For example, when the Modern held its "Abstract Painting and Sculpture in America" exhibition (1951), the show included both well-known works by the Stieglitz circle artists dating from the teens and twenties and examples of their recent paintings, including Dove's *Rising Tide* (1944), O'Keeffe's *From the Pelvis Series* (1947), and Marin's *The Fog Lifts* (1949). The show also featured a new acquisition by a controversial young artist, Jackson Pollock's *Number 1, 1948* (1948, fig. 8.5).[9]

Although Greenberg admired Stieglitz's work as a photographer, from an early point he expressed a marked distaste for Stieglitz's group project.[10] This attitude became apparent as early as 1942, when Greenberg reviewed Jerome Mellquist's book *The Emergence of an American Art* for *The New Republic* (June 15, 1942). The very title of the study already suggests the nature and stakes of the brewing confrontation. Mellquist was an art and literary critic and a personal friend of Stieglitz's who had based his book on conversations that he had conducted with the photographer during the late thirties and early forties.[11] Somewhat predictably, Mellquist's study charts the evolutionary history of American art beginning with the early modernism of Whistler and

Sargent, nods at the academic tradition of the American impressionists and the realism of The Eight, and "culminates" (to use Mellquist's term) in Stieglitz's achievement at 291 and in the "triumph" of Demuth, O'Keeffe, Hartley, Dove, and Marin. Much as in Rosenfeld's and Frank's earlier writings, Mellquist drew on familiar themes of organicism and spirituality to describe Stieglitz circle artworks. With *Port of New York* (1924) itself still a widely known text during the forties, *The Emergence of an American Art* marked the "emergence" of yet another new study that drew on Stieglitz's own embodied formalist rhetoric to celebrate his group project.[12]

In his review, Greenberg wrote that Mellquist's book was "singularly devoid of enlightenment" and incoherent in its critical judgments other than "to approve of everything and everyone more or less connected with Stieglitz," including "the ineffable O'Keeffe and the saccharine Dove." These uncomplimentary critical judgments made Greenberg's appraisal of Marin all the more striking. Greenberg wrote that "it is quite possible that [Marin] is the greatest living American painter."[13] As we shall see, this was but the first of many appreciative remarks that Greenberg would direct toward Marin during the forties, praise that always seemed heightened by the critic's negative evaluation of the other Stieglitz circle members.

While Greenberg was critical of Hartley's retrospective at the Museum of Modern Art, his most scathing assessment of the Stieglitz circle artists is found in his commentary on O'Keeffe's retrospective at that museum (*The Nation*, June 15, 1946). Citing O'Keeffe's work as a surrogate for Stieglitz's entire project, Greenberg characterized her painting as derivative and esoteric. He wrote that O'Keeffe was a member of the first generation of American modernists whose abstract works were based on

a new kind of hermetic literature with mystical overtones and a message—pantheism and pan-love and the repudiation of technics and rationalism, which were identified with the philistine economic world against which the early American avant-garde was so much in revolt. Alfred Stieglitz—who became Miss O'Keeffe's husband—incarnated, and

still incarnates, the messianism which in the America of that time was identified with ultra-modern art.

Continuing in this vein, Greenberg stated that O'Keeffe's paintings betrayed "a concern that has less to do with art than with private worship and the embellishment of private fetishes with secret and arbitrary meanings."[14] Greenberg thus parodied the Stieglitz circle's embodied formalist rhetoric by presenting their paintings as debased, highly personal fetishes that tended to be pantheistic, undisciplined, and indiscreetly "private."

In retrospect, it is clear that Greenberg was responding not only to O'Keeffe's paintings themselves but to the critical interpretations that her works had generated. For example, Robert M. Coates of *The New Yorker* stated that O'Keeffe "is now, of course, the most important living woman painter in America, and possibly in the world." Coates went on to observe that a paradox underpinned O'Keeffe's artistic production, one that stemmed from her "intense exultation of purity" combined with an "emphasis on the sexual . . . that is at times so direct as to be almost embarrassing, particularly because in her earlier work it seems to be completely unconscious."[15] Coates's review is more typical than not of the critical commentary that O'Keeffe's works elicited in 1946. When viewed collectively, the reviews of the O'Keeffe retrospective indicate that the Stieglitz circle's embodied formalist dialectic of erotic energy and aesthetic purity was so firmly entrenched in mainstream critical discourses as to be officially sanctioned and even repeated in more or less predictable patterns. For example, Jo Gibbs of *Art Digest* similarly located the appeal of O'Keeffe's works in their simultaneous display of "puritan, erotic, mystic and symmetrical" qualities. Emphasizing the slippage between the formal and the sexual aspects of her work, Gibbs observed that "some of the huge flowers and leaves are sheer design and decoration, others primevally libidinous."[16] Edward Alden Jewell of the *New York Times* expressed the familiar notion of a transparent relation between the artist and her paintings, asserting that "the painting is autobiographic as thoroughly as it is mystical. Each picture might be called a portrait of the artist herself."

Jewell further emphasized a dialogue between abstraction and naturalism, between generative materiality and transcendent universality, as threading through O'Keeffe's paintings. As he put it, O'Keeffe's work "is charged with a spirit of universality, even when expression appears tethered to what is immediate and finite. She paints a flower, a leaf, a shell, a tree, the desiccated skull of an animal, portraying these objects as microcosms; and it will be always the macrocosm—the enveloping sum of elements peculiar to life and death—that presses in, giving the concept its final radiance."[17]

If such critical discourses represented Greenberg's rhetorical target, his real institutional target was none other than the Museum of Modern Art itself. Greenberg concluded his review of the O'Keeffe exhibition with this admonishment: "That an institution as influential as the Museum of Modern Art should dignify this arty manifestation with a large-scale exhibition is a bad sign. I know that many experts—some of them on the museum's own staff—identify the opposed extremes of hygiene and scatology with modern art, but the particular experts at the museum should have had at least enough sophistication to keep them apart."[18] Thus in 1946 Greenberg rebuked the Museum of Modern Art for exhibiting paintings by the Stieglitz circle artists that were both dirty and clean, scatological and hygienic; in his opinion, these works were certainly not high art and should not be mistaken for such.

Greenberg's review immediately elicited a spirited response from Stieglitz. Although elderly and in fragile health, the photographer summoned up the acerbity to respond to the critic. In one of the last letters that he would ever write (the eighty-two-year-old Stieglitz died three and a half weeks later), Stieglitz offered his opinion not only of the article, but of Greenberg himself: "When through I said to myself, 'Great God, where did that man dig up that crassest of all stupidities?' For I have rarely met with any stupidity equal to that, expect maybe my own in reading any article signed by Greenberg. You are a master. That I will grant. So accept my congratulations at being the perfect thing you are."[19]

In Greenberg's writings, Stieglitz's project was made to repre-
sent the artistic tradition that had misfired, thereby leaving the
critic free to invent an alternative trajectory of American mod-
ernism. The stakes of Greenberg's conflict with Stieglitz were
practical as well as philosophical, given the role that the Museum
of Modern Art had played in promoting Stieglitz circle artworks.
The museum's support is evident in James Thrall Soby's review of
the O'Keeffe retrospective (*Saturday Review,* July 1946). Soby
was curator of paintings at the Museum of Modern Art and a
trustee of that institution. After praising O'Keeffe as "perhaps the
greatest of living women painters," Soby observed that she "cre-
ates a world" in her artwork through a combination of "psychic
confession," "symbolic language," and varying degrees of natural-
istic objectivity. With early works from Lake George as well as
O'Keeffe's more recent images of New Mexico clearly in view,
Soby wrote that, in O'Keeffe's world, bones and flowers are "some-
times abstract and vigorous, sometimes warm and fugitive," but
together they represent her unique accomplishment: "She created
this world; it was not there before; and there is nothing like it any-
where."[20] Soby observed that in images such as *Corn, Dark I*
(1924, fig. 4.7), viewers could perceive O'Keeffe's "vigorous" ab-
straction as embedded within the "warm" and "fugitive" natu-
ralism of her curling corn flower and jagged leaves. Thus
without actually referring to O'Keeffe's body itself, Soby's remarks
reflected Stieglitz's own views concerning the intrinsically inter-
woven relations between corporeal sensations, the natural world,
and abstract painterly form. Not surprisingly, Stieglitz was de-
lighted with Soby's review. As O'Keeffe herself later told the critic
Henry McBride, "I only read two reviews of my Museum show—
yours—and Sobys—Yours I read because I like you—Soby I
read because Stieglitz particularly asked me to—."[21] O'Keeffe's
biographer Roxana Robinson has pointed out that, even as
Stieglitz lay ill at An American Place during July of 1946, he
asked visitors to read Soby's essay aloud to him: "The review was
full of praise, which pleased Stieglitz particularly since Soby had
never liked O'Keeffe's work before: the current exhibition con-
vinced him."[22]

Greenberg's denunciation of the Stieglitz circle and of the institutional policies of the Museum of Modern Art did not end with the O'Keeffe retrospective.[23] In an important essay entitled "The Present Prospects of American Painting and Sculpture" (*Horizon*, 1947), Greenberg again linked the Stieglitz circle's "messianic" version of modernism to the supposedly misguided agenda of the museum: "The Museum of Modern Art, which fifteen years ago replaced Alfred Stieglitz as the principal impresario of modern art in America, is the chief exponent of this new good taste, substituting for Stieglitz's messianism a *chicté* that in the long run is almost an equal liability."[24] Given the pressing needs of the younger generation for exposure and recognition, Greenberg considered it all the more egregious that Stieglitz circle paintings and faddishly "chic" European artworks should be dignified by an institution of the stature of the Museum of Modern Art.

Yet even as he was launching this critique of the museum, Greenberg simultaneously sought the Modern's support for his favored artists, using provocative tactics to draw attention to his cause. When the museum organized the exhibition "American Paintings from the Museum Collection" during the 1948–1949 season, Greenberg complained to Alfred H. Barr, Jr., that the show was "vastly disappointing" since it included "scandalously few" works by the abstract expressionists amid its wide display of American paintings. Based on Barr's selections, Greenberg accused the museum of failing to encourage American modernists. As he told Barr: "One sees how remiss the museum has been lately in its duty to encourage modern American art . . . how little, how woefully little the Museum has to show for the expenditure of so much money, space, time, energy and—at least on the part of some—devotion."[25] Barr must have found himself in an interesting position during the later forties as he simultaneously faced external pressure from Greenberg and the internal pull of curators such as James Johnson Sweeney and Monroe Wheeler who, as the respective organizers of the O'Keeffe and Hartley retrospectives at the Modern Museum, represented advocates of Stieglitz circle art. Yet Stieglitz's embodied formalist project provided Greenberg with a counterdiscourse on which to build, one he could never

have obtained from the rather arid accounts of modernism in-
scribed within the schematic outlines of Barr's flowcharts or his
quasi-documentary monographs.[26]

## Greenberg's Revisionism

The recognition that Greenberg sought for the New York School
artists would soon be forthcoming. In part, Greenberg achieved
this by linking Marin and Pollock within a revised genealogy of
American modernism. During the early forties, Greenberg began
to lay out a history of significant American painting. In 1944 he
published articles on Thomas Eakins and Winslow Homer in *The
Nation*, essays that he considered sufficiently important to reprint
in a revised form under the heading "Art in the United States" in
his collection of critical writings *Art and Culture* (1961). Accord-
ing to Greenberg, Eakins's painting is distinguished by "ideal
chiaroscuro," or the use of darks and lights to convey psychologi-
cal and symbolic meanings. Greenberg noted similar dramatic
contrasts in Winslow Homer's early oil paintings, the works by
Homer that the critic most admired.[27] In subsequent essays
Greenberg identified expressive chiaroscuro as a distinctly
"American" feature in the works of Albert Pinkham Ryder, Robert
Newman, and George Fuller, and in the literature of Hawthorne,
Poe, Melville, and Henry James.[28] Greenberg also claimed that
this tradition of ideal chiaroscuro was manifested in Marin's and
Pollock's artworks. In November of 1943 Greenberg wrote of
"Marin's [eyes] conceived instinctively in darks and lights." In
this same essay Greenberg asserted that the "muddiness of color"
in Pollock's paintings "is the equivalent, even if in a negative,
helpless way, of that American chiaroscuro which dominated
Melville, Hawthorne, Poe, and has been best translated into
painting by Blakelock and Ryder."[29] In late 1947 Greenberg again
praised Pollock's "radically American" painting which, taking its
cues from cubism, retained a powerful sense of "classical
chiaroscuro."[30] In early 1948 the critic further stressed the im-
portance of Pollock's modulated surfaces. According to Green-

berg, Pollock's "concentration on surface texture and tactile qual-
ities" prevented the "danger of monotony that arises from the
even, all-over design which has become Pollock's consistent prac-
tice."[31] Thus, instead of slipping into the repetitive consistency of
"wallpaper patterns," Pollock's use of chiaroscuro and his em-
phasis on surface texture were crucial vitalizing elements that
precluded any lapse into the decorative or the banal.

In this 1948 review Greenberg also made special mention of
two of Pollock's works, dark paintings that bore the marine titles
*Sea Change* and *Full Fathom Five* (1947, fig. 8.1). Deferring
judgment on these innovative pictures, the critic noted: "It is in-
deed a mark of Pollock's powerful originality that he should pre-
sent problems in judgment that must await the digestion of each
new phase of his development before they can be solved. Since
Marin—with whom Pollock will in time be able to compete for
recognition as the greatest American painter of the twentieth cen-
tury—no other American artist has presented such a case. And
this is not the only point of similarity between these two superb
painters."[32]

What precisely did Greenberg mean by this superlative if un-
elaborated comparison? In part, he wished to establish the exis-
tence of an American artistic base sufficiently powerful that it
could shift the momentum of the art world from Paris to New
York.[33] Greenberg noted "how much the level of American Art has
risen in the last five years, with the emergence of new talents so
full of energy and content as Arshille Gorky, Jackson Pollock,
David Smith—and also when one realizes how consistently John
Marin has maintained a high standard, whatever the narrowness
of his art—then the conclusion forces itself, much to our own sur-
prise, that the main premises of Western art have at last migrated
to the United States, along with the center of gravity of industrial
production and political power."[34]

As these comments indicate, during the forties Marin played
a dual role for Greenberg in signifying both the continuation and
the revision of Stieglitz's artistic project. Notwithstanding Green-
berg's attempts to incorporate Marin into a revised genealogy of
American modernism, Stieglitz very much remained the artist's

primary point of reference. As I have noted, Marin received his
first retrospective at the Museum of Modern Art in October of
1936. In the catalogue that accompanied this exhibition, E. M.
Benson, Marin's first biographer, echoed the Stieglitz circle's em-
bodied formalist rhetoric when he praised the sexualized aes-
thetic of Marin's landscapes. Benson wrote: "At the core of
Marin's broadest generalizations one usually discovers the fertile
sperm of organic truth."[35] In his preface to this catalogue, Alfred
H. Barr, Jr., acknowledged the long-standing bond that existed be-
tween Marin and Stieglitz, stating that "this exhibition is in no
small part a tribute to [Stieglitz's] devoted championship of
Marin's work."[36] Along these lines, in a 1941 lecture delivered at
the Johns Hopkins University, the art historian Lionello Venturi
identified Marin and Louis Eilshemius as two contemporary
American painters "whose fame will probably last for centuries."
Venturi further noted that Marin is an artist "who has been ac-
claimed by American critics and was discovered many years ago
by Mr. Stieglitz."[37] And in a lengthy feature article on Marin pub-
lished in *The New Yorker* (March 14, 1942), the critic Matthew
Josephson similarly emphasized that Marin "has gone on for over
three decades producing his water colors and holding his shows
under the wing of Stieglitz, while his now seventy-eight-year-old
sponsor, though never accepting an agent's commission for selling
any picture, has throughout this period served as his agent, and
the names of the two old men have become almost inseparable."[38]

Marin's fame grew throughout the forties, a trend that contin-
ued even after Stieglitz's death. In 1947 Marin was given a major
retrospective at the Institute of Modern Art in Boston. The follow-
ing year MacKinley Helm published an important biography of
the painter.[39] When reviewing Marin's January 1948 exhibition at
An American Place in *Artnews*, Thomas B. Hess acknowledged
that Marin is "accepted without question as one of the greatest liv-
ing American artists."[40] The following month *Look* magazine
printed the results of its survey of museum directors and art crit-
ics to whom it had posed the question: "Which ten painters now
working in the United States, regardless of whether they are citi-
zens, do you believe to be the best?" John Marin appeared at the

very top of the list of most admired artists.[41] Greenberg alluded to this superlative assessment of Marin as "the greatest living American painter" in his review of Marin's December 1948 exhibition at An American Place.[42] Shortly thereafter, Dorothy Norman edited a lengthy volume of Marin's selected writings, excerpts of which appeared in *Artnews* (October 1949).[43] In his review of this text in *The New York Times Book Review* (December 11, 1949), Francis Henry Taylor, then director of the Metropolitan Museum of Art, echoed the Stieglitz circle's own highly gendered rhetoric when he described the scope of Marin's achievement and the character of his work: "Few artists have achieved the popularity and acceptance by their own generation that John Marin has so deservedly received. Inextricably connected in the public mind with the late Alfred Stieglitz, he has continued to be regarded as the dean of American water colorists—the epitome of an individual modernism untouched by the movements of the day, fearless, inquiring, essentially virile and rooted in his native soil."[44] As Taylor's comments suggest, although Stieglitz had died in 1946, his influence continued to live in the New York art world. This situation made it all the more imperative that Greenberg dissociate Marin from his mentor. Ironically, by strategically linking the careers of Marin and Pollock, Greenberg sought to exercise precisely the type of influence over Pollock's development that Stieglitz had exerted over Marin's.

Greenberg's aspirations for Pollock are evident in the laudatory language that he used throughout the forties to describe the painter. In late 1944 Greenberg began to single Pollock out for recognition as one of "the six or seven best young painters we possess." [45] Three years later Greenberg stated outright that Jackson Pollock is "the most powerful painter in contemporary America."[46] *Time* magazine soon called this judgment into question by reproducing Greenberg's statement and Pollock's painting *The Key* (1946) under a column dubiously entitled "The Best?"[47] *Life* magazine picked up on this question in August of 1949 by printing an article entitled: "Jackson Pollock: Is he the greatest living painter in the United States?"[48]

The issue of artistic status persisted into the following year and manifested itself at an event where Marin's and Pollock's paths actually crossed: the Twenty-Fifth Venice Biennale. Jointly organized by the Cleveland Museum of Art, the Museum of Modern Art, and The Art Foundation, one half of the United States Pavilion was filled with works by Gorky, de Kooning, Pollock, Hyman Bloom, Lee Gatch, and Rico Lebrun, while the other half was dedicated to a retrospective of 55 of Marin's artworks, the first one-man show that any American artist had ever received in a European public gallery. In the introduction to the Biennale catalogue, Marin's longtime patron Duncan Phillips acclaimed the artist as "one of the most gifted and important painters since Cézanne and perhaps the best of all masters in watercolor." Phillips went on to acknowledge the central role that Stieglitz had played in Marin's career: "[Stieglitz] gave Marin a lifelong protecting sponsorship, a place to exhibit every year, freedom to paint as he pleased and a management of his sales which enabled him to live far from the marketplace, close to the mountains and the sea."[49] *Artnews* corroborated Phillips's superlative assessment, noting that Marin is "generally recognized as the greatest living American painter."[50] In the exhibition catalogue for the Biennale, Alfred H. Barr, Jr., praised Pollock in almost equally lavish terms despite the fact that only three of Pollock's works were displayed in the show, writing that Pollock "has developed perhaps the most original art among the painters of his generation."[51]

Both Marin and Pollock attended the reception for the Biennale that was held in the penthouse of the Museum of Modern Art. Dorothy Norman, who accompanied Marin to the event, recalled his response to Pollock: "Marin and I clung close together, strangers in the unfamiliar assembly. Jackson Pollock and Lee Krasner, his wife, were introduced to me; in turn, I presented them to Marin. As they walked away, Marin whispered, 'Who's that Johnny?' A new period had indeed been born."[52] In this new period, Pollock's works were often featured alongside Marin's. Following the Venice Biennale, Marin's and Pollock's paintings appeared together in the Museum of Modern Art's "Abstract Painting and Sculpture in America" exhibition of 1951 and in a

show held the following year at the Paris Museum of Modern Art. For this latter exhibition, Barr selected works by Marin, Gorky, Stuart Davis, Pollock, Calder, David Smith, and Theodore Roszak to represent the advanced state of American art.[53] In 1952 two additional works by Pollock entered the Modern's permanent collection, *Number 12* (1949) and *Full Fathom Five* (1947, fig. 8.1).

*Full Fathom Five* is one of Pollock's early drip paintings, a densely layered abstract work whose thickly encrusted surface conceals a variety of underlying items. These objects include nails, tacks, buttons, a key, coins, cigarettes, and matches. It is as though the artist had emptied out his pockets, swept up his studio, deposited the detritus onto his canvas, and then proceeded to build an abstraction on top of what he had eliminated. The density of Pollock's paint skeins intensifies the viewer's search for the hidden objects trapped beneath the painting's fictive depth.[54] In addition to being a superb example of Pollock's early drip painting, *Full Fathom Five* also suggests some of the frictional and transformative qualities in Greenberg's posture toward Stieglitz. The phrase "Full Fathom Five" is from Shakespeare's play *The Tempest*, a tale of a shipwrecked ruler who was wrongfully deposed by an evil king but was ultimately restored to a position of power. Such machinations represent a struggle for power, authority, and patrimony not unlike that in which Greenberg and Stieglitz had engaged during the 1940s. "Full fathom five thy father lies, of his bones are coral made": the literal meaning of these lines is that the father of the addressee lies submerged under five fathoms, or thirty feet, of water.[55] Thus the phrase "full fathom five" is highly resonant with Greenberg's attempts to dismiss the influence of Stieglitz—now dead—and absorb his protégé Marin into Greenberg's own developmental model of American aesthetics. Like the coins and key in Pollock's painting, the Stieglitz circle's earlier embodied formalist project seems to be present by virtue of its need to be cast off, buried, and rewritten in Greenberg's subsequent formalist discourses.

Crucial to this transition was Greenberg's strategic dissociation of Marin and Stieglitz. For instance, Greenberg's review of the 1946 O'Keeffe retrospective contained no mention of Marin, an

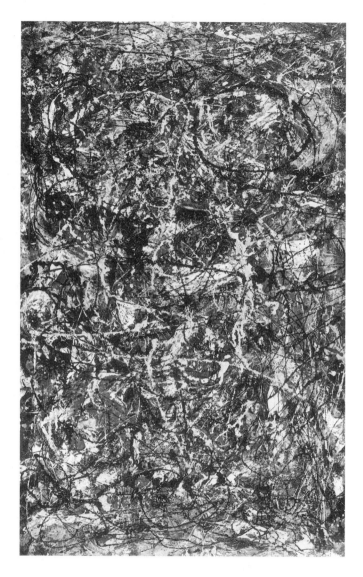

**8.1** Jackson Pollock, *Full Fathom Five*, 1947. Oil on canvas with nails, tacks, buttons, key, coins, cigarettes, matches, etc., 50 ⅞ × 30 ⅛ in. (129.2 × 76.5 cm). The Museum of Modern Art, New York. Gift of Peggy Guggenheim. Photograph ©2000 The Museum of Modern Art, New York. ©2000 Pollock-Krasner Foundation / Artists Rights Society (ARS), New York.

omission that suggests that the painter was being carefully quarantined from the "opposed extremes of hygiene and scatology" that supposedly contaminated the rest of the Stieglitz circle's productions. In "The Present Prospects of American Painting and Sculpture," Greenberg described Marin not as a Stieglitz circle artist but as one of the very few American painters ever to advance French impressionism further along in its development.[56] Through remarks such as these, Greenberg recontextualized Marin by locating his works not within the confines of Stieglitz circle painting, but within larger developments in European and American modernism.[57]

Greenberg's marginalization of Stieglitz and his recontextualization of Marin resemble the critic's dismissive treatment of Pollock's first mentor and Stieglitz's adversary, Thomas Hart Benton. During the early thirties Pollock had studied with Benton at the Art Students League in New York. Benton's influence is clearly visible in several of Pollock's early works. In a number of canvases, such as *Going West* (1934–1935, fig. 8.2), Pollock can be seen emulating his teacher's regionalist subject matter and his swirling, rhythmical painting style.[58] In 1937, a full two years after Benton had permanently left New York and returned to Missouri, he included a work by Pollock, *Departure*, in an exhibition that he mounted at the Associated American Artists gallery in New York.[59] Despite their initial closeness, however, during the forties Pollock would renounce his teacher's influence. In 1944

**8.2** Jackson Pollock, *Going West*, 1934–1935. Oil on fiberboard, 15 ⅛ × 20 ¾ in. National Museum of American Art, Smithsonian Institution. Gift of Thomas Hart Benton. ©2000 Pollock-Krasner Foundation / Artists Rights Society (ARS), New York.

Pollock specifically described the development of his abstract paintings as a reaction against his earlier training with Benton. As Pollock put it, "My work with Benton was important as something against which to react very strongly, later on; in this, it was better to have worked with him than with a less resistant personality who would have provided a much less strong opposition."[60]

Pollock's denial of Benton's influence is, however, somewhat misleading. As *Full Fathom Five* exemplifies, the drip paintings that Pollock began to execute in 1947 are in fact curiously resonant with Benton's own murals. In the previous chapter I noted that, when engaging the multiple, overlapping figures in Benton's Whitney murals, the viewer experiences a profound sense of perspectival split. The implication is that, in Benton's regionalist murals, "perspective" is not contained in any one area of the canvas but necessarily occupies multiple locations at once. In this sense, Benton's murals represent an earlier form of monumental "all-over" painting that Pollock would reinvent in his drip paintings. Unlike Benton's images, Pollock's abstract works deny three-dimensional space and thus preclude the possibility of a traditional single point perspective. Yet in both Benton's murals and in Pollock's drip paintings, perspective is not restricted to any one area of the surface, so theoretically it could be located anywhere (or perhaps everywhere) at once. Rather than being ideally situated in a fixed location on the canvas, "all-over" perspective is inherently mobile since it is dependent on the physical position that the viewing subject occupies at any given moment. Through this spectatorial dynamic, Benton's monumental figural compositions and Pollock's nonfigural abstractions can both be seen as representing a radical return to the beholder's body, in the sense that the experience of viewing these artworks is predicated on the viewer's own optical and corporeal self-positionings and identifications.

Just as revealing as Pollock's disavowal of his mentor's influence is Greenberg's treatment of Benton. In the several articles that Greenberg published on Pollock during the forties, the critic made no attempt whatsoever to link Pollock to his former teacher. It was not until 1957, a full year after Pollock's death, that Greenberg acknowledged the artist's early training with Benton.[61] Green-

berg's dismissal of Benton can be explained in part by the critic's own stance toward regionalism. The few comments that Greenberg made on this subject clearly indicate that he considered regionalist art to be a form of kitsch, a debased mass-cultural expression that was antithetical in both style and purpose to serious avant-garde art. Ironically, the excessively masculinized notion of American subjectivity that Benton projected onto his paintings provided the very basis for Greenberg's disparaging interpretation of regionalist art as vulgar and kitschy. For example, in a letter to the editor of *The Nation* (March 16, 1946), Greenberg expressed his distaste for the regionalists quite plainly: "Benton is and [Grant] Wood was among the notable vulgarizers of our period: they offered us an inferior product under the guise of high art."[62] Greenberg's dismissal, if not his actual erasure, of Benton's and Stieglitz's presences left the critic relatively free to reinvent Marin's and Pollock's achievements within his revised genealogy of American art.

## Formalism Reformulated: The Gothic and the Neo-Kantian Subject

Greenberg's early accounts of Pollock were consistent with descriptions of the artist published by his prominent colleagues. One of these was the critic and curator James Johnson Sweeney, who wrote a brief essay to accompany Pollock's 1943 exhibition at Peggy Guggenheim's Art of This Century gallery. Sweeney observed that "Pollock's talent is volcanic. It has fire. It is unpredictable. It is undisciplined. It spills itself out in a mineral prodigality not yet crystallized. It is lavish, explosive, untidy." According to Sweeney, because Pollock paints "from inner impulsion," his works are endowed with a sense of "vitality."[63] Thus as early as 1943, Pollock's expressive paint handling was imbued with connotations of masculine "vitality," as the artist's "explosive" paint flows were seen as the material equivalents of his own internal impulses. Pollock himself was so pleased with Sweeney's essay that he not only followed up by sending the critic an appre-

ciative letter but also made Sweeney a personal gift of one of the oil paintings exhibited in the show, a work entitled *Conflict*.[64]

Greenberg's review of Pollock's 1943 exhibition resonated in fundamental ways with Sweeney's account. Praising works such as *Conflict* and *Wounded Animal* as "among the strongest abstract paintings I have yet seen by an American," Greenberg also associated Pollock's painterly discharges with his artistic originality. As the critic put it, not only is Pollock "painting mostly with his own brush," but in the smaller works "Pollock's force has just the right amount of space to expand in."[65] Greenberg himself eventually acquired one of the oil paintings from Pollock's 1943 exhibition, a symbolic abstracted work entitled *The Mad Moon-Woman*.[66]

Another critical review that contributed to the early masculinization of Pollock's work is the essay that Manny Farber published in the *New Republic* (June 25, 1945). Farber observed that Pollock's painting style is "violent in its expression" yet simultaneously remains "well ordered" and compositionally "contained." Farber further remarked that "Pollock's aim in painting seems to be to express feeling that ranges from pleasant enthusiasm through wildness to explosiveness, as purely and as well as possible." Equating the artist himself with his energetic paint handling, Farber noted that the formal idiom of Pollock's abstract style "is very personal," since "the individuality is in the way the medium is used rather than in the peculiarities of subject matter." Finally, Farber built on the paradoxical conception of Pollock's art as violent yet contained, personal yet abstract: "The painting is laced with relaxed, graceful, swirling lines or violent ones, until the surface is patterned in whirling movement. In the best compositions these movements collide and repeat to project a continuing effect of virile, hectic action. The paint is jabbed on, splattered, painted in lava-like thicknesses and textures, scrabbled, made to look like smoke, bleeding, fire, and painted in great sweeping continuous lines." Despite the turbulence of Pollock's "virile" and "hectic" lines, Farber saw Pollock's painting as retaining an overall sense of abstract purity: "An extraordinary quality of Pollock's composing is the way he can continue a feeling with little deviation or loss of purity from one edge to the other of the most detailed design."[67]

This critical dialectic of explosive, virile energy and formal control is powerfully expressed in Greenberg's writings of the following year. When reviewing Pollock's third exhibition at Art of This Century in *The Nation* (April 13, 1946), Greenberg commended the artist for his "discipline" and his "willingness to be ugly in terms of contemporary taste. . . . Pollock's superiority to his contemporaries in this country lies in his ability to create a genuinely violent and extravagant art without losing stylistic control. His emotion starts out pictorially; it does not have to be castrated and translated in order to be put into a picture." On the basis of these qualities, Greenberg deemed Pollock "the most original contemporary easel-painter under forty."[68] In short, from an early point Pollock's artworks were characterized in paradoxical terms as being somehow violent *and* controlled, liberated *and* disciplined, and replete with a sense of vital ("non-castrated") energy that nonetheless lends itself pliably to (sublimated) pictorial expression. The complementary emphases on masculine derepression and aesthetic expressiveness that thread through Greenberg's account of Pollock are particularly notable given that such an appraisal came from a critic who, only a few years before, had outspokenly advocated the formal "purity" of advanced painting's autotelic engagement with its own medium.[69]

Greenberg returned to these themes later that year in an article that appeared in the French periodical *Les Temps Modernes* (August/September 1946). In this piece the critic identified the development of a genre of American painting that he described as "gothic, neo-expressionist and abstract." According to Greenberg, this work produces an elaborate baroque impression that evokes Poe "and is full of a sadistic and scatological sensibility." Yet at the same time, such painting "is disciplined by formal ambitions."[70] Greenberg further elaborated on these seemingly contradictory concepts the following year in his essay "The Present Prospects of American Painting and Sculpture." The critic again drew on the notion of "Gothic-ness" to characterize Pollock's art as aesthetically powerful despite its radical and extreme corporeality: "The most powerful painter in contemporary America and the only one who promises to be a major one is a Gothic, morbid,

and extreme disciple of Picasso's cubism and Miro's post-cubism, tinctured also with Kandinsky and Surrealist inspiration. His name is Jackson Pollock." According to Greenberg, Pollock's paintings at once evoke feelings of "violence, exasperation and stridency" yet remain pictorially consolidated: "Pollock's strength lies in the emphatic surfaces of his pictures, which it is his concern to maintain and intensify in all that thick, fuliginous flatness which began—but only began—to be the strong point of late cubism." Emphasizing the importance of the environment in which Pollock worked, Greenberg wrote: "For all its Gothic quality, Pollock's art is still an attempt to cope with urban life; it dwells entirely in the lonely jungle of immediate sensations, impulses and notions, therefore is positivist, concrete. Yet its Gothic-ness, its paranoia and resentment narrow it; large though it may be in ambition—large enough to contain inconsistencies, ugliness, blind spots and monotonous passages—it nevertheless lacks breadth."[71]

Thus in his writings of 1946 and 1947, Greenberg combined the notion of "Gothic-ness" with the themes of chaos, violence, ugliness, and "non-castrated" sexuality to establish a metaphorics of masculinity in Pollock's works. While Greenberg had associated the Gothic with surrealism,[72] he was also rewriting the meanings that the Museum of Modern Art had assigned to this term just the year before. In the catalogue that accompanied the exhibition "Romantic Painting in America" (1943), James Thrall Soby identified a "Gothick" impulse in American painting, one found most notably in the works of Washington Allston, Charles Burchfield, and Charles Demuth. Soby's conception of the "Gothick" was a romantic one associated with a mystical and melancholic sensibility.[73] But more important for Greenberg than these precedents in surrealism and romanticism was the formalist conception of the Gothic that was put forth by the German art historian and theorist Wilhelm Worringer, particularly Worringer's *Abstraction and Empathy* (1908) and *Form in Gothic* (1912). From the 1920s onward, both of these texts were well known to an English-speaking audience, largely through the efforts of the art historian and critic Herbert Read.[74]

In *Abstraction and Empathy* Worringer characterized empathy as a form of self-affirmation that stems from man's deep connection with nature. According to Worringer, a profound sense of interwovenness with the environment leads to feelings of "happy pantheism" and the creation of organic artworks. In contrast, Worringer described abstract art as displaying a self-conscious avoidance of three-dimensional space, a tendency that issues from man's intense sense of alienation, fear, and distrust of his environment. Unlike empathy, which reflects man's desire to reproduce his surroundings in organic and naturalistic forms, abstraction represents an attempt to transcend the world.[75]

When Greenberg's contemporary comments on Pollock and the Stieglitz circle are read comparatively in the light of Worringer's ideas, the theoretical underpinnings of his argument become apparent. In 1946 Greenberg found Stieglitz circle art to be pantheistic, "pan-loving," arbitrary, mystical, organic, and fetishistic. That year and the following one the critic described Pollock's works as "Gothic," morbid, extreme, violent, and ugly.[76] Furthermore, these categories were not neutral but connoted gendered and cultural hierarchies. Worringer considered the tendency toward abstraction to represent a more advanced stage of cultural development than the expression of empathy. While empathy was associated with the sensuous beauty of warm southern climates, abstraction was viewed as an artistic response to the more hostile and potentially violent northern environment. As a result, Pollock's "Gothic," violent, lonely, ugly, and profoundly original artworks were made to evoke a typology of masculinity, while the Stieglitz circle's "pantheistic" fetishistic, organic, and unoriginal paintings were characterized as derivative and feminized affectations spun from the residue of high culture. Worringer's concepts thus provided Greenberg with a means of theorizing abstract art as an embodied response to the lived environment which was, at the same time, embedded in a teleological narrative of cultural progress.[77]

If the Gothic came to be associated with the violent, extreme, and nonrepressed aspects of Pollock's modernist practice, Greenberg's adaptation of Immanuel Kant's writings constituted its ra-

tionalist counterpart.[78] Foremost among the Kantian principles that Greenberg would adopt were hierarchically structured relations between judgment and pleasure, between reason and desire. Within a Kantian framework, desire is subsumed under the aegis of judgment and reason to produce an interwoven yet controlled relation between these categories.[79] As Kant states in the "Critique of Aesthetic Judgment" section of his *Critique of Judgment* (1790), "For the faculty of desire there is reason, which is practical without mediation of any pleasure of whatsoever origin. Reason as a higher faculty determines for the faculty of desire the final end accompanied by pure intellectual delight in the object."[80] Throughout the *Critique* Kant posits a disinterested subject who is guided by universal laws and who is thus able to maintain firm categorical distinctions between the sensuous and the abstract realms. These conceptual boundaries are constituted as integral to the process of aesthetic reflection, an experience that is necessarily detached from the actual existence of the object.[81] Because pleasure is seen as issuing not from the presence of an object but from the subject's own contemplation of that object, desire itself becomes curiously disembodied within a Kantian framework. As Kant states in the *Critique,* "The consciousness of mere formal purpose in the play of the thinking faculties of the subject with imagining an object, is the pleasure itself."[82] Thus according to Kant, awareness of an object's "formal purpose" directly facilitates the subject's imaginative experience of that object, leaving the corresponding sense of pleasure effectively dematerialized. By performing these complex cognitive functions, the ideal Kantian subject is able to maintain a controlled relation between the intellectual and the physical realms, one that enables "him," paradoxically, to overcome *and* to remain within his own body at the same time.

In this universalizing context, the masculine gendering of the pronoun "him" is significant. As Christine Battersby has pointed out, "Kant has devised a so-called 'universal duty' of controlling and transcending emotion; but it is a duty that gains its legitimacy only by taking the male body and mind as ideal and norm."[83] Following Kant, the subjectivity that Greenberg inscribed within

Pollock's paintings is predicated on the paradoxical notion of a transcendent masculinity, one that connotes a powerful, autonomous subject who is nonetheless rooted in the conditions of his own embodied existence. Through this network of associations, the conceptual boundary demarcating constructions of Pollock's personal identity from the symbolic corporeality of his artworks becomes a highly porous one.

While neo-Kantian notions of discipline, control, and aesthetic containment are evident in Greenberg's discussions of Pollock's art as early as 1947, this theoretical approach would be more fully developed by 1952, when the critic published articles on Pollock in *Partisan Review* and *Harper's Bazaar*. Discussing the drip paintings that the artist produced between 1947 and 1950, Greenberg wrote that Pollock "strove for corporeality and laid his paint on thick and metallic." Echoing the Kantian notion of self-referentiality, Greenberg wrote that Pollock's painting represents "high classical art: not only the identification of form and feeling, but the acceptance and exploitation of the very circumstances of the medium of painting that limit such identification."[84] In turn, this emphasis on the materiality of the painterly medium enabled Greenberg to inscribe a sense of abstract physicality into Pollock's nonfigural works. Through these associations, Pollock's paintings were presented as self-sufficient, symbolic bodies that were at once solidly corporeal and classically sublimated. Greenberg stated this conception even more explicitly the following month in *Harper's Bazaar*. The critic wrote of the drip paintings that "each picture is the result of the fusion, as it were, of dispersed particles of pigment into a more physical as well as aesthetic unity—whence the air-tight and monumental order of his best paintings of that time."[85] Thus the densely fused quality of Pollock's drip paintings enabled these works to be seen and described as monumental, hermetically sealed, and inviolable presences. In this revised account of embodied formalist aesthetics, the integrity of the painted surface becomes coextensive with the seemingly autonomous existence of the creative masculine subject as a unique, discrete, and self-sufficient entity.

The "Gothic" associations of physical extremity and tran-
scendence and the neo-Kantian conceptions of autoreferentiality
and detachment that jointly inform Greenberg's discussions of
Pollock inherently preclude notions of relational identity and in-
tersubjective merger. Applying Battersby's insights on the im-
plicit masculinity of the ideal Kantian subject to Greenberg's
formalist theorizations of Pollock, I would suggest that the critic's
conceptions of artistic subjectivity could not structurally refer to
a feminine subject position. Perhaps Greenberg was simply artic-
ulating the values of the culture at large. In the various articles
and profile essays on Pollock that were published throughout the
forties and early fifties, Lee Krasner often hovers in the back-
ground as Pollock's wife, but she is not treated as an independent
subject or as an artist in her own right. Rather, she becomes a kind
of placeholder whose primary purpose is to reaffirm Pollock's own
heterosexual status. In both the public representations of Krasner
and in the reviews of O'Keeffe's retrospective at the Museum of
Modern Art (1946), female artistic identities are consistently pre-
sented not as autonomous and transcendent, but as dialogical and
invariably receptive to their "significant others."[86]
    This underlying association of femininity with relationality
and intersubjective merger further helps to account for Green-
berg's repudiation of the Stieglitz circle's version of embodied for-
malist aesthetics. Unlike the Stieglitz circle's celebration of the
interwoven and even "transparent" relations between the gen-
dered body, the natural world, and abstract painterly form, in
Greenberg's theoretical approach paintings were constituted as
autonomously embodied, sublimated fields that were inflected by
the masculine gender of their producer and structured by the lim-
itations of their own medium. Furthermore, Greenberg's powerful
coupling of masculine aggressiveness and aesthetic transcen-
dence in his conception of the Gothic, combined with the restora-
tion of conventional Enlightenment subjectivity implicit in his
neo-Kantianism, collectively effected a shearing off of relational,
erotic impulses from the gendered (yet always implicitly mascu-
line) subject. As a result of this cleavage in Greenberg's formalist
discourse, anxiety becomes representable just as desire becomes

unrepresentable in the critical constructions of Pollock's advanced abstract paintings.

Finally, these distinctions help to account for Greenberg's specific response to the Stieglitz circle artists, particularly the pivotal status of John Marin and the notable absence of Arthur Dove. As discussed in chapter 4, Dove's role in the Stieglitz circle's embodied formalist project was that of the "penetrator" and "impregnator" of receptive, implicitly feminized, pictorial surfaces. This construction of Dove's artistic persona was necessarily dependent upon the analogical presence of feminine responsiveness. In contrast, Marin's works promised the possibility of a self-sufficient heterosexual masculinity, one that functioned in the absence of female sexual presence. As discussed in chapter 5, throughout the twenties and thirties Marin's works were characterized as the product of the artist's joyous and spontaneous merger with the world followed by his ecstatic release. While critics expressly stated that Marin's ejaculations were fertilizing elements, the object of his attentions was not a woman per se but a vision, an artistic vision realized on paper. Thus while (according to the Stieglitz circle critics) the ejaculatory touch displayed in Marin's paintings issued from the artist's envelopment in the sensuous, natural world, Pollock's violent yet controlled, "noncastrated" paintings exemplified (according to Greenberg) a desire to escape from that world. In this sense, Greenberg's dismissal of Stieglitz and his appropriation of Marin can be seen as both an attempt to wipe the slate clean, as it were, of Stieglitz's inclusive and behaviorally unbounded project and as the restoration of a conventional sense of masculine order within a revised embodied formalist paradigm.

### Reviewing Marin's Frames: Flexible Backbones or the Afflictions of Artiness?

Given the nature of their respective projects, it is not surprising that Greenberg had trouble with the homemade decorated wooden picture frames that Marin frequently made to accompany his

work. In December of 1948, at the height of the critic's efforts to champion Marin and Pollock as preeminent figures in American modernism, Greenberg had to demur on two points in Marin's oeuvre: his handmade picture frames and the lingering traces of Stieglitz's influence in his paintings. Greenberg felt that both tended to detract from Marin's pictures themselves. As the critic put it, Marin's "idiosyncratic frames, designed by the artist himself and charming enough as objects in themselves, prevent one from getting a sufficiently clear impression of the paintings." Just as Greenberg found Marin's frames to be a liability, so too was the artist's previous connection with Stieglitz. Greenberg noted that elements of Stieglitz's "art evangelism," or the "art-and-America mystique," lingered in Marin's painting and even impaired its development. As he put it, "Marin is not yet rid of the artiness that he, like the rest of Stieglitz's protégés, contracted from that impresario."[87] Significantly, in the revised version of this essay that Greenberg published in *Art and Culture,* the critic actually conflated Stieglitz's influence on Marin with the "artiness" of his picture frames. Greenberg wrote: "'Artiness' was the affliction of all of Stieglitz' protégés. The frames, designed and decorated by himself, that Marin puts around his oils remind us of that. These frames may be charming objects in themselves, but they would hurt any kind of picture, and they have made it impossible so far to get a completely clear view of many of Marin's."[88] Despite his admiration for Marin's paintings, Greenberg could never get completely past the taint of "artiness" that he perceived in Marin's handmade frames and in the artist's primary frame of reference, Alfred Stieglitz.

Within Marin's oeuvre, frames functioned at once as external, decorative supplements to his artworks and as internal structuring devices that were integral to the formal stability of his compositions and to establishing the embodied connotations of his works. Along these lines, Marin repeatedly maintained that he was not a "pure" abstract painter, and he expressed his disdain for those who were. In a pamphlet published by An American Place (1946), Marin stated flatly, "There never was or never will be a non-objective art."[89] In the foreword to MacKinley Helm's biogra-

phy of him (1948), Marin pointedly characterized the work of the abstractionist as "a disease[d] approach" to painting and "a pleasure in torture" since it was based on a "hatred of all things Seen." Furthermore, the artist enlisted the Stieglitz circle's well-known metaphors to describe the supposedly alienated work of the abstractionists as "streamlined of all humanity where an old fashioned human embrace is quickly nullified by divorce."[90] In July of 1953 Marin again stated his contempt for abstract art. He told the critic Louis Kalonyme, "Personally myself speaking I've no place for—no want for—what is termed the abstract—the nonobjective—no not one—." Without mentioning Greenberg by name, Marin voiced his resentment of critics who cited his works to promote abstract art. Marin told Kalonyme that their philosophy is "I and my subordinates—we take over—we possess—you—Out of my way—I destroy you—I destroy all you term—the beautiful."[91] In contrast, Marin repeatedly maintained that his work was based on an "old fashioned" embrace of the natural world and its deep interwovenness with the self.

Indeed, residual traces of subject matter, most often of landscape, are evident in even the most freely handled of Marin's works. Yet during the later forties the artist also began to express an ambivalence toward his subject matter. Echoing Greenberg's own rhetorical terms, Marin told MacKinley Helm that his goal for the oils he made during the autumn of 1947 was "to give paint a chance to show itself entirely as paint. Using paint *as* paint . . . is different from using paint to paint a picture. I'm calling my pictures this year 'Movements in Paint' and not movement of boat, sea, or sky, because in these new paintings, although I use objects, I am representing paint first of all, and not the motif primarily."[92] Helm noted that Marin's "Movements in Paint" series culminated in "a large abstract landscape executed in a complicated pattern of planes. 'I am going to call it Sea or Mountain As You Will,' Marin said. 'The paint is the thing.'"[93]

As Marin suggested, *Movement—Sea or Mountain as You Will* (1947, fig. 8.3) is a highly ambivalent work, one that oscillates between representational legibility and vivid abstractedness, or to paraphrase the artist, the showcasing of "paint *as*

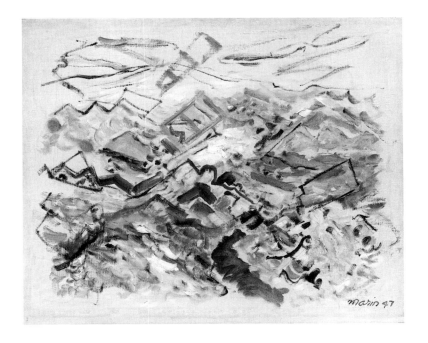

**8.3** John Marin, *Movement—Sea or Mountain as You Will*, 1947. Oil on canvas, 30 × 36 ¾ in. (76.2 × 93.3 cm). Museum of Fine Arts, Boston, Arthur G. Tompkins Residuary Fund. Courtesy Museum of Fine Arts, Boston. Reproduced with permission. ©1999 Museum of Fine Arts, Boston. All rights reserved.

paint." Emphatic brushstrokes provide a sense of coherence to this otherwise disorganized jumble of landscape fragments and loose, painterly forms. While Marin maintained that the "paint is the thing," at the same time he was adamant that his paintings were not abstractions. Regarding works such as *Movement—Sea or Mountain as You Will*, Marin told Helm, "The sea that I paint may not be *the* sea, but it is *a* sea, not an abstraction."[94] Marin's late landscapes thus stand poised between their iconography and their abstractedness. The very title of the series, *Movements in Paint*, suggests a sense of continuous motion that resonates with the equally flexible subtitle *Sea or Mountain as You Will*. Because Marin's work can be seen as *either* a landscape or a seascape depending upon the perception of the viewer, the image simultaneously floats between the two associations. This fluctuating quality enables Marin's painting to "move" in multiple directions at once. As a landscape or a seascape, the painting projects backward into the fictive depth of receding spatial planes. Yet as "paint about paint," the work calls attention to the formal patterns that unfold kinetically on its own lush surface. Underlying these formal operations is yet another paradox. Like many of Marin's late works, this painting is integrated in its own brokenness. That is, the pictorial unity of the design seems to lie in the flexible rhythms of the dense, painterly patches that appear to be suspended on the surface of the canvas yet are held together by the "connective tissue" of Marin's framing elements.

Two years after Marin painted *Movement—Sea or Mountain as You Will*, he described the formal relations of his artworks in terms of human anatomy. When explaining what makes a "good picture," Marin wrote that it is "Made—by an instinctive recognition of the—Basic—the great horizontal—the culmination of rest. The great upright—the culmination of activity—for all things sway away from or toward these two. . . . A recognition of the backbones—as it were—of movement—all objects within the picture obeying the magnetic pull of these backbones. Having not—these backbones of movement—in the mind's eye—there can be no real creation."[95]

Marin thus located a painting's mobility in its "backbones," those structures that enable the work to "move." Yet what exactly did Marin mean by a painting's "backbones"? As discussed in chapter 5, the central organizing elements, or "backbones," of Marin's paintings are his frames. *Movement—Sea or Mountain as You Will* not only displays a number of internal framing elements, but is also set in a "Marin frame." Located just outside the painted landscape, Marin's picture frame represents a hinge between the worlds of the artist, the viewer, and the painting. As such, it functions as a bridge between the physical and aesthetic realms, the dynamic location in which the Stieglitz circle's own embodied formalist discourses were themselves situated.

## Embedded Presences, Unbroken Surfaces

It is difficult to identify a precise visual connection between Marin's and Pollock's paintings, though Pollock himself may have hinted at the existence of one. Dorothy Norman has written that, during the early fifties, she established a friendly relationship with both Pollock and Krasner while they were living in East Hampton. During a visit to Norman's home, Pollock reportedly told her, "You know, I admired Marin greatly and for a while was even influenced by him."[96] While it is hard to know exactly what, if anything beyond mere politeness, Pollock may have meant by such a statement, it is clear that during the mid- and later forties Marin and Pollock were engaged in exploring similar questions in their artworks. These questions seem to concern the ways in which the artist could integrate elements of his own corporeal presence into the formal structures of his abstracted paintings. In October of 1949 a selection of Marin's writings was published in *Artnews*. In one of the excerpted statements, Marin described the "weight balances" that underpinned the production of his artworks. The artist wrote: "As my body exerts a downward pressure on the floor, the floor in turn exerts an upward pressure on my body. Too, the presence of the air against my body, my body against the air, all this I have to recognize when building the picture."[97] In an equally

well-known statement published in 1947, Pollock remarked on the ways in which he situated his body in relation to his abstract works. Beginning that year, the artist removed his larger canvases from their easels and placed them on the floor. Pollock described this painting process in the magazine *Possibilities:*

> I prefer to tack the unstretched canvas to the hard wall or floor. I need the resistance of a hard surface. On the floor I am more at ease. I feel nearer, more a part of the painting, since this way I can walk around it, work from the four sides and literally be *in* the painting. This is akin to the method of the Indian sand painters of the West.
>
> I continue to get further away from the usual painter's tools such as easel, palette, brushes, etc. I prefer sticks, trowels, knives, and dripping fluid paint or a heavy impasto with sand, broken glass, and other foreign matter added.[98]

Similarly, in an interview that he gave to his neighbor William Wright in 1950, the artist admitted that he sometimes entered his own canvas. Pollock stated: "I do step into the canvas occasionally—that is, working from the four sides I don't have to get into the canvas too much."[99]

Photographs by Hans Namuth taken that summer at Pollock's Long Island studio (fig. 8.4) show the artist, as he says, "*in* the painting," standing on his canvas, dripping paint onto its surface.[100] While working in this manner, Pollock's body literally merges with the surface of his artwork. As a result, the artist's own physical presence, along with the paint, sand, broken glass, and other artistic materials, becomes a primary reference point in the drip paintings. Taken together, these references help to sustain a dialogical relation between embodiment and aesthetics in Pollock's works. On the one hand, traces of Pollock's corporeal presence serve as analogues for the physical movements of the creative subject immersed in his own artworks. Yet on the other hand, such conspicuous traces of physicality also signify the artist's active participation in contemporary cultural formations that define artistic creativity and serve it up as a kind of performance.[101]

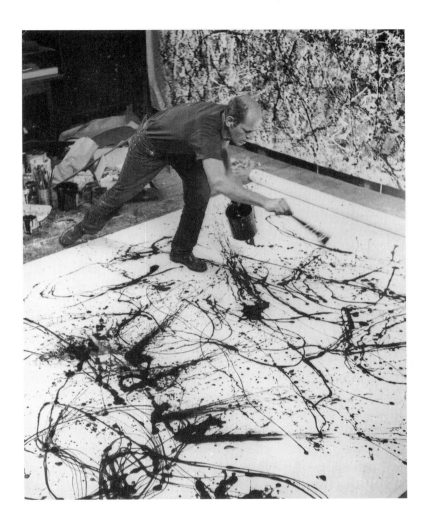

**8.4** Hans Namuth, *Jackson Pollock at Work, 1950.* Photograph by Hans Namuth. © 1991 Hans Namuth Estate. Courtesy Center for Creative Photography, The University of Arizona.

This sense of an embedded corporeal presence in Pollock's abstractions is powerfully expressed in paintings such as *Number 1, 1948* (1948, fig. 8.5), one of the three works by Pollock exhibited at the Venice Biennale of 1950.[102] This artwork contains a diverse range of paint marks, including mat areas of poured paint; a lively maze of thick, flat strokes; and heavily impastoed paint skeins. Just as this range of marks suggests the different ways in which Pollock applied paint to his canvas, so too do various traces of Pollock's physical presence emerge on the surface of his artwork. In the upper right corner of the painting, a series of black handprints appears dramatically against the beige canvas. In fact, this pattern of handprints extends around the perimeter of the entire painting, with the hand reaching out from the center. In order to achieve this pattern, Pollock would had to have been kneeling literally in the center of the canvas and extending gesturally around.[103] Pollock's handprints gradually merge with his paint skeins to suggest that one manifestation of "the artist's hand" has fused with another. A third trace of Pollock's "hand" is found in the signature that appears along the bottom edge of the painting. Like the handprints, the signature is clearly legible yet nearly blends into the paint marks that appear just above it.[104] In this manner, Pollock's presence is manifested in three distinct registers in *Number 1, 1948*, including the corporeal (the encircled pattern of handprints), the linguistic (the artist's signature), and the aesthetic (the paint marks). Each is an artifact of the related activities of touching, writing, and painting, and all affirm Pollock's identity as an embodied subject, an author, and an artist.

Moreover, the gendered connotations associated with Pollock's earlier works can be seen as continuous with the formal operations of the drip paintings.[105] In a sense, Pollock's "all-over" paintings are inherently whole (and hence "non-castrated") because they cannot be broken down into their component pieces. That is, Pollock's paint skeins cannot be unraveled. Instead, when paired with the artist's own statements and the critical commentary that accompanied them, the drip paintings' complex, unbroken surfaces make these images appear as dense, monumental presences.

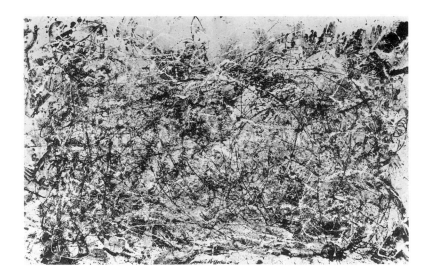

**8.5** Jackson Pollock, *Number 1, 1948.*
Oil and enamel on unprimed canvas, 68
in. × 8 feet 8 in. (172.7 × 264.2 cm). The
Museum of Modern Art, New York. Pur-
chase. Photograph ©2000 The Museum
of Modern Art, New York. ©2000 Pol-
lock-Krasner Foundation / Artists Rights
Society (ARS), New York.

As in the Stieglitz circle's embodied formalist discourses, notions of generativity in Pollock's artistic practice were expressed through a central paradox. In both cases, the artist is described (and describes himself) as interacting immersively with something that is not the self—the physical environment and his painterly materials—in order to sustain a coherent version of the self. Like Marin's frames and weight balances, Pollock's comments in *Possibilities* suggest that the artist experienced a kind of productive collapse between the boundaries of the self and those of his painting.[106] As Pollock stated, "When I am *in* my painting, I'm not aware of what I'm doing. . . . It is only when I lose contact with the painting that the result is a mess. Otherwise there is pure harmony, an easy give and take, and the painting comes out well."[107] Thus it is precisely the blurring of the physical and categorical boundaries between the self and the painting that ultimately serves to consolidate and sustain those very boundaries as the site of Pollock's artistic originality.

Within these complementary categorical blurrings lies yet another paradox consisting of the interplay between control and uncontrol in the artist's ostensive ability to regulate his painterly outpourings while maintaining the capacity to marshal an explosive vitality in these same fluid discharges.[108] While Marin's flows of oil and watercolor were organized by an elaborate system of internal and external framing devices, Pollock's "all-over" paintings were guided largely by the degree of agency that the artist was able to exert over his painting technique.[109] Pollock himself adamantly asserted his ability to control his own paint flows. In the radio interview with Wright quoted above, Pollock noted the freedom of movement that his painting technique afforded him, and insisted, "with experience—it seems to be possible to control the flow of the paint, to a great extent, and I don't use—I don't use the accident—'cause I deny the accident."[110] Pollock similarly refuted the characterization of his artwork as chaotic in *Time* magazine (December 11, 1950), dispatching a message to the editor that declared: "NO CHAOS DAMN IT. DAMNED BUSY PAINTING."[111] Such interjections can be read as the rhetorical equivalents of aggression erupting within an as-

sertion of control. Robert M. Coates of *The New Yorker* (December 9, 1950) identified this dual tendency in Pollock's drip paintings when he observed that "the drawing is irregular and sinuously curved, while the composition, instead of being orderly and exact, is exuberant and explosive."[112] In 1948 Henry McBride noted a similar dynamic in Marin's artworks when he wrote that Marin's "firmer command over procedure" in his watercolors "is due to the artist's temperament which is nervously explosive."[113] In short, a leitmotif surrounding Marin and Pollock is the notion that their painterly discharges were powerful detonations that did not destroy, but instead creatively built up, the formal (and symbolically embodied) structures of their artworks.

## Epilogue: Formalism's Embodied Subjects and Unbroken Histories

In the recurrence of these themes may perhaps lie the unexpected legacy of Stieglitz's critical project. Two years after Pollock's premature death in 1956, Greenberg wrote an essay entitled "Byzantine Parallels," which he published in *Art and Culture*. Discussing the drip paintings of Pollock's "middle period," the critic described the artist's ability to create a radiant space between his paintings and their spectators, one "which consists in the projection of an indeterminate surface of warm and luminous color in front of the actual painted surface." Greenberg explained that Pollock achieved this effect "with his aluminum paint and interlaced threads of light and dark pigment. This new kind of modernist picture, like the Byzantine gold and glass mosaic, comes forward to fill the space between itself and the spectator with its radiance. And it combines in similar fashion the monumentally decorative with the pictorially emphatic, at the same time that it uses the most self-evidently corporeal means to deny its own corporeality."[114] According to Greenberg, the corporeality of Pollock's drip paintings is thus as sensual as it is fugitive, as these works extend their "warm and luminous" presences into the interstitial space between themselves and their viewers.

While such a critical formulation is clearly distinct from Huneker's notion of the absent fourth wall and the Stieglitz circle's emphases on artistic and corporeal transparency, it would be wrong, I feel, to dismiss their similarities too quickly. Greenberg's critical statements return us to the Kantian paradoxes of abstract pleasure and the disembodied body as the critic strategically evokes the attributes of the body in order to deny and transcend them while, inevitably, reinscribing their very corporeal appeal. Although Greenberg describes a linear trajectory unfolding between decorative embodiment and aesthetic transcendence, these states are not polarized but inherently loop back onto themselves in a continuous circuit of reference and desire. In this manner, categorical boundaries are established only to be crossed and recrossed upon each encounter with the drip paintings, just as the artworks themselves are repeatedly constituted as symbolic bodies that are meant to be relished and disavowed each time the spectator stands amidst their radiance.[115]

For both Greenberg and the Stieglitz circle, formalist discourses were instrumental in inscribing such relations between bodies and paintings as either mutually intertwined and potentially eroticized or discretely contained and aesthetically autonomous—or perhaps as something of both. In each case, critical language itself serves as either the bridge into or the barrier enclosing the symbolic body of the painting. Despite the differences in their respective critical programs, for both Greenberg and the Stieglitz circle formalist discourse was based on a strong internal dialectic between gendered corporeality and impalpable disembodiment, the latter of which variously took the forms of spirituality, opticality, or transcendence. This combination of meanings enabled a single artwork to inhabit two domains simultaneously, that of material sensuousness and that of aesthetic and conceptual complexity. As a result, formalism represented a metaphysical discourse that was not limited, but rather fundamentally enriched, by its own conceptions of physicality.

In tracing the subtlety and endurance of formalism as a discursive paradigm, it is my hope that this study raises new questions about the conceptual flexibility of formalist criticism itself,

particularly the gendered nature of its underpinnings and the versatile role that it played in the formation and development of American modernism. Even in its seemingly most rigid and extreme guises, who else *but* the formalist critic was able to determine what the painterly "body" and its concomitant notions of aesthetic purity would consist of? Whether clothed in the Stieglitz circle's mysticism or later in Greenberg's positivism, formalist criticism was crucially heightened and concretized by being rooted in the body and, ultimately, sustained by the fluid promise of its own rhetoric.

*Notes*

## Introduction

1.  Sue Davidson Lowe, *Stieglitz: A Memoir/Biography* (New York: Farrar, Straus, Giroux, 1983), pp. 257–258. O'Keeffe's previous one-person exhibition had been held at Stieglitz's first gallery, 291, from April 3 to May 14, 1917.

2.  Henry McBride, "Art News and Reviews—Woman as Exponent of the Abstract," *New York Herald* (February 4, 1923), sec. 7, p. 7; reprinted in Barbara Buhler Lynes, *O'Keeffe, Stieglitz, and the Critics, 1916–1929* (Chicago and London: University of Chicago Press, 1989), p. 187. See pp. 63–73 of this study for an analysis of O'Keeffe's 1923 exhibition.

3.  Paul Rosenfeld, "The Paintings of Georgia O'Keeffe: The Work of the Young Artist Whose Canvases Are to Be Exhibited in Bulk for the First Time This Winter," *Vanity Fair* 19 (October 1922); reprinted in Lynes, *O'Keeffe*, p. 178.

4.  Rosenfeld, "The Paintings of Georgia O'Keeffe," p. 177.

5.  Rosenfeld, "The Paintings of Georgia O'Keeffe," p. 178.

6.  Helen Appleton Read, "Georgia O'Keeffe's Show an Emotional Escape," *Brooklyn Daily Eagle* (February 11, 1923), p. 2B; reprinted in Lynes, *O'Keeffe*, p. 192.

7.  Paul Strand's letter appeared in "Art Observatory: Exhibitions and Other Things," *The World* (February 11, 1923), p. 11M; reprinted in Lynes, *O'Keeffe*, p. 194.

8.  Herbert J. Seligmann, "Georgia O'Keeffe, American," *MSS* 5 (March 1923), p. 10; reprinted in Lynes, *O'Keeffe*, p. 196.

9.  Although there is no specific listing of Rosenfeld's ownership of an O'Keeffe canna lily under the relevant provenance sections of the O'Keeffe catalogue raisonné, period archival documents clearly establish his possession of such a painting. These documents include the letters that Alfred Stieglitz sent to Rosenfeld (September 10, 1921, Yale Collection of American Literature, Beinecke Rare Book and Manuscript Library, Yale University; hereafter cited as YCAL) and Rebecca Strand's letter to Stieglitz and O'Keeffe (August 1922, YCAL), quoted in Benita Eisler, *O'Keeffe & Stieglitz: An American Romance* (New York: Penguin Books, 1991), p. 264.

10. On this point see Lowe, *Stieglitz*, p. 257.

11. Waldo Frank, *The Re-discovery of America: An Introduction to a Philosophy of American Life* (New York: Charles Scribner's Sons, 1929), p. 23.

12. Kathleen Pyne, *Art and the Higher Life: Painting and Evolutionary Thought in Late Nineteenth-Century America* (Austin: University of Texas Press, 1996). Pyne is currently at work on a study of feminine creativity in Stieglitz circle art.

13. James Huneker, "Henrik Ibsen," in *Iconoclasts: A Book of Dramatists* (New York: Charles Scribner's Sons, 1905), p. 2. "The Fourth Wall" and "The Magic Wall" were potential titles that Huneker considered for *Iconoclasts*. Huneker later told the critic Edward G. Marsh that he regretted not having kept one of these titles. (James Huneker to Edward G. Marsh, May 17, 1905, Dartmouth College Library.)

14. James Huneker, "Matisse, Picasso, and Others," in *The Pathos of Distance: A Book of a Thousand and One Moments* (New York: Charles Scribner's Sons, 1913), p. 146.

15. Reproduced in *Camera Work* 23 (July 1908), pp. 11–12.

16. Conrad Fiedler, *On Judging Works of Visual Art* (1876; Berkeley and Los Angeles: University of California Press, 1957).

17. Heinrich Wölfflin, *Classic Art: An Introduction to the Italian Renaissance* (1898), trans. Peter and Linda Murray (Ithaca: Cornell University Press, 1952); and Wölfflin, *Principles of Art History: The Problem of the Development of Style in Later Art* (1916; New York: Dover Publications, 1950).

18. Wilhelm Worringer, *Abstraction and Empathy: A Contribution to the Psychology of Style* (1908), trans. Michael Bullock (New York: International Universities Press, 1980). Worringer would elaborate on these themes in his study *Form in Gothic*, trans. and ed. Herbert Read (London: G. P. Putnam's, 1927).

19. Vernon Lee, *Beauty & Ugliness and Other Studies in Psychological Aesthetics* (London and New York: John Lane, 1912); and Lee, *The Beautiful: An Introduction to Psychological Aesthetics* (Cambridge: Cambridge University Press, 1913).

20. Roger Fry, *Vision and Design* (1909; New York: Times Mirror Company, 1974). See also Clive Bell, *Art* (New York: Frederick A. Stokes, 1913).

21. Scholars have also pointed out that the art nouveau style corresponded to contemporary developments in French psychology. The differences between the French and American situations are, however, substantive. The theories of Jean-Martin Charcot, the French physician closely associated with the art nouveau movement, tended to be idiosyncratic in nature and officially concerned with pathology. On this subject see Debora L. Silverman, *Art Nouveau in Fin-de-Siècle France: Politics, Psychology, and Style* (Berkeley and Los Angeles: University of California Press, 1989).

22. See especially Clement Greenberg, "Towards a Newer Laocoon," *Partisan Review* (July-August 1940); reprinted in *Clement Greenberg: The Collected Essays and Criticism*, ed. John O'Brian, 4 vols. (Chicago and London: University of Chicago Press, 1986–1993), vol. 1, pp. 23–38.

23. Clement Greenberg, "Jackson Pollock's New Style," *Harper's Bazaar* (February 1952); reprinted in Greenberg, *Collected Essays*, vol. 3, p. 106. See also Greenberg's description of Pollock in "Feeling Is All," *Partisan Review* (January-February 1952), reprinted on pp. 105–106 of that volume.

24. Clement Greenberg, "Review of an Exhibition of Georgia O'Keeffe," *The Nation* (June 15, 1946), and "The Present Prospects of American Painting and Sculpture," *Horizon* (October 1947); in Greenberg, *Collected Essays*, vol. 2, pp. 87, 166.

25.  Clement Greenberg, "Review of the Exhibitions of Worden Day, Carl
     Holty, and Jackson Pollock," *The Nation* (January 24, 1948), in Green-
     berg, *Collected Essays*, vol. 2, p. 203.

26.  Waldo Frank, *Our America* (New York: Boni and Liveright, 1919),
     pp. 176–177.

## 1    Puritan Repression and the Whitmanic Ideal: The Stieglitz Circle and Debates in American High Culture, 1916–1929

1.   Paul Rosenfeld, "American Painting," *The Dial* 71 (December 1921),
     p. 665.

2.   Rosenfeld, "American Painting," p. 665.

3.   At the outset, it seems important to acknowledge that I will not be under-
     taking a broad reconstruction of the social, cultural, and intellectual con-
     texts in which the Stieglitz circle writers worked. Not only is such a proj-
     ect well beyond the scope of this essay, but several books have been devot-
     ed to this subject. They include Edward Abrahams, *The Lyrical Left:
     Randolph Bourne, Alfred Stieglitz, and the Origins of Cultural Radicalism
     in America* (Charlottesville: University Press of Virginia, 1986); Steven
     Biel, *Independent Intellectuals in the United States, 1910–1945* (New York
     and London: New York University Press, 1992); Casey Nelson Blake,
     *Beloved Community: The Cultural Criticism of Randolph Bourne, Van Wyck
     Brooks, Waldo Frank, and Lewis Mumford* (Chapel Hill and London:
     University of North Carolina Press, 1990); T. J. Jackson Lears, *No Place of
     Grace: Antimodernism and the Transformation of American Culture,
     1880–1920* (New York: Pantheon Books, 1981); Henry F. May, *The End of
     American Innocence: A Study of the First Years of Our Own Time,
     1912–1917* (New York: Alfred A. Knopf, 1959); Miles Orvell, *The Real
     Thing: Imitation and Authenticity in American Culture, 1880–1940*
     (Chapel Hill and London: University of North Carolina Press, 1989); and
     Steven Watson, *Strange Bedfellows: The First American Avant-Garde* (New
     York: Abbeville, 1991).

4.   Arnold Schwab has pointed out that Huneker considered *Painted Veils* to
     be a sequel to his autobiography *Steeplejack*, which was published the
     same year. See Arnold T. Schwab, *James Gibbons Huneker: Critic of the
     Seven Arts* (Stanford: Stanford University Press, 1963), p. 261.

5.   Schwab, *James Gibbons Huneker*, p. 267. Istar, or Ishtar, is the Babylonian
     goddess of love and war. Commonly identified with the goddess Venus,
     Istar is also known as the daughter of Sin. Schwab notes that there are

traces of a third singer, Sibyl Sanderson, in the character of Easter Brandes.

6. James Huneker, *Painted Veils* (New York: Modern Library, 1920), p. 85. Huneker published a volume of critical writings under the name *Egoists: A Book of Supermen* (New York: Charles Scribner's Sons, 1909).

7. H. L. Mencken, "James Huneker," in *A Book of Prefaces* (New York: Alfred A. Knopf, 1917), pp. 163–164. Mencken's remarks on Huneker's anti-Puritanism are particularly telling given Huneker's profoundly ambivalent feelings toward his own religion, Roman Catholicism.

8. James G. Huneker, review of the paintings of Frank Burty in *Puck*, reproduced in *Camera Work* 45 (June 1914), p. 43.

9. Alfred Stieglitz to James Huneker, March 8, 1915, Dartmouth College Library.

10. Waldo Frank, *Our America* (New York: Boni & Liveright, 1919), pp. 188–190.

11. Frank, *Our America*, pp. 188–190.

12. See for example Huneker's reviews of John Marin and Alfred Maurer, reproduced in *Camera Work* 27 (July 1909), p. 42; and his reviews of Marsden Hartley and Max Weber, reprinted in *Camera Work* 38 (April 1912), p. 42.

13. By 1925 Rosenfeld's succession of Huneker was a fait accompli. As Edmund Wilson remarked, Rosenfeld "has performed the function of appreciator, of romantic critic, more satisfactorily than has perhaps anyone else in English. He has . . . a more accomplished art than Huneker." See Edmund Wilson, "Paul Rosenfeld," *The New Republic* 43 (June 3, 1925), p. 48.

14. Edmund Wilson, "Paul Rosenfeld: Three Phases," in Jerome Mellquist and Lucie Wiese, eds., *Paul Rosenfeld: Voyager in the Arts* (New York: Creative Age Press, 1948), pp. 3–4. In this same volume Joseph Warren Beach also compared Rosenfeld's writing to Huneker's.

15. Van Wyck Brooks, *Days of the Phoenix: The Nineteen-Twenties I Remember* (New York: E. P. Dutton & Co., 1957), p. 9.

16. For one of Stieglitz's laments on the pervasive repression in American aesthetics, see Alfred Stieglitz, "Regarding the Modern French Masters Exhibition," *Brooklyn Museum Quarterly* 8 (July 1921), pp. 112–113.

17. Nathan G. Hale, Jr., *The Rise and Crisis of Psychoanalysis in the United States: Freud and the Americans, 1917–1985* (New York and Oxford: Oxford University Press, 1995), pp. 57–58. Similarly, John D'Emilio and Estelle B. Freedman have noted that by the 1930s the Puritans were commonly equated with their successors, the Victorians, and all had become the targets of cultural critics. See John D'Emilio and Estelle B. Freedman,

*Intimate Matters: A History of Sexuality in America* (New York: Harper & Row, 1988), p. xi.

18. Frederick J. Hoffman, *Freudianism and the Literary Mind* (Baton Rouge: Louisiana State University Press, 1945), p. 61.

19. Henry Adams, *The Education of Henry Adams: An Autobiography* (1907, Boston: Houghton Mifflin Co., 1927), pp. 383–387. T. J. Jackson Lears has discussed Adams as a critic of modern culture whose writings reflect a tendency toward antimodern psychic ambivalence. See Jackson Lears, *No Place of Grace*, chapter 7.

20. Benjamin De Casseres, "The Great American Sexquake," *The International* 8 (June 1914), p. 195.

21. H. L. Mencken, "The National Letters" (1920), in *The American Scene: A Reader* (New York: Vintage Books, 1982), p. 62. As early as 1915 Mencken published an essay entitled "Puritanism as a Literary Force" (*Smart Set* 45 [1915], p. 153) in which he attributed America's problems to Puritanism, evangelism, political moralism, and money-grabbing.

22. William Carlos Williams, *In the American Grain* (1925; New York: New Directions, 1956), pp. 110, 112.

23. Frank, *Our America*, p. 28. Wanda M. Corn provides an extensive analysis of the cultural symbols of the Puritan and the Pioneer in the writings of the Stieglitz circle and their colleagues in *The Great American Thing: Modern Art and National Identity, 1915–1935* (Berkeley and Los Angeles: University of California Press, 1999), pp. 3–40.

24. Herbert J. Seligmann, *D. H. Lawrence: An American Interpretation* (1924; New York: Haskell House Publishers, 1971), pp. 61, 66, 71. In many ways Lawrence's critique of modern industrial culture, and his emphases on nature, sex, and mysticism, display an affinity with Stieglitz circle discourses. In 1929 Edmund Wilson identified similar thematic preoccupations in Lawrence's novel *Lady Chatterly's Lover.* Wilson wrote: "D. H. Lawrence's theme is a high one: the self-affirmation and the triumph of life in the teeth of all the sterilizing and demoralizing forces—industrialism, physical depletion, dissipation, careerism and cynicism—of modern English society." See Edmund Wilson, "Signs of Life: *Lady Chatterly's Lover,*" review dated July 3, 1929, reprinted in *The Shores of Light: A Literary Chronicle of the Twenties and Thirties* (New York: Farrar, Straus and Young, Inc., 1952), p. 405.

25. D. H. Lawrence, *Studies in Classic American Literature* (1923; New York: Penguin Books, 1977), p. 186. For a discussion of the significance that D. H. Lawrence held for Georgia O'Keeffe, particularly his "visionary celebration of organic nature," see Bonnie L. Grad, "Georgia O'Keeffe's

Lawrencean Vision," *Archives of American Art Journal* 38 (2000), pp. 2–19.

26. Van Wyck Brooks, *America's Coming-of-Age* (New York: B. W. Huebsch, 1915). In 1908 Brooks had published a study entitled *The Wine of the Puritans* in which he criticized the Puritans' narrowness and insularity. Recently Lawrence W. Levine has used the terms "highbrow" and "lowbrow" to discuss the ideological motivations underlying the distinctions between elite and popular culture. Levine has argued that the sacralization of high culture has served as a means for asserting class boundaries and hierarchies. See Lawrence W. Levine, *Highbrow/Lowbrow: The Emergence of Cultural Hierarchy in America* (Cambridge, MA and London: Harvard University Press, 1988).

27. George Santayana, "The Genteel Tradition in American Philosophy" (1913), in David A. Hollinger and Charles Capper, eds., *The American Intellectual Tradition: A Sourcebook* (New York and Oxford: Oxford University Press, 1993), vol. 2, pp. 97–109. Santayana's concepts influenced the writings of both Van Wyck Brooks and the cultural critic Harold E. Stearns. In his 1922 essay "The Literary Life," Brooks commented further on these gendered social divisions. He wrote that because the American man is principally devoted to making money and pursuing material ends, he leads a sterile and spiritually impoverished life. Brooks attributed these tendencies to the American Pioneer heritage, which placed an excessive emphasis on work. See Van Wyck Brooks, "The Literary Life," in Harold E. Stearns, ed., *Civilization in the United States: An Inquiry by Thirty Americans* (New York: Harcourt, Brace & Co., 1922), pp. 182–185. In addition, Stearns's essay in this volume, "The Intellectual Life," is a critique of American intellectual and cultural life and a caustic indictment of the genteel tradition in terms similar to Brooks's.

28. *The Seven Arts* was published between November of 1916 and October of 1917. An early editorial statement expressed the project of the journal in the following terms: "It is our faith and the faith of many, that we are living in the first days of a renascent period, a time which means for America the coming of that national self-consciousness which is the beginning of greatness." ("Editorial Statement," *The Seven Arts* 1 [November 1916], p. 52.) After a year the magazine ceased publication because Aileen Rankine, the magazine's benefactor, withdrew her support due to the antiwar views expressed in the journal. Steven Biel has commented on the ideological foundations of both *The Seven Arts* and *The New Republic* in *Independent Intellectuals*, p. 58.

29. Waldo Frank, *The Re-discovery of America: An Introduction to a Philosophy of American Life* (New York and London: Charles Scribner's Sons, 1929), p. 318.

30. Brooks, *Days of the Phoenix*, p. 20.

31. Rolland was best known to an American audience for his study *Beethoven*, an account of the composer's life and music. This work was first published in the United States in 1917. That year Rosenfeld reviewed Rolland's books on Handel and Beethoven for *The New Republic*.

32. Romain Rolland, "America and The Arts," trans. Waldo Frank, *The Seven Arts* 1 (November 1916), p. 51. In fact, Rolland's statements would prove to have a significant long-term effect on Stieglitz circle discourses. As late as 1939 the painter William Einstein reproduced passages from Rolland's 1916 article in a pamphlet that accompanied Georgia O'Keeffe's exhibition at An American Place. A copy of this pamphlet can be found in the Whitney Museum Papers, Archives of American Art, Smithsonian Institution, reel N679, frames 168–169.

33. Traubel was Whitman's companion and amanuensis during the later years of the poet's life. See Horace Traubel, "With Walt Whitman in Camden," *The Seven Arts* 2 (1917), pp. 627–637.

34. William Carlos Williams, "America, Whitman, and the Art of Poetry," *The Poetry Journal* 8 (1917), p. 31.

35. Harold E. Stearns, "The Intellectual Life," in Stearns, ed., *Civilization in the United States: An Inquiry by Thirty Americans* (New York: Harcourt, Brace, & Co., 1922), p. 149.

36. Marsden Hartley, "A Painter's Faith," *The Seven Arts* 2 (August 1917), p. 505.

37. Between 1913 and 1915 Marsden Hartley lived and worked in Germany. Not only do Hartley's works of the period reflect the influence of the German expressionists, but in 1913 Hartley exhibited his paintings in the Neue Kunst Salon in Munich and the Der Sturm exhibition in Berlin, and in 1915 at the Schames Galerie in Frankfurt and the Münchener Graphik-Verlag in Berlin. During the early teens Hartley himself was especially close to the painter Franz Marc.

38. Rosenfeld to Wilson, July 22, 1923, YCAL.

39. Frank, *Our America*, pp. 9, 10.

40. Lewis Mumford, *The Golden Day: A Study in American Experience and Culture* (New York: Boni & Liveright, 1926), pp. 282–283. Between 1927 and 1936 Lewis Mumford, Paul Rosenfeld, and Alfred Kreymborg would coedit five volumes of *The American Caravan*, a yearbook of contemporary American literature. The editors dedicated the first *American Caravan* "To a Teacher, Alfred Stieglitz."

41. Sadakichi Hartmann, one of the critics close to Stieglitz during the early days of 291, had actually known Whitman. See Jane Calhoun Weaver, ed., *Sadakichi Hartmann: Critical Modernist* (Berkeley and Los Angeles: University of California Press, 1991).

42. Horace Traubel, "Stieglitz," *The Conservator* 27 (December 1916), p. 137. In addition to this article, between 1915 and 1917 Stieglitz and Traubel exchanged a few pieces of friendly correspondence. Four letters dated between May 21, 1915, and April 23, 1917, have been preserved in YCAL.

43. Frank, *Our America*, p. 181.

44. Paul Rosenfeld, "Stieglitz," *The Dial* 70 (April 1921), p. 406.

45. Brooks, *Days of the Phoenix*, p. 2.

46. On the image of the native soil as a shared cultural symbol, see Corn, *The Great American Thing*, pp. 32–33.

47. Rosenfeld, "American Painting," pp. 665–666. Rosenfeld continued his defense of American modernism in the September 1922 issue of *Vanity Fair*. Rosenfeld's article was a response to the critic J. E. Spingarn's attack on the younger generation of artists and writers in *The Freeman*. Spingarn had mounted a conservative defense of past artistic masters and a critique of modernity, which he characterized as "the disease of the intellectualist who strives to make up for his artistic emptiness by the purely intellectual creation of 'new forms.'" See J. E. Spingarn, "The Younger Generation: A New Manifesto," *The Freeman* (June 7, 1922), pp. 296–298; and Paul Rosenfeld, "The Younger Generation and Its Critics," *Vanity Fair* 19 (September 1922), pp. 53, 84, 106.

48. In the revised version of the Dove essay that Rosenfeld published in *Port of New York*, the convergent themes of anti-Puritanism, derepression, and split subjectivity would become even more pronounced. Rosenfeld wrote that "Dove comes out [of] a culture commencing to base itself upon the whole personality. In Ryder, the old Puritan dividedness still obtained; the fugitive state from body and earth; the duality of body and soul. That is passed in the new man." See Paul Rosenfeld, *Port of New York: Essays on Fourteen American Moderns* (New York: Harcourt, Brace and Co., 1924), p. 173.

49. Rosenfeld, "American Painting," p. 666.

50. Anderson to Rosenfeld, undated letter, reproduced in Mellquist and Wiese, eds., *Voyager in the Arts*, pp. 201–202.

51. Rosenfeld, *Port of New York*, p. vi.

52. Hoffman, *Freudianism and the Literary Mind*, p. 242.

53. Rosenfeld, *Port of New York*, p. 191.

54. Rosenfeld, *Port of New York*, p. 176.

55. Harold A. Loeb, *The Broom* (January 1922), pp. 381–382.

56. Heap and Anderson were each fined $50 and fingerprinted as common criminals. It was not until 1933 that Federal Judge John M. Woolsey ruled that *Ulysses* was not pornographic material and could be admitted into the United States. By this time *The Little Review* had discontinued publication, its final issue appearing on the eve of the Depression. Much of the above information is based on Jane Heap's obituary in *The New York Times* (June 23, 1964), p. 33. For further information on this periodical and its editors, see Shari Benstock, *Women of the Left Bank, Paris, 1900–1940* (Austin: University of Texas Press, 1986), pp. 363–381; and Watson, *Strange Bedfellows*.

57. Jane Heap reprinted her comments and Rosenfeld's telegram in *The Little Review* 9 (Autumn 1922), pp. 37–38.

58. Sherwood Anderson, "Four American Impressions," *The New Republic* 32 (October 11, 1922), pp. 171–173.

59. Jane Heap, "Words," *The Little Review* 9 (Autumn 1922), pp. 37–38.

60. Hart Crane, "Anointment of Our Well Dressed Critic," *The Little Review* 9 (Winter 1922), p. 23.

61. The egg was also a central motif in the works of the sculptor Constantin Brancusi. In March of 1914 Stieglitz gaze Brancusi his first one-man exhibition in the United States at 291. The show included six heads in marble and bronze, a figure in wood, and a bird in brass. For a discussion of the egg as a symbol of birth, generativity, and procreative love in Brancusi's oeuvre, see Anna C. Chave, *Constantin Brancusi: Shifting the Bases of Art* (New Haven and London: Yale University Press, 1993).

62. Rosenfeld, "American Painting," p. 670.

63. Along these lines, in *The Little Review* Jane Heap characterized Anderson as "pre-natal and he writes about a pre-natal America."

64. Alfred Stieglitz to Rebecca Strand, July 15, 1922, YCAL.

65. For an account of the historical usage of the term "egghead," including a remark Carl Sandburg made in 1918 when he noted that "'Egg heads' is the slang here for editorial writers," see *The Oxford English Dictionary* (Oxford: Clarendon Press, 1989), vol. 5, p. 93.

66. For a discussion of the ways in which Heap and Anderson's personal relationship shaped the character of *The Little Review*, see Benstock, *Women of the Left Bank*, p. 379; and Watson, *Strange Bedfellows*, pp. 296–297.

67. Gorham Munson, "The Mechanics for a Literary Secession," *S4N* 22 (November 1922), n.p. In this text Munson located Waldo Frank on the fringes of the Dada secessionist project.

68. Edmund Wilson, "An Imaginary Conversation: Mr. Paul Rosenfeld and Mr. Matthew Josephson," *The New Republic* 38 (April 9, 1924), pp. 179–182. A few weeks later Wilson published a second imaginary dialogue between Van Wyck Brooks and F. Scott Fitzgerald. For a discussion of the issues raised by these dialogues, see Biel, *Independent Intellectuals*, p. 35.

69. Both *Broom* and *Secession* would fold in 1924, the same year that Wilson's article was published.

70. Wilson, "Imaginary Conversation," p. 179.

71. Wilson, "Imaginary Conversation," p. 180. In this context it is significant that, while both the Stieglitz critics and the Dadaists made various references to a broader American culture, neither group actually made any serious attempt to engage with the mass public.

72. This editorial statement appeared in *Secession* 1 (Spring 1922). In addition to the polemics detailed above, Munson published unsympathetic reviews of Rosenfeld's *Men Seen* (1925) and of his autobiography *The Boy in the Sun* (1928), claiming that in both cases Rosenfeld's writings were excessively emotional, subjective, and undisciplined. See Gorham B. Munson, "Without Chart and Compass," *The Saturday Review of Literature* 1 (July 4, 1925), pp. 871–872; and Gorham Munson, "Quality of Readability," *The Bookman* 68 (November 1928), pp. 336–337.

73. Malcolm Cowley, *Exile's Return* (1934), quoted in Brom Weber, *Hart Crane: A Biographical and Critical Study* (New York: The Bodley Press, 1948), p. 239.

74. Ernest Boyd, "Aesthete: Model 1924," *The American Mercury* 1 (January 1924), p. 54.

75. *Aesthete* 1 (February 1925), table of contents, p. 21. Rosenfeld and Anderson were not the only Stieglitz circle writers to be ridiculed in *Aesthete*. In an article entitled "Dada, Dead or Alive," the literary critic and philosopher Kenneth Burke attacked Waldo Frank's critique of the Dada movement as being patently elitist. See Kenneth Burke, "Dada, Dead or Alive," *Aesthete* 1 (February 1925), p. 25.

## 2   Faith, Love, and the Broken Camera: Alfred Stieglitz and New York Dada

1. Portions of this chapter first appeared as "Alfred Stieglitz and New York Dada: Faith, Love and the Broken Camera," *History of Photography* 21 (Summer 1997), pp. 156–161. For a similar discussion of Picabia's portrait of Stieglitz, see Wanda M. Corn, *The Great American Thing: Modern Art and National Identity, 1915–1935* (Berkeley and Los Angeles: University of California Press, 1999), p. 23. It should be noted that, a few months

after this image appeared in *291*, Picabia expressed his belief in the machine's ability to suggest human characteristics. His comments on the principles underlying his mechanomorphic portraits shed light on his enigmatic portrait of Stieglitz. "In seeking forms through which to interpret ideas or by which to expose human characteristics," Picabia remarked, "I have come at length upon the form which appears most brilliantly plastic and fraught with symbolism. I have enlisted the machinery of the modern world and introduced it into my studio." Francis Picabia is quoted in Frederick MacMonnies, "French Artists Spur on American Art," *New York Tribune*, October 24, 1915, cited in William Camfield, *Francis Picabia: His Art, Life and Times* (Princeton: Princeton University Press, 1979), p. 77. Richard Whelan also discusses Picabia's portrait in *Alfred Stieglitz: A Biography* (Boston and New York: Little, Brown and Co., 1995), pp. 349–350.

2.    Marius De Zayas, *291* 5–6 (July-August 1915), p. 6. Significantly, although he accused Stieglitz of "failing" in his efforts on behalf of modern art, De Zayas used a procreative metaphor to describe Stieglitz's work as a photographer. In this essay De Zayas wrote that Stieglitz "married Man to Machinery and Obtained issue."

3.    From a different perspective than the one advanced in the present study, Stephen E. Lewis situates Stieglitz's and De Zayas's disagreements over issues of commercialism within larger period debates on aesthetic idealism and commodity culture. See Stephen E. Lewis, "The Modern Gallery and American Commodity Culture," *Modernism/Modernity* 4 (September 1997), pp. 67–91.

4.    Biographical information regarding this period of Stieglitz's life is based primarily on Sue Davidson Lowe, *Stieglitz: A Memoir/Biography* (New York: Farrar Straus Giroux, 1983), pp. 198–200; and Whelan, *Alfred Stieglitz*, pp. 348–352.

5.    Unlike the present study, much of the scholarship on Alfred Stieglitz focuses on the earlier portion of the photographer's career. See for example William Inness Homer, *Alfred Stieglitz and the American Avant-Garde* (Boston: New York Graphic Society, 1977); and Geraldine Wojno Kiefer, *Alfred Stieglitz: Scientist, Photographer, and Avatar of Modernism, 1880–1913* (New York and London: Garland Publishing, 1991). Bram Dijkstra's study *The Hieroglyphics of a New Speech: Cubism, Stieglitz, and the Early Poetry of William Carlos Williams* (Princeton: Princeton University Press, 1969) describes the period through the early 1920s, and more than two-thirds of Whelan's biography deals with Stieglitz's life until 1918.

6. For a discussion of the New York Dada movement, see Francis M. Naumann and Beth Venn, *Making Mischief: Dada Invades New York* (New York: Whitney Museum of American Art, 1996); and "Art II: New York Hosts *Tout le Monde*" in Steven Watson, *Strange Bedfellows: The First American Avant-Garde* (New York: Abbeville, 1991).

7. Lowe, *Stieglitz*, p. 197. A handful of cordial if perfunctory letters that Arensberg and Stieglitz exchanged are preserved at YCAL. For a description of the Arensberg salon, see William Carlos Williams, *The Autobiography of William Carlos Williams* (New York: Random House, 1953), pp. 136–137.

8. Marsden Hartley, *Adventures in the Arts: Informal Chapters on Painters, Vaudeville, and Poets* (New York: Boni and Liveright, 1921), p. 111.

9. The unsigned article "Francis Picabia and His Puzzling Art: An Extremely Modernized Academician," appeared in the November 1915 issue of *Vanity Fair.*

10. Stieglitz to Henry McBride, April 20, 1928, McBride Papers, Archives of American Art, Smithsonian Institution, reel NMcB12, frame 485. A copy of the pamphlet that accompanied Picabia's 1928 exhibition at The Intimate Gallery can be found in the New York Public Library Papers, Archives of American Art, Smithsonian Institution, reel N121, frame 605.

11. Lowe, *Stieglitz*, p. 197.

12. Herbert J. Seligmann, *Alfred Stieglitz Talking: Notes on Some of His Conversations, 1925–1931* (New Haven: Yale University Library, 1966), pp. 110, 118.

13. Duchamp's comments are reproduced in Dorothy Norman, *Alfred Stieglitz: An American Seer* (Millerton, NY: Aperture, 1960), p. 128.

14. Kermit S. Champa, "The Wise or Foolish Virgin," in *Over Here! Modernism: The First Exile, 1914–1919* (Providence: David Winton Bell Gallery, 1989), p. 20.

15. Lowe, *Stieglitz*, p. 300.

16. Stieglitz to Sheldon Cheney, February 1924, Cheney Papers, Archives of American Art, Smithsonian Institution, reel 3947, frame 456. Duchamp himself later corroborated his lack of involvement with 291. In an interview conducted on January 27, 1968, Duchamp reportedly told Peter van der Huyden Moak "that he did not have contact with '291' while in New York." See Peter van der Huyden Moak, "Cubism and the New World: The Influence of Cubism on American Painting 1910–1920," Ph.D. dissertation, University of Pennsylvania, 1970, p. 84, n. 127.

17. For example, on March 8, 1928, Katherine Dreier wrote to Duchamp, "I wish you would realize that Stieglitz is no friend of yours" (YCAL).

Duchamp elusively if cuttingly replied, "You don't seem to have ever grasped my relationship with Stieglitz." He continued, "I never thought that he was a friend of mine—But I add who can I call a friend of mine" (Duchamp to Dreier, April 18, 1928, YCAL).

18. Marcel Duchamp in *Manuscripts* 4 (December 1922), quoted in *The Writings of Marcel Duchamp,* ed. Michel Sanouillet and Elmer Peterson (New York: Oxford University Press, 1973), p. 165.

19. Recently Rhonda Roland Shearer has proposed the alternative, controversial theory that Duchamp's readymades may be unique artworks altered and manipulated by the artist himself, and not simply mass-produced objects. See Leslie Camhi, "Did Duchamp Deceive Us?" *Artnews* 98 (February 1999), pp. 98–102.

20. Duchamp's remarks were made in a talk delivered at the Museum of Modern Art, New York on October 19, 1961, quoted in *The Writings of Marcel Duchamp,* p. 141.

21. For a comprehensive analysis of this artwork, see William A. Camfield, *Marcel Duchamp: Fountain* (Houston: The Menil Collection and Houston Fine Art Press, 1989).

22. For a discussion of the contradictory Freudian associations that Duchamp invested in this work, see Kermit S. Champa, "Charlie Was Like That," *Artforum* 12 (March 1974), pp. 54–59.

23. This account is given by Rudi Blesh in *Modern Art USA* (New York, 1956), p. 79, and is reproduced in Camfield, *Fountain,* p. 33. Regarding this work see also Thierry de Duve, *Kant After Duchamp* (Cambridge, MA and London: MIT Press, 1996), pp. 98–99.

24. Beatrice Wood, "Marcel," in Rudolf E. Kuenzli and Francis M. Naumann, eds., *Marcel Duchamp: Artist of the Century* (Cambridge, MA and London: MIT Press, 1990), p. 14.

25. Quoted in Camfield, *Fountain,* p. 33.

26. Stieglitz to McBride, April 19, 1917, McBride Papers, Archives of American Art, Smithsonian Institution, reel NMcB12, frame 445. Hoping to gain support for his friend, Charles Demuth also appealed to McBride to cover the story of the *Fountain,* writing, "If you think you could do anything with this material for your Saturday article we would appreciate it very much." Demuth to McBride, undated letter in the McBride papers, Archives of American Art, Smithsonian Institution, reel NMcB10, frames 149–150.

27. Quoted in Whelan, *Alfred Stieglitz,* p. 382.

28. Stieglitz to O'Keeffe, April 19, 1917, YCAL, quoted in Camfield, *Fountain,* p. 35.

29. Regarding the authorship of the editorial, see Camfield, *Fountain*, pp. 37–39.

30. "The Richard Mutt Case," *The Blind Man* 2 (May 1917), p. 5.

31. Regarding the paradoxes surrounding the issue of authorship in the readymades, see Octavio Paz, "The Castle of Purity," in *Marcel Duchamp: Appearance Stripped Bare*, trans. Rachel Phillips and Donald Gardner (New York: Little, Brown, 1978), p. 22.

32. In his important book *Infinite Regress: Marcel Duchamp, 1910–1941*, David Joselit proposes a reading of what he terms the "transactual" model in Duchamp's art as one that interrogates the intersection of measurement, language, and inscription with the artist's interests in materiality and carnality. By considering the complex ways in which objectivity and subjectivity are made to "infinitely regress" toward one another in Duchamp's works, Joselit demonstrates that objects and subjects are not stable entities but are necessarily dynamic artifacts of a conceptual process. See David Joselit, *Infinite Regress: Marcel Duchamp, 1910–1941* (Cambridge, MA and London: MIT Press, 1998).

33. Clement Greenberg, "Counter-Avant-Garde," *Art International* 15 (May 20, 1971), pp. 16–19. From a different ideological perspective, Peter Bürger has also noted that, through the readymades, Duchamp called into question the institution of art itself. In *Theory of the Avant-Garde* Bürger argues that the autonomy of art has been falsely linked to its removal from the praxis of life. This removal, which has been defined as the aesthetic or essence of art, is the necessary precondition for the avant-garde's rejection of art. Thus by signing mass-produced objects, the Dadaists mounted a radical critique of individual creativity and, within it, a negation of individual creation. See Peter Bürger, *Theory of the Avant-Garde*, trans. Michael Shaw (Minneapolis: University of Minnesota Press, 1984), esp. pp. 46–51.

34. Alfred Stieglitz, in *The Blind Man* 2 (May 1917), p. 15.

35. Because Duchamp was not yet generally known to be R. Mutt in 1917, my remarks on the author function surrounding the *Fountain* pertain mainly to Stieglitz and to the other members of the New York avant-garde who would have been familiar with Duchamp's project.

36. Regarding the project of the readymades in general, it is also possible to read Duchamp's authorizing a readymade as an act that transforms his name into a kind of commodity. As such, this gesture undermines the artistic value that the signature infuses into the art object. The issue of context is crucial to this reading of Duchamp's signature as a mark of commodification. Because the "consumers" of Duchamp's readymades presum-

ably would be the same as the audience for easel paintings and other rec-
ognized forms of high art, Duchamp's signature exposes the fact that all of
the exhibited artworks, signed or unsigned, are, at some level, commodi-
ties. However, like the "readymades" themselves, Duchamp's signature
simultaneously seems to support and resist the logic of commodification.
Because it is not printed or reproduced, Duchamp's signature signifies an
"original" authorial mark, one that reaffirms the notion that an "authentic"
artistic presence is the operative force behind the artwork. Thus another
paradox of the readymades is that Duchamp's signature reinscribes the
notion of artistic "authenticity" even as it critiques and reconfigures this
construct by invoking the possibility of potentially endless reproduction.

37.  Camfield, *Fountain*, p. 28.

38.  Camfield, *Fountain*, p. 35, n. 42. It is also possible that Louise Norton
submitted the *Fountain* to the Society.

39.  Hartley expressed his feelings toward military life in Berlin in a May 1913
letter to Stieglitz (YCAL), and in his autobiography, *Somehow a Past: The
Autobiography of Marsden Hartley*, ed. Susan Elizabeth Ryan (Cambridge,
MA: MIT Press, 1996). For a comprehensive discussion of the "coded-
ness" of homosexual imagery in Hartley's Berlin military paintings, see
Patricia McDonnell, "El Dorado: Marsden Hartley in Imperial Berlin," in
*Dictated by Life: Marsden Hartley's German Paintings and Robert Indiana's
Hartley Elegies* (Minneapolis: Frederick R. Weisman Art Museum,
University of Minnesota, 1995).

40.  For a discussion of Stieglitz's photograph, see Camfield, *Fountain*,
pp. 54–55.

41.  De Duve, *Kant after Duchamp*, p. 117. While de Duve views Stieglitz's
photograph of the *Fountain* as an example of Duchamp having brilliantly
manipulated Stieglitz (see especially pp. 116–120 of this text), the reading
that I am proposing suggests that Stieglitz and Duchamp engaged in a more
reciprocal form of manipulation to advance their own artistic agendas. It
seems highly unlikely that Stieglitz would have gone to the trouble of care-
fully photographing the *Fountain*, providing a copy of the print for publi-
cation in *The Blind Man*, and encouraging Henry McBride to come to 291
to view the *Fountain*—and, even more importantly from Stieglitz's point of
view, his photograph of this work—if the *Fountain* hadn't served Stieglitz's
own aesthetic and ideological purposes. In soliciting and receiving such
strong support from Stieglitz at a crucial moment in his American recep-
tion, Duchamp can even be seen as having briefly become one of Stieglitz's
proteges, if not actually a subject of aesthetic appropriation by Stieglitz.

42.  Stieglitz would reiterate his critique of "inflated names" four years later
when commenting to Henry McBride on his desire for anonymity and

unfettered artistic expression in conjunction with his own photography exhibition at the Anderson Galleries. (Stieglitz to Henry McBride, April 1921, McBride Papers, Archives of American Art, Smithsonian Institution, reel NMcB12, frames 450–451.)

43. Rosalind Krauss has compared Duchamp's readymades to photographs: "The readymade's parallel with the photograph is established by its process of production. It is about the physical transposition of an object from the continuum of reality into the fixed condition of the art-image by a moment of isolation, or selection." See Rosalind E. Krauss, *The Originality of the Avant-Garde and Other Modernist Myths* (Cambridge, MA and London: MIT Press, 1985), p. 206. Richard Whelan has also pointed out that a parallel of sorts existed between Duchamp's readymades and Stieglitz's photographs, in that detractors had insisted that photographs, unlike paintings, were not hand-made works of art. (Whelan, *Alfred Stieglitz*, p. 383.)

44. Quoted in Arturo Schwarz, *The Complete Works of Marcel Duchamp* (London: Thames and Hudson, 1969), p. 143. Schwarz provides a lengthy and intense analysis of *The Large Glass* in chapter 11 of this study, pp. 143–191. See also Chapter 4, "Desire, Delay, and the Fourth Dimension," in Jerrold Seigel, *The Private Worlds of Marcel Duchamp: Desire, Liberation, and the Self in Modern Culture* (Berkeley and Los Angeles: University of California Press, 1995).

45. Charles Demuth to Alfred Stieglitz, February 5, 1929, YCAL.

46. Jeffrey Weiss has pointed out that another possible iconographic source for *The Large Glass* concerns the statistics on population decline that the French government published around 1912. In part, the fear of depopulation was attributed to the "bachelor," a situation that was in turn parodied in popular music-hall songs and jokes. See Jeffrey Weiss, *The Popular Culture of Modern Art: Picasso, Duchamp, and Avant-Gardism* (New Haven and London: Yale University Press, 1994), p. 141.

47. All quotations and descriptions of the bachelors and the bride are based on Duchamp's notes in the *Green Box* (a collection of notes on the *Large Glass* that he published in 1934), quoted in *The Writings of Marcel Duchamp*, pp. 26–71.

48. In the *Green Box*, Duchamp described this second form of stripping as "stripping voluntarily imagined by the bride desiring."

49. Along these lines, Octavio Paz has noted that *The Bride Stripped Bare by her Bachelors, Even* is a work poised between eroticism and irony. See Paz, *The Castle of Purity*, esp. pp. 70–71.

50. See especially Discourse Six, "Vision," of Rene Descartes's *Discourse on Method* (1639). Martin Jay has noted that Cartesian dualism valorizes the disembodied eye, and that Duchamp's disparagement of the sensuous, painterly (or what Duchamp called the "retinal") surfaces of painting is in keeping with the general tendency toward the devaluation of vision in twentieth-century French thought. See Martin Jay, *Downcast Eyes: The Denigration of Vision in Twentieth-Century French Thought* (Berkeley and Los Angeles: University of California Press, 1994), esp. pp. 81 and 161–170. However, it should be noted that while Descartes may have described bodily processes in highly mechanistic terms, he (unlike Duchamp) claimed that it is the soul, not the eye, that sees. Interestingly enough, it is precisely the combination of these elements, the mechanical and the spiritual, that enables Descartes to formulate a coherent, unproblematic, and ideal subject. The organization of subjectivity in Descartes's writings is possible because of the way in which he described the subject as unified, generalizable, and curiously elevated from the body.

51. Katherine S. Dreier and [Roberto] Matta Echaurren, *Duchamp's Glass: An Analytical Reflection* (New York: Société Anonyme, 1944), n.p. A copy of this pamphlet is on file in the New York Public Library Papers, Archives of American Art, Smithsonian Institution, reel N31, frames 50–57.

52. Dreier and Matta, *Duchamp's Glass*, frame 53.

53. Dreier and Matta, *Duchamp's Glass*, frame 53.

54. Dreier and Matta, *Duchamp's Glass*, frame 56.

55. This move in Duchamp's art is consistent with another aspect of Descartes's philosophy, which Martin Jay has described as "the speculative tradition of identitarian reflexivity, in which the subject is certain only of its mirror image." See Jay, *Downcast Eyes*, p. 70.

56. Thierry de Duve has argued that, in his early paintings, Duchamp metaphorically substituted the notion of "painting" for the concept of "woman," so that the painter's desire for the woman becomes a metaphor for his desire to become a painter. See Thierry de Duve, *Pictorial Nominalism: On Marcel Duchamp's Passage from Painting to the Readymade*, trans. Dana Polan (Minneapolis: University of Minnesota Press, 1991), esp. p. 20.

57. I am grateful to Dian Kriz for pointing out the importance of the American context in which Dreier's and Matta's remarks were made, since this reconnects their project to Stieglitz's.

58. At the same time that he worked on *The Large Glass*, Duchamp advanced a more overt gender parody in his experiments with a female persona whom he called Rrose Sélavy (a pun on the phrase, "Eros, c'est la vie").

Like his readymades, this name signals Duchamp's selection and entitling of a particular construction of himself. The painter Florine Stettheimer captured this "split" dialogue of selfhood in her portrait of Duchamp conversing with his alter-ego, Rrose Sélavy. In Stettheimer's witty representation, the "real" and very bored-looking Duchamp sits on a stool and turns the crank that grinds out his alternative self-representation, the poised, pink, and charming Rrose Sélavy. Reminiscent of the *Chocolate Grinder,* Stettheimer's portrait features Duchamp's rather narcissistic self-manipulations as the focus of her representation. Resonating with Duchamp's bigendered personas, the chess figure Stettheimer suspends over Duchamp's head is the knight. Unlike any other piece on the board, the knight literally "goes both ways" (moves at once vertically and horizontally). In addition, the frame bordering the painting shows the repeated letters M.D., a parade of Duchamp's initials that symbolically threatens to slide or fall off the corners and the edges of the frame.

59. Paul Strand, "Alfred Stieglitz and a Machine," reproduced in Waldo Frank et al., eds., *America & Alfred Stieglitz: A Collective Portrait* (1934; Millerton, NY: Aperture, 1979), pp. 137–139.

60. Paul Rosenfeld, "Stieglitz," *The Dial* 70 (April 1921), p. 405.

61. Sherwood Anderson, "Alfred Stieglitz," *The New Republic* 35 (October 25, 1922), p. 215.

62. Stieglitz to O'Keeffe, October 7, 1916, quoted in Sarah Greenough and Juan Hamilton, *Alfred Stieglitz: Photographs & Writings* (Washington, D.C.: National Gallery of Art, 1983), p. 201. The previous year Picabia himself described the relation between machine and soul which facilitated his mechanomorphic portraits: "The machine has become more than a mere adjunct of life. It is really a part of human life—perhaps the very soul." Quoted in Camfield, *Francis Picabia,* p. 77.

63. Stieglitz to Herbert J. Seligmann, September 1920, YCAL.

64. The term "intellectualism" came to function as a code word in Stieglitz circle discourses for Duchamp, or at least for the central tenets of his art. In particular, "intellectualism" designated that which was separated from the body, and thus was nonspiritual, sterile, and foreign (and even more specifically, impotent and French). For example, Rosenfeld remarked that O'Keeffe's paintings "come out of general American life; not out of analyses of Cézanne and Picasso. They come out of the need of personal expression of one who has never had the advantage of the art treasures of Europe and has lived life without the help of the city of Paris; out of the necessity of one who shows no traces of intellectualization and has a mind born of profoundest feeling." See Paul Rosenfeld, *Port of New York: Essays on*

*Fourteen American Moderns* (New York: Harcourt, Brace, and Company, 1924), p. 204.

65. Rosenfeld, "Stieglitz," p. 402.

66. Rosenfeld, *Port of New York*, p. 245.

67. Rosenfeld, "Stieglitz," p. 401.

68. Waldo Frank, *The Re-discovery of America: An Introduction to a Philosophy of American Life* (New York and London: Charles Scribner's Sons, 1929), p. 87.

69. Frank, *The Re-discovery of America*, p. 87.

70. John Marin, "Can a Photograph Have the Significance of Art?" *Manuscripts* 4 (December 1922), reproduced in Herbert J. Seligmann, ed., *Letters of John Marin* (Westport, CT: Greenwood Press, 1970), n.p.

71. In *The Optical Unconscious* Rosalind Krauss notes that for Duchamp, the brain is inseparable "from other kinds of organic activity within the physical body." She also points out that what Greenberg "detests in Duchamp's art is its pressure toward desublimation. 'Leveling' he calls it. The attempt to erase distinctions between art and non-art, between the absolute gratuitousness of form and the commodity. The strategy, in short, of the readymade." See Rosalind E. Krauss, *The Optical Unconscious* (Cambridge, MA and London: MIT Press, 1994), pp. 125, 142.

72. It should be noted that Stieglitz's conception of "abstraction" was essentially a photographic one. Stieglitz once described his photography to Henry McBride as "certain abstract ideas I have actually put into forms" (Stieglitz to Henry McBride, April 1921, McBride Papers, Archives of American Art, Smithsonian Institution, reel NMcB12, frame 450).

73. Rosenfeld, *Port of New York*, p. 241.

74. Norman, *Alfred Stieglitz: An American Seer*, p. 144. Stieglitz's notion of "equivalents" demonstrates the way in which the photographer transformed a Baudelairean and symbolist concept into an ostensibly personal and "American" one. In fact, Rosalind Krauss has argued that Stieglitz's "Equivalents" series constitute "masterpieces of Symbolist art." See Rosalind Krauss, "Alfred Stieglitz's 'Equivalents,'" *Arts Magazine* 54 (February 1980), pp. 34–37. It should also be noted that clouds have traditionally been seen as a privileged site for the expression of individual character in romantic art, as for example in Constable's oeuvre.

75. Lewis Mumford, "The Metropolitan Milieu," in *America and Alfred Stieglitz: A Collective Portrait* (New York: Doubleday, Doran & Co., 1934), p. 37.

76. See Jay, *Downcast Eyes*, p. 167. Arturo Schwarz has written that, while it is difficult to know why Duchamp failed to complete the Glass, "this may

be paralleled to his failure to have any male progeny." (Schwarz, *Marcel Duchamp*, p. 147.) Schwarz also provides a Freudian interpretation of this work on pp. 147–148 of this study.

## 3   Alfred Stieglitz and His Critics: An Aesthetics of Intimacy

1.   Such interactions represented a highly atypical development in dealer-critic relations. To an unprecedented degree, Stieglitz conceptualized his circle of artists and critics as a kind of extended family. This approach enabled him to establish close personal relationships with key critics while at the same time collaborating with them professionally to promote a carefully strategized and intentionally provocative reading of his group's artworks. Stieglitz's relationships with Frank and Rosenfeld differed, for example, from those that Durand-Ruel had established with the impressionist artists and critics, relations that later set the pattern for those practiced by dealers such as Vollard and Kahnweiler. Yet the Stieglitz circle critics were like their predecessors in functioning as publicists for the artists and as theoreticians who explicated the more difficult aspects of modernist works to the public. For an account of the dealer-critic system in later nineteenth-century France, see Harrison C. and Cynthia White, *Canvases and Careers: Institutional Change in the French Painting World* (Chicago and London: University of Chicago Press, 1993); Nicholas Green, "Dealing in Temperaments: Economic Transformation of the Artistic Field in France during the Second Half of the Nineteenth Century," *Art History* 10 (March 1987), pp. 59–78; and Green, *The Spectacle of Nature: Landscape and Bourgeois Culture in Nineteenth-Century France* (Manchester and New York: Manchester University Press, 1990).

2.   Regarding the often emotionally charged relationships between Rosenfeld, Frank, and Stieglitz, see especially Wanda M. Corn, *The Great American Thing: Modern Art and National Identity, 1915–1935* (Berkeley and Los Angeles: University of California Press, 1999), pp. 3–40. Corn's book first became available to me just as my own study was going to press. Her meticulous scholarship offers much insight into Stieglitz's, Rosenfeld's, and Frank's self-positioning vis-à-vis American cultural nationalism of the 1920s. Particularly valuable is her extended analysis of Rosenfeld's *Port of New York* and other important Stieglitz circle texts in order to address the issues of "what was American about American culture, anyway? And once this question was answered, how could these American traits lead to the creation of an authentic national art?" (p. 5). On Stieglitz's relations with his house critics, see also Corn's "Apostles of the New American Art:

Waldo Frank and Paul Rosenfeld," *Arts Magazine* 54 (February 1980), pp. 159–163; Sherman Paul's introductory essay to Paul Rosenfeld, *Port of New York* (Urbana and London: University of Illinois Press, 1966), pp. vii–lvi; Hugh M. Potter, *False Dawn: Paul Rosenfeld and Art in America, 1916–1946* (Ann Arbor: UMI Press for the University of New Hampshire, 1980); and Charles L. P. Silet, *The Writings of Paul Rosenfeld* (New York and London: Garland, 1981).

3.  The earliest existing piece of correspondence that Rosenfeld sent to Stieglitz is dated December 29, 1915, YCAL.

4.  Rosenfeld's maternal great-uncle, Joseph Obermeyer, was Stieglitz's father-in-law. See Potter, *False Dawn*, p. 12.

5.  This information has been provided by the Alumni Records Office, Yale University.

6.  Peter Minuit, "291 Fifth Avenue," *Seven Arts* 1 (November 1916), p. 64.

7.  Minuit, "291 Fifth Avenue," p. 65.

8.  Van Wyck Brooks, *Days of the Phoenix: The Nineteen-Twenties I Remember* (New York: E. P. Dutton & Co., 1957), p. 7.

9.  Edmund Wilson, "Paul Rosenfeld: Three Phases," in Jerome Mellquist and Lucie Wiese, eds., *Paul Rosenfeld: Voyager in the Arts* (New York: Creative Age Press, 1948), p. 7.

10. On this portrait, see also Richard Whelan, *Alfred Stieglitz: A Biography* (Boston and New York: Little, Brown and Co., 1995), p. 413. During the later teens and early twenties Stieglitz developed a set of symbols through which to express his vision of American modernism, and one of his most frequently cited images was that of apples and apple trees. For the Stieglitz circle, apples were a metaphor for indigenous artistic generativity. Rooted in the soil, the tree bears fruit and thus embodies the qualities of nativeness and fecundity. Rosenfeld owned one of O'Keeffe's paintings of apples, and apple imagery is also found in Charles Demuth's poster portrait of Georgia O'Keeffe (1923, fig. 6.8). For a discussion of the symbolism of apples in Stieglitz circle artworks, see Charles C. Eldredge, *Georgia O'Keeffe: American and Modern* (New Haven and London: Yale University Press, 1993), pp. 180–187.

11. Sue Davidson Lowe, *Stieglitz: A Memoir/Biography* (New York: Farrar Straus Giroux, 1983), p. 236.

12. Waldo Frank, *Our America* (New York: Boni and Liveright, 1919), pp. 186, 184.

13. Frank, *Our America*, p. 181.

14. Charles Duncan was one of the two painters who, along with René Lafferty, O'Keeffe shared her first exhibition at 291, "Georgia O'Keeffe—C. Duncan—René Lafferty," May 23–July 5, 1916.

15. Rosenfeld to Stieglitz, November 3, 1920, YCAL.

16. Regarding this portrait group, see also Benita Eisler, *O'Keeffe & Stieglitz: An American Romance* (New York: Penguin Books, 1991), pp. 231–232.

17. Rosenfeld to Stieglitz, December 16, 1920, YCAL.

18. The other three books are Waldo Frank's *Our America* (1919), Van Wyck Brooks's *The Ordeal of Mark Twain* (1920), and Carl Sandburg's collection of poems *Smoke and Steel* (1920).

19. Rosenfeld to Stieglitz, December 16, 1920, YCAL. As partial recompense, Rosenfeld sent Stieglitz a book by D. H. Lawrence that the photographer had expressed an interest in.

20. Alfred Stieglitz, "A Statement," in *145 Photographs* (New York: Anderson Galleries, February 7–14, 1921). A copy of this flyer can be found in the Forbes Watson Papers, Archives of American Art, Smithsonian Institution, reel D57, frames 92–94.

21. Henry McBride, "Art News and Reviews—Stieglitz's Life Work in Photography," *The New York Herald* (February 13, 1921), p. 5.

22. Georgia O'Keeffe, "Introduction," *Georgia O'Keeffe: A Portrait by Alfred Stieglitz* (New York: Metropolitan Museum of Art, 1978).

23. Stieglitz to R. Child Bayley, October 9, 1919, quoted in Sarah Greenough and Juan Hamilton, *Alfred Stieglitz: Photographs & Writings* (Washington, D.C.: National Gallery of Art, 1983), p. 203.

24. Alfred Stieglitz to Dorothy Norman, quoted in Dorothy Norman, *Encounters: A Memoir* (New York: Harcourt, Brace, Jovanovich, 1987), p. 60.

25. Paul Rosenfeld, "Stieglitz," *The Dial* 70 (April 1921), p. 398. In addition to this essay, Waldo Frank contributed a piece on the Stieglitz retrospective to a Paris periodical, and Herbert J. Seligmann published a glowing article on Stieglitz, "A Photographer Challenges," in *The Nation* 112 (February 16, 1921), p. 268.

26. Rosenfeld, "Stieglitz," p. 399.

27. Rosenfeld, "Stieglitz," p. 407.

28. Rosenfeld to Stieglitz, September 10, 1921, YCAL.

29. Stieglitz to Rosenfeld, September 10, 1921, YCAL.

30. My account of the paintings by O'Keeffe in Rosenfeld's personal art collection is based on both the information published in the Georgia O'Keeffe catalogue raisonné and on the following pieces of correspondence in YCAL: Stieglitz to Rosenfeld, September 10, 1921; Rosenfeld to Stieglitz,

September 14, 1922; Rosenfeld to Stieglitz, July 8, 1923; and Rebecca Strand to Georgia O'Keeffe and Alfred Stieglitz, August 1922, quoted in Eisler, *O'Keeffe and Stieglitz*, p. 264. The O'Keeffe catalogue raisonné lists the following four paintings by O'Keeffe as having once belonged to Rosenfeld: *Untitled (Lake George Landscape)* (cat. #332); *Lake George* (cat. #395); *Alligator Pears* (cat. #419); and *Dark Iris No. III* (cat. # 602). See Barbara Buhler Lynes, *Georgia O'Keeffe Catalogue Raisonné* (New Haven and London: Yale University Press, 1999), vol. 1, pp. 179, 212, 226, and 351.

31. Rosenfeld owned at least five watercolors by John Marin, including *House* (1913), *Pine Tree* (1914), *Trees and Lake* (1917), and two images from Marin's Deer Isle, Maine, series, *Island, Sun and Ships* and *Movement, Boats and Sea*. Rosenfeld's collection also contained a range of works by Marsden Hartley, including Hartley's landscape *Deserted Farm*, his *Indian Composition* (1914–1915), and at least four still lifes: *Pears* (1911), *Three Pears* (c. 1913), *Figs and Bananas* (c. 1913), and an image of a lily. Rosenfeld owned at least three oil paintings by Arthur Dove, including *Machinery* (1921), *Silver Ball* (1930), and *Harlem River Boats*. Rosenfeld also attempted to purchase Arthur Dove's painting *Waterfall* (1925), now in the Phillips Collection. However, in early 1926 Stieglitz insisted that Rosenfeld relinquish the painting to Duncan Phillips after the collector had expressed interest in the work. On this subject, see Stieglitz's letter to Arthur Dove of March 6, 1926, in Ann Lee Morgan, ed., *Dear Stieglitz, Dear Dove* (Cranbury, NJ and London: Associated University Presses, 1988), p. 125; and the letters Stieglitz and Phillips exchanged between January 22 and February 8, 1926, in Elizabeth Hutton Turner, *In the American Grain: The Stieglitz Circle at the Phillips Collection* (Washington, DC: Counterpoint and the Phillips Collection, 1995), pp. 111–115.

32. Brooks, *Days of the Phoenix*, p. 10. In August of 1922 Rosenfeld loaned the novelist Sherwood Anderson a painting by Marsden Hartley, an artist whom Anderson greatly admired (Rosenfeld to Stieglitz, August 29, 1922, YCAL).

33. Brooks, *Days of the Phoenix*, p. 67.

34. Herbert J. Seligmann, "Plowman of the Future," in Mellquist and Wiese, eds., *Voyager in the Arts*, p. 239.

35. Rosenfeld to Stieglitz, September 30, 1922, YCAL.

36. Wilson, "Rosenfeld: Three Phases," p. 7. Rosenfeld is known to have owned a handful of paintings by artists outside of Stieglitz's immediate circle. The works include Florence Cane's *Still Life* (1921), Oscar Bluemner's

*Barns* (1924), William Sherwood's *Leaf,* and two paintings by Paul Nagle, both entitled *Still Life.*

37.  Paul Rosenfeld, *Port of New York: Essays on Fourteen American Moderns* (New York: Harcourt, Brace and Company, 1924).

38.  Paul Rosenfeld, "Water-Colours of John Marin: A Note on the Work of the First American Painter of the Day," *Vanity Fair* 18 (April 1922), pp. 48, 88, 92, 110; "Marsden Hartley: Characteristics of the Work of One of the Very Great Talents among Present Day American Artists," *Vanity Fair* 18 (August 1922), pp. 47, 84, 94, 96; and "Georgia O'Keeffe: The Work of the Young Artist Whose Canvases Are to Be Exhibited in Bulk for the First Time This Winter," *Vanity Fair* 19 (October 1922), pp. 56, 112, 114.

39.  Norman, *Encounters,* p. 66.

40.  The letters that Stieglitz and Rosenfeld exchanged between July and November of 1923 suggest that Stieglitz read and edited, if not actually wrote portions of, the essays on O'Keeffe, Hartley, Dove, Marin, and himself. By 1935 Rosenfeld was revising some of his essays, and he told Stieglitz that he was in a quandary as to giving permission for reprinting the essay on O'Keeffe that had appeared in *Port of New York.* Rosenfeld reported that he felt dissatisfied with the piece and unsure as to whether it could "either represent its subject today or myself." (Rosenfeld to Stieglitz, July 18, 1935, YCAL.)

41.  Stieglitz's own portrait was taken by Paul Strand.

42.  In addition to the Stieglitz circle artists, the other subjects treated in *Port of New York* include Albert P. Ryder, Van Wyck Brooks, Carl Sandburg, William Carlos Williams, Margaret Naumburg, Kenneth Hayes Miller, Roger H. Sessions, and Randolph Bourne.

43.  Rosenfeld to Stieglitz, September 1, 1923, YCAL.

44.  Stieglitz to Rosenfeld, September 5, 1923, YCAL. It should be noted that, despite his staunch advocacy of an emergent American modernism, Stieglitz continually demanded recognition for his earlier efforts at introducing modern European art to an American audience, becoming irate when he did not get the acknowledgment he felt he deserved. For example, late in 1926 Stieglitz was outraged by Walter Pach's review of an exhibition by the sculptor Constantin Brancusi in *The Nation* 123 (December 1, 1926, p. 566) which began with the statement, "In 1913, when the Armory Show gave to America its first sight of the post-impressionist schools, . . ." Needless to say, Pach did not mention Stieglitz's exhibitions of postimpressionist works at 291. Stieglitz was furious with *The Nation* and threatened to publish his own pamphlet telling the "real story" of modern art in America. (See Stieglitz's correspondence to Freda Kirchway, managing

editor of *The Nation*, of November 27, December 5, and December 10, 1926, YCAL.) Stieglitz's proprietary feelings over 291 suggest that he continued to assign great importance to his earlier efforts at promoting modern art in America. He probably felt that such acknowledgment would put the American artists on a more equal footing with their European counterparts by strengthening the credibility of his own connoisseurial judgments and reasserting his track record of sponsoring truly innovative modern art.

45. Hutchins Hapgood, *A Victorian in the Modern World* (New York: Harcourt, Brace and Company, 1939), pp. 337–338.

46. See for example Stieglitz's February 4, 1932, letter to Elizabeth McCausland, art critic for the *Springfield Republican*, in which Stieglitz refers her to *Port of New York* for biographical information. (Elizabeth McCausland Papers, Archives of American Art, Smithsonian Institution, reel D384B, frame 19.)

47. For a discussion of Stieglitz's photographs and Rosenfeld's text as complementary works of portraiture, see Corn, *The Great American Thing*, pp. 38–40. Corn aptly points out that *Port of New York* was but one of several texts that effectively supported the Stieglitz circle's public relations and promotional strategies, and that these materials had much in common with contemporary advertising and marketing practices.

48. See Frank to Stieglitz, July 13, 1923, YCAL.

49. Whelan, *Alfred Stieglitz*, p. 470.

50. Search Light [Waldo Frank], *Time Exposures* (New York: Boni and Liveright, 1926), p. 178.

51. Waldo Frank, "Alfred Stieglitz: The World's Greatest Photographer," *McCall's Magazine* 54 (May 1927), pp. 24, 107–108.

52. Lowe, *Stieglitz*, p. 360. It should be noted, however, that Stieglitz's correspondence with Frank continued until 1944.

53. Paul Rosenfeld, "Alfred Stieglitz," *The Commonweal* 44 (August 2, 1946), p. 381.

**4    Arthur Dove and Georgia O'Keeffe:
Corporeal Transparency and Strategies of Inclusion**

1. Stieglitz's comments are recorded in Dorothy Norman, *Encounters: A Memoir* (New York: Harcourt, Brace, Jovanovich, 1987), p. 91. Similarly, in 1926 Stieglitz told the collector Duncan Phillips that Hartley, Marin, Dove, and O'Keeffe are "my babies." See Stieglitz to Duncan Phillips, February 1, 1926, quoted in Elizabeth Hutton Turner, *In the American Grain: The Stieglitz Circle at the Phillips Collection* (Washington, DC: Counterpoint and the Phillips Collection, 1995), p. 114.

2. Stieglitz to Sheldon Cheney, August 23, 1923, Cheney Papers, Archives of American Art, Smithsonian Institution, reel 3947, frame 445.

3. The artists generally seemed to recognize and appreciate Stieglitz's efforts on their behalf. For example, Marsden Hartley told Gertrude Stein, "I owe [Stieglitz] everything for the success of the past . . . And . . . for all this time I have been one of his spiritual & practical cares." (Hartley to Stein, October 1913, in Donald Gallup, ed., *The Flowers of Friendship* [New York: Octagon, 1979], p. 85.) Similarly, O'Keeffe told a reporter that Stieglitz "sees the great needs we have, and in order that we may work and yet live, Stieglitz, when he believes in one of us, fights with all his strength and force for that one, and with that one, against all the organized prejudices and politics which try to dominate the world of art, as well as that of life." (Blanche C. Matthias, "Georgia O'Keeffe and the Intimate Gallery: Stieglitz Showing Seven Americans," *Chicago Evening Post Magazine of the Art World* [March 2, 1926], p. 14, reproduced in Barbara Buhler Lynes, *O'Keeffe, Stieglitz and the Critics, 1916–1929* [Chicago and London: University of Chicago Press, 1989], p. 250.) In addition, Stieglitz's personal correspondence with Arthur Dove, Duncan Phillips, and Henry McBride all contain telling details about the artists' financial situations and Stieglitz's efforts on their behalf.

4. O'Keeffe admired Dove's work throughout her life. She expressed her preference for his paintings in a March 31, 1952, letter to Donald Gallup, quoted in Jack Cowart et al., *Georgia O'Keeffe: Art and Letters* (Washington: National Gallery of Art and New York Graphic Society Books, 1987), p. 262. And in an interview with Robert Metzger (1972), O'Keeffe acknowledged that Dove was an important influence even though his works were "always more abstract." See Robert Paul Metzger, "Biomorphism in American Painting," Ph.D. diss., University of California, Los Angeles, 1973, p. 81.

5. Georgia O'Keeffe, *Georgia O'Keeffe* (New York: Penguin Books, 1977), n.p. In this book O'Keeffe also commented on the relations she perceived between abstraction, natural subjects, and the self: "It is surprising to me to see how many people separate the objective from the abstract. Objective painting is not good painting unless it is good in the abstract sense . . . For me that is the very basis of painting. The abstraction is often the most definite form for the intangible thing in myself that I can only clarify in paint." For additional comments by O'Keeffe on the relationship between naturalism and abstraction in her work, see her letter to John I. H. Baur of April 22, 1957, in Cowart et al., *O'Keeffe: Art and Letters*, pp. 266–267, and her statements quoted in Lynes, *O'Keeffe*, pp. 180–182.

6.   Dove to Stieglitz, August 1921, quoted in Ann Lee Morgan, ed., *Dear Stieglitz, Dear Dove* (Cranbury, NJ: Associated University Presses, 1988), p. 75.

7.   Biographical information on this part of Dove's life is based on the letters Dove and Stieglitz exchanged and the accompanying commentary provided by Morgan in *Dear Stieglitz*, pp. 75–78. From an early point, their letters reveal deep trust and friendship.

8.   As Rosenfeld put it, "If these two artists [Dove and Marin] instance in their work the unification of the male, the oils, water-colours, and black and whites of Georgia O'Keeffe instance the complement." See Paul Rosenfeld, "American Painting," *Dial* 71 (December 1921), p. 666.

9.   Rosenfeld, "American Painting," p. 665.

10.  Stieglitz to Sheldon Cheney, August 24, 1923, Cheney Papers, Archives of American Art, Smithsonian Institution, reel 3947, frames 449–450. Cheney's book, *A Primer of Modern Art*, was published by Boni and Liveright in 1924. Cheney's *Primer* was written as an introductory guide to modern art and was intended to promote a general understanding and appreciation of European and American modernism. Cheney's text reflects the influences of formalist and imagist writers such as Willard Huntington Wright, Clive Bell, and Ezra Pound, all of whom are acknowledged in the introduction. Stieglitz's correspondence with Cheney prior to the publication of this volume reveals that Stieglitz advised Cheney on where he could view paintings, and that he tried to shape Cheney's understanding of the Stieglitz circle artists. In turn, Cheney's *Primer* shares key similarities with Stieglitz circle discourses, especially in their mutual polemic against realism and their belief that notions of aesthetics are tied to spirituality. Not surprisingly, Stieglitz responded positively to Cheney's work. After receiving a copy of the book in February of 1924, Stieglitz told Cheney that his text was "a door opener." However, unlike Stieglitz and his critics, Cheney posited a developmental model of painterly evolution that he saw culminating in the "purified" forms of abstract art (see esp. p. 158 of the *Primer* for a discussion of this evolution). In this respect, Cheney's writings are less evocative of Stieglitz than of Clement Greenberg, a writer for whom Cheney was an important precursor. However, Cheney's role in popularizing Stieglitz circle works, and his impact on the artistic and critical practices of the Stieglitz circle in general, largely remain open questions. Stieglitz's correspondence with Cheney can be found in the Sheldon Cheney Papers, Archives of American Art, Smithsonian Institution, reel 3947, esp. frames 441–464 and 487–490.

11. This work, now in a private collection, is illustrated in Morgan, *Dear Stieglitz*, p. 94.

12. Stieglitz to Sheldon Cheney, August 24, 1923, Cheney Papers, Archives of American Art, Smithsonian Institution, reel 3947, frames 449–450.

13. Rosenfeld to Stieglitz, July 22 and August 5, 1923, YCAL. In the July 22 letter Rosenfeld told Stieglitz that he had discussed the Dove article with Herbert Seligmann, who was a help to him.

14. Paul Rosenfeld, *Port of New York: Essays on Fourteen American Moderns* (New York: Harcourt, Brace and Company, 1924), pp. 170–171. In his later critical writings Rosenfeld tended to place greater emphasis on what he saw as the psychic and mystical aspects of Dove's work, but he maintained its relation to O'Keeffe's art even while emphasizing their differences. In 1932 Rosenfeld wrote: "If [Dove] remains closest to O'Keeffe, and if his painting, because of its abstractness and its luminosity of color, is almost blood-brother to hers, the relative normality and accessibility, perhaps even commonplaceness of his sister artist's far more passionate experiences, leave the breach of their products wide." See Paul Rosenfeld, "The World of Arthur G. Dove," *Creative Art* 10 (June 1932), p. 428.

15. Anne M. Wagner has interpreted O'Keeffe's tendency to combine multiple themes and shifting reference points in her art as consistent with the artist's larger strategy of destabilizing gender, bodily experience, and unified identity in her own artistic and self-constructions. See Anne M. Wagner, *Three Artists (Three Women): Modernism and the Art of Hesse, Krasner, and O'Keeffe* (Berkeley and Los Angeles: University of California Press, 1996). In contrast, I am concerned with how the relationship between body and painting operated historically in the works of Stieglitz and the five painters with whom he was most closely associated after the closing of 291, including O'Keeffe. Thus instead of focusing on the ways in which multiple and even hybrid possibilities of gender and embodiment were *internal* to O'Keeffe's oeuvre, I am interested in tracing the ways in which O'Keeffe's "femininity" became mapped onto a larger framework of gendered and aesthetic oppositions that were deployed *externally* in the construction of the Stieglitz circle's group identity.

16. Edmund Wilson, "The Stieglitz Exhibition," *The New Republic* (March 18, 1925), reprinted in *The American Earthquake: A Documentary of the Twenties and Thirties* (Garden City, NY: Doubleday, 1958), p. 98.

17. Stieglitz, "Woman in Art," from an October 9, 1919, letter to Stanton Macdonald-Wright, quoted in Dorothy Norman, *Alfred Stieglitz: An American Seer* (Millerton, NY: Aperture, 1973), p. 137.

18. Wilson, "The Stieglitz Exhibition," pp. 101–102.

19. O'Keeffe interview with Dorothy Seiberling (1974), quoted in Lynes, *O'Keeffe*, p. 158.

20. Frederick J. Hoffman, *Freudianism and the Literary Mind* (Baton Rouge: Louisiana State University Press, 1945), p. 1.

21. Ann Douglas, *Terrible Honesty: Mongrel Manhattan in the 1920s* (New York: Farrar, Straus, and Giroux, 1995), p. 146.

22. As John D'Emilio and Estelle B. Freedman have noted, during this period "sex was becoming, in the view of modern theorists, a common characteristic that motivated both men and women, and expressed one's deepest sense of self." See John D'Emilio and Estelle B. Freedman, *Intimate Matters: A History of Sexuality in America* (New York: Harper & Row, 1988), p. 234.

23. Douglas, *Terrible Honesty*, p. 147.

24. Nathan G. Hale, Jr., *The Rise and Crisis of Psychoanalysis in the United States: Freud and the Americans, 1917–1985* (New York and Oxford: Oxford University Press, 1995), vol. 2, pp. 57–58. On this topic see also Hoffman, *Freudianism*, pp. 53–58, 86.

25. James Strachey provides the dates and content of Freud's English translations in his editor's note to Sigmund Freud, *Three Essays on the Theory of Sexuality*, trans. James Strachey (New York: Basic Books, 1975), pp. ix–x. As Hoffman has pointed out, these two studies "contained most of what was to be tagged as 'Freudianism' by the layman." See Hoffman, *Freudianism*, p. 48.

26. Search Light [Waldo Frank], *Time Exposures* (New York: Boni & Liveright, 1926), p. 97.

27. Norman, *Alfred Stieglitz*, p. 129.

28. Hutchins Hapgood, *A Victorian in the Modern World* (New York: Harcourt, Brace, and Company, 1939), p. 382.

29. Edmund Wilson, "The Progress of Psychoanalysis," *Vanity Fair* 16 (August 1920), p. 41.

30. Search Light, *Time Exposures*, pp. 96, 99–100.

31. Rosenfeld, *Port of New York*, p. 186.

32. Edmund Wilson, "Paul Rosenfeld," *The New Republic* 43 (June 3, 1925), p. 48.

33. Sue Davidson Lowe, *Stieglitz: A Memoir/Biography* (New York: Farrar Straus Giroux, 1983), pp. 211, xxi.

34. Stieglitz's letter to Ellis's American publisher is dated October 17, 1911 (YCAL).

35. Stieglitz to Rosenfeld, November 17, 1923, YCAL.

36. Havelock Ellis, *The Dance of Life* (Boston and New York: Houghton Mifflin Company, 1923), p. 111. In *Three Essays on the Theory of Sexuality,* Freud had identified sublimation as one of the origins of artistic activity, a process through which sexual drives are applied to other fields. See Freud, *Three Essays,* p. 104.

37. Havelock Ellis, "Auto-Eroticism," in *Studies in the Psychology of Sex* (1905; New York: Random House, 1936), vol. 1, p. 282.

38. Alfred Stieglitz, "Georgia O'Keeffe—C. Duncan—René Lafferty," *Camera Work* 48 (October 1916), p. 12. Barbara Buhler Lynes has noted that Stieglitz encouraged Freudian interpretations of O'Keeffe's artworks: see Barbara Buhler Lynes, "Georgia O'Keeffe and Feminism: A Problem of Position," in Norma Broude and Mary D. Garrard, eds., *The Expanding Discourse: Feminism and Art History* (New York: Icon, 1992), p. 439. And in *O'Keeffe, Stieglitz, and the Critics, 1916–1929,* Lynes observes that Stieglitz used Freudian ideas as a promotional device for O'Keeffe's art (p. 24).

39. Hapgood, *A Victorian in the Modern World,* pp. 338, 337.

40. Dove to Stieglitz, July 11, 1930, in Morgan, *Dear Stieglitz,* p. 194.

41. Arthur Dove in Arthur Jerome Eddy, *Cubists and Post-Impressionism* (Chicago: A. C. McClurg & Co., 1914), p. 48 (emphasis in original).

42. Arthur G. Dove, statement in *The Forum Exhibition of Modern American Painters* (New York: M. Kennerley, 1916), n.p. In this statement Dove described essence, form, and pleasure as central to his artistic project, and stated his desire "to give in form and color the reaction that plastic objects and sensations of light from within and without have reflected in my inner consciousness."

43. Stieglitz to McBride, April 8, 1923, Henry McBride Papers, Archives of American Art, Smithsonian Institution, reel NMcB12, frame 467.

44. Stieglitz to Dove, July 18, 1923, in Morgan, *Dear Stieglitz,* p. 89.

45. Dove received passing notice in Sheldon Cheney's *A Primer of Modern Art* (New York: Boni and Liveright, 1924), esp. pp. 238–239. Demuth, Hartley, Marin, and O'Keeffe also were treated in this text.

46. Mather's book *The American Sprit in Art* (New Haven: Yale University Press, 1927) was published four years later. In this text modernism is roughly equated with a tendency toward abstraction, and Dove, Marin, Demuth, O'Keeffe, and Hartley are grouped together under the rubric "Recent Visionaries—The Modernists."

47. See the letters Dove and Stieglitz exchanged between October 7 and October 9, 1923, quoted in Morgan, *Dear Stieglitz,* pp. 93–96. Dove never published this book.

48. Regarding this portrait, Dove later told Stieglitz, "The one of you was on vellum with a smoked lens. Suggesting what I saw about you when you were speaking of your mother to Bloch the musician at your brother's house." (Dove to Stieglitz, October 3, 1942, in Morgan, *Dear Stieglitz,* p. 477.) Dove's *Portrait of Alfred Stieglitz* contains a photographic plate, a camera lens, clock and watch springs, and steel wool on cardboard. This unsigned and undated assemblage is in the collection of the Museum of Modern Art, where it has been assigned a date of 1925. Ann Lee Morgan has dated the work 1924 (*Dear Stieglitz,* p. 100). See also Barbara Haskell, *Arthur Dove* (San Francisco Museum of Art and the New York Graphic Society, 1974), p. 67.

49. Dove to Stieglitz, August 1925, in Morgan, *Dear Stieglitz,* p. 117.

50. Dove to Stieglitz, April 28, 1940, in Morgan, *Dear Stieglitz,* p. 439. The article by Rosenfeld was "Dove and the Independents," *The Nation* 150 (April 27, 1940), p. 549.

51. Rosenfeld, "American Painting," p. 665.

52. Rosenfeld, *Port of New York,* p. 169.

53. Rosenfeld, *Port of New York,* p. 170.

54. Waldo Frank, "The Art of Arthur Dove," *The New Republic* 45 (January 27, 1926), p. 269.

55. Frank, "Arthur Dove," p. 269.

56. Cheney, *A Primer,* p. 239. Drawing on the comments of Herbert Seligmann and Dove himself, Debra Bricker Balken has analyzed the sexual references embedded in Dove's water imagery, and she provides color reproductions of two of Dove's water images, *#4 Creek* (c. 1919) and *Penetration* (1924). See Debra Bricker Balken et al., *Arthur Dove: A Retrospective* (Addison Gallery of American Art and the MIT Press, 1998), p. 28 and plates #19 and #20.

57. A thematically related work is Dove's *River Bottom, Silver, Ochre, Carmine, Green* (c. 1920–1923, Michael Scharf Collection). Although presumably a view from above the water, this painting also suggests a strong sense of flow through its rippling verticality.

58. Frank, "Arthur Dove," p. 269.

59. Dove to Stieglitz, October 24, 1923, and August 15, 1924, in Morgan, *Dear Stieglitz,* pp. 97–98, 105–107.

60. In what was probably his first letter to Phillips, Stieglitz mentioned that he must read both Rosenfeld's *Port of New York* and Frank's article in the *New Republic,* and he offered to send Phillips a copy of Rosenfeld's book. Stieglitz's letter to Phillips of January 22, 1926, is reproduced in Turner, *In the American Grain,* p. 112.

61. Regarding this transaction, Stieglitz told Dove that, "The 'right' thing took place even if Friend P. R. is still peeved & acting 'kinder foolish.'" (Stieglitz to Dove, March 6, 1926, in Morgan, *Dear Stieglitz*, p. 125.) See also the letters Stieglitz and Phillips exchanged between January 22 and February 8, 1926, reprinted in Turner, *In the American Grain*, pp. 111–115.

62. Phillips turned out to be Dove's most important and regular patron during the artist's lifetime. Both Stieglitz and Dove had much at stake in building a relationship with Phillips. Yet it was Stieglitz himself who remained Dove's most important supporter. Waldo Frank emphasized Stieglitz's unstinting support of Dove in his 1926 article, and in 1930 Samuel M. Kootz noted that Dove "has been continuously sponsored by Alfred Stieglitz in the face of a hostile and non-understanding public." See Samuel M. Kootz, *Modern American Painters* (New York: Brewer & Warren, 1930), p. 36.

63. In addition to *Golden Storm* and *Waterfall*, Phillips took two paintings by O'Keeffe, *My Shanty, Lake George* and *Leaf Motif No. 1*. Phillips later exchanged O'Keeffe's *Leaf Motif No. 1* for her *Pattern of Leaves*. While his comments tended to be less overtly sexual than those of the Stieglitz circle critics, Phillips echoed many of their themes in his own writings. Phillips quoted Rosenfeld's writing on John Marin directly in his catalogue *A Collection in the Making* (Washington, DC: Phillips Memorial Gallery, 1926), p. 59. Rosenfeld's comments on Hartley and O'Keeffe, and Frank's writings on Dove, also were influential in shaping Phillips's descriptions of these artists. Phillips's essay "The Art of Arthur G. Dove" was printed in a flyer accompanying an exhibition of Dove's paintings held at An American Place from March 29 to May 10, 1938. A copy of this document can be found in the Whitney Museum Papers, Archives of American Art, Smithsonian Institution, reel N653, frame 447. See also Phillips's foreword to Frederick S. Wight, *Arthur G. Dove* (Berkeley and Los Angeles: University of California Press, 1958), p. 13.

64. Dove to Stieglitz, December 4, 1930, in Morgan, *Dear Stieglitz*, pp. 201–202. Interestingly, Dove may also have been referring to the white phallic form embedded in the center of O'Keeffe's painting *Abstraction* (1919), which he owned. This painting is illustrated in Barbara Buhler Lynes, *Georgia O'Keeffe Catalogue Raisonné* (New Haven and London: Yale University Press, 1999), vol. 1, cat. #286, p. 153.

65. Arthur Dove to Elizabeth McCausland, May 13, 1933, The Elizabeth McCausland Papers, Archives of American Art, Smithsonian Institution, reel D384 B, frame 142.

66. Dove to Stieglitz, March 31–April 3, 1929, in Morgan, *Dear Stieglitz,* p. 169.

67. Rosenfeld, *The World of Arthur G. Dove,* pp. 428–429.

68. Dove to Phillips, May 16–18, 1933, reproduced in Turner, *In The American Grain,* p. 151.

69. Stieglitz's comments are recorded in Herbert J. Seligmann, *Alfred Stieglitz Talking: Notes on Some of His Conversations, 1925–1931* (New Haven: Yale University Library, 1966), p. 135. See also Richard Whelan, *Alfred Stieglitz: A Biography* (Boston: Little, Brown, and Company, 1995), p. 428.

70. Rosenfeld, *Port of New York,* p. 205.

71. Stieglitz achieved a similar effect in his photographs through his tendency to crop his subjects. As originally printed, many of Stieglitz's photographs are quite small. Their diminutive size gives the impression of preciousness and requires that the viewer be in intimate physical contact with the objects in order to observe them.

72. See especially Wassily Kandinsky, *Concerning the Spiritual in Art* (1911), trans. M. T. H. Sadler (New York: Dover, 1977).

73. Arthur G. Dove, "An Idea," flyer accompanying the exhibition "Arthur G. Dove Paintings, 1927," held at The Intimate Gallery from December 12, 1927, through January 11, 1928. A copy of this pamphlet can be found in the Whitney Museum Papers, Archives of American Art, Smithsonian Institution, reel N653, frame 433.

74. The notion of transparent immediacy articulated in Dove's statement is a trope that recurs throughout expressionist writings such as Cheney's *A Primer of Modern Art* (1924) and his later book *Expressionism in Art* (1934). Typically, this concept was used to signify the hard-wired relationships between emotion, visuality, and spirituality that ostensibly were embodied in the formal structures of a work of art.

75. Stieglitz to Dove, December 3, 1937, in Morgan, *Dear Stieglitz,* pp. 392–393.

76. The letters Stieglitz and Dove exchanged provide detailed financial information regarding the sales of Dove's works, as well as much insight into the market situation for Marin's and O'Keeffe's paintings. For the Dove-Stieglitz correspondence, see Morgan, *Dear Stieglitz,* especially chapters 5 and 6. In addition, Stieglitz's correspondence with Henry McBride contains several references to the art market during the twenties and thirties. Stieglitz's letters are found in the Henry McBride Papers, Archives of American Art, Smithsonian Institution, reel NMcB12.

77. As the art historian Meyer Schapiro has brilliantly argued, the pictorial units of which a painting is composed, its "signs," do not have to be liter-

al but can be nonmimetic and formal. The intimate formal structure of nonmimetic signs in abstract painting owes its meaning to corresponding representational signs. Schapiro wrote, "For the aesthetic eye the body, and indeed any object, seems to incorporate the empty space around it as a field of existence. The participation of the surrounding void in the image-sign of the body is still more evident when several figures are presented; then the intervals between them produce a rhythm of body and void and determine effects of intimacy, encroachment and isolation, like the intervals of space in an actual human group." See Meyer Schapiro, "On Some Problems in the Semiotics of Visual Art: Field and Vehicle in Image-Signs," *Semiotica* 1 (1969), pp. 223–242.

78. Marsden Hartley, "Some Women Artists in Modern Painting," in *Adventures in the Arts: Informal Chapters on Painters, Vaudeville and Poets* (1921; New York: Hacker Art Books, 1972), p. 116.

79. This early fragment would be revised and expanded in his subsequent essays on O'Keeffe in the October 1922 issue of *Vanity Fair* and in *Port of New York* (1924). See Paul Rosenfeld, "The Paintings of Georgia O'Keeffe: The Work of the Young Artist Whose Canvases Are to Be Exhibited in Bulk for the First Time This Winter," *Vanity Fair* 19 (October 1922), pp. 56, 112, 114.

80. Rosenfeld, "American Painting," p. 666.

81. Freud wrote: "When erotogenic susceptibility to stimulation has been successfully transferred by a woman from the clitoris to the vaginal orifice, it implies that she has adopted a new leading zone for the purposes of her later sexual activity." In turn, Freud linked adult male sexual pleasure directly to the act of penetration, or more precisely, to "penetration into a cavity in the body which excites his genital zone." See Freud, *Three Essays*, pp. 87–88.

82. For an especially sharp critical response to issues of gender and sexuality in O'Keeffe's art, see Samuel M. Kootz's section on O'Keeffe in *Modern American Painters*, p. 49.

83. Alexander Brook, "February Exhibitions: Georgia O'Keefe [sic]," *The Arts* 3 (February 1923), p. 130, reprinted in Lynes, *O'Keeffe*, p. 194.

84. Herbert J. Seligmann, "Georgia O'Keeffe, American," *Manuscripts* 5 (March 1923), p. 10.

85. Rosenfeld, *Port of New York*, p. 205.

86. Interestingly, Anna C. Chave has also written that "O'Keeffe portrayed abstractly her experience of a feminine body, her body, alluding especially to areas that are invisible (and unrepresented) due to their interiority. She devised for viewers an ever-expanding catalogue of visual metaphors

for the experience of space and penetrability generally." See Anna C. Chave, "O'Keeffe and the Masculine Gaze," in Marianne Doezema and Elizabeth Milroy, eds., *Reading American Art* (New Haven and London: Yale University Press, 1998), p. 354. Yet in this essay Chave attempts to rehabilitate O'Keeffe's works from a feminist perspective, arguing that an underlying knowledge of her own body informed O'Keeffe's images and resulted in pictures that "may appeal to women by articulating the sensation of crevices and spaces not as an experience of lack and absence but as one of plentitude and gratification" (pp. 363–364).

87.  Rosenfeld, *Port of New York*, p. 199.

88.  Rosenfeld, *Port of New York*, pp. 201–202.

89.  Lewis Mumford also ascribed an explicitly eroticized meaning to O'Keeffe's flower paintings when he characterized them as the symbolic equivalents of a sexual union. Reviewing O'Keeffe's 1927 exhibition at The Intimate Gallery for the *New Republic*, Mumford wrote that in her floral images O'Keeffe "has revealed the intimacies of love's juncture with the purity and the absence of shame that lovers feel in their meeting; . . . she has, in sum, found a language for experiences that are otherwise too intimate to be shared." See Lewis Mumford, "O'Keefe [sic] and Matisse," *New Republic* 50 (March 2, 1927), pp. 41–42. This essay was reprinted in the pamphlet that accompanied O'Keeffe's 1928 exhibition at The Intimate Gallery.

90.  Stieglitz to Rosenfeld, November 9, 1924, YCAL. In this letter Stieglitz was comparing O'Keeffe's paintings with wildflower arrangements made by her sister Ida who was visiting Lake George.

91.  A related work is O'Keeffe's *Flower* (c. 1924, Museum of Modern Art), a painting originally owned by Florence Cane, the older sister of Waldo Frank's wife Margaret Naumburg. Florence Cane was an artist, art teacher, and a Westport friend of both Dove's and Rosenfeld's. See note 111 below.

92.  Wilson, *The Stieglitz Exhibition*, pp. 98–99.

93.  Frank, *Time Exposures*, p. 33.

94.  Henry McBride, "Georgia O'Keefe's [sic] Recent Work," *New York Sun* (January 14, 1928), p. 8.

95.  Charles Demuth, "Peggy Bacon," a pamphlet to accompany an exhibition at The Intimate Gallery, March 27–April 17, 1928. A copy of this pamphlet can be found in the Whitney Museum Papers, Archives of American Art, Smithsonian Institution, reel N653, frame 47.

96.  Georgia O'Keeffe, "About Myself," statement dated January 1939 and published in the pamphlet accompanying the exhibition "Georgia O'Keeffe: Exhibition of Oils and Pastels," held at An American Place from

January 22 to March 17, 1939. A copy of this pamphlet can be found in the Whitney Museum Papers, Archives of American Art, Smithsonian Institution, reel N679, frames 168–169.

97. Georgia O'Keeffe, "To MSS and Its 33 Subscribers and Others Who Read and Don't Subscribe!" *MSS* 4 (December 1922), pp. 17–18, quoted in Lynes, *O'Keeffe*, p. 182.

98. Georgia O'Keeffe, statement in *Alfred Stieglitz Presents One Hundred Pictures: Oils, Watercolors, Pastels, Drawings, by Georgia O'Keeffe, American*, The Anderson Galleries, January 29 to February 10, 1923. This statement is reproduced in Lynes, *O'Keeffe*, pp. 184–185.

99. Rosenfeld thanked Stieglitz for "the opportunity of observing [you and O'Keeffe] at close range for such a length of time." He then noted that his visit to Lake George gave him "a good start" on his writings. (Rosenfeld to Stieglitz, October 29, 1920, YCAL.)

100. Rosenfeld to Stieglitz, June 13, 1921, YCAL.

101. Rosenfeld to Stieglitz, August 23, 1921, YCAL.

102. Rosenfeld to O'Keeffe, October 1921, YCAL.

103. "The Female of the Species Achieves a New Deadliness: Women Painters of America Whose Work Exhibits Distinctiveness of Style and Marked Individuality," *Vanity Fair* 18 (July 1922), p. 50, reprinted in Lynes, *O'Keeffe*, p. 175.

104. O'Keeffe to Doris McMurdo, July 1, 1922, quoted in Cowart et al., *O'Keeffe: Art and Letters*, pp. 169–170.

105. Cowart et al., *O'Keeffe: Art and Letters*, p. 170.

106. O'Keeffe to Mitchell Kennerley, Fall 1922, in Cowart et al., *O'Keeffe: Art and Letters*, pp. 170–171.

107. Cowart et al., *O'Keeffe: Art and Letters*, p. 278, n. 26.

108. On this point see also Chave, "O'Keeffe and the Masculine Gaze," p. 361.

109. Henry McBride, "Art News and Reviews—Woman as Exponent of the Abstract," *New York Herald* (February 4, 1923), section 7, p. 7.

110. O'Keeffe to McBride, February 1923, in Cowart et al., *O'Keeffe: Art and Letters*, p. 171.

111. Rosenfeld to Stieglitz, September 1922, YCAL. In this letter Rosenfeld also mentioned that Florence Cane helped him to compose the O'Keeffe article. While Rosenfeld doesn't provide specific details on the extent of their collaboration, more or less describing their efforts as a game, it should be noted that the conceptual structure of the *Vanity Fair* article already was largely in place in Rosenfeld's 1921 *Dial* essay. His ideas undoubtedly were further augmented by subsequent conversations with Stieglitz.

112. Just how friendly this relationship was remains an open question given the erotic tenor of Rosenfeld's essays on O'Keeffe. At the same time, it should be noted that Rosenfeld's highly charged descriptions of O'Keeffe furthered his and Stieglitz's critical goal of stimulating the viewer's desire for her paintings.

113. This file (YCAL MSS 85, Box 212, Folder 3722) contains seven letters and one post card. All but one item date from the 1920s.

114. Regarding O'Keeffe's letters, Rosenfeld told Stieglitz that "She uses words etc. but it is all like her painting. One feels mountains & bright color & pleasant fruit, all without quite knowing why. She is so nice and gentle! I am glad she is reading Rosenfeld; one thing I know, it will not rob her of her sleep." (Rosenfeld to Stieglitz, October 12, 1923, YCAL.)

115. Rosenfeld to Stieglitz, November 15, 1923, YCAL.

116. As described in Virgil's *Aeneid*, the Hyrcan tiger was a particularly ferocious creature who inhabited Hyrcania, a wild region on the ancient Caspian Sea. See the *Oxford English Dictionary*, 2d ed. (Oxford: Clarendon Press, 1989), vol. 7, p. 585.

117. Rosenfeld to O'Keeffe, November 18, 1923, YCAL.

118. Stieglitz to Rosenfeld, April 25, 1924, YCAL.

119. The exhibition that Sweeney organized opened at the Museum of Modern Art on May 14, 1946. The monograph was never published.

120. O'Keeffe to Sweeney, July 28, 1945, in Cowart et al., *O'Keeffe: Art and Letters*, p. 242.

121. This pictorial tendency is apparent in some of her earliest canvases, such as *Black Spot III* (1919, Albright-Knox Art Gallery) and *Blue and Green Music* (1919, The Art Institute of Chicago), as well as some of her later paintings, such as *Black Place III* (1944, Estate of Georgia O'Keeffe), versions II and III of *It Was Yellow and Pink* (1960, Cleveland Museum of Art and the Estate of Georgia O'Keeffe), and even the enormous *Sky Above Clouds IV* (1965, The Art Institute of Chicago).

122. O'Keeffe to Anderson, September 1923, in Cowart et al., *O'Keeffe: Art and Letters*, p. 174.

123. O'Keeffe to Anderson, February 11, 1924, in Cowart et al., *O'Keeffe: Art and Letters*, p. 176.

124. Rosenfeld to O'Keeffe, September 9, 1921, YCAL.

125. O'Keeffe to Blanche Matthias, March 1926, in Cowart et al., *O'Keeffe: Art and Letters*, p. 183.

126. Reminiscing about her 1923 exhibition at the Anderson Galleries, O'Keeffe admitted that, more than anyone else, she cared most about what Stieglitz thought of her work. (O'Keeffe, *Georgia O'Keeffe*, n.p.)

127. Sarah Whitaker Peters, *Becoming O'Keeffe: The Early Years* (New York: Abbeville, 1991), pp. 167–168.

128. Peters, *Becoming O'Keeffe*, p. 339, n. 31. Anne M. Wagner has pointed out that in 1932 O'Keeffe posed for additional nude photographs that were as eroticized as the earlier works. See Wagner, *Three Artists*, pp. 95, 306–307, n. 106.

129. *Georgia O'Keeffe: A Portrait by Alfred Stieglitz* (New York: Metropolitan Museum of Art, 1978).

130. For example, Anna C. Chave has written that Stieglitz "successfully marketed O'Keeffe's art as a kind of soft-core pornography or as a sop to male fantasies by perverting her images into reifications of male desire, of the pleasure men imagine themselves giving women." See Chave, "O'Keeffe and the Masculine Gaze," p. 363.

131. Barbara Buhler Lynes has discussed the complications that stemmed from the intertwining of O'Keeffe's personal involvement with Stieglitz and the practical necessity of her dependence on him for both professional recognition and financial well-being. (See Lynes, "Georgia O'Keeffe and Feminism," p. 444.) And in her important study *O'Keeffe, Stieglitz, and the Critics, 1916–1929*, Lynes has argued that while O'Keeffe did not openly challenge Stieglitz's interpretation of her art, from the mid-1920s onward she attempted to control her image, in part by cultivating a severe, austere persona that contradicted the eroticized interpretations of her work.

132. O'Keeffe to McBride, January 1927, reproduced in "Reaction and Revolution 1900–1930," *Art in America* 53 (August/September 1965), p. 79.

133. O'Keeffe to Frank, January 10, 1927, in Cowart et al., *O'Keeffe: Art and Letters*, p. 185.

134. In letters to Ettie Stettheimer and Mabel Dodge Luhan (August and September 1929), O'Keeffe expressed her conflicting feelings for Stieglitz. See Cowart et al., *O'Keeffe: Art and Letters*, pp. 195–199.

135. O'Keeffe to Russell Vernon Hunter, Spring 1932, in Cowart et al., *O'Keeffe: Art and Letters*, p. 207.

136. *Georgia O'Keeffe, A Portrait by Alfred Stieglitz*, n.p.

## 5 John Marin: Framed Landscapes and Embodied Visions

1. While virtually every writer on Marin emphasizes the artist's debt to Stieglitz, the particular nature of the two men's relationship is most closely examined in Timothy Robert Rodgers's study, "Making the American Artist: John Marin, Alfred Stieglitz, and Their Critics, 1900–1936," Ph.D. dissertation, Brown University, 1994.

2.  Paul Rosenfeld, *Port of New York: Essays on Fourteen American Moderns* (New York: Harcourt, Brace and Company, 1924), p. 162.

3.  Rosenfeld, *Port of New York*, pp. 154, 164–165.

4.  Marius de Zayas, *How, When, and Why Modern Art Came to New York*, ed. Francis M. Naumann (Cambridge and London: MIT Press, 1996), p. 87. In 1921 Rosenfeld had remarked that Marin, Dove, and O'Keeffe "were intimately associated with the Photo-Secession gallery, were championed by it, exhibited, and furthered in the many ways in which that institution furthered those who came in contact with it." Paul Rosenfeld, "American Painting," *Dial* 71 (December 1921), pp. 667–668.

5.  Herbert J. Seligmann, *Alfred Stieglitz Talking: Notes on Some of His Conversations, 1925–1931* (New Haven: Yale University Library, 1966), p. 1, reporting a conversation in late 1925. See pp. 130–131 for another account of this story.

6.  Alfred Stieglitz, "Four Marin Stories," *Twice a Year* 8–9 (1942), p. 158. Another version of the first part of this story is found in Dorothy Norman, *Alfred Stieglitz: An American Seer* (Millerton, NY: Aperture, 1960), pp. 97–99.

7.  Seligmann, *Alfred Stieglitz Talking*, pp. 128–129.

8.  Henry Miller, "Stieglitz and Marin," *Twice a Year* 8–9 (1942), p. 153.

9.  These exhibitions included a retrospective of Marin's watercolors held at the Intimate Gallery from December 7, 1925, through January 11, 1926, and the exhibition "Marin: 50 Watercolors" held at An American Place from December 15, 1929, through January 25, 1930.

10. Alfred Stieglitz to A. E. Gallatin, December 3, 1922, Albert Eugene Gallatin Papers, The New-York Historical Society. Stieglitz was pleased with Gallatin's description of Marin in his study of American watercolorists. Gallatin called Marin "a visionary" who "is not interested in formulas; the roots of his art are deeply embedded in the soil of New England, and it is there that his genius derives most of its nourishment." A. E. Gallatin, *American Water-Colourists* (New York: E. P. Dutton, 1922), p. 18.

11. Stieglitz to Henry McBride, June 29, 1922, McBride Papers, Archives of American Art, Smithsonian Institution, reel NMcB 12, frame 460. Much later Rosenfeld posited a physical resemblance between Marin and his art. Rosenfeld noted that "at excited moments, he also resembled his future water colors." Paul Rosenfeld, "John Marin's Career," *The New Republic* 90 (April 14, 1937), p. 289.

12. Henry McBride, "Marin Water-Colors are on View.—Masterly Art Not Yet Fully Appreciated," *New York Sun* (December 12, 1925), reprinted in a flyer accompanying the exhibition "John Marin at The Intimate Gallery," December 7, 1925, to January 11, 1926.

13. Seligmann, *Alfred Stieglitz Talking*, p. 88.

14. Herbert J. Seligmann, ed., *Letters of John Marin* (1931; Westport, CT: Greenwood Press, 1970).

15. Dove to Stieglitz, July 5, 1931, quoted in Ann Lee Morgan, ed., *Dear Stieglitz, Dear Dove* (Cranbury, NJ: Associated University Presses, 1988), p. 227.

16. Another such index of Stieglitz's success can be gauged by the market conditions that he was able to cultivate for Marin's works. While details of various financial transactions are found throughout the primary source material on Marin, the most infamous example undoubtedly concerns Stieglitz's well-publicized efforts to get the collector Duncan Phillips to pay $6,000 for a single Marin watercolor. For Stieglitz's and Phillips's respective accounts of this incident, see Alfred Stieglitz's privately published pamphlet of April 17, 1927, and Duncan Phillips's letter to Henry McBride of March 19, 1927, in the Henry McBride Papers, Archives of American Art, Smithsonian Institution, reel NMcB12, frames 477, 480–481. For further analysis and commentary see Timothy Robert Rodgers, "Alfred Stieglitz, Duncan Phillips and the '$6000 Marin'," *Oxford Art Journal* 15 (1992), pp. 54–66; and Elizabeth Hutton Turner, "The Stieglitz Circle at The Phillips Collection," in *In the American Grain* (Washington, DC: Counterpoint and The Phillips Collection, 1995), pp. 18–22.

17. Stieglitz to Sheldon Cheney, August 24, 1923, Cheney Papers, Archives of American Art, Smithsonian Institution, reel 3947, frame 449.

18. Sheldon Cheney, *A Primer of Modern Art* (New York: Boni and Liveright, 1924), p. 235.

19. Edmund Wilson, "The Stieglitz Exhibition," (1925), in *The American Earthquake: A Documentary of the Twenties and Thirties* (Garden City, NY: Doubleday, 1958), pp. 100, 102.

20. Herbert J. Seligmann, "John Marin and the Real America" (New York: An American Place, November 3, 1932), n.p. A copy of this pamphlet can be found in the New York Public Library papers, Archives of American Art, Smithsonian Institution, reel N53, frame 953.

21. Rosenfeld, "American Painting," p. 664.

22. Rosenfeld, *Port of New York*, p. 158. One measure of the influential nature of Rosenfeld's writings is that quotations from this essay are reproduced in Duncan Phillips's book, *A Collection in the Making* (New York: E. Weyhe and the Phillips Memorial Gallery, 1926), pp. 59–60.

23. Rosenfeld, *Port of New York*, pp. 153, 163. The highly gendered rhetoric on Marin's painting would continue well into the 1930s, as discussed in the final chapter of this study.

24. Rosenfeld, *Port of New York*, p. 156.

25. Rosenfeld, *Port of New York*, pp. 161–162.

26. Rosenfeld to Stieglitz, July 22, 1923, YCAL.

27. The works included Marin's watercolors *House* (1913), *Pine Tree* (1914), *Trees and Lake* (1917), and the two Deer Isle, Maine, images *Island, Sun and Ships* and *Movement, Boats and Sea*.

28. Stieglitz set up the fund such that for every hundred dollars an individual contributed, he or she would receive two and one-half times the value of that amount in Marin's artworks. Regarding the Marin Fund, see Norman, *Alfred Stieglitz*, p. 164.

29  Norman, *Alfred Stieglitz*, p. 208.

30. Louis Kalonyme, "The Art Makers," *Arts and Decoration* (December 1926), p. 63. Kalonyme published a version of this essay as "John Marin: Promethean" in *Creative Art* 4 (September 1928), pp. 40–41. For a related discussion see Herbert J. Seligmann, "American Water Colours in Brooklyn," *International Studio* 74 (December 1921), p. clx.

31. Kalonyme, "The Art Makers," p. 63.

32. Sigmund Freud, *The Interpretation of Dreams*, trans. James Strachey (New York: Basic Books, 1965), p. 439, n. 1.

33. John Marin, "To My Paint Children," exhibition catalogue published by An American Place, February 14, 1938, n.p. A copy of this catalogue can be found in the Whitney Museum Papers, Archives of American Art, Smithsonian Institution, reel N674, frames 662–664.

34. Rosenfeld, *Port of New York*, pp. 158, 163, 166.

35. Duncan Phillips, *The Artist Sees Differently* (New York: E. Weyhe, 1931), p. 130.

36. Although my discussion will focus on two paintings Marin made during the early 1920s, the artist continued to work in this manner throughout the 1920s and 1930s. For example, Marin's painting *Street Crossing, New York* (1928, Phillips Collection) is an urban scene set in a "Marin frame" in which the painting's perspective is guided by Marin's "pull forces." And in his painting *Tree No. 1, Cape Split, Maine* (1933, Yale University Art Gallery), Marin uses something like "pull forces" to demarcate the angular structure of the tree and the stylized geometry of the kaleidoscopic planar background. Both the Phillips Collection and the Museum of Fine Arts, Boston contain fine examples of Marin's late calligraphic works, including *Movement—Sea and Sky* (1946); *Movement—Sea or Mountain, as You Will* (1947); *Apple Tree in Blossom* (1948); and *Spring No. 1* (1953).

37. John Marin, text for Marin exhibition at the Photo-Secession Gallery, 1913, in the New York Public Library Papers, Archives of American Art, Smithsonian Institution, reel N53, frame 941. See also Marin's catalogue statement for *The Forum Exhibition of Modern American Painters* (New York: M. Kennerley, 1916), n.p.

38. Rosenfeld, *Port of New York*, p. 155.

39. As Rosenfeld put it, "this perception of movement reported by his eye is the basis of Marin's form." Rosenfeld, *Port of New York*, p. 161.

40. For an extended discussion of the issue of fluids in feminist theory, see Elizabeth Grosz, *Volatile Bodies: Toward a Corporeal Feminism* (Bloomington and Indianapolis: Indiana University Press, 1994), p. 195. For a discussion of male seminal fluids, see pp. 198–202.

41. John Marin, "John Marin, by Himself," *Creative Art* 4 (September 1928), pp. xxxviii–xxxix.

42. Marin to Stieglitz, October 7 to October 12, 1920, quoted in Seligmann, ed., *Letters of John Marin*. See also Marin's letter of August 14, 1923, in this volume, and Marin's statement in Dorothy Norman, *Encounters: A Memoir* (New York: Harcourt, Brace, Jovanovich, 1987), p. 93.

43. Lewis Mumford, "Brancusi and Marin," *New Republic* 49 (December 15, 1926), p. 112.

44. The exception that proves the rule of this interpretive pattern is found in Glen Mullin's review of the "Alfred Stieglitz Presents Seven Americans" exhibition for *The Nation* 120 (May 20, 1925), pp. 577–578. Mullin took issue with Marin's works, noting, "He seemed to be sporting solemnly with intellectual notations to such a degree as to stifle in the beholder all imaginative delight."

45. Samuel M. Kootz, *Modern American Painters* (New York: Brewer & Warren, 1930), pp. 45–46.

46. Kootz, *Modern American Painters*, p. 20. Two other "virile" artists whom Kootz singled out for praise were Peter Blume and Preston Dickinson.

47. Rosenfeld, *Port of New York*, pp. 158–159.

48. Paul Rosenfeld, "Art: An Essay on Marin," *The Nation* 134 (January 27, 1932), pp. 122–124.

49. Marin to Stieglitz, July 20, 1931, quoted in Barbara Rose, *Readings in American Art 1900–1975* (New York: Praeger Publishers, 1975), p. 61. Many of Marin's letters are consistent in tone with the passage quoted above.

50. For a discussion of these formal and conceptual operations, see Katherine S. Dreier and [Roberto] Matta Echaurren, *Duchamp's Glass: An Analytical Reflection* (New York: Société Anonyme, 1944). A copy of this pamphlet

can be found in the New York Public Library Papers, Archives of American Art, Smithsonian Institution, reel N31, frames 50–57.

6   **Marsden Hartley and Charles Demuth: The Edges of the Circle**

1.  At least twice during the thirties Demuth's works were exhibited posthumously at An American Place. Stieglitz exhibited Demuth's paintings as part of a group show at An American Place from November 27 through December 31, 1936, and Demuth's poster portrait of William Carlos Williams, *I Saw the Figure 5 in Gold* (1928), was on display at An American Place from December 29, 1938, through January 19, 1939.

2.  For a discussion of Demuth's marginalized position in the Stieglitz circle, see Wanda M. Corn, *The Great American Thing: Modern Art and National Identity, 1915–1935* (Berkeley and Los Angeles: University of California Press, 1999), pp. 193–237. Some individuals have attributed Demuth's marginalization in the Stieglitz circle to the perception that, as a watercolorist, he would be a potential competitor of Marin's. For example, in an interview with Demuth's first dealer, Charles Daniel, Emily Farnham records Daniel's comment that "Alfred Stieglitz didn't want to carry someone who would be in competition with Marin." Emily Farnham, "Charles Demuth: His Life, Psychology, and Works," Ph.D. diss., Ohio State University, 1959, p. 991. When recalling his visit to the "Alfred Stieglitz Presents Seven Americans" exhibition (1925), Edmund Wilson remembered Stieglitz's effusive praise of Marin and his marginalization of Demuth and concluded that "if Stieglitz played Demuth down, it was undoubtedly for the reason that he did not belong to the inner group of the artists whom he had himself introduced and to promoting whose reputations he had so jealously devoted his energies." Edmund Wilson, "The Stieglitz Exhibition," in *The American Earthquake: A Documentary of the Twenties and Thirties* (Garden City, NY: Doubleday, 1958), p. 102. As late as 1931 the critic Henry McBride noted that "while Mr. Demuth is not technically a member of the little band that flourishes under the Stieglitz aegis, he follows fittingly in the wake of Marin, O'Keefe [sic], Hartley and Dove, and belongs within the particular American tradition that is so staunchly maintained at this unique art center." Henry McBride, "Exhibitions in New York: Charles Demuth: An American Place," *Artnews* 29 (April 18, 1931), p. 10.

3.  In many respects the construction of sexuality expressed in Stieglitz circle writings is consistent with that found in the popular press during the teens and twenties. John D'Emilio has located the rise of homosexual communal

identity in the United States within the larger movement toward sexual liberation in American culture. During the first two decades of the twentieth century, D'Emilio has noted, male homosexuals began to establish gathering places in urban areas, including saloons, clubs, restaurants, literary societies, public bathhouses, YMCAs, and annual drag balls in St. Louis and Washington, D.C. Yet just as an urban gay and lesbian subculture was emerging in the United States, a backlash of legal, medical, and religious discourses condemned homosexuality as a criminal, pathological, or immoral behavior. See John D'Emilio and Estelle B. Freedman, *Intimate Matters: A History of Sexuality in America* (New York: Harper & Row, 1988), pp. 227–229; and John D'Emilio, *Sexual Politics, Sexual Communities: The Making of a Homosexual Minority in the United States, 1940–1970* (Chicago and London: University of Chicago Press, 1983), pp. 10–22. Michel Foucault has described this concurrent rise of two conflicting developments in the history of sexuality in terms of "the tactical polyvalence of discourses." Just as medical, legal, and scientific treatises attempted to categorize what were considered to be sexual perversions, homosexuality drew on these very regulatory discourses in order to speak in its own behalf and demand acknowledgment of its legitimacy. See Michel Foucault, *The History of Sexuality,* trans. Robert Hurley (New York: Vintage Books, 1990), p. 101. For an extensive discussion of the emergence of sexual classifications and the rise of homosexual communities in the United States, see George Chauncey, *Gay New York: Gender, Urban Culture, and the Making of the Gay Male World, 1890–1940* (New York: Basic Books, 1994).

4. Havelock Ellis, "Sexual Inversion" (1910), in *Studies in the Psychology of Sex,* vol. 2 (New York: Random House, 1936), p. 1.

5. Ellis, "Sexual Inversion," p. 59.

6. Ellis, "Sexual Inversion," pp. 319, 321, 354.

7. Ellis, "Sexual Inversion," pp. 24, 32, 293–294.

8. Ellis, "Sexual Inversion," pp. 287–288. For another example of the naming of the tropes of male homosexuality, see Sherwood Anderson's letter to his son John in *The Portable Sherwood Anderson,* ed. Horace Gregory (New York: Viking Press, 1949), p. 588.

9. Ellis, "Sexual Inversion," p. 296.

10. Sigmund Freud, *Three Essays on the Theory of Sexuality* (1910), trans. James Strachey (New York: Basic Books, 1975), pp. 4–5. For Ellis's response to Freud's theorization, see pp. 304–309 of *Sexual Inversion.*

11. Freud, *Three Essays,* p. 11, n. 1.

12. Paul Rosenfeld, *Port of New York: Essays on Fourteen American Moderns* (New York: Harcourt, Brace and Company, 1924), pp. 95–96.

13. Rosenfeld to Stieglitz, October 29, 1920, YCAL.

14. Townsend Ludington relates the details of Hartley's ambiguous relationship with Barnes in *Marsden Hartley: The Biography of an American Artist* (Boston: Little, Brown and Company, 1992), pp. 36–37.

15. Rosenfeld to Stieglitz, November 3, 1920, YCAL. In this letter Rosenfeld also repeated the nickname that had recently been given to Hartley, "the monk of fear." Rosenfeld's letter to Stieglitz of August 15, 1926 (YCAL), contains further, related comments on his views of Hartley's New Mexico paintings.

16. Stieglitz to Rosenfeld, November 5, 1920, YCAL.

17. Rosenfeld to Stieglitz, September 19, 1921, YCAL.

18. Rosenfeld, *Port of New York*, pp. 97–98.

19. Rosenfeld, *Port of New York*, p. 85.

20. Marius de Zayas, *291* 5–6 (July-August 1915), p. 6.

21. In his classic study of romantic and decadent literature, *The Romantic Agony*, Mario Praz has traced the interrelated themes of sadism, homosexuality, and the sacrilegious in the writings of Gide, Wilde, and Verlaine. In more general terms, Praz notes the conjunction of pleasure and pain, desire and cruelty, and death and beauty in the writings of Poe, Novalis, Shelley, the Marquis de Sade, Gourmont, Lorrain, Barres, and various other authors. In his commentary on Huysmans's novel *À Rebours*, Praz wrote, "Sadism and Catholicism, in French Decadent literature, become the two poles between which the souls of neurotic and sensual writers oscillate." See Mario Praz, *The Romantic Agony*, trans. Angus Davidson (Oxford and New York: Oxford University Press, 1970), p. 321.

22. Rosenfeld's essay "Paint and Circuses" first appeared in the December 1921 issue of *The Bookman*. A modified version of this essay was published in Rosenfeld's collection of literary essays, *Men Seen: Twenty-Four Modern Authors* (New York: Dial Press, 1925), pp. 177–188.

23. Rosenfeld to Stieglitz, August 23, 1921, YCAL.

24. Rosenfeld to Stieglitz, July 8, 1923, YCAL.

25. Stieglitz to Rosenfeld, July 10, 1923, YCAL.

26. Rosenfeld, *Port of New York*, p. 87. Interestingly, during the 1920s Rosenfeld owned two examples of Hartley's still lifes of pears from the 1911 series, including the work reproduced in this study and one that is reproduced in Samuel M. Kootz, *Modern American Painters* (New York: Brewer & Warren, 1930), plate 25. During the twenties Rosenfeld apparently loaned the latter painting to his friend Florence Cane, because in

Frank Jewett Mather, Jr.'s, study *The American Spirit in Art* (New Haven: Yale University Press, 1927), this work is reproduced above the caption "in the possession of Mrs. Florence Cane, New York" (p. 165, plate 268). Regarding the painting reproduced in this study, "as indicated by a stamp on verso, *Pears* was one of the paintings auctioned in 1921 to finance Hartley's return to Europe." See *American Paintings and Sculpture in the University Art Museum Collection* (Minneapolis: University of Minnesota, 1986), p. 155. By October of 1921 Rosenfeld had also acquired a Hartley landscape entitled *Deserted Farm*. This painting is reproduced in Herbert J. Seligmann, "The Elegance of Marsden Hartley—Craftsman," *International Studio* 74 (October 1921), p. lii, and on pp. 148–150 of the Minneapolis catalogue. Both works are now in the collection of the Frederick R. Weisman Art Museum. These paintings, which are part of the Hudson Walker Collection, were acquired by Walker directly from Rosenfeld himself. I am grateful to Kathleen M. Bennewitz for sharing provenance information with me from the original record books of the Hudson Walker Collection. In addition to these works, three other paintings once owned by Rosenfeld are now part of the collection of the Frances Lehman Loeb Art Center at Vassar College. These works include Hartley's *Three Pears* (c. 1913), *Figs and Bananas* (c. 1913), and *Indian Composition* (1914–1915).

27. Rosenfeld, *Port of New York*, p. 92.

28. Rosenfeld, *Port of New York*, p. 87.

29. Rosenfeld, *Port of New York*, p. 86.

30. Rosenfeld, *Port of New York*, p. 88. With its allusion to the decline of a great civilization, Rosenfeld's reference to Alexandria functions as a trope of degeneracy. By the 1920s this was a well-established theme. Richard von Krafft-Ebing linked the notions of debauchery, adultery, and luxury to discourses of cultural degeneration in *Psychopathia Sexualis* (1886). Citing the examples of Greece, Rome, and France under Louis XIV and Louis XV, Krafft-Ebing posited that personal decay was consistent with a larger tendency toward effeminacy, lewdness, and luxuriance in a nation. See Richard von Krafft-Ebing, *Psychopathia Sexualis: A Medico-Forensic Study*, trans. Harry E. Wedeck (New York: G. P. Putnam's Sons, 1965), p. 27. Regarding these constructions, Eve Kosofsky Sedgwick has noted that across a wide range of literature and ideology, "there is a peculiarly close, though never precisely defined, affinity between same-sex desire and some historical condition of moribundity, called 'decadence,' to which not individuals or minorities but whole civilizations are subject." Eve Kosofsky Sedgwick, *Epistemology of the Closet* (Berkeley and Los Angeles:

University of California Press, 1990), pp. 11, 128. Bram Dijkstra has also commented on the relationship between gender, sexuality, and the notion of social degeneration in *Idols of Perversity: Fantasies of Feminine Evil in Fin-de-Siècle Culture* (New York and Oxford: Oxford University Press, 1986), pp. 203–209.

31. Rosenfeld, *Port of New York*, p. 94. Curiously, Hartley himself participated in the heterosexual coding of Marin's Maine paintings, describing them as chaste, vigorous, and solid in his 1928 essay, "The Recent Paintings of John Marin." This piece is reprinted in Gail R. Scott, ed., *On Art by Marsden Hartley* (New York: Horizon Press, 1982), pp. 77–81.

32. Seligmann, "The Elegance of Marsden Hartley," p. liii.

33. Deogh Fulton, "Cabbages and Kings," *International Studio* 81 (May 1925), p. 146.

34. Wilson, "The Stieglitz Exhibition," p. 100.

35. Henry McBride, "The Stieglitz Group at Anderson's," *New York Sun* (March 14, 1925), p. 13.

36. Mather, *The American Spirit*, p. 165.

37. Kootz, *Modern American Painters*, p. 42.

38. In turn, Hartley wrote appreciative essays on Stieglitz's modernist project at both 291 and An American Place. See Marsden Hartley, "What is 291?" (1915) and "291—and the Brass Bowl" (1934), in *On Art*, pp. 63–65, 81–87.

39. Hartley's remarks are reproduced in Henry McBride, "Modern Art," *Dial* 70 (January 1921), pp. 113–114.

40. Three months later Hartley published an article, "Dissertation on Modern Painting," in which he again asserted that art is an intellectual pursuit. See Marsden Hartley, "Dissertation on Modern Painting," *The Nation* 112 (February 9, 1921), pp. 235–236. In *The Nation* Hartley identified himself as "a painter and art critic particularly associated with the Société Anonyme in New York City." Hartley's self-description is found on the bottom of p. 236, "Contributors to This Supplement."

41. Marsden Hartley, *Adventures in the Arts: Informal Chapters on Painters, Vaudeville, and Poets* (New York: Boni and Liveright, 1921), p. 247.

42. Marsden Hartley, "Art—and the Personal Life," *Creative Art* 4 (June 1928), p. xxxi.

43. Stieglitz may have believed in the sincerity of Hartley's undertaking; he gave the painter one-man shows at An American Place in 1930, 1936, and 1937.

44. Marsden Hartley, "Return of the Native," quoted in *The Art Digest* 6 (May 1, 1932), p. 15.

45. Hartley, "On the Subject of Nativeness—A Tribute to Maine," exhibition catalogue at An American Place, April 20-May 17, 1937, pp. 4, 5. The text is reproduced in Herschel B. Chipp, *Theories of Modern Art* (Berkeley and Los Angeles: University of California Press, 1984), p. 530.

46. Hartley to Stieglitz, November 15, 1937, YCAL.

47. J. W. L., "The Virile Paintings by Marsden Hartley," *Artnews* 38 (March 16, 1940), p. 15. For other favorable readings of Hartley's work see M. D., "The Climax of Hartley's Painting in Powerful Coastal Scenes," *Artnews* 37 (March 26, 1938), p. 21; "Marsden Hartley Holds His 25th Solo Show," *Art Digest* 13 (March 15, 1939), p. 52; "Marsden Hartley in Successful Solo Show," *Art Digest* 16 (March 15, 1942), p. 15; and "Marsden Hartley: He Sees the Mystic Side of American Life," *Pictures on Exhibit* (1942), pp. 110–111.

48. Paul Rosenfeld, "Marsden Hartley," *The Nation* 157 (September 18, 1943), p. 326.

49. Jerome Mellquist, "Marsden Hartley, Visionary Painter," *The Commonweal* 39 (December 31, 1943), p. 278.

50. On these themes in Hartley's oeuvre, see Jonathan Weinberg, *Speaking for Vice: Homosexuality in the Art of Charles Demuth, Marsden Hartley, and the First American Avant-Garde* (New Haven and London: Yale University Press, 1993).

51. Hartley, *Somehow a Past*, p. 42, YCAL.

52. Hartley's statement appeared in the leaflet that accompanied his exhibition at 291, April 4 to May 22, 1916. This statement is reprinted in *Camera Work* 48 (October 1916), p. 12.

53. The Registrar's card index at the Metropolitan Museum of Art lists the former title of the painting. For a discussion of the iconographic and sexual references in this painting see Weinberg, *Speaking for Vice*, pp. 3, 32, 152, 154, and 161–162; and Bruce Robertson, *Marsden Hartley* (Washington, DC: National Museum of American Art and Harry N. Abrams, 1995), pp. 56–64.

54. Hartley to Stieglitz from Berlin, May 1913, YCAL.

55. Hartley, *Somehow a Past*, YCAL, p. 43. For a discussion of the encodedness of homosexual imagery in Hartley's Berlin paintings, see Patricia McDonnell, "El Dorado: Marsden Hartley in Imperial Berlin," in *Dictated by Life: Marsden Hartley's German Paintings and Robert Indiana's Hartley Elegies* (Minneapolis: University of Minnesota, Frederick R. Weisman Art Museum, 1995), pp. 15–43.

56. Cole's, Caffin's, and McBride's comments are reproduced in *Camera Work* 48 (October 1916), pp. 58–60.

57. During his youth the photographer had lived and studied in Germany, learning photography under Professor Hermann Wilhelm Vogel at the Berlin Polytechnikum. Regarding Stieglitz's time in Germany, see Sue Davidson Lowe, *Stieglitz: A Memoir/Biography* (New York: Farrar, Straus, Giroux, 1983), pp. 75, 80–81.

58. Stieglitz's comments are recorded in Dorothy Norman, *Alfred Stieglitz: An American Seer* (Millerton, NY: Aperture, 1973), p. 124. See also Stieglitz's letter to Georgia O'Keeffe of June 24, 1917, in Sarah Greenough and Juan Hamilton, *Alfred Stieglitz: Photographs & Writings* (Washington, D.C.: National Gallery of Art, 1983), p. 202.

59. Although not precisely a portrait, Hartley's *Eight Bells Folly, Memorial for Hart Crane* (1933) is another such work in this genre.

60. In *Speaking for Vice* (p. 185) Weinberg notes: "According to Mervin Jules, who purchased the work from Hartley's dealer, Hudson Walker, the painting was meant to be a self-portrait."

61. Regarding his feelings for Mason, Hartley once noted that Mason lived "utterly for the consummate satisfaction of the flesh, the kind of flesh making no difference. . . . He will give as much love to a man as to a woman." Marsden Hartley, "Cleophas and His Own," reprinted in Gerald Ferguson, *Marsden Hartley and Nova Scotia* (Halifax, Nova Scotia: Mount Saint Vincent University Art Gallery, 1987), p. 98. In 1937 Hartley almost prophetically described his feelings for the fishermen of Maine and the poignant sense of impending death that surrounds them, writing, "Husbands and sons are drowned at sea, and this is just as natural to hear as if they died of the measles or of a fever, and these men who are pretty much as children always, go to their death without murmur and without reproach." See Hartley, "On the Subject of Nativeness," p. 2.

62. Hartley's later dealer Hudson Walker also compared Hartley's Nova Scotia paintings to his Berlin Officer series. See Hudson D. Walker, "Marsden Hartley," *The Kenyon Review* (Spring 1947), pp. 256–257.

63. Hartley to Stieglitz, November 12, 1914, YCAL.

64. Weinberg, *Speaking for Vice*, p. 185.

65. Weinberg, *Speaking for Vice*, p. 188.

66. Hartley was well acquainted with Santo imagery and with the practices of the Penitentes, members of a religious fraternity within the Hispanic population of New Mexico. The devotional rituals of the Penitentes include self-inflicted pain, such as flagellation, as acts of penance. Several of Hartley's paintings from 1918 and 1919, such as *Blessing the Melon* (1918, Philadelphia Museum of Art), were inspired by Santo images belonging to Mabel Dodge Luhan, who owned a large collection of these works. In addi-

tion, Hartley published articles on the peoples of the Southwest in 1920 and 1922. See especially Marsden Hartley, "The Scientific Esthetic of the Red Man," *Art and Archeology* 13 (March 1922), pp. 113–119 and (September 1922), pp. 137–139. For a discussion of Santo paintings and modern art see Sheldon Cheney, *Expressionism in Art* (New York: Liveright Publishing Corporation, 1934), pp. 295–302.

67. Susan Elizabeth Ryan, "Marsden Hartley: Practicing the 'Eyes' in Autobiography," in *Somehow a Past: The Autobiography of Marsden Hartley* (Cambridge, MA and London: MIT Press, 1997), p. 32.

68. This reading was suggested to me by Kermit Champa during a discussion of the image. In addition, Leo Bersani's book *Homos* (Cambridge, MA and London: Harvard University Press, 1995) contains a valuable discussion of sadomasochism in relation to the theorization of gay identity. For a discussion of masochism and male subjectivity from a psychoanalytic point of view, see Kaja Silverman, *Male Subjectivity at the Margins* (New York and London: Routledge, 1992), especially chapter 5.

69. I am reluctant to call Hartley's painting a "self-death portrait" because I believe that Hartley was more profoundly engaged with the pain of living and the experience of loss than he was with his own death per se when he painted this work. In producing this self-portrait, Hartley used death and eroticism as raw materials for the cathartic but ultimately generative process of his art making. Thus the picture seems to me to be less a death portrait than an expression of Hartley's ambivalent feelings about life and death itself. In addition, the painting's provenance suggests that this portrait was a kind of confessional work for Hartley. Jonathan Weinberg has written that Hudson Walker, Hartley's dealer from 1937 to 1940, convinced the artist not to exhibit this work publicly. Instead, Walker sold the painting to a private patron named Mervin Jules with the understanding that it would not be shown while either Hartley or Walker were still alive. (See Weinberg, *Speaking for Vice*, p. 190.) Weinberg obtained this information during a 1988 interview with Jules.

70. Hartley to Arnold Rönnebeck, November 8, 1936, YCAL.

71. Willard Huntington Wright, "Modern Art: Four Exhibitions of the New Style of Painting," *International Studio* 60 (January 1917), p. xcviii.

72. Guy Pène du Bois, New York *Evening Post*, quoted in "Water-Color—A Weapon of Wit: Art Critics Dispute the Diabolic Delicacies of Charles Demuth's Brush," *Current Opinion* 66 (January 1919), p. 52. However, this article also noted that, in a more recent review, du Bois had written that "there is no greater master of water-color alive" than Demuth.

73. Paul Rosenfeld, "American Painting," *Dial* 71 (December 1921), p. 662.

74. Rosenfeld, "American Painting," p. 663.

75. Paul Rosenfeld, "Art: Charles Demuth," *The Nation* 133 (October 7, 1931), pp. 371–373.

76. Carl Van Vechten, "Charles Demuth and Florine Stettheimer," *The Reviewer* 2 (February 1922), pp. 269–270. Significantly, fifteen years later Henry McBride began his catalogue essay for Demuth's memorial exhibition at the Whitney by refuting the "perverse" associations of Demuth's flower paintings. McBride wrote: "The flower pieces of Charles Demuth are serene. All the precautions for purity have been taken. No thought of the 'disasters of war' has been allowed to enter in. Sin, corruption, malice, terror—mistakes of any kind—are unknown to them." See Henry McBride, "Charles Demuth, Artist," *Charles Demuth Memorial Exhibition* (New York: Whitney Museum of American Art, December 15, 1937–January 16, 1938), n.p.

77. A. E. Gallatin, *American Water-Colourists* (New York: E. P. Dutton, 1922), p. 22. Demuth himself admired Gallatin's study, telling the author that "the book is very beautiful, and too, very flattering. But really it is beautiful." (Charles Demuth to Albert Eugene Gallatin, December 14, 1922, Albert Eugene Gallatin Papers, The New-York Historical Society.) On December 3, 1922, Stieglitz also wrote appreciatively to Gallatin, thanking him for the two copies of the book that Gallatin had sent for himself and for Marin.

78. Mather, *The American Spirit in Art*, p. 163.

79. Kootz, *Modern American Painters*, p. 32.

80. Henry McBride, "Demuth's First Exhibition," *The Sun*, November 1, 1914, reprinted in *The Flow of Art: Essays and Criticism of Henry McBride*, ed. Daniel Catton Rich (New York: Athenaeum, 1975), p. 69.

81. Louis Kalonyme, "The Art Makers," *Arts and Decoration* (December 1926), p. 63.

82. Rosenfeld, "Charles Demuth," pp. 371–372.

83. Henry McBride, "Demuth," *New York Sun*, April 10, 1926, in *The Flow of Art*, pp. 217–218.

84. A. E. Gallatin, *Charles Demuth* (New York: William Edwin Rudge, 1927), p. 3.

85. Charles Demuth to A. E. Gallatin, February 8, 1922, Albert Eugene Gallatin Papers, The New-York Historical Society. Gallatin's personal collection included at least two works by Marin, *River Effect, Paris* and *Casco Bay, Maine*.

86. Demuth to Stieglitz, March 12, 1923, YCAL.

87. On this point see Henry McBride, "Charles Demuth," 1937, n.p.

88. There is some confusion as to whether Demuth exhibited a portrait of Marin or of Charles Duncan in the 1925 show. Helen Appleton Read identified Demuth's four portrait subjects in her review of the exhibition as Dove, Hartley, O'Keeffe, and Marin. See Helen Appleton Read, "New York Exhibitions: Seven Americans," *The Arts* 7 (April 1925), pp. 229–231. Yet the well-known poster portrait of Marin that contains the words "Marin/Play" (YCAL) is dated 1926, and thus could not have been shown at the Anderson Galleries in 1925. Robin Jaffee Frank has speculated that either a study or unfinished version of the Marin portrait could have been exhibited in 1925. See Robin Jaffee Frank, *Charles Demuth: Poster Portraits 1923–1929* (New Haven: Yale University Art Gallery, 1994), p. 112, n. 10. Demuth's own correspondence with Stieglitz substantiates Frank's supposition. On June 2, 1924, Demuth informed Stieglitz that he had finished his portrait of Dove and was working on a Marin poster (Demuth to Stieglitz, June 2, 1924, YCAL).

89. For a detailed discussion of these works see Frank, *Charles Demuth*, and Barbara Haskell, *Charles Demuth* (New York: Whitney Museum of American Art and Harry N. Abrams, 1987), chapter 6. Writing in *Creative Art*, the critic Angela E. Hagen suggested some of the important paradoxes of these works: "We might call them sublimated posters, or we might call them phantasies of precision (if that were not too paradox). . . . Isolated figures and letters grow, even when rendered with hard sign-painter's gold, into significance and meaning, that certain cults have invested in numbers." See Angela E. Hagen, "Around the Galleries: Demuth Watercolors and Oils at 'An American Place,'" *Creative Art* 8 (June 1931), pp. 442–443.

90. As early as 1916 Stieglitz had photographed Demuth, and Demuth had in turn thanked Stieglitz "for the Something which I found so often this winter at 291 and which you make so possible." Demuth to Stieglitz, April 19, 1916, YCAL.

91. Demuth to Stieglitz, November 28, 1921, YCAL.

92. In a letter to Stieglitz dated August 31, 1921 (YCAL), Demuth wrote about the "American idea" as though it were a mutually shared notion. In this letter Demuth also mentioned that he wanted to leave his current dealer, Charles Daniel, and he seemed to be looking to Stieglitz for support and possible sponsorship. On February 19, 1922, Demuth asked Stieglitz to arrange the pricing of his works, and later that year he sent Stieglitz and O'Keeffe a Christmas card in which he wrote that 1923 "contains one of 'our' numbers!" (Demuth to Stieglitz and O'Keeffe, Christmas 1922, YCAL.) Four months later, the Metropolitan Museum of Art bought one of

Demuth's watercolors. Demuth almost apologized to Stieglitz that the museum had acquired one of his works instead of one by the other Stieglitz circle artists (Demuth to Stieglitz, April 21, 1923, YCAL).

93.  Norman, *Alfred Stieglitz: An American Seer,* p. 170.

94.  Demuth to Stieglitz, January 29, 1923, YCAL.

95.  Lowe, *Stieglitz,* p. 260.

96.  Demuth to Stieglitz, July 7, 1924, YCAL.

97.  Demuth to Stieglitz, January 16, 1924, YCAL. The poster portrait of Duchamp is not known to exist. The previous year Demuth told the critic Forbes Watson that Duchamp "has been his strongest influence of late years." See Forbes Watson, "Charles Demuth," *The Arts* 3 (January 1923), p. 78.

98.  Demuth thanked Stieglitz for the photograph of Duchamp and described its hanging in his room in a letter dated June 29, 1927 (YCAL).

99.  Duchamp aptly expressed the complexity of Demuth's situation in the brief "Tribute" to the artist that he wrote in 1949. When describing Demuth, Duchamp stated: "Demuth was . . . one of the few artists whom all other artists liked as a real friend, a rare case indeed. His work is a living illustration of the disappearance of a 'Monroe Doctrine' applied to Art; for today, art is no more the crop of privileged soils, and Demuth is among the first to have planted the good seed in America." Duchamp's statement captures the ambivalent nature of Demuth's position. On the one hand, Duchamp emphasized Demuth's ability to combat American provincialism. Yet on the other hand, Duchamp uses what is arguably the Stieglitz circle's most ubiquitous nationalist metaphor for artistic and embodied fertility, that of the soil and the planting of seeds, to praise the *non-nationalist, non-isolationist* posture of Demuth's artistic achievement. See Marcel Duchamp, "A Tribute to the Artist," New York, 1949, in Andrew Carnduff Ritchie, *Charles Demuth* (New York: Museum of Modern Art and Arno Press, 1969), p. 17.

100.  Elizabeth Luther Cary noted the position of the poster portraits in her article "New York Exhibitions: Seven Americans," *The Arts* 7 (April 1925). The critic Deogh Fulton was even less complimentary, comparing the paintings to "the side-show to the circus." Deogh Fulton, "Cabbages and Kings," *International Studio* 81 (May 1925), p. 146. Helen Appleton Read wrote, "Demuth offers portraits of O'Keefe [sic], Dove and others in a code for which we have not the key. Being Demuths they are necessarily beautiful in their sure and delicate craftsmanship." Helen Appleton Read, "News and Views on Current Art," *Brooklyn Daily Eagle* (March 15, 1925), p. 2B. And in his review in *The Nation,* Glen Mullin wrote,

"Charles Demuth's portrait posters were excellent. Even though one as an outsider did not get the full force of the comic symbols, he could at least admire the craft employed." Glen Mullin, "Alfred Stieglitz Presents Seven Americans," *The Nation* 120 (May 20, 1925), p. 578.

101. Jonathan Weinberg also reads this work as a self-portrait in *Speaking for Vice*, and he convincingly argues that the image depicts a homosexual encounter. In particular, he points to the towel which "covers up" the huddled group of figures, "hiding" the contact which is transpiring between them, and the way in which the men's feet touch or just barely touch, a gesture so intimate that it lies outside the bounds of propriety for heterosexual male contact. See Weinberg, *Speaking for Vice*, pp. 23–24.

102. Richard Weyand has identified the setting for Demuth's Turkish Bath series as the Lafayette Baths in New York City. (See Farnham, "Charles Demuth," p. 399.) Weinberg has pointed out that Demuth's baths could also be located in Berlin or Paris. See Weinberg, *Speaking for Vice*, p. 92.

103. Chauncey, *Gay New York*, p. 207.

104. Chauncey, *Gay New York*, p. 219.

105. Weinberg, *Speaking for Vice*, p. 102.

106. Weinberg, *Speaking for Vice*, pp. 24, 90. Weinberg's book provides crucial primary information obtained from personal interviews, facts that make my analysis possible.

107. In one group a man stares at the exposed buttocks of a bending figure, while in the other a standing man and one who appears to be kneeling are probably engaging in fellatio. Like Weinberg, I interpret this background scene as an overt representation of a homosexual encounter.

108. The facial features and deportment of the central figure in *At a House in Harley Street* are very similar to those of the foreground character in Demuth's *At the Golden Swan*, a work that Henry McBride has identified as a Demuth self-portrait. See Henry McBride, "Demuth: Phantoms from Literature," *Art News* 49 (March 1950), p. 19.

109. Demuth placed *At a House in Harley Street* for sale with the Kraushaar Gallery during the late 1920s. According to the gallery, Demuth dealt directly with Kraushaar during the late 1920s and 1930s. While there is no record of the specific date when Demuth left the image, the painting was purchased by Abby Aldrich Rockefeller in January 1930. Mrs. Rockefeller donated the work to the Museum of Modern Art in June of 1935.

110. Henry McBride, "Water-Colours by Charles Demuth," *Creative Art* 5 (September 1929), p. 635.

111. In addition to Demuth, the twenties saw a great interest in the writings of Henry James. Van Wyck Brooks's study of James appeared in several installments of the *Dial* during 1923. And the November 1924 issue of *The Arts* contained four of Demuth's illustrations for *The Turn of the Screw* to accompany Edna Kenton's article "Henry James to the Ruminant Reader: The Turn of the Screw, with Four Drawings by Charles Demuth," *The Arts* 6 (November 1924), pp. 245–255.

112. Rosenfeld, "American Painting," pp. 662–663.

113. McBride, "Phantoms from Literature," p. 19.

114. Henry McBride, "Charles Demuth, Artist," *Charles Demuth Memorial Exhibition* (New York: Whitney Museum of American Art, December 15, 1937–January 16, 1938).

115. Marsden Hartley, "Farewell, Charles: An Outline in Portraiture of Charles Demuth—Painter," in Alfred Kreymborg, Lewis Mumford, and Paul Rosenfeld, eds., *The New Caravan* (New York: W. W. Norton & Company, 1936), pp. 557–559.

116. Although this character only makes a brief appearance at the beginning of the story, James's description is quite detailed. He was "a gentleman, a bachelor in the prime of life. . . . One could easily fix his type; it never, happily, dies out. He was handsome and bold and pleasant, off-hand and gay and kind. . . . [The governess] figured him as rich, but as fearfully extravagant—saw him all in a glow of high fashion, of good looks, of expensive habits, of charming ways with women." See Henry James, "The Turn of the Screw," in *The Portable Henry James*, ed. Morton Dauwen Zabel (New York and London: Penguin Books, 1979), pp. 198–199.

117. To extend this reading of self-portraiture even further, Kermit Champa suggested to me that Demuth might also be painting a split self-portrait in the figures of the two children, Flora and Miles, in his illustrations for this story. This interpretation is based on a reading of sexual ambivalence on Demuth's part, which would allow him to identify with both the male and female children in this disturbing narrative. For a discussion of Demuth's engagement with stories that feature transitory sexuality and gender shifting, see Kermit S. Champa, "Charlie Was Like That," *Artforum* 12 (March 1974), pp. 54–59.

118. James, "Turn of the Screw," p. 199.

119. As Edmund Wilson has noted, in period interpretations of James's story, "the theory is, then, that the governess who is made to tell the story is a neurotic case of sex repression, and that the ghosts are not real ghosts but hallucinations of the governess." See Edmund Wilson, "The Ambiguity of Henry James," in *The Triple Thinkers: Twelve Essays on Literary Subjects*

(New York: Oxford University Press, 1963), p. 88. Regarding their expressive similarities, the novelist and photographer Carl Van Vechten wrote that Demuth's sketches for Henry James's stories "do not reveal; they conceal. They keep the secret of the master in a decorative manner." See Van Vechten, "Charles Demuth," p. 269.

120. Henry McBride, "Exhibitions in New York: Charles Demuth: An American Place," *Artnews* 29 (April 18, 1931), p. 10.

121. Angela E. Hagen, "Demuth Watercolors and Oils at 'An American Place,'" *Creative Art* 8 (June 1931), pp. 441–442.

122. As noted above, McBride identified a similar self-portrait detail in Demuth's watercolor *At the Golden Swan* (1919), another scene that Demuth set in a popular New York City club.

123. Hartley, "Farewell, Charles," p. 555.

7    **Modernism's Masculine Subjects:**
     **Alfred Stieglitz versus Thomas Hart Benton**

1.   Waldo Frank et al., eds., *America & Alfred Stieglitz: A Collective Portrait* (New York: Doubleday, Doran & Co., 1934). Dorothy Norman describes the process of the book's evolution in *Encounters: A Memoir* (New York: Harcourt, Brace, Jovanovich, 1987), pp. 114–115.

2.   During the thirties Stieglitz periodically attempted to link his activities at An American Place to the work he had begun at 291. Stieglitz held the retrospective exhibition "Beginnings and Landmarks: '291'" at An American Place from October 27 to December 27, 1937. The pamphlet that accompanied this show contained an article by Ralph Flint entitled "'291' Again!" See Ralph Flint, "'291' Again!," *"It Must Be Said"* 7 (New York: An American Place, October 1937). A copy of this pamphlet can be found in the New York Public Library Papers, Archives of American Art, Smithsonian Institution, reel N121, frames 634–636.

3.   Editors' introduction, in Frank et al., eds., *America & Alfred Stieglitz*, p. 13.

4.   Not surprisingly, some of the most favorable reviews came from critics who were more or less closely associated with Stieglitz himself. Elizabeth McCausland published a very positive review, "America, Alfred Stieglitz: Extraordinary Career Shown in 'Collective Biography'" in the *Springfield* [Massachusetts] *Republican* (December 2, 1934). The Literary Guild periodical *Wings* 8 (December 1934) contained appreciative articles by Carl Van Doren, Dorothy Norman, Sheldon Cheney, and Fred J. Ringel. In addition, Eric Estorick published a positive review in the *Nation* 140 (January 23, 1935). However, the art critic Edward Alden Jewell characterized

*America & Alfred Stieglitz* as a "confused" attempt to celebrate Stieglitz's project, one that "has fostered a sort of half-idolatrous worship, an atmosphere of incantation and pseudo-mystical brooding upon the thisness and thatness of life and the human soul; a cult—it really seems to amount to that—befogged by clouds of incense and bemused by an endless flow of words." Edward Alden Jewell, "Alfred Stieglitz and Art in America," *New York Times Book Review* (December 23, 1934), p. 4. Likewise, John Chamberlain commented on the "deep inarticulateness" of this "yearning book." Regarding Stieglitz's followers, Chamberlain concluded that ultimately "their 'affirmations' are exceedingly nebulous." John Chamberlain, "Books of the Times," *New York Times* (December 31, 1934), p. 11. For other uncomplimentary reviews, see Lewis Gannett's essay in the *New York Herald Tribune* (December 4, 1934), p. 17; and Frank Jewett Mather, Jr.'s, article in the *Saturday Review of Literature* 11 (December 8, 1934).

5.   Thomas Hart Benton, "America and/or Alfred Stieglitz," *Common Sense* 4 (January 1935), p. 24.

6.   Benton, "America and/or Alfred Stieglitz," p. 24.

7.   Benton, "America and/or Alfred Stieglitz," p. 24. Along these lines, Benton wrote that Paul Rosenfeld's and Lewis Mumford's essays amounted to little more than a kind of rationalized foreplay. He described their essays as "propaganda Art and a reflex of desire. The purpose of such Art, in its proper psychological environment, is to prepare some adored one for our antics, to assure her and ourselves also that though we are going to act more or less like goats, we are really 'not that way.'"

8.   Benton, "America and/or Alfred Stieglitz," p. 22. The critic John Chamberlain admitted that he was pleased that Benton had taken Stieglitz and his artists down a notch: "I am glad that some one has come along to rescue me from a feeling of insufficiency in the presence of some Marins, some Doves and some O'Keeffes." Chamberlain, "Books of the Times," p. 11.

9.   Alfred Stieglitz to Thomas Hart Benton, December 29, 1934, YCAL. For Stieglitz's further, outraged comments to his followers, see Stieglitz's letters to Elizabeth McCausland, January 2, 1935, Elizabeth McCausland Papers, Archives of American Art, Smithsonian Institution, reel D384B, frames 88–90; and to Arthur Dove, January 2, 1935, YCAL, quoted in Ann Lee Morgan, ed., *Dear Stieglitz, Dear Dove* (Cranbury, NJ: Associated University Presses, 1988), p. 325. As Stieglitz told Dove, "Gangsterdom in every field is in the ascendancy.—It all makes me smile. I'm accustomed to all that sort of thing. One can't escape envy—malice—being hit below the belt by bullies & cowards.—Great sport."

10. Benton to Stieglitz, January 1, 1935, YCAL.

11. Stieglitz to Benton, January 2, 1935, YCAL.

12. Stieglitz is quoted in Dorothy Norman, "Alfred Steiglitz [sic] Speaks and Is Overheard," *The Art of Today* 6 (February 1935), pp. 3, 4. Stieglitz's grandniece and biographer, Sue Davidson Lowe, has noted that despite their many differences, Benton publicly paid tribute to Stieglitz on his eightieth birthday. See Sue Davidson Lowe, *Stieglitz: A Memoir/Biography* (New York: Farrar Straus Giroux, 1983), p. 371.

13. My discussion of the theoretical aspects of synchromist painting is based on Willard Huntington Wright, *Modern Painting: Its Tendency and Meaning* (New York: Dodd, Mead and Company, 1915), pp. 267–299; and Wright's *The Creative Will: Studies in the Philosophy and the Syntax of Aesthetics* (New York: John Lane Company, 1916). For a discussion of the synchromist movement, see also Gail Levin, *Synchromism and American Color Abstraction, 1910–1925* (New York: Whitney Museum of American Art and George Braziller, 1978).

14. Erika Doss has identified Michelangelo's bas-relief *The Battle of the Lapiths and the Centaurs* of c. 1492 as the basis for Benton's painting. See Erika Doss, *Benton, Pollock, and the Politics of Modernism: From Regionalism to Abstract Expressionism* (Chicago and London: University of Chicago Press, 1991), pp. 40–41.

15. Although Benton eventually disassociated himself from the synchromists, Wright's theories continued to influence his writings. For example, in his article "Mechanics of Form Organization in Painting," *The Arts* (February 1927), pp. 95–96, Benton echoed Wright's discussion of the ways in which the rhythms of the body become translated into painting.

16. Macdonald-Wright to Stieglitz, March 8, 1920, YCAL, quoted in Levin, *Synchromism*, p. 36.

17. Despite his contemporary affiliation with Macdonald-Wright, Benton asserted his artistic independence in the personal statement he published in the "Forum Exhibition" catalogue. He wrote: "I find it . . . impossible to ally myself definitely with any particular school of aesthetics, either in its interpretative or constructive aspects." See Thomas Hart Benton, *The Forum Exhibition of Modern American Painters* (New York: Anderson Galleries, 1916), n.p.

18. Thomas Hart Benton to John Weischel, undated letter (c. 1917), Newark Museum Papers, Archives of American Art, Smithsonian Institution, reel N60–2, frame 43.

19. Rosenfeld himself found Benton's paintings to be disagreeably cold and hard. In a letter to Stieglitz written the previous autumn, Rosenfeld

remarked that Benton's painting felt to him like "a piece of open bathroom plumbing—cold vulcanized lead." Rosenfeld to Stieglitz, October 29, 1920, YCAL.

20. Paul Rosenfeld, "American Painting," *Dial* 71 (December 1921), p. 661.

21. Rosenfeld, "American Painting," p. 665.

22. Benton to Stieglitz, December 9, 1921, YCAL. Earlier that year Rosenfeld had written that Benton's paintings owe much to Stanton Macdonald-Wright's color experiments. Paul Rosenfeld, "The Academy Opens Its Doors," *The New Republic* 26 (May 4, 1921), p. 291. This article was a review of an exhibition of modern American art held at the Pennsylvania Academy of the Fine Arts, April 16–May 15, 1921. Benton and Stieglitz served together on the selection and hanging committees for this show.

23. Benton to Stieglitz, December 9, 1921, YCAL.

24. Benton and Craven became friends during the early teens and were occasionally roommates together in New York.

25. It should be noted, however, that Craven produced some positive critical commentary on two painters closely associated with Stieglitz, John Marin and Georgia O'Keeffe. In a 1921 article in the magazine *Shadowland*, Craven wrote admiringly of Marin's paintings and acknowledged Stieglitz's role in promoting Marin's career. See Thomas Jewell Craven, "John Marin," *Shadowland* 5 (October 1921), pp. 11, 75–77. Craven also wrote appreciatively of Marin's painting in *The Nation* (March 19, 1924), an article that Stieglitz reprinted in a pamphlet that accompanied Marin's exhibition at An American Place, November 7–December 27, 1938. In addition, Stieglitz reproduced favorable quotations from Craven's two books, *Men of Art* (1931) and *Modern Art* (1934), in a pamphlet which accompanied Georgia O'Keeffe's exhibition at An American Place, January–March 1935. As this practice suggests, Stieglitz quoted Craven selectively to imply a show of support for his artists. Rosenfeld, however, gave *Men of Art* a largely unfavorable review in *The Nation*. Rosenfeld identified the central tendencies of Craven's book as anti-academic and anti-French, and he wrote that Craven's privileging of heroic subject matter made him inattentive to a painting's formal qualities. Rosenfeld concluded his review by underscoring the conflict between the Stieglitz circle and the regionalists. He wrote that nothing "but willfulness can permit one to see weight and power on the wall spaces of the New School for Social Research decorated by Benton, and thinness in the small landscapes and still-lives of Georgia O'Keeffe." See Paul Rosenfeld, "Art: A Defense of Sensibility," *The Nation* 132 (May 6, 1931), p. 513.

26. Thomas Craven, "Art and the Camera," *The Nation* 118 (April 16, 1924).

27. Seumas Beg [Herbert J. Seligmann], "The Great Crenton-Baven Conspiracy," a manuscript that Seligmann sent to Stieglitz on September 2, 1925 (YCAL).

28. Thomas Hart Benton, "My American Epic in Paint," *Creative Art* 3 (December 1928), quoted in Matthew Baigell, ed., *A Thomas Hart Benton Miscellany: Selections from His Published Opinions, 1916–1960* (Lawrence: University Press of Kansas, 1971), p. 17. Later in this article Benton wrote that "the technique of getting that depth, as a mechanical process, I had been studying a long time, motivated partly, I must admit, by a desire to undo the theories of the abstractionists."

29. Benton, "My American Epic," p. 18.

30. Thomas Craven, *Modern Art: The Men, the Movements, the Meaning* (1934; New York: Simon and Schuster, 1940), p. 318.

31. Craven, *Modern Art*, p. xx.

32. Craven, *Modern Art*, p. 311. Craven's scathing assessment of Stieglitz's career was slightly tempered by his acknowledgment that "Stieglitz brought plainly before the critics and the public the value of art as human activity" (p. 313).

33. Craven, *Modern Art*, p. 312.

34. Alfred Stieglitz's brief essay, "A Statement," was published in the pamphlet that accompanied Stieglitz's exhibition at the Anderson Galleries, New York, February 1921. A copy of this pamphlet can be found in the Forbes Watson Papers, Archives of American Art, Smithsonian Institution, reel D57, frame 92.

35. Craven's anti-Semitic rhetoric can be located within a contemporary historical context. As David Gerber has pointed out, anti-Semitic attitudes, which peaked in America between 1920 and 1950, were manifested in "quite substantial incidence of social discrimination and in widely circulated, demeaning stereotypes." Gerber has noted that the Great Depression exacerbated anti-Semitic sentiments and ultimately fostered a political climate unsympathetic to Jews. For a brief history of anti-Semitism in America, see David A. Gerber's entry on this subject in the *Encyclopedia of American Social History*, vol. 3 (New York: Charles Scribner's Sons, 1993), pp. 2107–2111.

36. Craven, *Modern Art*, p. 313.

37. Stieglitz to Benton, January 2, 1935, YCAL.

38. Stieglitz to Sheldon Cheney, May 10 and May 25, 1934, Cheney Papers, Archives of American Art, Smithsonian Institution, reel 3947, frames 462, 464. In general, critical responses to Craven's book were sharply divided on the basis of the reviewer's own sympathy with modernism. For example,

the conservative critic Frank Jewett Mather, Jr., celebrated the fact that Craven's work "will hit the mark, give pain, draw blood. Many Davids have already assailed the Goliath Modernism, and usually with indifferent success. . . . Mr. Craven's intelligent ferocity brings his dirk well into the joints of Goliath's harness." Frank Jewett Mather, Jr., *Books* (May 13, 1934), p. 1. As one of my anonymous readers pointed out, in Mather's analysis Jewish modernism is, ironically, made to represent Goliath, while WASP populism is associated with the youthful David.

39.  Lewis Mumford, "Books: General," *New Yorker* (May 12, 1934), p. 94.

40.  Craven, *Modern Art*, pp. 343, 352. Craven wrote (p. 343) that "Benton is American. He has the rawhide individualism, the cynical laugh, the rough humor, the talent for buffoonery, and something of the typical Westerner's sentimental slant on life." Benton's autobiography *An Artist in America* (1937), like his paintings themselves, transformed portraiture, or the representation of particular human identities, into a series of genre problems by locating the "authentic" American within collective regional typologies.

41.  Regarding the depiction of racial and ethnic types in Benton's murals, Henry Adams has noted that in the lunette Benton's *New Masses* reader "with his curly hair, sloping forehead, prominent nose, and recessive chin" was widely viewed as an anti-Semitic caricature. Henry Adams, *Thomas Hart Benton: An American Original* (New York: Alfred A. Knopf, 1989), p. 188. Adams also notes that at the Art Students League Stuart Davis led a movement to have Benton's murals destroyed due to the racism manifested in Benton's portrayal of black people. Because of the murals, the black students, as well as many Jews and liberals, withdrew from Benton's art classes.

42.  Thomas Hart Benton, *The Arts of Life in America* (New York: Whitney Museum of American Art, 1932), p. 4. In addition to the works mentioned above, reproduced in the catalogue are three ceiling panels which are not on display at the New Britain Museum. One depicts *Unemployment, Radical Protest, Speed,* while the other two illustrate *Folk and Popular Songs.*

43.  Henry McBride, "Whitney Museum Decorations Still a Subject for Debate," New York *Sun.* A copy of this article can be found in the New York Public Library Papers, Archives of American Art, Smithsonian Institution, reel N53, frame 357.

44.  Benton, *The Arts of Life in America*, p. 9.

45.  Erika Doss discusses at length the links between Benton's artistic practice and period developments in film making and mass communication. See Doss, *Benton*, esp. pp. 42–43 and chapter 3.

46. Benton worked hard to achieve his pictorial effects. As Henry Adams has noted, with the exception of the murals he painted in Jefferson City, Missouri, Benton devoted more time to the Whitney paintings than he did to any other project during the 1930s. See Adams, *Thomas Hart Benton*, p. 185.
47. Craven, *Modern Art*, p. 346.
48. Sheldon Cheney, *Expressionism in Art* (New York: Liveright Publishing Corporation, 1934), pp. 186–187.
49. Paul Rosenfeld, "Ex-Reading Room," *The New Republic* 74 (April 12, 1933), p. 245. Adams also describes the original hanging arrangement of the murals in *Thomas Hart Benton*, p. 184.
50. Rosenfeld, "Ex-Reading Room," pp. 245, 246. Rosenfeld concluded his review with a backhanded compliment that was worthy of Stieglitz himself, observing that, despite the shortcomings of the Whitney paintings, they nonetheless represented a significant advancement over Benton's murals in the New School for Social Research. (The New School murals are illustrated in Doss, *Benton*, pp. 69–81.) Henry Adams has noted that critical reactions to Benton's paintings began to polarize during the early thirties. As a result, the Whitney murals received extremely mixed reviews. Adams summarizes much of this commentary in *Thomas Hart Benton*, pp. 189–191. Benton's critics seemed generally to agree with Rosenfeld that the Whitney murals represented an advance over his previous work.
51. Benton, *The Arts of Life*, pp. 11–12.
52. Rosenfeld, "Ex-Reading Room," p. 246.
53. Benton, *The Arts of Life*, pp. 10–11.
54. However strongly Benton stated their oppositions, Marsden Hartley for one did not believe that the distinctions between modernist painting and Benton's brand of regionalism were either "pure" or rigidly fixed. In an image that literally joined Benton's paintings with the bodies of his American subjects, Hartley quipped in 1939 that the people of the Midwest "got Thomas Benton stuffing his disguised modern art in the name of pure Americanism up their arses and down their throats." See Marsden Hartley to Rogers Bordley, August 11, 1939, quoted in Townsend Ludington, *Marsden Hartley: The Biography of an American Artist* (Boston: Little, Brown and Company, 1992), p. 268.
55. Benton, *The Arts of Life*, p. 5.
56. This had also been Willard Huntington Wright's strategy during the teens when describing synchromist paintings, including Benton's works. By asserting that Michelangelo, and secondarily, Daumier, provided the bases for synchromism, the painters not only became connected to a great artis-

tic tradition, but they distinguished themselves from the contemporary European movements of orphism and cubism. Specifically, in *Modern Painting* Willard Huntington Wright identified Daumier as a bridge figure between Michelangelo and the moderns. See Wright, *Modern Painting*, pp. 61, 279.

57. As Rozsika Parker and Griselda Pollock have observed, there simply is no "female equivalent to the reverential term 'Old Master'." See Rozsika Parker and Griselda Pollock, *Old Mistresses: Women, Art, and Ideology* (New York: Pantheon Books, 1981), pp. 87, 114.

58. Craven, *Men of Art*, pp. 157, 125.

59. Dove to Stieglitz, April 6, 1931, YCAL, in Morgan, *Dear Stieglitz*, p. 217. John Sloan was an American realist painter and printmaker who had exhibited with The Eight. Dove's comments may refer to the destructive program of the Nazis, and hence may anticipate the Nazis' repudiation of "degenerate" modern art in 1933. Dove's remarks also recall the destructive program of Savonarola (1452–1498), a Dominican monk who came to Florence and preached reform and extreme piety. Savonarola rose to political as well as spiritual power after the ouster of the Medici family. Under his rule the Florentines burned vanities and renounced paganism.

60. Stieglitz circle writings are consistent with modernist discourses which identify El Greco as a forerunner of expressionism in general, and of Cézanne in particular. For two different interpretations of this stylistic genealogy, see Paul Rosenfeld, *By Way of Art* (New York: Coward-McCann, 1928), p. 105, and Craven, *Men of Art*, pp. 288–289. For a more comprehensive discussion of the various ways in which twentieth-century critics, including Roger Fry, Paul Lafond, Julius Meier-Graefe, and Franz Marc, identified El Greco as a precursor to modernism, especially to cubism and expressionism, see Jonathan Brown, "El Greco, the Man and the Myths," in *El Greco of Toledo* (Boston: Little, Brown and Company, 1982), pp. 15–33; and Jonathan Brown, "The Redefinition of El Greco in the Twentieth Century," *Studies in the History of Art* 13 (Washington, DC: National Gallery of Art, 1984), pp. 29–32.

61. Rosenfeld, *By Way of Art*, p. 104.

62. Rosenfeld, *By Way of Art*, p. 110.

63. Charles Demuth, "Across a Greco Is Written," *Creative Art* 5 (September 1929), p. 630.

64. Craven, *Men of Art*, p. 304.

65. Craven, *Men of Art*, pp. 286–287.

66. Lincoln Kirstein, "Mural Painting," in *Murals by American Painters and Photographers* (New York: Museum of Modern Art, May 1932), p. 8.

67. According to a database printout that the Museum of Modern Art provided to me, this painting was accepted in 1938 as a gift from Marshall Field upon exchange for another Benton painting that Field had given to the museum in 1937.

68. Thomas Craven, "American Men of Art," and "Politics," *Scribner's* 92 (November 1932), pp. 266, 466.

69. *Whitney Museum of American Art, History, Purpose, and Activities* (New York, January 1935), p. 5.

70. In addition to the *Arts of Life in America* murals, by 1935 the Whitney also owned two of Benton's oil paintings, *Martha's Vineyard* and *The Meal;* two of his lithographs; and several of his drawings, many of which were studies for mural projects. Yet during the thirties Benton's relations with the Whitney were severely strained due to his insistence on additional payments for the murals. Even worse, Benton publicly misrepresented the museum's financial obligations to him. Regarding Benton's embarrassing quarrel with Juliana Force, director of the Whitney Museum, over payment of the murals, see Adams, *Thomas Hart Benton*, pp. 179–184. When the Whitney Museum moved to a new building in 1954, it sold the Benton murals to the New Britain Museum of American Art for $500. Despite the Whitney's rebuff of Benton, Craven remained his faithful partisan. In the foreword to the brief catalogue that the New Britain Museum published in 1954, Craven wrote: "The murals now on display are the most distinguished wall decorations in America."

71. Three of the thirteen Stieglitz circle works that the Whitney Museum had acquired were subsequently deaccessioned from the permanent collection. The deaccessioned works include Demuth's *From the Garden of the Chateau*, 1921–1925; Hartley's *Kinsman Falls*, 1930; and O'Keeffe's *Skunk Cabbage*. Arthur Dove was the only Stieglitz circle artist not represented in the Whitney's collection during the thirties. According to a database printout that the Whitney Museum provided to me, during the 1930s the Stieglitz circle's works were exhibited as follows: Charles Demuth's *Daisies* (1918) was shown in five different Whitney exhibitions; Demuth's *August Lilies* (1921) was shown in four exhibitions; Demuth's *My Egypt* (1927) was shown in three exhibitions; Marin's watercolor *Sunset* (1914) was shown in six exhibitions; Marin's *Deer Isle, Maine* (1923) was shown in four exhibitions; O'Keeffe's *The White Calico Flower* (1931) was shown in five exhibitions; and O'Keeffe's *The Mountain, New Mexico* (1931) was shown in five exhibitions.

72. Stieglitz to Dove, April 2, 1931, YCAL, in Morgan, *Dear Stieglitz*, p. 216.

73. "Art," *Time* 24 (December 24, 1934), p. 25. During the early thirties *Time* often expressed unsympathetic views toward European modernism and promoted American representational and illustrational art.

74. "Art," *Time*, p. 24.

75. Dove to Stieglitz, January 4, 1935, YCAL, in Morgan, *Dear Stieglitz*, p. 326.

76. Benton's statement appeared in Henry McBride's article "Mr. Benton Will Leave Us Flat: Is Sick of New York and Explains Why," *New York Sun* (April 12, 1935).

77. Thomas Hart Benton, *An Artist in America* (New York: Robert M. McBride & Company, 1937), p. 260.

78. While Benton assumed the stature of a "public" artist during the thirties, Stieglitz repeatedly shielded his group from any connection to politics. In 1933 Rosenfeld stated this position explicitly in an article in *Scribner's:* "It never has been, and it never will be the function of the artist to espouse the cause of 'the world' and to defend its special interests." Paul Rosenfeld, "The Authors and Politics," *Scribner's Magazine* 93 (May 1933), p. 318. Rosenfeld's article was written as a protest against the support that several writers had expressed for the American Communist party. Five years later Dove and Stieglitz responded harshly to an article in which the critic Elizabeth McCausland suggested that O'Keeffe's art was becoming more realistic and objective in response to dominant social trends. See Elizabeth McCausland, "Gallery Notes," *Parnassus* 10 (February 1938), p. 29; Dove's and Stieglitz's responses are recorded in Morgan, *Dear Stieglitz*, pp. 395–396.

79. Stieglitz to McBride, March 5, 1940, Henry McBride Papers, Archives of American Art, Smithsonian Institution, reel NMcB8, frame 131.

80. Paul Rosenfeld, "Art: Murals in the Future," *The Nation* 151 (November 16, 1940), p. 485. Matthew Baigell has pointed out that Benton himself never completed any projects for the governmental programs. (Baigell, *Miscellany,* p. 35.)

81. Stieglitz to Selden Rodman, May 24, 1941, YCAL.

## 8   The Contest for "the Greatest American Painter of the Twentieth Century": Alfred Stieglitz and Clement Greenberg

1. This phrase appears in Alfred M. Frankfurter's description of Marin in "American Art Abroad," *Artnews* 48 (October 1946), p. 20. The magazine also listed Max Weber, Walt Kuhn, Stuart Davis, and Arthur G. Dove as "Old Masters," with Marin appearing at the very top of the list.

2.  Clement Greenberg, "Review of Exhibitions of Worden Day, Carl Holty, and Jackson Pollock," *The Nation* (January 24, 1948), reprinted in *Clement Greenberg: The Collected Essays and Criticism*, ed. John O'Brian, 4 vols. (Chicago and London: University of Chicago Press, 1986–1993), vol. 2, p. 203.

3.  Dorothy Norman, *Encounters: A Memoir* (New York: Harcourt, Brace, Jovanovich, 1987), pp. 90–91.

4.  Beginning with the 1939–1940 season at An American Place, Stieglitz would limit his exhibition schedule to showing works by Marin, Dove, and O'Keeffe almost exclusively. For a record of these exhibitions, see Sue Davidson Lowe, *Stieglitz: A Memoir/Biography* (New York: Farrar Straus Giroux, 1983), pp. 436–437.

5.  *Trois siècles d'art aux Etats-Unis* (Paris: Musée du Jeu de Paume, May-July 1938). Among the artworks reproduced in this catalogue are Marin's *Lower Manhattan*, Demuth's *Dancing Sailors*, O'Keeffe's *Bob's Steer Head*, and Dove's *Nigger Gone Fishin'*.

6.  These works included, from O'Keeffe's collection, Marin's *White Horses, Sea Movement off Deer Isle, Maine; From Deer Isle; Wet Weather;* and *Sunset, Casco Bay;* and from Rosenfeld's collection, Marin's *Island, Sun and Ships;* and *Movement, Boats and Sea, Deer Isle, Maine*.

7.  By 1946 the following works had entered the Museum of Modern Art's permanent collection: Demuth's *The Shine* (1916), *Vaudeville Musicians* (1917), *Flowers* (1915), *At a House in Harley Street* (1918), *Dancing Sailors* (1918), *Vaudeville Dancers* (1918), *Acrobats* (1919), *Stairs, Provincetown* (1920), *Corn and Peaches* (1929); Dove's collage *Grandmother* (1925) and his painting *Willows* (1940); Hartley's print *Dish of Apples and Pears* (1923) and two oil paintings, *Boots* (1941) and *Evening Storm, Schoodic, Maine* (1942); several prints by Marin as well as his watercolors *Camden Mountain across the Bay* (1922), *Lower Manhattan* (1922), and *Buoy, Maine* (1931); O'Keeffe's painting *Lake George Window* (1929) and four of her charcoal drawings, including *Banana Flower* (1933), *Eagle Claw and Bean Necklace* (1934), and two works entitled *Kachina* (both of 1934).

8.  In addition to the Museum of Modern Art, in 1944 Stieglitz and his circle were also honored by a major exhibition at the Philadelphia Museum of Art. The show "History of an American, Alfred Stieglitz: '291' and After" featured over 300 works by the Stieglitz circle artists that ranged from Stieglitz's activities at the Little Galleries of the Photo-Secession to his work at An American Place. See Henry Clifford and Carl Zigrosser, *History of an American, Alfred Stieglitz: "291" and After* (Philadelphia:

Philadelphia Museum of Art, 1944). In contrast to this critical recognition, Stieglitz received only passing mention in Sidney Janis's contemporary study, *Abstract & Surrealist Art in America* (New York: Reynal & Hitchcock, 1944), p. 46.

9.  The museum had acquired *Number 1* in 1950, the second work by Pollock to enter the Modern's permanent collection. The first was *The She-Wolf* (1943), which the museum had purchased in 1944.

10. For Greenberg's comments on Stieglitz's photography, see *Collected Essays*, vol. 1, pp. 108, 213; and vol. 2, p. 60.

11. Jerome Mellquist, *The Emergence of an American Art* (New York: Charles Scribner's Sons, 1942). On the development of Mellquist's text, see Richard Whelan, *Alfred Stieglitz: A Biography* (Boston: Little, Brown, & Co., 1995), p. 566.

12. In the brief tribute to Rosenfeld that *Artnews* published after the critic's death in 1946, the magazine noted that *Port of New York* was Rosenfeld's best-known book, "praising progress of art in the U.S." See "Obituaries," *Artnews* 45 (August 1946), p. 9. It should also be noted that, despite Greenberg's distaste for Stieglitz circle criticism, Edmund Wilson's appreciative essay on Rosenfeld, "Paul Rosenfeld Three Phases: Portrait of a Humanist Man of Letters," was published in *Commentary* 5 (February 1948); Greenberg was associate editor of this journal.

13. Greenberg, *Collected Essays*, vol. 1, pp. 106–108.

14. Greenberg, *Collected Essays*, vol. 2, pp. 85–87.

15. Robert M. Coates, "The Art Galleries: Mostly Women," *New Yorker* (May 25, 1946), pp. 73, 75.

16. Jo Gibbs, "The Modern Honors First Woman—O'Keeffe," *Art Digest* 20 (June 1, 1946), p. 6.

17. Edward Alden Jewell, "O'Keeffe: 30 Years: Museum of Modern Art Presents a Full View of Her Work—Other Shows," *New York Times* (May 19, 1946), section 2, p. 6. In addition, see Jewell's preliminary review of this exhibition, "Exhibition Offers Work by O'Keeffe," *New York Times* (May 15, 1946), p. 19; and "O'Keeffe's Woman Feeling," *Newsweek* (May 27, 1946), pp. 92, 94.

18. Greenberg, *Collected Essays*, vol. 2, pp. 85–87. See also Michael Leja's commentary on Greenberg's review in *Reframing Abstract Expressionism: Subjectivity and Painting in the 1940s* (New Haven and London: Yale University Press, 1993), pp. 34–36.

19. Alfred Stieglitz to Clement Greenberg, June 17, 1946, YCAL.

20. James Thrall Soby, "The Fine Arts: To the Ladies," *Saturday Review* 29 (July 1946), pp. 14–15.

21. Georgia O'Keeffe to Henry McBride, July 19, 1948, quoted in Jack Cowart et al., *Georgia O'Keeffe: Art and Letters* (Washington, DC: National Gallery of Art, 1988), p. 247.

22. Roxana Robinson, *Georgia O'Keeffe* (New York: HarperCollins, 1989), p. 463.

23. See for example Greenberg's review of the Museum of Modern Art's fifteenth anniversary exhibition, entitled "Art in Progress" (*The Nation*, June 10, 1944), in Greenberg, *Collected Essays*, vol. 1, p. 213.

24. Greenberg, *Collected Essays*, vol. 2, p. 169.

25. Greenberg's comments to Barr are quoted in Alice Goldfarb Marquis, *Alfred H. Barr, Jr., Missionary for the Modern* (Chicago and New York: Contemporary Books, 1989), p. 248.

26. On the jacket of the catalogue that accompanied the Museum of Modern Art's exhibition *Cubism and Abstract Art* (1936), Alfred H. Barr, Jr., famously presented a flowchart in which he diagrammed the various movements and influences that he saw as contributing to the development of modern abstract art. Beginning with elements such as Japanese prints, synthetism, and neo-impressionism of the 1890s, Barr plotted a plastic sequence that led to what he identified as the two primary tendencies in abstraction of the 1930s, geometrical and nongeometrical abstract art. Thus in contrast to the Stieglitz circle's more flamboyant notions of gendered formalism and embodied abstractions, Barr propounded a linear, schematic conception of the developmental history of modern abstract art. This flowchart is reproduced as the frontispiece to Alfred H. Barr, Jr., *Cubism and Abstract Art* (Cambridge, MA and London: The Belknap Press, 1986).

27. Greenberg, *Collected Essays*, vol. 1, p. 237.

28. Greenberg, *Collected Essays*, vol. 1, pp. 220–223.

29. Greenberg, *Collected Essays*, vol. 1, p. 165. Significantly, Greenberg was partially recapitulating the Stieglitz circle's genealogy of American modernism, since Rosenfeld had also begun *Port of New York* with a discussion of Albert Pinkham Ryder.

30. Greenberg, *Collected Essays*, vol. 2, p. 166.

31. Greenberg, *Collected Essays*, vol. 2, p. 201.

32. Greenberg, *Collected Essays*, vol. 2, pp. 202–203.

33. For a discussion of the political and contextual aspects of abstract expressionism and Greenberg's role in promoting American ideology, see Serge Guilbaut, *How New York Stole the Idea of Modern Art: Abstract Expressionism, Freedom, and the Cold War*, trans. Arthur Goldhammer (Chicago and London: University of Chicago Press, 1983).

34. Greenberg, *Collected Essays*, vol. 2, p. 215.

35. E. M. Benson, "John Marin—'and Pertaining Thereto'," in *John Marin: Watercolors, Oil Paintings, Etchings* (New York: Museum of Modern Art, 1936), p. 31.

36. Alfred H. Barr, Jr., "Preface and Acknowledgment," in Benson, *John Marin*, p. 9.

37. Lionello Venturi, *Art Criticism Now* (Baltimore: Johns Hopkins University Press, 1941), p. 23.

38. Matthew Josephson, "Profiles: Leprechaun on the Palisades," *New Yorker* (March 14, 1942), p. 26. See also Henry Miller, "Stieglitz and Marin," *Twice a Year* 8–9 (1942), pp. 146–155.

39. MacKinley Helm, *John Marin* (New York: Pellegrini & Cudahy; Boston: Institute of Contemporary Art, 1948).

40. Thomas B. Hess, "Marin," *Artnews* 46 (January 1948), p. 25.

41. "Are These Men the Best Painters in America Today?" *Look* 12 (February 3, 1948), p. 44.

42. Greenberg, *Collected Essays*, vol. 2, p. 268.

43. Dorothy Norman, ed., *The Selected Writings of John Marin* (New York: Pellegrini & Cudahy, 1949).

44. Francis Henry Taylor, "Marin's Letters Overflow with Shrewdness and Faith," *The New York Times Book Review* (December 11, 1949), section 7, p. 1.

45. Greenberg, *Collected Essays*, vol. 1, p. 239.

46. Greenberg, *Collected Essays*, vol. 2, p. 166.

47. "Art: The Best?" *Time* 50 (December 1, 1947), p. 55.

48. "Jackson Pollock: Is He the Greatest Living Painter in the United States?" *Life* 27 (August 8, 1949), p. 42. The article acknowledged that "Pollock, at the age of 37, has burst forth as the shining new phenomenon of American art."

49. Duncan Phillips's essay and the other introductory statements on the artists, which appear in Italian in the Biennale catalogue, were reprinted in English in *Artnews* 49 (Summer 1950), pp. 20–23, 60.

50. "7 Americans Open in Venice," *Artnews* 49 (Summer 1950), p. 20.

51. Pollock's three paintings were *Number 1* (1948), *Number 12* (1949), and *Number 23* (1949). For a complete list of Marin's 55 items on display, see *Catalogo, XXV Biennale di Venezia* (Venezia: Alfieri Editore), 1950, pp. 376–379. Despite such words of praise, European critics were generally unsympathetic to the American artists. In his account of the Biennale, Alfred M. Frankfurter remarked that the "appreciated but unloved logic of our organic abstractionists (though it would be out of place for me to dis-

cuss the U.S. pavilion at length) has swept nobody off his feet." See Alfred M. Frankfurter, "International Report," *Artnews* 49 (September 1950), p. 57. For Greenberg's response to the Americans' reception at the Biennale, see Greenberg, *Collected Essays*, vol. 3, pp. 59–62.

52. Norman, *Encounters*, p. 288.

53. On this selection process see Marquis, *Alfred H. Barr, Jr.*, p. 264.

54. Kirk Varnedoe adds another layer of complexity to the issue of buried presences in *Full Fathom Five*. He notes that "X-rays taken by The Museum of Modern Art's Chief Conservator, James Coddington, suggest an initial top-to-bottom figure in the picture; subsequent layerings of paint and detritus may have responded to its legs-torso-head shape, until alternating layers of thickly applied oil and poured silver or black enamel left little trace of its generative structure." See Kirk Varnedoe, "Comet: Jackson Pollock's Life and Work," in *Jackson Pollock* (New York: Museum of Modern Art, 1998), p. 50.

55. At the same time, this phrase signifies not only the "death of the father" but his aestheticization, the process by which his corpse undergoes "a sea change": "Full fathom five thy father lies,/Of his bones are coral made;/Those are pearls that were his eyes." This poetic imagery thus describes the conditions in which the body becomes a work of art, a process not unlike the Stieglitz circle's own notion of embodied formalism.

56. Greenberg, *Collected Essays*, vol. 2, p. 161.

57. For further examples of Greenberg's decontextualization of Marin from the other Stieglitz circle artists, see Greenberg, *Collected Essays*, vol. 1, pp. 134, 163, 165, 171; and vol. 2, pp. 12, 46, 215, 267. As discussed below, an important exception to this pattern is Greenberg's 1948 article on Marin in vol. 2, pp. 268–270.

58. Another mark of Benton's influence on Pollock's career is the attention Pollock devoted to the Renaissance and baroque masters. Michael Leja has noted the relationship between images Pollock made in 1939 and 1940, a time when he was exploring the role of the unconscious in his art, and drawings the artist made after Rubens. (See Leja, *Reframing Abstract Expressionism*, p. 134.) During the thirties Benton and Pollock developed a very close personal as well as professional relationship. Pollock became close to Benton's entire family, including his wife Rita and son T. P. For a detailed account of Benton and Pollock's relationship, see Steven Naifeh and Gregory White Smith, *Jackson Pollock: An American Saga* (New York: Clarkson N. Potter, 1989).

59. Pollock's contribution to Benton's exhibition is described in "Benton, Historian of 'Backwood America,'" *Art Digest* 12 (November 1, 1937),

p. 7. This article misidentifies the title of the painting as *Threshing*, and Pollock himself as one of Benton's Missouri students. For a commentary on this exhibition, see Erika Doss, *Benton, Pollock, and the Politics of Modernism: From Regionalism to Abstract Expressionism* (Chicago and London: University of Chicago Press, 1991), p. 326.

60. Jackson Pollock, "Jackson Pollock [a questionnaire]," *Arts & Architecture* 61 (February 14, 1944), p. 14. Five years later *Life* magazine characterized Pollock's drip paintings as explicitly opposed to Benton's "realist" works. In an article provocatively entitled "Jackson Pollock: Is He the Greatest Living Painter in the United States?" *Life* 27 (August 8, 1949, p. 45), the magazine noted that Pollock "studied in New York under Realist Thomas Benton but soon gave this up in utter frustration and turned to his present style."

61. Greenberg, *Collected Essays*, vol. 4, p. 45. Greenberg would note Benton's influence on the painter in 1961 and again in 1967; see vol. 4, pp. 109, 245.

62. Greenberg, *Collected Essays*, vol. 2, p. 64.

63. James Johnson Sweeney, foreword to "Jackson Pollock: Paintings and Drawing," Art of This Century, November 9–27, 1943. This catalogue is reproduced in Francis V. O'Connor and Eugene V. Thaw, eds., *Jackson Pollock: A Catalogue Raisonné of Paintings, Drawings, and Other Works* (New Haven and London: Yale University Press, 1978), vol. 4, p. 230.

64. See Jackson Pollock to James Johnson Sweeney, November 3, 1943, in O'Connor and Thaw, eds., *Pollock Catalogue Raisonné*, document 50, vol. 4, p. 230. The collection information and exhibition history of *Conflict* is given in entry #91 of the catalogue. Both this painting and Sweeney's essay would reappear in an exhibition of Pollock's works held at The Arts Club of Chicago (March 3–31, 1945).

65. Greenberg, *Collected Essays*, vol. 1, p. 166.

66. See the entry for item #84 of the Pollock *Catalogue Raisonné*.

67. Manny Farber, "Jackson Pollock," *New Republic* 112 (June 25, 1945), p. 871.

68. Greenberg, *Collected Essays*, vol. 2, pp. 74–75.

69. In his essay "Towards a Newer Laocoon," *Partisan Review* (July-August 1940), Greenberg had advocated the "acceptance, willing acceptance, of the limitations of the medium of the specific art." This essay is reproduced in *Collected Essays*, vol. 1, p. 32.

70. Clement Greenberg, "L'art américain au XXe siècle," *Les Temps Modernes* (August/September 1946), p. 350.

71. Greenberg, *Collected Essays*, vol. 2, p. 166. Later in this essay Greenberg would also reference Nietzsche's *The Birth of Tragedy.*

72. For Greenberg's association of the Gothic with surrealism, see *Collected Essays*, vol. 1, p. 226.

73. James Thrall Soby and Dorothy C. Miller, *Romantic Painting in America* (New York: Museum of Modern Art, 1943).

74. In 1924 Read edited *Speculations,* a collection of essays by the British critic and philosopher T. E. Hulme which included a lengthy summary of the main premises of *Abstraction and Empathy.* (T. E. Hulme, "Modern Art," *Speculations: Essays on Humanism and the Philosophy of Art,* ed. Herbert Read [London: Kegan Paul, 1924], pp. 82–90.) Worringer recapitulated his formulation of these discursive constructs in *Form in Gothic,* a work that Read translated and introduced in 1927. (Wilhelm Worringer, *Form in Gothic,* trans. Herbert Read [London: G. P. Putnam's Son, 1912].) In addition, Lionello Venturi briefly discussed Worringer's notion of empathy in *History of Art Criticism,* trans. Charles Marriott (New York: E. P. Dutton & Co., 1936), p. 274.

75. Wilhelm Worringer, *Abstraction and Empathy: A Contribution to the Psychology of Style,* trans. Michael Bullock (1908; New York: International Universities Press, 1980).

76. While clearly indebted to Worringer, Greenberg's interpretation of Pollock was also undoubtedly influenced by the artist's own works. One of Pollock's earliest abstract images is a painting entitled *Gothic* (1944). A slightly later picture, which Greenberg particularly admired, bears the related title *Cathedral* (1947).

77. Greenberg's notion of the Gothic was not without its own capacity to connote gendered excess. As T. J. Clark has written, "Again, I do not want for a moment to suggest that Pollock's art ever stopped being Gothic; and the heart of its Gothic-ness, clearly, was its veering between sexual rage and euphoria." See T. J. Clark, *Farewell to an Idea: Episodes from a History of Modernism* (New Haven and London: Yale University Press, 1999), p. 358.

78. As John O'Brian has pointed out, Kant's theories were so influential for Greenberg that the critic prominently featured the "Critique of Aesthetic Judgment" (part of the 1790 *Critique of Judgment*) in a course on critical method that he taught at Black Mountain College in North Carolina in 1950. See John O'Brian, introduction to Greenberg, *Collected Essays,* vol. 3, pp. xxii, 287. By 1960 Greenberg explicitly identified the Kantian roots of his conception of modernism. As the critic wrote, "I identify Modernism with the intensification, almost the exacerbation, of this self-critical tendency that began with the philosopher Kant. Because he was the first to

criticize the means itself of criticism, I conceive of Kant as, the first real Modernist." Clement Greenberg, "Modernist Painting" (*Forum Lectures*, 1960), in *Collected Ess*ays, vol. 4, p. 85.

79. See Immanuel Kant, *Critique of Judgment*, Part I, Section 9, in Carl J. Friedrich, ed., *The Philosophy of Kant: Immanuel Kant's Moral and Political Writings* (New York: Modern Library, 1993), p. 312.

80. Kant, *Critique of Judgment*, pp. 311–312.

81. Kant, *Critique of Judgment*, pp. 314–315.

82. Kant, *Critique of Judgment*, p. 328.

83. Christine Battersby, *The Phenomenal Woman: Feminist Metaphysics and the Patterns of Identity* (New York and London: Routledge, 1998), p. 66. Battersby further points out that, within the history of Western metaphysics, it is the male self that is privileged as unitary and contained (p. 57).

84. Greenberg, *Collected Essays*, vol. 3, p. 105.

85. Greenberg, *Collected Essays*, vol. 3, p. 106.

86. Anne M. Wagner discusses the complex construction of Lee Krasner's artistic identity at length in her study *Three Artists (Three Women): Modernism and the Art of Hesse, Krasner, and O'Keeffe* (Berkeley and Los Angeles: University of California Press, 1996), chapter 3. For a related analysis of Krasner's work and the construction of feminine subjectivity in the abstract expressionist movement, see my essay "Krasner and Pollock: Touching and Transcending the Margins of Abstract Expressionism" in Roger M. Buergel and Stefanie-Vera Kockot, eds., *Abstrakter Expressionismus: Konstruktionen ästhetischer Erfahrung* (Dresden and Amsterdam: Verlag der Kunst, 2000), pp. 145–154.

87. Greenberg, *Collected Essays*, vol. 2, pp. 269, 270.

88. Clement Greenberg, *Art and Culture* (Boston: Beacon Press, 1961), p. 183.

89. Marin's statement is reproduced in Norman, *Selected Writings*, p. 216.

90. John Marin, foreword to Helm, *John Marin*, n.p.

91. John Marin, "An Artist's Testament," letter to Louis Kalonyme, July 7, 1953, Louis Kalonyme Papers, Archives of American Art, Smithsonian Institution, reel 2814, frames 220–222.

92. Quoted in Helm, *John Marin*, p. 101.

93. Helm, *John Marin*, p. 102.

94. Quoted in Helm, *John Marin*, p. 103.

95. Marin's statement appeared in a catalogue for an exhibition at the Downtown Gallery, April 1949. A copy of this statement is reprinted in Norman, *Selected Writings*, p. 230.

96. Quoted in Norman, *Encounters*, p. 288.

97. Dorothy Norman, "The Writings of Marin," *Artnews* 48 (October 1949), p. 42.

98. Jackson Pollock, "My Painting," *Possibilities* 1 (Winter 1947–1948). This statement is reproduced in *Jackson Pollock* (New York: Museum of Modern Art Bulletin 24, 1956–1957), p. 33.

99. Jackson Pollock, interview with William Wright, taped in 1950 and broadcast on radio station WERI in Westerly, Rhode Island, in 1951. A transcript of this interview is reproduced in the Pollock *Catalogue Raisonné*, document 87, p. 251.

100. Regarding the historical and theoretical significance of these photographs, see Barbara Rose, ed., *Pollock Painting* (New York: Agrinde Publications, 1980).

101. For a discussion of the performative dimensions of Pollock's artistic practice and their implications for both the criticism of Clement Greenberg and Harold Rosenberg, see Amelia Jones, *Body Art/Performing the Subject* (Minneapolis and London: University of Minnesota Press, 1998), chapter 2.

102. For an extended discussion of this painting, see Clark, *Farewell to an Idea*, chapter 6.

103. Michael Leja has generously shared with me this account of the process by which *Number 1* was made, as related by the conservator Carol Mancusi-Ungaro.

104. The fusion of signature and paint stroke that I describe reiterates a central trope of formalist criticism. Recall the presence of this theme in Charles Demuth's essay "Across a Greco Is Written," as discussed in chapter 7.

105. In contrast to these formal operations, Briony Fer has argued that works in which Pollock cuts away at his painted surfaces, such as *Out of the Web*, serve to foreground issues of damage and violence in Pollock's art. Fer has asserted that the mutilation of the canvas represents a "cut" in the spectator's field of vision, leaving vision no longer unified but "castrated." See Briony Fer, *On Abstract Art* (New Haven and London: Yale University Press, 1997), pp. 94–107.

106. It is precisely this collapse of boundaries between the corporeal presence of the artist and the formal and iconographic structures of his paintings that Michael Fried theorizes in his (much later) account of Gustave Courbet. In *Courbet's Realism*, Fried summarizes his project by stating: "In the chapters that follow I repeatedly suggest that central, foreground figures depicted from the rear are in various respects surrogates for the painter (or, as I shall chiefly say, the painter-beholder) and moreover that they evoke the possibility of quasi-corporeal merger between the painter-beholder and themselves." See Michael Fried, *Courbet's Realism* (Chicago and London: University of Chicago Press, 1990), pp. 47–48. Interestingly,

Fried's discussion of Courbet may have its roots in an earlier discursive tradition that encompassed both Pollock's self-descriptions and Greenberg's embodied formalist accounts of the artist.

107. Jackson Pollock, "My Painting."

108. For a discussion of the complex ways in which seemingly contrary impulses in Pollock's paintings, including those of control and uncontrol, chaos and order, subjective unity and fragmentation, and conceptions of inner and outer man, relate to contemporary discourses on modern man, see Leja, *Reframing Abstract Expressionism*, chapter 5.

109. Regarding the structuring of Pollock's works, Ann Eden Gibson has pointed out that Leon Bocour, Pollock's paint supplier, remembered seeing charcoal outlines delineating the early stages of Pollock's large abstract paintings. See Ann Eden Gibson, *Abstract Expressionism: Other Politics* (New Haven and London: Yale University Press, 1997), p. 5. Kirk Varnedoe has similarly noted that "in his fully developed drip method, [Pollock] may sometimes have started with a loosely cartooned figure or animal, using familiar motions of rendering like an athlete doing warm-ups or a musician running scales; but he then built more free-form returns over this opening matrix as a way of dissolving the imagery into abstraction." See Varnedoe, "Comet," p. 49. See also Pepe Karmel's essay in this catalogue, "Pollock at Work: The Films and Photographs of Hans Namuth," especially pp. 107–111.

110. Pollock to Wright in O'Connor and Thaw, eds., *Pollock Catalogue Raisonné*, document 87, vol. 4, p. 251. The painter Kenneth Noland expressed his admiration for the degree of control that Pollock exercised in his "one-shot" painting technique. Noland's comments are reproduced in Florence Rubenfeld, *Clement Greenberg: A Life* (New York: Scribner's, 1997), p. 162. To be sure, other artists and critics questioned Pollock's ability to control his paint flows in more or less insulting terms. For a summary of these opinions, see Anna C. Chave, "Pollock and Krasner: Script and Postscript," *Res* 24 (Autumn 1993), pp. 95–111.

111. Jackson Pollock to *Time* magazine, December 11, 1950.

112. Robert M. Coates, "The Art Galleries: Extremists," *New Yorker* (December 9, 1950), p. 110.

113. McBride's comments are reprinted in "Our Box Score of the Critics," *Artnews* 46 (February 1948), p. 46.

114. Greenberg, *Art and Culture*, p. 169.

115. For a different account of the relationship between corporeality and transcendence in Greenberg's critical discussions of Pollock, see chapter 6 of Rosalind E. Krauss, *The Optical Unconscious* (Cambridge, MA and London: MIT Press, 1993).

*Selected Bibliography*

**Primary Sources**

Archives of American Art, Smithsonian Institution, Washington, D.C. The Papers of Thomas Hart Benton, Sheldon Cheney, Louis Kalonyme, Henry McBride, Elizabeth McCausland, the New York Public Library, the Newark Museum, Forbes Watson, and the Whitney Museum of American Art.

Dartmouth College Library, Hanover, New Hampshire. The Papers of James Gibbons Huneker.

The Charles Demuth Foundation, Lancaster, Pennsylvania. The Papers of Charles Demuth.

The John Hay Library, Brown University, Providence, Rhode Island. The Harris Collection of American Literature.

The New-York Historical Society, New York, New York. The Albert Eugene Gallatin Papers.

Special Collections, Vassar College Libraries, Poughkeepsie, New York. The Papers of Paul Rosenfeld.

Yale Collection of American Literature, Beinecke Rare Book and Manuscript Library, Yale University, New Haven, Connecticut. The Archives of Thomas Hart Benton, Charles Demuth, Arthur Dove, Waldo Frank, Marsden Hartley, Stanton Macdonald-Wright, Henry McBride, Lewis Mumford, Paul Rosenfeld, Herbert J. Seligmann, Alfred Stieglitz/Georgia O'Keeffe, and Rebecca Strand.

## Secondary Sources

Abrahams, Edward. *The Lyrical Left: Randolph Bourne, Alfred Stieglitz, and the Origins of Cultural Radicalism in America.* Charlottesville: University Press of Virginia, 1986.

Adams, Henry. *The Education of Henry Adams: An Autobiography.* Boston: Houghton Mifflin Co., 1927.

Adams, Henry. *Thomas Hart Benton: An American Original.* New York: Alfred A. Knopf, 1989.

*Aesthete* 1 (New York, February 1925): 21.

Allara, Pamela Edwards. "The Watercolor Illustrations of Charles Demuth." Ph.D. diss., Johns Hopkins University, 1970.

*American Paintings and Sculpture in the University Art Museum Collection.* Minneapolis: University of Minnesota Press, 1986.

Anderson, Sherwood. "Alfred Stieglitz." *The New Republic* 35 (October 25, 1922): 215.

———. "Four American Impressions." *The New Republic* 32 (October 11, 1922): 171–173.

———. *Sherwood Anderson's Notebook.* New York: Boni and Liveright, 1926.

"Are These Men the Best Painters in America Today?" *Look* 12 (February 3, 1948): 44.

"Art." *Time* 24 (December 24, 1934): 25.

"Art: The Best?" *Time* 50 (December 1, 1947): 55.

Baigell, Matthew, ed. *A Thomas Hart Benton Miscellany: Selections from His Published Opinions, 1916–1960.* Lawrence: University Press of Kansas, 1971.

Balken, Debra Bricker, et al. *Arthur Dove: A Retrospective.* Cambridge, MA and London: MIT Press, 1997.

Barnes, Djuna. *Nightwood.* New York: Harcourt, Brace & Co., 1937.

Barr, Alfred H., Jr. *Cubism and Abstract Art.* Cambridge, MA and London: Belknap Press, 1986.

————. *John Marin: Watercolors, Oil Paintings, Etchings.* New York: Museum of Modern Art, 1936.

Battersby, Christine. *The Phenomenal Woman: Feminist Metaphysics and the Patterns of Identity.* New York and London: Routledge, 1998.

Bender, Thomas. *New York Intellect: A History of Intellectual Life in New York City, from 1750 to the Beginnings of Our Own Time.* New York: Alfred A. Knopf, 1987.

Benson, E. M. *John Marin: Watercolors, Oil Paintings, Etchings.* New York: Museum of Modern Art, 1936.

Benstock, Shari. *Women of the Left Bank, Paris, 1900–1940.* Austin: University of Texas Press, 1986.

Benton, Thomas Hart. "America and/or Alfred Stieglitz." *Common Sense* 4 (January 1935): 22–24.

————. *An Artist in America.* New York: Robert M. McBride & Company, 1937.

————. *The Arts of Life in America.* New York: Whitney Museum of American Art, 1932.

"Benton, Historian of 'Backwood America.'" *Art Digest* 12 (November 1, 1937): 7.

Bersani, Leo. *The Freudian Body: Psychoanalysis and Art.* New York: Columbia University Press, 1986.

————. *Homos.* Cambridge, MA and London: Harvard University Press, 1995.

Bersani, Leo, and Ulysse Dutoit. *The Forms of Violence: Narrative in Assyrian Art and Modern Culture.* New York: Schocken Books, 1985.

Biel, Steven. *Independent Intellectuals in the United States, 1910–1945.* New York and London: New York University Press, 1992.

Blake, Casey Nelson. *Beloved Community: The Cultural Criticism of Randolph Bourne, Van Wyck Brooks, Waldo Frank, and Lewis Mumford*. Chapel Hill and London: University of North Carolina Press, 1990.

Boyd, Ernest. "Aesthete: Model 1924." *The American Mercury* 1 (January 1924): 51–56.

Brennan, Marcia. "Krasner and Pollock: Touching and Transcending the Margins of Abstract Expressionism." In Roger M. Buergel and Stefanie-Vera Kockot, eds., *Abstrakter Expressionismus: Konstruktionen ästhetischer Erfahrung*. Dresden and Amsterdam: Verlag der Kunst, 2000.

Brooks, Van Wyck. *America's Coming of Age*. New York: B. W. Huebsch, 1915.

———. *Days of the Phoenix: The Nineteen-Twenties I Remember*. New York: E. P. Dutton & Co., 1957.

Brown, Jonathan. "El Greco, the Man and the Myths." In *El Greco of Toledo*. Boston: Little, Brown and Company, 1982.

———. "The Redefinition of El Greco in the Twentieth Century." *Studies in the History of Art*, vol. 13. Washington, DC: National Gallery of Art, 1984.

Bürger, Peter. *Theory of the Avant-Garde*. Trans. Michael Shaw. Minneapolis: University of Minnesota Press, 1984.

Burke, Kenneth. "Dada, Dead or Alive." *Aesthete* 1 (New York, February 1925): 25.

Butler, Judith. *Bodies that Matter: On the Discursive Limits of "Sex."* New York and London: Routledge, 1993.

———. *Gender Trouble: Feminism and the Subversion of Identity*. New York and London: Routledge, 1990.

Camfield, William. *Francis Picabia: His Art, Life and Times*. Princeton: Princeton University Press, 1979.

———. *Marcel Duchamp: Fountain*. Houston: The Menil Collection and Houston Fine Art Press, 1989.

Camhi, Leslie. "Did Duchamp Deceive Us?" *Artnews* 98 (February 1999): 98–102.

Carrier, David. *Principles of Art History Writing*. University Park, PA: Pennsylvania State University Press, 1991.

*Catalogo, XXV Biennale di Venezia*. Venezia: Alfieri Editore, 1950.

Champa, Kermit S. "Charlie Was Like That." *Artforum* 12 (March 1974): 54–59.

———. "The Wise or Foolish Virgin." In *Over Here! Modernism: The First Exile, 1914–1919*. Providence: David Winton Bell Gallery, 1989.

*Charles Demuth Memorial Exhibition*. New York: Whitney Museum of American Art, 1937.

Chauncey, George. *Gay New York: Gender, Urban Culture, and the Making of the Gay Male World, 1890–1940*. New York: Basic Books, 1994.

Chave, Anna C. *Constantin Brancusi: Shifting the Bases of Art*. New Haven and London: Yale University Press, 1993.

———. "O'Keeffe and the Masculine Gaze." In Marianne Doezema and Elizabeth Milroy, eds., *Reading American Art*. New Haven and London: Yale University Press, 1998.

———. "Pollock and Krasner: Script and Postscript." *Res* 24 (Autumn 1993): 95–111.

Cheney, Sheldon. *Expressionism in Art*. New York: Liveright Publishing Corporation, 1934.

———. *A Primer of Modern Art*. New York: Boni and Liveright, 1924.

Chipp, Herschel B. *Theories of Modern Art*. Berkeley and Los Angeles: University of California Press, 1984.

Clark, T. J. *Farewell to an Idea: Episodes from a History of Modernism*. New Haven and London: Yale University Press, 1999.

Clifford, Henry, and Carl Zigrosser. *History of An American, Alfred Stieglitz: "291" and After*. Philadelphia: Philadelphia Museum of Art, 1944.

Coates, Robert M. "The Art Galleries." *New Yorker* (January 17, 1948): 57.

———. "The Art Galleries: Extremists." *New Yorker* (December 9, 1950): 110.

———. "The Art Galleries: Mostly Women." *New Yorker* (May 25, 1946): 73, 75.

Corn, Wanda M. "Apostles of the New American Art: Waldo Frank and Paul Rosenfeld." *Arts Magazine* 54 (February 1980): 159–163.

———. *The Great American Thing: Modern Art and National Identity, 1915–1935*. Berkeley and Los Angeles: University of California Press, 1999.

Cowart, Jack, et al. *Georgia O'Keeffe: Art and Letters*. Washington: National Gallery of Art and New York Graphic Society Books, 1987.

Crane, Hart. "Anointment of Our Well Dressed Critic." *The Little Review* 9 (Winter 1922): 23.

Craven, Thomas. "American Men of Art." *Scribner's* 92 (November 1932): 266, 466.

—. *Men of Art.* New York: Simon and Schuster, 1931.

—. *Modern Art: The Men, the Movements, the Meaning.* New York: Simon and Schuster, 1940.

M. D. "The Climax of Hartley's Painting in Powerful Coastal Scenes." *Artnews* 37 (March 26, 1938): 21.

Dean, Carolyn J. *Sexuality and Modern Western Culture.* New York: Twayne Publishers, 1996.

De Casseres, Benjamin. "The Great American Sexquake." *The International* 8 (June 1914): 195.

De Duve, Thierry. *Clement Greenberg between the Lines.* Trans. Brian Holmes. Paris: Editions dis Voir, 1996.

—. *Kant after Duchamp.* Cambridge, MA and London: MIT Press, 1996.

—. *Pictorial Nominalism: On Marcel Duchamp's Passage from Painting to the Readymade.* Trans. Dana Polan. Minneapolis: University of Minnesota Press, 1991.

D'Emilio, John. *Sexual Politics, Sexual Communities: The Making of a Homosexual Minority in the United States, 1940–1970.* Chicago and London: University of Chicago Press, 1983.

D'Emilio, John, and Estelle B. Freedman. *Intimate Matters: A History of Sexuality in America.* New York: Harper & Row, 1988.

Demuth, Charles. "Across a Greco Is Written." *Creative Art* 5 (September 1929): 629, 634.

De Zayas, Marius. *How, When, and Why Modern Art Came to New York.* Ed. Francis M. Naumann. Cambridge, MA and London: MIT Press, 1996.

—. *291* 5–6 (July–August 1915): 6.

Dijkstra, Bram. *The Hieroglyphics of a New Speech: Cubism, Stieglitz, and the Early Poetry of William Carlos Williams.* Princeton: Princeton University Press, 1969.

—. *Idols of Perversity: Fantasies of Feminine Evil in Fin-de-Siècle Culture.* New York and Oxford: Oxford University Press, 1986.

Doss, Erika. *Benton, Pollock, and the Politics of Modernism: From Regionalism to Abstract Expressionism.* Chicago and London: University of Chicago Press, 1991.

Douglas, Ann. *Terrible Honesty: Mongrel Manhattan in the 1920s.* New York: Farrar, Straus and Giroux, 1995.

Dreier, Katherine S., and [Roberto] Matta Echaurren. *Duchamp's Glass: An Analytical Reflection.* New York: Société Anonyme, 1944.

Du Bois, Guy Pène. "Water-Color—A Weapon of Wit: Art Critics Dispute the Diabolic Delicacies of Charles Demuth's Brush." *Current Opinion* 66 (January 1919): 51–53.

Duchamp, Marcel. *The Writings of Marcel Duchamp.* Ed. Michel Sanouillet and Elmer Peterson. New York: Oxford University Press, 1973.

Eddy, Arthur Jerome. *Cubists and Post-Impressionism.* Chicago: A. C. McClurg & Co., 1914.

Eisler, Benita. *O'Keeffe and Stieglitz: An American Romance.* New York: Doubleday, 1991.

Eldredge, Charles C. *Georgia O'Keeffe: American and Modern.* New Haven and London: Yale University Press, 1993.

Ellis, Havelock. *The Dance of Life.* Boston and New York: Houghton Mifflin, 1923.

———. *Studies in the Psychology of Sex.* 4 vols. Philadelphia: F. A. Davis and Co., 1927.

"Evolution of Thomas Hart Benton as an Artist." *Life* 6 (April 24, 1939): 70–71.

Farber, Manny. "Jackson Pollock." *New Republic* 112 (June 25, 1945): 871.

Farnham, Emily. "Charles Demuth: His Life, Psychology, and Works." Ph.D. diss, Ohio State University, 1959.

"The Female of the Species Achieves a New Deadliness." *Vanity Fair* 18 (July 1922): 50.

Fer, Briony. *On Abstract Art.* New Haven and London: Yale University Press, 1997.

Ferguson, Gerald. *Marsden Hartley and Nova Scotia.* Halifax, Nova Scotia: Mount Saint Vincent University Art Gallery, 1987.

Fiedler, Conrad. *On Judging Works of Visual Art.* Berkeley and Los Angeles: University of California Press, 1957.

Flint, Ralph. "'291' Again!" *"It Must Be Said"* 7. New York: An American Place, October 1937.

*The Forum Exhibition of Modern American Painters.* New York: M. Kennerley, 1916.

Foucault, Michel. *The History of Sexuality.* Trans. Robert Hurley. New York: Vintage Books, 1990.

Frank, Robin Jaffee. *Charles Demuth: Poster Portraits 1923–1929.* New Haven: Yale University Art Gallery, 1994.

Frank, Waldo. "The Art of Arthur Dove." *The New Republic* 45 (January 27, 1926): 269.

————. *Our America.* New York: Boni and Liveright, 1919.

————. *The Re-discovery of America: An Introduction to a Philosophy of American Life.* New York and London: Charles Scribner's Sons, 1929.

Frank, Waldo, et al., eds. *America & Alfred Stieglitz: A Collective Portrait.* New York: Doubleday, Doran & Company, 1934.

Frankfurter, Alfred M. "American Art Abroad." *Artnews* 48 (October 1949): 20.

————. "International Report." *Artnews* 49 (September 1950): 57.

Freud, Sigmund. *The Interpretation of Dreams.* Trans. James Strachey. New York: Basic Books, 1965.

————. *Three Essays on the Theory of Sexuality.* Trans. James Strachey. New York: Basic Books, 1975.

Fried, Michael. *Courbet's Realism.* Chicago and London: University of Chicago Press, 1990.

Friedman, B. H. *Jackson Pollock: Energy Made Visible.* New York: Da Capo Press, 1995.

Fry, Roger. *Vision and Design.* New York: Times Mirror Company, 1974.

Fulton, Deogh. "Cabbages and Kings." *International Studio* 81 (May 1925): 146.

Fuss, Diana. *Essentially Speaking: Feminism, Nature and Difference.* New York and London: Routledge, 1989.

Gallatin, A. E. *American Water-Colourists.* New York: E. P. Dutton, 1922.

————. *Charles Demuth.* New York: William Edwin Rudge, 1927.

Gallup, Donald, ed. *The Flowers of Friendship.* New York: Octagon, 1979.

Gerber, David A. "Anti-Semitism." *Encyclopedia of American Social History.* New York: Charles Scribner's Sons, 1993.

Gibbs, Jo. "The Modern Honors First Woman—O'Keeffe." *Art Digest* 20 (June 1, 1946): 6.

Gibson, Ann Eden. *Abstract Expressionism: Other Politics.* New Haven and London: Yale University Press, 1997.

Goodnough, Robert. "Pollock Paints a Picture." *Artnews* 50 (May 1951): 38–41, 60–61.

Grad, Bonnie L. "Georgia O'Keeffe's Lawrencean Vision." *Archives of American Art Journal* 38 (2000): 2–19.

Greenberg, Clement. "L'art américain au XXe Siècle." *Les Temps Modernes* (August/September 1946): 340–352.

————. *Art and Culture.* Boston: Beacon Press, 1961.

————. *The Collected Essays and Criticism.* Ed. John O'Brian. 4 vols. Chicago and London: University of Chicago Press, 1986–1993.

Greenough, Sarah, and Juan Hamilton. *Alfred Stieglitz: Photographs & Writings.* Washington, DC: National Gallery of Art, 1983.

Grosz, Elizabeth. *Volatile Bodies: Toward a Corporeal Feminism.* Bloomington and Indianapolis: Indiana University Press, 1994.

Guilbaut, Serge. *How New York Stole the Idea of Modern Art: Abstract Expressionism, Freedom, and the Cold War.* Trans. Arthur Goldhammer. Chicago and London: University of Chicago Press, 1983.

Hagen, Angela E. "Around the Galleries: Demuth Watercolors and Oils at 'An American Place.'" *Creative Art* 8 (June 1931): 442–443.

Hale, Nathan G., Jr. *The Rise and Crisis of Psychoanalysis in the United States: Freud and the Americans, 1917–1985.* New York and Oxford: Oxford University Press, 1995.

Hapgood, Hutchins. *A Victorian in the Modern World.* New York: Harcourt, Brace, 1939.

Hartley, Marsden. *Adventures in the Arts: Informal Chapters on Painters, Vaudeville, and Poets.* New York: Boni and Liveright, 1921.

————. "Art—and the Personal Life." *Creative Art* 4 (June 1928): 31.

————. "Dissertation on Modern Painting." *The Nation* 112 (February 9, 1921): 235–236.

———. "Farewell, Charles: An Outline in Portraiture of Charles Demuth—Painter." In Alfred Kreymborg et al., eds. *The New Caravan.* New York: W. W. Norton, 1936.

———. "A Painter's Faith." *The Seven Arts* 2 (August 1917): 505.

———. "Return of the Native." *The Art Digest* 6 (May 1, 1932): 15.

———. "The Scientific Esthetic of the Red Man." *Art and Archeology* 13 (March 1922): 113–119 and (September 1922): 137–139.

Haskell, Barbara. *Arthur Dove.* San Francisco Museum of Art and the New York Graphic Society, 1974.

———. *Charles Demuth.* New York: Whitney Museum of American Art and Harry N. Abrams, 1987.

Heap, Jane. "Words." *The Little Review* 9 (Autumn 1922): 37–38.

Helm, MacKinley. *John Marin.* New York: Pellegrini & Cudahy, 1948.

Hess, Thomas B. *Abstract Painting.* New York: Viking Press, 1951.

———. "Marin." *Artnews* 46 (January 1948): 25.

Hoffman, Frederick J. *Freudianism and the Literary Mind.* Baton Rouge, LA: Louisiana State University Press, 1945.

Homer, William Inness. *Alfred Stieglitz and the American Avant-Garde.* Boston: New York Graphic Society, 1977.

Huneker, James. *Egoists: A Book of Supermen.* New York: Charles Scribner's Sons, 1909.

———. *Iconoclasts: A Book of Dramatists.* New York: Charles Scribner's Sons, 1905.

———. *Ivory Apes and Peacocks.* New York: Charles Scribner's Sons, 1916.

———. *Painted Veils.* New York: The Modern Library, 1920.

———. *The Pathos of Distance: A Book of a Thousand and One Moments.* New York: Charles Scribner's Sons, 1913.

———. *Unicorns.* New York: Charles Scribner's Sons, 1917.

"Jackson Pollock: Is He the Greatest Living Painter in the United States?" *Life* 27 (August 8, 1949): 42–45.

James, Henry. *The Portable Henry James.* Ed. Morton Dauwen Zabel. New York: Penguin Books, 1979.

Janis, Sidney. *Abstract & Surrealist Art in America*. New York: Reynal & Hitchcock, 1944.

Jay, Martin. *Downcast Eyes: The Denigration of Vision in Twentieth-Century French Thought*. Berkeley and Los Angeles: University of California Press, 1994.

Jewell, Edward Alden. "Alfred Stieglitz and Art in America." *New York Times Book Review* (December 23, 1934): 4.

————. "O'Keeffe: 30 Years: Museum of Modern Art Presents a Full View of Her Work—Other Shows." *New York Times* (May 19, 1946): sec. 2: 6.

*John Marin: A Retrospective Exhibition*. Boston: Institute of Modern Art, 1947.

Jones, Amelia. *Body Art: Performing the Subject*. Minneapolis: University of Minnesota Press, 1998.

Jones, Howard Mumford, ed. *Letters of Sherwood Anderson*. Boston: Little, Brown, and Company, 1953.

Joselit, David. *Infinite Regress: Marcel Duchamp, 1910–1941*. Cambridge, MA and London: MIT Press, 1998.

Josephson, Matthew. "Profiles: Leprechaun on the Palisades." *New Yorker* (March 14, 1942): 26–35.

Kalonyme, Louis. "The Art Makers." *Arts and Decoration* (December 1926): 63, 105, 108.

————. "Georgia O'Keeffe: A Woman in Painting." *Creative Art* 2 (January 1928): xxxv–xl.

————. "John Marin: Promethean." *Creative Art* 4 (September 1928): xl–xli.

Kandinsky, Wassily. *Concerning the Spiritual in Art*. Trans. M. T. H. Sadler. New York: Dover, 1977.

Kant, Immanuel. *The Philosophy of Kant: Immanuel Kant's Moral and Political Writings*. Ed. Carl J. Friedrich. New York: Modern Library, 1993.

Kenton, Edna. "Henry James to the Ruminant Reader: The Turn of the Screw, with Four Drawings by Charles Demuth." *The Arts* 6 (November 1924): 245–255.

Kiefer, Geraldine Wojno. *Alfred Stieglitz: Scientist, Photographer, and Avatar of Modernism, 1880–1913*. New York and London: Garland Publishing, 1991.

Kirstein, Lincoln. "Mural Painting." *Murals by American Painters and Photographers*. New York: Museum of Modern Art, 1932.

Kootz, Samuel M. *Modern American Painters*. New York: Brewer & Warren, 1930.

Krafft-Ebing, Richard von. *Psychopathia Sexualis: A Medico-Forensic Study*. Trans. Harry E. Wedeck. New York: G. P. Putnam's Sons, 1965.

Krauss, Rosalind E. "Alfred Stieglitz's 'Equivalents.'" *Arts Magazine* 54 (February 1980): 34–37.

———. *The Optical Unconscious*. Cambridge, MA and London: MIT Press, 1994.

———. *The Originality of the Avant-Garde and Other Modernist Myths*. Cambridge, MA and London: MIT Press, 1985.

Kreymborg, Alfred. *Troubadour: An Autobiography*. New York: Boni and Liveright, 1925.

Kuenzli, Rudolf E., and Francis M. Naumann, eds. *Marcel Duchamp: Artist of the Century*. Cambridge, MA and London: MIT Press, 1990.

J. W. L. "The Virile Paintings by Marsden Hartley." *Artnews* 38 (March 16, 1940): 15.

Landau, Ellen G. *Jackson Pollock*. New York: Harry N. Abrams, 1989.

———. *Lee Krasner: A Catalogue Raisonné*. New York: Harry N. Abrams, 1995.

Lawrence, D. H. *Studies in Classic American Literature*. New York: Penguin Books, 1977.

Lears, T. J. Jackson. *No Place of Grace: Antimodernism and the Transformation of American Culture, 1880–1920*. New York: Pantheon Books, 1981.

Lee, Vernon. *Beauty and Ugliness and Other Studies in Psychological Aesthetics*. London and New York: John Lane, 1912.

Leja, Michael. *Reframing Abstract Expressionism: Subjectivity and Painting in the 1940s*. New Haven and London: Yale University Press, 1993.

Levin, Gail. *Synchromism and American Color Abstraction, 1910–1925*. New York: Whitney Museum of American Art and George Braziller, 1978.

Levine, Lawrence W. *Highbrow/Lowbrow: The Emergence of Cultural Hierarchy in America*. Cambridge, MA and London: Harvard University Press, 1988.

Lewis, Stephen E. "The Modern Gallery and American Commodity Culture." *Modernism/Modernity* 4 (September 1997): 67–91.

Loeb, Harold A. *The Broom* (January 1922): 381–382.

Lowe, Sue Davidson. *Stieglitz: A Memoir/Biography.* New York: Farrar, Straus, Giroux, 1983.

Ludington, Townsend. *Marsden Hartley: The Biography of an American Artist.* Boston: Little, Brown and Company, 1992.

Lynes, Barbara Buhler. "Georgia O'Keeffe and Feminism: A Problem of Position." In Norma Broude and Mary D. Garrard, eds., *The Expanding Discourse: Feminism and Art History.* New York: HarperCollins, 1992. 436–449.

———. *Georgia O'Keeffe Catalogue Raisonné.* New Haven and London: Yale University Press, 1999.

———. *O'Keeffe, Stieglitz, and the Critics, 1916–1929.* Chicago and London: University of Chicago Press, 1989.

Marin, John. "John Marin by Himself." *Creative Art* 4 (September 1928): 35–39.

———. "Marin Writes." *John Marin: A Retrospective Exhibition.* Boston: Institute of Modern Art, 1947.

Marquis, Alice Goldfarb. *Alfred H. Barr, Jr., Missionary for the Modern.* Chicago and New York: Contemporary Books, 1989.

"Marsden Hartley: He Sees the Mystic Side of American Life." *Pictures on Exhibit* (1942): 110–111.

"Marsden Hartley Holds His 25th Solo Show." *Art Digest* 13 (March 15, 1939): 52.

"Marsden Hartley in Successful Solo Show." *Art Digest* 16 (March 15, 1942): 15.

Mather, Frank Jewett, Jr. *The American Sprit in Art.* New Haven: Yale University Press, 1927.

———. *Books* (May 13, 1934): 1.

May, Henry F. *The End of American Innocence: A Study of the First Years of Our Own Time, 1912–1917.* New York: Alfred A. Knopf, 1959.

McBride, Henry. "Art News and Reviews—Stieglitz's Life Work in Photography." *New York Herald* (February 13, 1921): 5.

———. "Art News and Reviews—Woman as Exponent of the Abstract." *New York Herald* (February 4, 1923): 7.

———. "Demuth: Phantoms from Literature." *Artnews* 49 (March 1950): 18–21.

————. "Exhibitions in New York: Charles Demuth: An American Place." *Artnews* 29 (April 18, 1931): 10.

————. "Georgia O'Keefe's [sic] Recent Work." *New York Sun* (January 14, 1928): 8.

————. "Marin Water-Colors Are on View.—Masterly Art Not Yet Fully Appreciated." *New York Sun* (December 12, 1925).

————. "Modern Art." *The Dial* 70 (January 1921): 113–114.

————. "Mr. Benton Will Leave Us Flat: Is Sick of New York and Explains Why." *New York Sun* (April 12, 1935).

————. "The Stieglitz Group at Anderson's." *New York Sun* (March 14, 1925): 13.

————. "Water-Colours by Charles Demuth." *Creative Art* 5 (September 1929): 634–635.

McDonnell, Patricia. "El Dorado: Marsden Hartley in Imperial Berlin." In *Dictated by Life: Marsden Hartley's German Paintings and Robert Indiana's Hartley Elegies*. Minneapolis: Frederick R. Weisman Art Museum, 1995.

Mellquist, Jerome. *The Emergence of an American Art*. New York: Charles Scribner's Sons, 1942.

————. "Marsden Hartley, Visionary Painter." *The Commonweal* 39 (December 31, 1943): 276–278.

————. Mellquist, Jerome, and Lucie Wiese, eds. *Paul Rosenfeld: Voyager in the Arts*. New York: Creative Age Press, 1948.

Mencken, H. L. "James Huneker." In *A Book of Prefaces*. New York: Alfred A. Knopf, 1917.

————. "The National Letters." In *The American Scene: A Reader*. New York: Vintage Books, 1982.

————. "Puritanism as a Literary Force." *Smart Set* 45 (1915): 153.

Metzger, Robert Paul. "Biomorphism in American Painting." Ph.D. diss., University of California, Los Angeles, 1973.

Miller, Henry. "Stieglitz and Marin." *Twice a Year* 8–9 (1942): 146–155.

Minuit, Peter [Paul Rosenfeld]. "291 Fifth Avenue." *Seven Arts* 1 (November 1916): 61–65.

Moak, Peter van der Huyden. "Cubism and the New World: The Influence of Cubism on American Painting 1910–1920." Ph.D. diss., University of Pennsylvania, 1970.

Morgan, Ann Lee, ed. *Dear Stieglitz, Dear Dove.* Cranbury, NJ: Associated University Presses, 1988.

Mullin, Glen. "Alfred Stieglitz Presents Seven Americans." *The Nation* 120 (May 20, 1925): 578.

Mumford, Lewis. "Autobiographies in Paint." *New Yorker* (January 18, 1936): 48.

———. "Books: General." *New Yorker* (May 12, 1934): 94.

———. "Brancusi and Marin." *New Republic* 49 (December 15, 1926): 112.

———. *The Golden Day: A Study in American Experience and Culture.* New York: Boni & Liveright, 1926.

———. "O'Keefe [sic] and Matisse." *New Republic* 50 (March 2, 1927): 41–42.

Munson, Gorham. "The Mechanics for a Literary Secession." *S4N* 22 (November 1922).

———. "Quality of Readability." *The Bookman* 68 (November 1928): 336–337.

———. "Without Chart and Compass." *The Saturday Review of Literature* 1 (July 4, 1925): 871–872.

Naifeh, Steven, and Gregory White Smith. *Jackson Pollock: An American Saga.* New York: Clarkson N. Potter, 1989.

Naumann, Francis, and Beth Venn. *Making Mischief: Dada Invades New York.* New York: Whitney Museum of American Art, 1996.

Norman, Dorothy. *Alfred Stieglitz: An American Seer.* Millerton, NY: Aperture, 1960.

———. "Alfred Steiglitz [sic] Speaks and Is Overheard." *The Art of Today* 6 (February 1935): 3–4.

———. *Encounters: A Memoir.* New York: Harcourt, Brace, Jovanovich, 1987.

———. ed. *The Selected Writings of John Marin.* New York: Pellegrini & Cudahy, 1949.

———. "The Writings of Marin." *Artnews* 48 (October 1949): 42.

"Obituaries." *Artnews* 45 (August 1946): 9.

O'Connor, Francis V., and Eugene V. Thaw, eds. *Jackson Pollock: A Catalogue Raisonné of Paintings, Drawings, and Other Works.* 4 vols. New Haven and London: Yale University Press, 1978.

O'Keeffe, Georgia. *Georgia O'Keeffe.* New York: Penguin Books, 1977.

————. *Georgia O'Keeffe: A Portrait by Alfred Stieglitz.* New York: Metropolitan Museum of Art, 1978.

————. "Stieglitz: His Pictures Collected Him." *New York Times Magazine* (December 11, 1949): 24–30.

————. "To MSS and Its 33 Subscribers and Others Who Read and Don't Subscribe!" *Manuscripts* 4 (December 1922): 17–18.

Orvell, Miles. *The Real Thing: Imitation and Authenticity in American Culture, 1880–1940.* Chapel Hill and London: University of North Carolina Press, 1989.

"Our Box Score of the Critics." *Artnews* 46 (February 1948): 46.

Pach, Walter. "Art: Brancusi." *The Nation* 123 (December 1, 1926): 566.

Parker, Rozsika, and Griselda Pollock. *Old Mistresses: Women, Art, and Ideology.* New York: Pantheon Books, 1981.

Paul, Sherman. "Paul Rosenfeld." In *Port of New York by Paul Rosenfeld.* Urbana and London: University of Illinois Press, 1966: vii–lvi.

Paz, Octavio. *Marcel Duchamp: Appearance Stripped Bare.* Trans. Rachel Phillips and Donald Gardner. New York: Little, Brown, and Company, 1978.

Peters, Sarah Whitaker. *Becoming O'Keeffe: The Early Years.* New York: Abbeville, 1991.

Phillips, Duncan. *The Artist Sees Differently.* New York: E. Weyhe, 1931.

————. *A Collection in the Making.* Washington, DC: Phillips Memorial Gallery, 1926.

Pollock, Jackson. "Jackson Pollock [a questionnaire]." *Arts & Architecture* 61 (February 14, 1944): 14.

————. "My Painting." *Jackson Pollock.* New York: Museum of Modern Art Bulletin 24 (1956–1957): 33.

Potter, Hugh M. *False Dawn: Paul Rosenfeld and Art in America, 1916–1946.* Ann Arbor: UMI Press for the University of New Hampshire, 1980.

Praz, Mario. *The Romantic Agony.* Trans. Angus Davidson. Oxford and New York: Oxford University Press, 1970.

Pyne, Kathleen. *Art and the Higher Life: Painting and Evolutionary Thought in Late Nineteenth-Century America.* Austin: University of Texas Press, 1996.

"Reaction and Revolution 1900–1930." *Art in America* 53 (August/September 1965): 79.

Read, Helen Appleton. "News and Views on Current Art." *Brooklyn Daily Eagle* (March 15, 1925): 2B.

———. "New York Exhibitions: Seven Americans." *The Arts* 7 (April 1925): 229–231.

Read, Herbert, ed. *Speculations: Essays on Humanism and the Philosophy of Art.* By T. E. Hulme. London: Kegan Paul, 1924.

Rich, Daniel Catton, ed. *The Flow of Art: Essays and Criticism of Henry McBride.* New York: Athenaeum, 1975.

"The Richard Mutt Case." *The Blind Man* 2 (May 1917): 5.

Ritchie, Andrew Carnduff. *Charles Demuth.* New York: Museum of Modern Art and Arno Press, 1969.

Robertson, Bruce. *Marsden Hartley.* Washington, DC: National Museum of American Art and Harry N. Abrams, 1995.

Robinson, Roxana. *Georgia O'Keeffe.* New York: HarperCollins, 1989.

Rodgers, Timothy Robert. "Alfred Stieglitz, Duncan Phillips and the '$6000 Marin'." *Oxford Art Journal* 15 (1992): 54–66.

———. "Making the American Artist: John Marin, Alfred Stieglitz, and Their Critics, 1900–1936." Ph.D. diss., Brown University, 1994.

Rolland, Romain. "America and the Arts." Trans. Waldo Frank. *The Seven Arts* 1 (November 1916): 47–51.

Rose, Barbara, ed. *Pollock Painting.* New York: Agrinde Publications, 1980.

———. *Readings in American Art 1900–1975.* New York: Praeger Publishers, 1975.

Rosenfeld, Paul. "The Academy Opens Its Doors." *The New Republic* 26 (May 4, 1921): 290–291.

———. "Alfred Stieglitz." *The Commonweal* 44 (August 2, 1946): 381.

———. "American Painting." *The Dial* 71 (December 1921): 649–670.

———. "Art: A Defense of Sensibility." *The Nation* 132 (May 6, 1931): 510–512.

———. "Art: An Essay on John Marin." *The Nation* 134 (January 27, 1932): 122–124.

———. "Art: Murals in the Future." *The Nation* 151 (November 16, 1940): 485.

———. *By Way of Art.* New York: Coward-McCann, 1928.

———. "Charles Demuth." *The Nation* 133 (October 7, 1931): 371–373.

———. "Dove and the Independents." *The Nation* 150 (April 27, 1940): 549.

———. "Ex-Reading Room." *The New Republic* 74 (April 12, 1933): 245–246.

———. "John Marin's Career." *The New Republic* 90 (April 14, 1937): 289–292.

———. "Marsden Hartley." *The Nation* 157 (September 18, 1943): 326.

———. *Men Seen: Twenty-Four Modern Authors.* New York: Dial Press, 1925.

———. "Paint and Circuses." *The Bookman* 54 (December 1921): 387.

———. "The Paintings of Georgia O'Keeffe." *Vanity Fair* 19 (October 1922): 56, 112, 114.

———. *Port of New York: Essays on Fourteen American Moderns.* New York: Harcourt, Brace, and Company, 1924.

———. "Stieglitz." *The Dial* 70 (April 1921): 397–409.

———. "The World of Arthur G. Dove." *Creative Art* 10 (June 1932): 426–430.

———. "The Younger Generation and Its Critics." *Vanity Fair* 19 (September 1922): 53, 84, 106.

Rubenfeld, Florence. *Clement Greenberg: A Life.* New York: Scribner, 1997.

Ryan, Susan Elizabeth, ed. *Marsden Hartley: Somehow a Past.* Cambridge, MA and London: MIT Press, 1997.

Santayana, George. "The Genteel Tradition in American Philosophy." In David A. Hollinger and Charles Capper, eds., *The American Intellectual Tradition: A Sourcebook.* New York and Oxford: Oxford University Press, 1993: 97–109.

Schapiro, Meyer. "On Some Problems in the Semiotics of Visual Art: Field and Vehicle in Image-Signs." *Semiotica* 1 (1969): 223–242.

Schwab, Arnold T. *James Gibbons Huneker: Critic of the Seven Arts.* Stanford: Stanford University Press, 1963.

Schwarz, Arturo. *The Complete Works of Marcel Duchamp.* London: Thames and Hudson, 1969.

Scott, Gail R., ed. *On Art by Marsden Hartley*. New York: Horizon Press, 1982.

Search Light [Waldo Frank]. *Time Exposures*. New York: Boni and Liveright, 1926.

Sedgwick, Eve Kosofsky. *Epistemology of the Closet*. Berkeley and Los Angeles: University of California Press, 1990.

Seigel, Jerrold. *The Private Worlds of Marcel Duchamp: Desire, Liberation, and the Self in Modern Culture*. Berkeley and Los Angeles: University of California Press, 1995.

Seligmann, Herbert J. *Alfred Stieglitz Talking: Notes on Some of His Conversations, 1925–1931*. New Haven: Yale University Library, 1966.

————. "American Water Colours in Brooklyn." *International Studio* 74 (December 1921): clx.

————. *D. H. Lawrence: An American Interpretation*. New York: Haskell House, 1971.

————. "The Elegance of Marsden Hartley—Craftsman." *International Studio* 74 (October 1921): lii.

————. "Georgia O'Keeffe, American." *Manuscripts* 5 (March 1923): 10.

————. ed. *Letters of John Marin*. Westport, CT: Greenwood Press, 1970.

————. "A Photographer Challenges." *The Nation* 112 (February 16, 1921): 268.

————. "Port of New York." *The Dial* 76 (June 1924): 544–547.

"7 Americans Open in Venice." *Artnews* 49 (Summer 1950): 20–23, 60.

Silet, Charles L. P. *The Writings of Paul Rosenfeld: An Annotated Bibliography*. New York and London: Garland Publishing, 1981.

Silverman, Debora Leah. *Art Nouveau in Fin-de-Siècle France: Politics, Psychology, and Style*. Berkeley and Los Angeles: University of California Press, 1989.

Silverman, Kaja. *Male Subjectivity at the Margins*. New York and London: Routledge, 1992.

Soby, James Thrall. "The Fine Arts: To the Ladies." *Saturday Review* 29 (July 1946): 14–15.

Soby, James Thrall, and Dorothy C. Miller. *Romantic Painting in America*. New York: Museum of Modern Art, 1943.

Stearns, Harold E., ed. *Civilization in the United States: An Inquiry by Thirty Americans.* New York: Harcourt, Brace and Co., 1922.

Stieglitz, Alfred. "A Statement." *145 Photographs.* New York: Anderson Galleries, 1921.

———. "Four Marin Stories." *Twice a Year* 8–9 (1942): 153–158.

———. "Regarding the Modern French Masters Exhibition: A Letter." *Brooklyn Museum Quarterly* 8 (July 1921): 107–112.

Tashjian, Dickran. *William Carlos Williams and the American Scene, 1920–1940.* New York and Berkeley: Whitney Museum of American Art and the University of California Press, 1978.

Taylor, Francis Henry. "Marin's Letters Overflow with Shrewdness and Faith." *The New York Times Book Review* (December 11, 1949): sec. 7: 1.

Traubel, Horace. "Stieglitz." *The Conservator* 27 (December 1916): 137.

———. "With Walt Whitman in Camden." *The Seven Arts* 2 (1917): 627–637.

*Trois siècles d'art aux Etats-Unis.* Paris: Musée du Jeu de Paume (May-July 1938).

Turner, Elizabeth Hutton. *In the American Grain: The Stieglitz Circle at the Phillips Collection.* Washington, DC: Counterpoint, 1995.

Van Vechten, Carl. "Charles Demuth and Florine Stettheimer." *The Reviewer* 2 (February 1922): 269–270.

Varnedoe, Kirk, and Pepe Karmel. *Jackson Pollock.* New York: Museum of Modern Art, 1998.

Venturi, Lionello. *Art Criticism Now.* Baltimore: Johns Hopkins University Press, 1941.

———. *History of Art Criticism.* Trans. Charles Marriott. New York: E. P. Dutton & Co., 1936.

Wagner, Anne M. *Three Artists (Three Women): Modernism and the Art of Hesse, Krasner, and O'Keeffe.* Berkeley and Los Angeles: University of California Press, 1996.

Watson, Forbes. "Charles Demuth." *The Arts* 3 (January 1923): 78.

———. "Seven American Artists Sponsored by Stieglitz." *The World* (March 15, 1925): 5M.

Watson, Steven. *Strange Bedfellows: The First American Avant-Garde.* New York: Abbeville, 1991.

Weaver, Jane Calhoun, ed. *Sadakichi Hartmann: Critical Modernist*. Berkeley and Los Angeles: University of California Press, 1991.

Weber, Brom, ed. *Hart Crane: A Biographical and Critical Study*. New York: Bodley Press, 1948.

—————. *The Letters of Hart Crane 1916–1932*. New York: Hermitage House, 1952.

Weinberg, Jonathan. *Speaking for Vice: Homosexuality in the Art of Charles Demuth, Marsden Hartley, and the First American Avant-Garde*. New Haven and London: Yale University Press, 1993.

Weiss, Jeffrey. *The Popular Culture of Modern Art: Picasso, Duchamp, and Avant-Gardism*. New Haven and London: Yale University Press, 1994.

Whelan, Richard. *Alfred Stieglitz: A Biography*. Boston: Little, Brown and Company, 1995.

*Whitney Museum of American Art, History, Purpose, and Activities*. New York: Whitney Museum, 1935.

Wight, Frederick S. *Arthur G. Dove*. Berkeley and Los Angeles: University of California Press, 1958.

Williams, William Carlos. "America, Whitman, and the Art of Poetry." *The Poetry Journal* 8 (1917): 31.

—————. *The Autobiography of William Carlos Williams*. New York: Random House, 1951.

—————. *In the American Grain*. New York: New Directions, 1956.

Wilson, Edmund. *The American Earthquake: A Documentary of the Twenties and Thirties*. Garden City, NY: Doubleday, 1958.

—————. *Classics and Commercials: A Literary Chronicle of the Forties*. New York: Farrar, Straus and Company, 1950.

—————. "An Imaginary Conversation: Mr. Paul Rosenfeld and Mr. Matthew Josephson." *The New Republic* 38 (April 9, 1924): 179–182.

—————. "Paul Rosenfeld." *The New Republic* 43 (June 3, 1925): 48.

—————. "The Progress of Psychoanalysis." *Vanity Fair* 16 (August 1920): 86.

—————. *The Shores of Light: A Literary Chronicle of the Twenties and Thirties*. New York: Farrar, Straus, and Young, 1952.

————. *The Triple Thinkers: Twelve Essays on Literary Subjects.* New York: Oxford University Press, 1963.

Wilson, Richard Guy, et al. *The Machine Age in America, 1918–1941.* New York: Brooklyn Museum and Harry N. Abrams, 1986.

Wolfe, Judith. "Jungian Aspects of Jackson Pollock's Imagery." *Artforum* 11 (November 1972): 65–73.

Wölfflin, Heinrich. *Classic Art: An Introduction to the Italian Renaissance.* Trans. Peter and Linda Murray. Ithaca: Cornell University Press, 1952.

————. *Principles of Art History: The Problem of the Development of Style in Later Art.* New York: Dover Publications, 1950.

Wood, Paul, et al. *Modernism in Dispute: Art Since the Forties.* New Haven and London: Yale University Press, 1993.

Worringer, Wilhelm. *Abstraction and Empathy: A Contribution to the Psychology of Style.* Trans. Michael Bullock. New York: International Universities Press, 1980.

————. *Form in Gothic.* Trans. Herbert Read. London: G. P. Putnam's Son, 1927.

Wright, Willard Huntington. *The Creative Will: Studies in the Philosophy and the Syntax of Aesthetics.* New York: John Lane Company, 1916.

————. "Modern Art: Four Exhibitions of the New Style of Painting." *International Studio* 60 (January 1917): xcvii.

————. *Modern Painting: Its Tendency and Meaning.* New York: Dodd, Mead and Company, 1915.

# Index